P9-DMQ-979

the *demon*
—*and*—
the *angel*

BOOKS BY EDWARD HIRSCH

POETRY

For the Sleepwalkers (1981)
Wild Gratitude (1986)
The Night Parade (1989)
Earthly Measures (1994)
On Love (1998)

PROSE

How to Read a Poem and Fall in Love with Poetry (1999)
Responsive Reading (1999)

EDITOR

Transforming Vision: Writers on Art (1994)

EDWARD HIRSCH

the demon
—and—
the angel

SEARCHING FOR THE SOURCE
OF ARTISTIC INSPIRATION

HARCOURT, INC.

New York San Diego London

Requests for permission to make copies of any part
of the work should be mailed to the following address:
Permissions Department, Harcourt, Inc.,
6277 Sea Harbor Drive, Orlando, Florida 32887-6777.

www.HarcourtBooks.com

Library of Congress Cataloging-in-Publication Data
Hirsch, Edward.
The demon and the angel: searching for the source
of artistic inspiration/Edward Hirsch.
p. cm.
Includes bibliographical references and index.
ISBN 0-15-100538-9
1. Creation (Literary, artistic, etc.) I. Title.
BH301.C84 H57 2002
153.3'5—dc21 2001005434

Text set in Simoncini Garamond
Designed by Linda Lockowitz
First edition
A C E G I K J H F D B

Printed in the United States of America

For Philip Levine

Contents

Preface

ART IS BORN FROM STRUGGLE and touches an anonymous center. Art is inexplicable and has a dream-power that radiates from the night mind. It unleashes something ancient, dark, and mysterious into the world. It conducts a fresh light.

These felt thoughts first began to form in my mind more than thirty years ago when I thrilled to the discovery of a lecture on artistic inspiration by the Spanish poet Federico García Lorca, and then stubbornly paired it in my mind with Ralph Waldo Emerson's essay "The Poet." Nothing in my education had suggested that I should put the two pieces together, but for weeks I walked around with the dual provocations—one an intuition of Spanish genius and high Modernism, the other a triumph of American Romanticism—reverberating in my head. Something about Lorca's joyful darkness seemed to counter and match Emerson's ferocious light.

"Whatever has black sounds, has *duende,*" Lorca declared: "These 'black sounds' are the mystery."

"Art is the path of the creator to his work," Emerson affirmed:

Doubt not, O poet, but persist. Say, "It is in me, and shall out." Stand there, baulked and dumb, stuttering and stammering, hissed and hooted, stand and strive, until, at last, rage draw out of thee that *dream*-power which every night

shows thee is thine own; a power transcending all limit and privacy, and by virtue of which a man is the conductor of the whole river of electricity.

This book seeks metaphors for artistic inspiration. It brings together Lorca's black sounds and Emerson's white fire as it tracks the intuitive process—the mysterious force, the volcanic path—that leads from the creator to the finished work.

The Demon and the Angel serves, I hope, as the next chapter after my book *How to Read a Poem and Fall in Love with Poetry.* It takes up where that book left off and suggests that what we choose to call inspiration—a force from within, or below, or above—is also a necessary ingredient in our thinking about art. ("Blessed is the day when the youth discovers that Within and Above are synonyms," Emerson attests in his *Journals.*) There is something rich and strange in all genuine or top-level works of art. This enigmatic power is a crucial element in making art what it is: an irreducible experience, an essential form of being.

Several key figures are interwoven throughout these pages— Emerson and Lorca, Rainer Maria Rilke and W. B. Yeats, Walter Benjamin and Paul Klee, among others—and this study is meant to be, at least in part, a testament to them. These creative spirits serve as guides to the vast precincts that art opens within us.

I begin by characterizing Lorca's notion of duende. The duende gives a local habitation and a name—a Spanish one—to that indefinable force which animates different creators and infuses their deepest efforts. The duende offers us an entranceway. "But there are neither maps nor disciplines to help us find the duende," Lorca said, and yet he has stimulated and incited me to search out the duende in many places, to detect its hidden vibrations whenever possible, to fathom its unfathomable presence. He has been an initiating presence, a Virgilian guide, and I call upon him often for insight, while also daring to widen his focus

and extend his ideas, to apply his vision to a variety of creative figures—especially poets—from different periods of time. It seems worthwhile to tease out some of the implications of his intuitions, especially in relationship to the American arts. As Emerson writes in one of his finest essays, "Circles":

> The one thing which we seek with insatiable desire is to forget ourselves, to be surprised out of our propriety, to lose our sempiternal memory, and to do something without knowing how or why…Nothing great was ever achieved without enthusiasm. The way of life is wonderful: it is by abandonment.

From his Spanish vantage point, Lorca viewed North American culture, perhaps a little naively, through an overly bright Whitman-like lens, and this served to deepen his rage when confronted with the harsh realities of American urban life. It might have been a lesser shock for him had he entered America with Hawthorne or Melville or even with Poe under his arm. Using Lorca's notion of duende as a starting point, I find myself compelled by moments when American art gives up "the optative mood" and takes a downward swerve, a darker turn, when it abandons itself to unknown forces, and suddenly finds itself confronting death itself. Walt Whitman's poem "Out of the Cradle Endlessly Rocking," Martha Graham's ballet *Deaths and Entrances,* Jackson Pollock's black pourings, Robert Johnson's Mississippi blues, Miles Davis's modal approach in *Kind of Blue*—all serve as primary examples.

Lorca has provoked me to find the duende in individual works, and, sometimes, to locate it at particular turning points within these works. The duende is an enabling figure, like Freud's idea of the uncanny or Proust's perception of involuntary memory, because it makes something visible that might otherwise be invisible, that has been swimming under the surface all along. It is

life-giving and life-enhancing. One finds it in works with powerful undertow. It surfaces wherever and whenever a demonic anguish suddenly charges and electrifies a work of art in the looming presence of death.

The duende has a strong kinship with the more universal figure of the demon. It can be traced backward in time to the Greek idea of the *daimon* (or in Latin *daemon,* which forms the etymological link to *demon*). The figure of the *daimon*—of a true undying self—is a distant ancestor of Lorca's duende. W. B. Yeats offers us a guide here, since he worked out an entire mythology around the idea of an internal artistic conflict with one's *daimon.* The relationship between the *daimon,* the demon, and the duende— three external figures (three names) for the artistic night mind— is one of the subjects of this exploration. Another underlying theme is the relationship between reason and unreason, between rational and irrational elements in works of art. A variety of figures—from the Sufi Master Ibn 'Arabī to John Keats and Edgar Allan Poe—offer convincing testimonies to the plasticity of the creative imagination, to the notion of a reverie in which consciousness is still active.

The angel is the necessary counter-figure to the demon, and its luminous presence floods many exemplary works of art. It seems worth investigating what happens when the angel, a pure being, falls out of the celestial spheres (or is evicted) and becomes a terrestrial presence, entering our impure human terrain. Rainer Maria Rilke is a primary model here, an extraordinary modern guide. There are striking likenesses between the rising duende and the falling angel when they enter works of art, yet there is also a key difference. Whereas Lorca's figure bursts up from below, from the earth itself, Rilke's figure descends from above—it drops down from a transcendental source.

The duende (or the demon) and the angel are vital spirits of creative imagination. They are anomalous figures. They come only

when something enormous is at risk, when the self is imperiled and pushes against its limits, when death is possible. They embody an irrational splendor. I have wrestled with them often, and invoke them here with a sense of their enduring power. Awe bears traces of the holy. It is both rapturous and terrifying, because it puts one in the space of the transcendental, the world beyond, and thus also in the presence of death. The demon and the angel are two external figures for a power that dwells deep within us. They are the imagination's liberating agents, who unleash their primal force into works of art.

This book is meant to be a tribute with wings.

Only Mystery

I WISH I HAD BEEN IN Buenos Aires on October 20, 1933, when Federico García Lorca delivered a lecture that he called "Juego y teoría del duende" ("Play and Theory of the Duende"). Lorca was testifying to his own poetic universe, as his biographer Ian Gibson has recognized. It would have been electrifying to hear him, because on that night, addressing the members of the Friends of Art Club, the spirit of artistic mystery entered the room. It moved at the speed of Lorca's voice and burned like incense in the rich air. It was palpable to the audience, as if Lorca had thrown open the windows so that everyone present could hear the primitive wing beats shuddering in the darkness outside. The floor shifted a little under everyone's feet. The lamps trembled. Thinking about it now, sixty-nine years later, I can see the stammering flames leaping off the typescript of Lorca's talk. I feel the ancient heat.

(One month later, at the Buenos Aires PEN Club, Lorca and Pablo Neruda staged a happening at a luncheon in their honor. The two simpatico poets—one from the *Vega* of Granada in southern Spain, the other from a small frontier town in rural southern Chile—used a bullfighting tradition to improvise a speech about the great Nicaraguan poet Rubén Darío, which they delivered alternately from different sides of the table. "Ladies...," Neruda began, "...and gentlemen," Lorca continued: "In bullfighting there

is what is known as 'bullfighting *al alimón,*' in which two toreros, holding one cape between them, outwit the bull together." The virtuoso antiphonal performance at first bewildered and then delighted the audience as the visible spirit of praise started darting back and forth across the room. Darío was the enthralling inventor of Hispanic *modernismo* [a term he coined] who fused Continental Symbolism with Latin American subjects and themes, effecting a fresh musical synthesis—a "musical miracle"—in Spanish-language poetry. He was therefore a poet both of Spain and of the Americas, the Old and the New Worlds, and Lorca and Neruda were magically linking themselves through him, as if by electrical impulses.)

Whoever speaks or writes about the duende should begin by invoking the crucial aid and spirit of this chthonic figure, as Lorca did whenever he read aloud from the manuscript of *Poet in New York*. The Dionysian spirit of art needs to be invited into the room. "Only mystery enables us to live," Lorca wrote at the bottom of one of the drawings he did in Buenos Aires: "Only mystery." It behooves any of us who would meditate on the subject of artistic inspiration to open the doors wide into the night and welcome into the house the spirit of inhabitable awe.

Invoking the Duende

THE AUDIENCE'S SENSE OF expectation as Lorca invoked the duende before a homecoming reading of his New York poems must have been running high. One imagines him sitting at a small table in front of a crowded room in Madrid—confident, charismatic, yet clumsy, vulnerable, "a solitary being for whom solitude was intolerable," as Ernesto Pérez Guerra once put it. (Guerra also observed that Lorca was "social by will and solitary by nature.") He looks serenely at home, but also slightly disheveled, a bit askew. He is secretly preparing to do battle. He shuffles his notes for a talk that is sui generis—part lecture, part memoir, part recital—and then launches in: "Whenever I speak before a large group I always think I must have opened the wrong door," he begins disarmingly—

> Some friendly hands have given me a shove, and here I am. Half of us wander around completely lost, among drop curtains, painted trees, and tin fountains, and just when we think we have found our room or our circle of lukewarm sun, we meet an alligator who swallows us alive, or…an audience, as I have. And today the only show I can offer you is some bitter, living poetry. Perhaps I can lash its eyes open for you.

Lorca was a jubilant hunter of joy who sometimes liked to veer sideways into performance. He knew his New York poems

were a radical departure from his immensely popular *Gypsy Ballads,* the style of which he had left behind, and he suspected they could be notoriously difficult. He needed to conquer the audience. At heart he considered a poetry reading not an entertainment but a struggle, hand-to-hand combat with a complacent mass, an exposure of his very flesh. He was bewildered by indifference. He understood his own vulnerability, and wanted badly to communicate to strangers. "Let us agree that one of man's most beautiful postures is that of St. Sebastian," he said:

> Well then, before reading poems aloud to so many people, the first thing one must do is invoke the *duende.* This is the only way that all of you will succeed at the hard task of understanding metaphors as soon as they arise, without depending on intelligence or on a critical apparatus, and be able to capture, as fast as it is read, the rhythmic design of the poem.

> ("Lecture," *Poet in New York*)

The poet invoked the duende in order to foster a deep and necessary intimacy with an audience. It was a connection he secretly craved, but also feared because of its radical exposure. He sometimes began his talks more frontally, with a moment of absolute purity, of concentrated focus; with a plaintive call, a visible posture of openness and vulnerability. Here is how he began one recital of his recent work:

> I want to summon up all the good will, all the purity of intention I have, because like all true artists I yearn for my poems to reach your hearts and cause the communication of love among you, forming the marvelous chain of spiritual solidarity that is the chief end of any work of art.

This may introduce a poetry reading, but it has the underlying texture of sacred speech, of the quest for spiritual connection.

Poetic Fact

LORCA'S ENIGMATIC NEW POEMS were filled with what he called *hecho poético* (the "poetic fact" or "poetic event"), images that followed a strange inner logic "of emotion and of poetic architecture," metaphors that arose so quickly that in order to be understood they demanded a sympathetic attentiveness, a capacity for rapid association and for structured reverie, and a willing suspension of disbelief. As an example of an *hecho poético,* he cited his well-known love poem "Sleepwalking Ballad," with its radiant refrain: *Verde que te quiero verde* ("Green, how much I want you green"). He said: "If you ask me why I wrote 'a thousand glass tambourines / were wounding the dawn,' I will tell you that I saw them, in the hands of angels and trees, but I will not be able to say more...." Lorca's myriad crystal tambourines wounding the new day are a fresh poetic fact, an extrasensory event that strikes the reader or listener as something that has been creatively added to nature, something beyond natural or even metaphorical description, something visionary.

Lorca's mode of thinking has sometimes been confused with Surrealism, though he rejected psychic automatism as a technique and insisted on "the strictest self-awareness" in his creation of images that have an emotive poetic logic rather than a disembodied rational logic. "If it is true that I am a poet by the grace of God—or of the devil," he told Gerardo Diego in 1932, "I am also a poet

by virtue of technique and effort." Lorca wanted "sharp profiles and visible mystery," and his imagery was meant as an intersecting point of contact between his inner and outer worlds. He also sought a poetry infused with emotion, with the true voice of feeling, and this further distinguished him from the French Surrealists. He said, "The great artists of the south of Spain, whether Gypsy or flamenco, whether they sing, dance, or play, know that no emotion is possible unless the duende comes" (*Deep Song*).

What Lorca meant by the poetic fact seems akin to what Hart Crane meant when he wrote in his essay "General Aims and Theories" of finding "a logic of metaphor" beyond the boundaries of "so-called pure logic." Crane's poems feel drunk with words. He was more interested in associational meanings than in ordinary logic, and characteristically combined unusual and highly connotative words in unexpected and musical ways. He, too, was organizing poems through the "implicit emotional dynamics" of sudden conjunctions, and a concept of duende would have helped readers to follow his associative mode of poetic thinking, his systematic disordering of the senses, his strategic verbal extravagances and collisions, his innovative methods. "Language has built towers and bridges," he concluded, "but itself is inevitably as fluid as always."

The concepts of the "poetic fact" and the "logic of metaphor" hearken back to the way that John Keats exalted poetic thinking freed from habitual trains of thought, from analytic logical procedures. "I am the more zealous in this affair," he wrote in a key letter to Benjamin Bailey in 1817, "because I have never yet been able to perceive how any thing can be known for truth by consequitive reasoning." Keats favored a drifting imaginative logic in his poems, and this fascination with associative drift put him in advance of the Romantic Modernists to come. Such drifting consciousness enacted in poems can never be entirely understood through rational means. "I am certain of nothing but of the

holiness of the Heart's affections and the truth of Imagination," Keats famously declared. "What the imagination seizes as Beauty must be truth." "As for me, I can explain nothing," Lorca said, "but stammer with the fire that burns inside me, and the life that has been bestowed on me" ("Lecture," *Poet in New York*). It was only when the duende was present, he believed, that one could be *sure* of being loved and understood.

A Mysterious Power

LORCA DRAFTED HIS LECTURE about the duende during a two-week journey on the Italian ocean liner *Conte Grande,* and he further revised it after he arrived in Buenos Aires. It was the first of four lectures he delivered to the Friends of Art Club. It was so successful, and the audience demand so great, that he repeated it two weeks later. Lorca was always reluctant to "entomb" his work in publication (his manuscripts mostly had to be dragged out of him by entreating friends), but he trusted the tangible response of live audiences and commonly repeated, and continued to revise, his lectures and readings many times over the years.

I first encountered Lorca's piece in Ben Belitt's version of "The Duende: Theory and Divertissement," which appeared as one of the appendices to his translation of *Poet in New York* (1955). Belitt's useful version was supplanted twenty-five years later by Christopher Maurer's definitive "Play and Theory of the Duende," which was translated from the typewritten manuscript and corrected by the poet, in the Lorca family archives. It is one of the centerpieces of Maurer's stimulating selection of Lorca's essays, lectures, and readings, *Deep Song and Other Prose* (1980). This can also now be supplemented by his richly illustrative little book, an anthology of some of Lorca's relevant poems and prose writings, *In Search of Duende* (1998).

The duende (the etymology comes from *duen de casa,* "lord

of the house") has generally been considered in Spanish folklore something like a household version of the Yiddish *dybbuk* ("a clinging soul"): an imp, a hobgoblin, a sly poltergeist-like trickster who meddles and stirs up trouble. It connects to Gypsy culture, since the Spanish Romany word *duquende* has virtually the same meaning as duende. The spirit may have ridden the rails of the Gypsies moving east. It may also have crossed the ocean with the Spaniards, because the duende haunts the rural households of many Latin American countries as a malign, unruly, and anarchic spirit.

There are two such whimsical sprites in Lorca's play *The Love of Don Perlimplín for Belisa in His Garden,* a work he called a "grotesque" tragedy. They appear as childlike troublemakers who arrive *deus ex machina* at the end of Scene 1. Oddly, they play a kind of metanarrative role, facing the audience from the prompt box, commenting on the action of the play itself, throwing on great blue hoods. They have apparently been busy covering and uncovering things "in this tiny darkness":

SECOND SPRITE: Don Perlimplín, do we help or hinder you?
FIRST SPRITE: Help: because it is not fair to place before the
 eyes of the audience the misfortune of a good man.
SECOND SPRITE: That's true, little friend, for it's not the same
 to say: "I have seen," as "It is said."

It's as if these duendes—tiny Modernist characters, demons of misfortune—are pretending to be forces of dramatic inevitability, Greek fates.

Lorca playfully claimed to have been visited by such a winged figure early one morning in Buenos Aires in 1933. This one was more jubilant. It flew into his hotel room wearing a colorful costume and a pointed hood. As if he were Prospero calling to Ariel, he decided that he could summon the airy spirit back to life and subsequently control its movements. "Do you understand the

consequences," he teasingly asked an Argentine reporter who must have been somewhat bemused, or bewildered, or enchanted. "Can you dare to imagine it…my duende perched on my shoulder as I give my lectures?" One wonders if Lorca, in his own playful way, was summoning up the tangible figure of his inspiration in order to prove that his subject—the duende—was an actual presence, a charmed demon, a motive force.

The duende, then, is first of all a figure of the Spanish folk imagination, a clever sprite, a clinging spirit. But in Andalusia, as Christopher Maurer points out, "the word duende is also applied to the ineffable, mysterious charm of certain gifted people, especially flamenco singers. The Andalusian says that a cantaor *has* duende." The singer who *has* duende is driven and possessed. Thus, while one flamenco glossary defines *duende* as "ghost, demon or spirit in folk music and dancing," another characterizes it as "deep, trance-like emotion," and a third calls it "the indefinable life force that illuminates flamenco performers and listeners." It is both a troublesome spirit and a passionate visitation. It seems to suggest both contact with the depths and access to our higher selves.

Lorca uses the word *duende* in a special Andalusian sense as a term for the obscure power and penetrating inspiration of art. He described it, quoting Goethe on Paganini, as "a mysterious power which everyone senses and no philosopher explains" (*Deep Song*). For him, the concept of duende, which could never be entirely pinned down or rationalized away, was associated with the spirit of earth, with visible anguish, irrational desire, demonic enthusiasm, and a fascination with death. It is an erotic form of dark inspiration. Lorca liked to repeat the legendary Gypsy singer Manuel Torre's statement, "All that has black sounds has duende" (*Deep Song*).

(Lorca claimed that Torre declared when he heard Manuel de

Falla playing his own composition *Nocturno del Generalife* that the classical composer "had more culture in the blood than any man I have ever known" [*Deep Song*]. Torre was practically the first *cantaor* to sing *cante jondo,* or deep song, naturally, from his chest instead of his throat—the flamenco term for it is *voz naturá* ["natural vocal register"]—and Lorca once overheard him saying, "What you must search for, and find, is the black torso of the Pharaoh." Torre believed that the Gypsies originated in Egypt, and Lorca dedicated his poem "Flamenco Vignettes" to "Manuel Torre, '*Niño de Jerez,*' descended from a line of Pharoahs.")

There is an interesting parallel to *duende* in the Spanish and Portuguese term *saudade*—a profoundly bittersweet nostalgia one hears in fado and in Brazilian music. (Whereas we tend to consign a dark nostalgia to the all-encompassing category of sentimentality, thereby trivializing and dismissing it, the Hispanic sensibility has wisely saved it as a poignant and durable feeling relating to the transitoriness of life.) *Duende* and *saudade* are two Hispanic names for something we don't have an official word or term for in English, but can recognize when manifested in music and called back in poetry.

Duende rises through the body. It burns through the soles of a dancer's feet, or expands in the torso of a singer. It courses through the blood and breaks through a poet's back like a pair of wings. It smokes through the lungs; it scorches the voice; it magnetizes the words. It is risky and deathward leaning. "The duende does not come at all unless he sees that death is possible," Lorca says (*Deep Song*). Duende, then, means something like artistic inspiration in the presence of death. It has an element of mortal panic and fear. It has the power of wild abandonment. It speaks to an art that touches and transfigures death, that both woos and evades it, as when Lorca rhythmically concludes his early poem "Malagueña" from his book *Poema del cante jondo* (*Poem of the*

Deep Song): "La muerte / entra y sale, / y sale y entra / la muerte / de la taberna."

> Death
> is coming in and leaving
> the tavern,
> death
> leaving and coming in.

The malagueña is a form of flamenco song (*cante intermedio*) that is not danced but is always accompanied by a guitar. ("Black horses and sinister / people are riding / over the deep roads / of the guitar.") Lorca borrows and adapts the form here to capture the rhythm of death as a palpable but invisible presence entering and leaving through the portal of a common drinking space (a *taberna*), almost like a menacing stranger or a mournful wind. The incantatory quality of the repetition and reversal of *la muerte* coming in and going, going and coming in, gives the rhythmical feeling of death blowing through an endless present.

The Hidden Spirit of Disconsolate Spain

THERE ARE COUNTRIES THAT DRAW the curtains on death, treating it as a finality roped off from the rest of life, Lorca noted, but Spain is a country where the curtains are flung open, the ropes are cut, and death is invited into the room, like the lemon-colored light squeezed from dawn. "A dead man in Spain is more alive as a dead man than any place else in the world," Lorca said (*Deep Song*). Maybe he was right. Lorca considered the duende a vitally Spanish phenomenon. He called his lecture "a simple lesson in the hidden spirit of disconsolate Spain" (*Deep Song*). His goal was to unearth and identify that spirit in Spanish culture, to expose it to the light. He would be its Saint John the Baptist, its trumpeting messenger, its artistic and spiritual advocate.

There is no hierarchy in the arts. Duende can inform any art form, which is to say, as Lorca did, that all the arts are capable of duende, though he himself felt that it found its fullest expression in music, dance, and spoken poetry, "for these arts require a living body to interpret them, being forms that are born, die, and open their contours against an exact present" (*Deep Song*). Lorca wrote from the body, which he trusted as a vehicle for the mobility of art, the vessel of our transformation. He intuited how the body sets the scale for imaginative things. "The body is our mode

of perceiving scale," Susan Stewart writes perceptively in her book *On Longing.* Lorca invariably located the body as the source—the site—of our unconscious understandings.

There are artists who use their bodies to throw themselves into the present tense, who crave precipices. Lorca was powerfully attracted to the dangerous immediacy of duende, the way it becomes scorchingly present, shockingly alive. He trusted how it delivers itself. He believed that audiences from his part of Spain—that is, audiences schooled in its demonic spirit—always recognized its appearance: "All over Andalusia, from the rock of Jaén to the whorled shell of Cádiz, the people speak constantly of the 'duende,' and identify it accurately and instinctively whenever it appears" (*Deep Song*).

Lorca did not have to go far afield to seek out the ancient spirit of death in southern Spain. He found it embodied everywhere around him in the exact present. Indeed, Lorca's hidden spirit was part of the very fabric of a culture that his friend Pedro Salinas, one of the leading Spanish poets of the 1920s and 1930s and an exile, once called "the culture of death." Unlike Rilke, for example, who had to dig far down into the innermost regions of his psyche to unearth his personal feelings about death, to nourish and forge a personal death for himself ("O Lord, grant each of us our own ripe death," he writes in *The Book of Hours,* "The great death we bear within ourselves / is the fruit which every growing serves"), Lorca did not have to search very deeply, as Salinas puts it, "along the innermost galleries of his soul." Rather:

> He discovers it all around him, in the native air that gives him breath, in the singing of the servants in his house, in books written in his tongue, in the churches of his city; he finds it in all his individual personality that has to do with

people, with the inheritance of the past. Lorca was born in a country that for centuries has been living out a special kind of culture that I call the "culture of death."

Lorca discovered duende piercing the skin of all the arts around him. He heard it trilling at the dawn of the Spanish lyric. He heard it in the "beheaded, Dionysian scream" of a nineteenth-century *cantaor*'s *siguiriya* (a song written in tercets or quatrains of six-six-eleven-six syllables), Silverio Franconetti y Aguilar (*Deep Song*), whom he elsewhere calls the "last Pope of *cante jondo*," and in "the dirges sung by Asturian women with flame-filled torches" in an annual procession on All Soul's Day, which is November 2 (*Deep Song*). When he and Manuel de Falla organized a Cante Jondo Festival in Granada in June 1922, he heard it in the opening-night performance of an old, nearly forgotten *cantaor*, Diego Bermúdez Cañete, "el Tenazas" ("Pincers"), and he felt it incipient in eleven-year-old Manuel Ortega, "el Caracol" ("The Snail"), who was destined for a career mining the depths of deep song. He also saw it passing supply over the bodies of Cádiz dancers, whom he considered the true leaping inheritors of the Greek mysteries that Nietzsche so ardently pursued. "The duende works on the body of the dancer as the wind works on sand," the poet said (*Deep Song*).

Lorca found the spirit moving through paint in the "moon-frozen heads" of Zurburán, in the drastic yellows of El Greco, in the haunted chimeras of Goya. He might well have also summoned up—it is entirely in keeping with his argument—the duende of the Andalusian Picasso, especially in *Les Demoiselles d'Avignon* (1907), a painting that shattered the illusion of "realistic" art and closed the door on the nineteenth century. Picasso's canvas is an exorcism, a space where archaic forms empower a revolutionary sensibility and destruction weds creation, a Modernist work where

five courtesans from Barcelona take on the hieratic bodies of Iberian votive sculptures and the facial characteristics of African tribal masks. It is a painting both sacred and profane.

Here is Lorca's appealingly apocryphal description of the "flamenco" duende of Saint Theresa:

> "Flamenco" not because she caught a bull and gave it three magnificent passes (which she did!) and not because she thought herself very lovely in the presence of Fray Juan de Miseria, nor because she slapped the papal nuncio, but because she was one of the few creatures whose duende... pierced her with a dart and wanted to kill her for having stolen his deepest secret, the subtle bridges that unite the five senses with the raw wound, that living cloud, that stormy ocean of Love freed from Time.
>
> *(Deep Song)*

The duende's "deepest secret," the poet seems to be telling us here, is that it seeks an incarnate immortality, a mystic freedom, Love embodied and rising beyond the manacles of Time.

Lorca felt the duende burning with a pagan fire at the heart of Spanish Catholicism, and thus he discovered it seething in apses, crypts, and chapels, in the extravagant cathedrals of Mallorca and Toledo, in religious chants and festival dances, in the innumerable blood-soaked rites of Good Friday. He found it displayed in the ritual spectacle of the bullfight, where the *torero* "must fight both death, which can destroy him, and geometry—measurement, the very basis of the festival" (*Deep Song*). Lorca considered the bullfight—the *corrida*—not a sport but "a religious mystery," a solemn and even sacred public rite with pagan roots and Christian overtones, an "authentic religious drama where, as in the Mass, a god is adored and sacrificed." (The poet Antonio Machado similarly characterized it as a "sacrifice...to an

unknown god.") He deeply appreciated the grave, irrational force and self-forgetful joy of the *torero,* who risked the ultimate to play with the bull and raised technique to a new level of splendor in the presence of death. As he once explained to the Italian writer Giovanni Papini, he considered the contest between man and bull as a human triumph, the "public and solemn enactment of human virtue over the lower interests…the superiority of spirit over matter, of intelligence over instinct, of the smiling hero over the frothing monster."

Lorca was also deeply proud of the impure, syncretistic nature of Andalusian culture, a sea with many sources, and he singled out four athletic figures whose separate duendes spoke to the living heritage of the culture of southern Spain:

> From the crepuscule of the ring, Legartijo with his Roman duende, Joselito with his Jewish duende, Belmonte with his baroque duende, and Cagancho with his Gypsy duende show poets, painters, musicians, and composers the four great roads of Spanish tradition.
>
> (*Deep Song*)

In a strikingly homegrown tactic, Lorca chose four legendary figures from the bullfight to demonstrate and symbolize for contemporary artists what he saw as the four major tributaries to the native tradition.

It seems that Lorca was assiduously clearing the space for his own work in his lecture on the duende. He had a decided cultural agenda; he was secretly schooling the Spanish spirit even as he made that spirit known to the New World. His piece in praise of the duende was also a piece in praise of the special character of southern Spain. "Being born in Granada has given me a sympathetic understanding of those who are persecuted—the Gypsy, the black, the Jew, the Moor which all Granadans have inside

them," Lorca once said. His national spirit was radically pluralis-tic. He was now redrawing the artistic map of his country. Groups that had been marginalized were resituated at the center, the red-hot core.

Lorca's lecture was a way for him to link all the arts together. He was fashioning a modern mosaic, singing the ferocious death-ward beauties of his native culture. He was holding up as exem-plary its liturgical forms, its spiritual fusions, its expressive arts. He was staging its meanings, its living style. He was serving as the theoretical agent—the bodily vehicle—of its duende.

An Apprenticeship

"DEATH! SHE INSINUATES HERSELF into everything. Repose, silence, serenity are apprenticeships. Death is everywhere," Lorca said in one of his autobiographical talks. He was both fascinated and terrified by "the great conqueror," a mysterious shadow companion who seemed at times to walk with him—he was always a clumsy walker—and darken his joy, which was so exuberant and childlike. That shadow self slipped almost imperceptibly into his piano playing; it shaded his playful style of drawing, and welled up from underneath his *Poems of Deep Song*. It stalked through the *Gypsy Ballads*, a book steeped in *gitano* (Gypsy) blood whose main protagonist is the figure of *Pena* (Anguish). And it took savage delight in *Poet in New York*, a violent confrontation with the New World that at one time was going to be called *Introduction to Death*.

Lorca's fear of death took its most bizarre form in his youthful compulsion to act out his own demise and burial in shockingly literal ways. Once during Carnival, he costumed himself as a bullfighter who had received a fatal goring in the ring—a *cornada*—and got his friends to hoist and carry his body, supposedly oozing blood, through the streets of Granada. Many fellow students in his Residencia in Madrid recollected similar late-night pranks and performances in which he threw himself across a bed, pretended to be overtaken by rigor mortis, and directed everyone through

an exuberant funeral procession and burial. One such friend was Salvador Dalí (another was Luis Buñuel), who for some time was like a brother to Lorca, and years later vividly recalled:

> I remember his death-like, terrible expression as, stretched on his bed, he parodied the different stages of his own slow decomposition. In this game the process of putrefaction lasted for five days. Then he would describe his coffin, the positioning of the corpse, and, in detail, the scene of the shutting of the coffin and the progress of the funeral procession through the streets, full of potholes, of his native Granada. Then, when he was sure that he had provoked in us a sufficient unease, he would jump up and break out into wild laughter…; finally, he would push us towards the door and go back to bed, there to sleep tranquilly, liberated from his anxiety.

Dalí shared something of Lorca's morbid terror and surreal humor, his haunted fascination with human finality. When the poet visited Dalí's family in Cadaqués and Barcelona during Holy Week in 1925, Dalí made some quick preliminary sketches of him feigning death. Dalí's sister also took photographs of Lorca in a sleeping, corpselike posture. These combined pictures became the basis for the unmistakable likeness of the poet's face that appears lying on its side in Dalí's painting *Still Life (Invitation to Dream)*. Lorca's large, circular head floats peacefully above a white shape pressed into a dark silhouette of Dalí's own face. A strange, foreboding, sawlike "apparatus" figures to the left of their heads. The motif recurs in Dalí's painting *Honey Is Sweeter than Blood* (1927), where both Lorca's and Dalí's decapitated heads are surrounded by a bleeding nude, mutilated organs, rotting and transparent donkeys, and columns of huge ringed needles. While Dalí was working on the painting, Lorca suggested that it should be called *Forest of Apparatuses* because of the anthropo-

morphic and geometrical shapes—the "apparatuses"—that served (or so Dalí would have it) to fend off the nightmare. Dalí theorized a "Saintly Objectivity," a force that could be vented and expressed only when distanced and controlled.

The two friends were equally haunted by the figure of Saint Sebastian, which they each represented both in writings and drawings. Dalí's first major publication, "Saint Sebastian" (1927), dedicated to Lorca, prefigures the proto-Surrealist works to come. His description of the saint and the various apparatuses surrounding him—the "exact instruments"—creates the verbal texture of a De Chirico painting. Dalí said, "The scent of Saint Sebastian was a pure pretext for an aesthetics of objectivity."

The correspondence between Lorca and Dalí suggests a nervous awareness of the homoerotic and sadomasochistic aspects underlying Saint Sebastian's martyrdom, which was somehow mixed up in their own erotically repressed relationship to each other. Much was at stake both personally and aesthetically when they fenced over their competing images of the saint pierced by arrows. Lorca eloquently summed up one fundamental difference:

> I had never thought that St. Sebastian had colored arrows. St. Sebastian's arrows are made of steel, but the difference between you and me is that you see those arrows fastened into him, sturdy arrows that never come loose, and I see them as long arrows...at the moment they are wounding him. Your marble St. Sebastian is unlike mine of flesh and blood, for mine dies moment by moment. And that is the way it must be. If my St. Sebastian were too plastic I would not be a lyric poet but a sculptor...

The flesh-and-blood figure dying moment by moment becomes the heroic emblem of Lorca's own anxieties and fears, inscribed and transformed in his lyric poetry. "Oh Salvador Dalí, of

the olive-colored voice!" the poet sings out in his "Ode to Salvador Dalí":

> I do not praise your halting adolescent brush
> or your pigments that flirt with the pigment of your times,
> but I laud your longing for eternity with limits.

Lorca also praised "the steady aim" of Dalí's arrows. He admired the artist's quest for a holy objectivity, but recognized that his own art was more heedless and subjective, darkened by a need for sacred passion.

Lorca rejoiced in the impulsive fluidity of drawing, the sheer pleasure of making "senseless black strokes with the pen." He used it as a shorthand method of thinking. Drawing was for him a calmer haven, less imperiled than writing, more grounded and harmonious. "When I do a purely abstract thing, it always has (I believe) a safe conduct pass of smiles and a rather human equilibrium," he wrote to his art critic friend Sebastiá Gasch:

> My state is always happy, and this dreaming of mine is not
> dangerous for me, because I have defenses; it is dangerous
> for one who lets himself be fascinated by the great dark mirrors that poetry and madness wield at the bottom of their
> chasms.

Lorca felt that in making graphic art he had his feet planted firmly on the ground, which was not the case with writing, where he moved through fiercer and more abysmal ground and was sometimes lifted into stranger and more unknown dimensions. "One returns from inspiration as one returns from a foreign land," he said. "The poem is the narration of the voyage." The demons Lorca tended to keep at bay in his exuberant graphic art were released into his poems and plays, which are more desperately shadowed by death, and more fully become rites of exorcism.

Lorca was death-haunted, obsessively drawn to blood rites and sacrificial rituals, which is one of the things that compelled him most about the ceremony of the *corrida*. He had limited technical knowledge of bullfighting, but a strong feeling for the national *fiesta* as a recurrent form of sacrifice, at one time even planning to write a *Tauromaquia*. Like Picasso, he was ever an avant-garde primitivist and mythologizer. In a transatlantic radio broadcast from 1935, a prose piece posthumously dubbed "Poem of the Bull," Lorca recalled the childhood lesson that Spain is shaped on the map like a bull's hide, "a sacrificial animal," and declared:

> In the midst of the Iberian summer they open the rings—
> the altars. Man sacrifices the brave bull, offspring of the
> sweet cow, goddess of the dawn, who is alive in the dew.
> And the huge heavenly cow, a mother whose blood is always
> being shed, demands that man, too, be sacrificed.

After characterizing this myth of exchange, he goes on to catalog a series of heroic *toreros* ("From Pepe Hillo to my unforgettable Ignacio Sánchez Mejías, from Espartero and Antonio Montes to Joselito") who were torn apart by the sharp horns of the bulls, "a chain of glorious deaths: the deaths of Spaniards sacrificed by a dark religion which almost no one understands." Lorca suggests that the modern-day Spanish bullfight is a ritual sacrifice originating in Andalusia as ancient Tartessus, the oldest civilization in Europe. It reenacts an archaic rite found in early Iberian and Dionysian bull cults.

Lorca's sense of the ceremony of death ritualized in the bullfight found its fullest expression in his poem "Lament for Ignacio Sánchez Mejías" (1934), one of the signal elegies of the century just past and a poem with ferocious duende. The grief-stricken lamentation memorializes the poet's reckless, polymathic friend

who suffered a fatal goring in the ring even as it seeks to enact, as Lorca said, the "heroic, pagan, popular, and mystic beauty that exists in the fight between man and bull."

Sánchez Mejías was a well-known matador passionately interested in flamenco, theater, and literature. He retired from the ring in 1927 in order to devote himself to playwriting and manage the career of his lover, Encarnación López Júlvez, "La Argentinita," a splendid singer and dancer who performed with élan the dance of the injured butterfly in Lorca's play *The Butterfly's Evil Spell.* The poet and the singer also collaborated on five records of folk songs. Lorca's *Lament* was dedicated to her with a 1935 drawing of an Andalusian dancer surrounding the words *A mi querida amiga* on the dedication page of the finished book.

In 1927, the same year he met his lover and retired, Sánchez Mejías invited Lorca as one of a group he dubbed the "seven Madrid literati" (including Rafael Alberti, Gerardo Diego, and Jorge Guillén) to the Góngora tercentenary in Seville, and the two became fast friends. The poet enthusiastically introduced the matador at a lecture on bullfighting at Columbia University in 1930. When he heard four years later that his friend was planning to come out of retirement to fight again, he said, "Ignacio has just announced his own death to me."

That same aura of fatality permeates the first section of the poem "The Goring and the Death," wherein Lorca obsessively repeats the line *at five in the afternoon* twenty-eight times in fifty-two lines. He pictures and prepares the precise moment of the bullfighter's death, which he sets at the traditional opening hour of the bullfight, with preternatural clarity and focus:

> At five in the afternoon.
> It was exactly five in the afternoon.
> A boy brought the white sheet
> *at five in the afternoon.*

A basketful of lime in readiness
at five in the afternoon.
Beyond that, death and death alone
at five in the afternoon.

The insistent repetitions give this section the feeling of a burial procession, a summons to mourning. Lorca's biographer Leslie Stainton points out that the poet's choice of the resonant hour of five o'clock (Sánchez Mejías actually died at 9:45 in the morning) echoes the announcement in a Madrid newspaper on the day of the funeral that the procession would begin "at five o'clock in the afternoon." The next day, the same paper reported that the coffin left the chapel "at exactly five o'clock." Lorca seized on this as the inevitable hour of reckoning. As he said later: "When I was composing the lament, the line with the fateful 'five in the afternoon' filled my head like the tolling of a bell, and I broke into a cold sweat thinking that such an hour was waiting for me, too. Sharp and precise like a knife. The hour was the awful thing."

Horrifying five in the afternoon!
The stroke of five on every clock.
The dark of five in the afternoon.

Sánchez Mejías's navy blue "suit of lights" had been extinguished. He was forty-three years old. Elsewhere in the poem, Lorca focuses with characteristically obsessive detail on the decomposing process of his friend's body, a rotting cadaver engulfed in "fetid silence." He could not bear to look at it ("No, I refuse to see it!"), nor could he bear to glance away. He memorializes his friend as a kind of ancient warrior, a hero, "a great fighter in the ring," "a good mountaineer on the heights," even as he chants the sacrificial death, the tragic confrontation:

Oh white wall of Spain!
Oh black bull of sorrow!
Oh hardened blood of Ignacio!

Lorca was superstitious, and resolutely refused to name in his poem the murderous bull who killed Ignacio. Its bitterly ironic name carried too much foreboding personal weight: "Granadino."

Lorca's lament progresses from "Presence of the Body," in which he finally lets go of his friend's physical presence and releases his spirit ("Go now, Ignacio. Feel no more the hot bellows. / Sleep, soar, repose"), to "Absence of the Soul," a traumatized public acknowledgment that "Your silent recollection does not know you / because your death is forever." There is no return. The dead hero lies discarded and forgotten, though, as in a traditional elegy, the singer vows to keep his memory alive:

No one knows you. No one. But I sing you—
sing your profile and your grace, for later on.
The signal ripeness of your mastery.
The way you sought death out, savored its taste.
The sadness just beneath your gay valor.

Not soon, if ever, will Andalusia see
so towering a man, so venturesome.
I sing his elegance with words that moan
and remember a sad breeze in the olive groves.

Lorca felt his own destiny was somehow intertwined with his friend's fate, and the day after the funeral confessed to a young French writer:

Ignacio's death is like my own death, an apprenticeship for my own death. I feel an astonishing sense of calm. Is it, perhaps, because I intuitively expected it to happen? There are moments when I see the dead Ignacio so vividly that I can

imagine his body, destroyed, pulled apart by worms and
brambles, and I find only a silence which is not nothingness,
but mystery.

Lorca's memorial is suffused with an empathy so strong that it al-
most turns into something else: a premonition. Maybe it carries a
secret sense of a self-elegy in the making, as if the poet were re-
hearsing his own extinction, transposing his fate, practicing for
the bitter death that would engulf him two years later. One
might almost apply Lorca's conclusion about his friend's death
to his own tragic end: "Poets are mediums," he said, "and Igna-
cio, who was a poet, did everything he could to escape from his
death, but everything he did only helped to tighten the strings of
the net."

It's difficult at times not to see signs of Lorca's actual death at
the age of thirty-eight—his brutal murder by a fascist firing squad
at the outbreak of the Spanish civil war—in his life. They creep
into his face at odd moments in old photographs, in a sadness
around the eyes, a vague foreboding. Amid so much joy is a whiff
of doom. He must have been terrified when he was taken out to
be shot at dawn on August 19, 1936, along with two bullfighters
and a schoolteacher. It was an infamous day in the Spanish calen-
dar: who can forget it was his Spanish countrymen who murdered
one of the deepest creative embodiments of their nation's spirit?
Lorca's assassination, like the Spanish poet Miguel Hernández's
death at the age of thirty-one, is one of the countless devastating
tragedies of blood-soaked Republican Spain.

In her book *On Bullfighting,* the Scottish writer A. L. Ken-
nedy suggests that images of Lorca can't help but have a prefigur-
ing hint of extinction. "He only seems free of his ghost in pictures
taken while he's performing," she says: "In front of an audience,
the champion of duende seems entirely unself-conscious and
entirely happy at his work." This creative phenomenon has often

been described by performers of all types, including artists and bullfighters. It's a moment of joyous release and habitation, of transfiguring intensity, of freedom and transport. "It grants an access to self-forgetting without self-destruction, and it's a moment that can seem worth almost any price, even the torero's ultimate risk," Kennedy concludes. "This selfless place, this energetic peace, may also be all the performer recalls of something observers might well define as duende."

Between Eros and Thanatos

DUENDE IN LORCA'S POEMS has a fiery element of Eros, of raging unfulfilled passion, that isn't always apparent—and may in fact be repressed—in his lecture on the subject. The element that he picks up in his poems from flamenco, of tragic, sensual, fateful passion, is a crucial aspect of duende. It is part of the profound (Andalusian–Moorish–Gypsy) soul cry. He recognizes this in his lecture on deep song: "Whether they come from the heart of the Sierra, the orange groves of Seville, or from harmonious Mediterranean shores, the songs have common roots: love and death."

Lorca's rural sensibility connects to that of the balladeer, linking it to a true folk sensibility. "From my very first steps in poetry, in 1919, I devoted much thought to the ballad form," he said, "because I realized it was the vessel best shaped to my sensibility." Lorca's *Gypsy Ballads* fuse the narrative element of *cante jondo* with his own sense of the lyrical, and capture something of what he recognized as the ballad of Andalusian pain, "which is the struggle of the loving intelligence with the incomprehensible mystery that surrounds it."

The poet learned from the Gypsy singer how to integrate performance into composition, oral elements into written poems. Like Yeats's sequence of Cuchulain plays, Lorca's tragic drama is also keenly ritualistic, almost Hellenic, almost as stylized in its sense of fatefulness as Noh drama or Kabuki theater. The emotions

are broad strokes, primary colors. These are not dramas of psychological complexity, but plays of fate.

A tragic sense of destiny flows through all Lorca's work, animating his ballads and lyrics, his lyrical ballads, his book of "Songs," as in his eerie, emblematic early poem "Rider's Song":

> Córdoba.
> Distant and lonely.
>
> Black pony, large moon,
> in my saddlebag olives.
> Well as I know the roads,
> I shall never reach Córdoba.
>
> Over the plain, through the wind,
> black pony, red moon.
> Death keeps a watch on me
> from Córdoba's towers.
>
> Oh, such a long way to go!
> And, oh, my spirited pony!
> Ah, but death awaits me
> before I ever reach Córdoba.
>
> Córdoba.
> Distant and lonely.

The horseman desperately needs to reach Córdoba—we never learn why—but knows with equally fatal certainty that he will fail. Córdoba becomes the geographical sign of a broken journey toward a mysterious unreachable destination. An inescapable presence, death watches over and awaits him all along the way.

Lorca connected this poem with the feeling in his "Ballad of Black Pain" (from *Gypsy Ballads*), a poem he wrote in the same month:

The Pain of Soledad Montoya is the root of the Andalusian people. It is not anguish, because in pain one can smile, nor does it blind, for it never produces weeping. It is a longing without object, a keen love for nothing, with the certainty that death (the eternal care of Andalusia) is breathing behind the door.

Lorca said that "Rider's Song" "seems to picture that prodigious Andalusian Omar ibn-Hafsun exiled forever from his fatherland," a reference to the ninth-century Muslim rebel. In the first draft of the poem, reproduced in facsimile in Lorca's *Obras completas* (*Complete Works*), the last stanza opens with a line subsequently crossed out: "Mi niña! Mi amor mi niña!" This indicates that the rider was trying to join his beloved.

There is an important tension operating in Lorca's work between Eros and Thanatos, love and death. This tension, which he heard at the heart of *cante jondo,* is so great that at times it seems to be powering the poems themselves, from *Poem of the Deep Song* (1921) to *Gypsy Ballads* (1924–27) to *Sonnets of Dark Love* (1935). Death is strangely eroticized. One could go through Lorca's work picking out representative images of this, such as the way that blood blooms into roses, and so forth.

Eros and Thanatos are repeatedly yoked together in Lorca's key work *The Divan at Tamarit* (1931–34), a series of twenty love poems in which he pays homage to Arab love poetry by loosely using the verse forms of classical Arabic poetry (ghazals and qasidas) as an improvisatory base. He wrote five of them in April 1934, on a trip home to Spain from Buenos Aires, where he had directed the premiere of *Blood Wedding* and delivered his lecture on the duende. The poems in *The Divan* (a place near Granada) *at Tamarit* (an Arabic word for a gathering or anthology) evoke a joy tinged with unbearable sadness. They seem driven by an anguished

memory of lost love and a desperate struggle to transcribe and transfigure that experience into poetry itself. Love and death become virtually indistinguishable. Lorca's editor calls the book "the last will and testament of an elegiac poet: the grave utterance of unsatisfied desire in the shadow of death."

"Blood of your veins in my mouth," the poet sings out, "your mouth now lightless for my death" ("Ghazal of Love Unforeseen"). "I don't want to hear that the dead lose no blood," he exclaims, "that the decomposed mouth is still begging for water" ("Ghazal of Dark Death").

> There is no one who can kiss
> without feeling the smile of those without faces;
> there is no one who can touch
> an infant and forget the immobile skulls of horses.
>
> ("Ghazal of the Flight")

"I keep looking / to be consumed in luminous death," he concludes. Death alone can calm the singer and still his feverish longings.

> I want nothing else, only that hand,
> for the daily unctions and my agony's white sheet.
> I want nothing else, only that hand,
> to carry a wing of my own death.
>
> Everything else all passes away.
> Now blush without name. Perpetual star.
> Everything else is something else: sad wind,
> while the leaves flee, whirling in flocks.
>
> ("Qasida of the Impossible Hand")

These poems manifest Lorca's underlying subject: how the cause of life is also the cause of death, how one transmutes into the other, and how the deep purpose of both—it is also the purpose of art—is passion.

Lorca's way of implicating Eros in Thanatos can be mystifying. His way of making one out of the other can seem paradoxical, even contradictory. How can it not be? Lorca's characteristic positions seem, like so many aspects of Modernism, both radical and conservative. Duende has its major part to play in the Modernist dimensions and ideology of his thinking. His borrowing from what seemed to be authentic folk traditions (he made a false distinction, for example, one that he later revised, between the "unknown" or "amateur" performers of *cante jondo* and the "professional" singers of flamenco) is "modern" in the same way that Bartók and Kodály going to Transylvania and then bringing Gypsy modes into "classical" music is modern. It is parallel to what Yeats aspired to find when he went collecting traditional folklore with Lady Gregory in the Irish countryside, which he then wrote into his Romantic ballads and stories. It is kindred to the half-imagined primitivism of Stravinsky's *Rite of Spring,* and the erotic borrowings in Nijinsky's modes of modern dance, and the spectacles Diaghilev created as context for that art.

Lorca was very much an artist of the 1920s and 1930s. He was of his time. He had a love of the countryside springing from his childhood ("All my emotions tie me to it," he said) and a fundamentally agrarian vision, which he playfully called his "agrarian complex." This is one reason that his outcry was so great when he confronted the American city. He modernized his art with the hybrid of the primitive, and in New York replaced Gypsies with blacks and flamenco with the blues. Like Bartók, Janáček, and Stravinsky, like Yeats and Synge, he turned to the art of the countryside for inspiration. There is an element of tribalism in these artists, a sense of nationalism coming to the salvation of art and revitalizing it. This is partly an inheritance from Johann von Gottfried Herder (1744–1803), often deemed the father of European nationalism and the originator of populism, who

located the soul of a nation in the folk art of its people and rec-ognized the profundity of the local. The local is one of the en-during sources of art. It is the welcome side of such ethnic feelings in an epoch that will teach humanity just how deadly the modernism of nationality can be.

The Majesty of the
Incomprehensible

LORCA CHANTED THE DEEPLY Hispanic character of the duende. Spain is a country where death is a particular kind of cultural construction. (Perhaps only Mexico can rival it as a culture of death, as Octavio Paz makes evident in *The Labyrinth of Solitude*.) And yet he recognized many agonistic figures from other countries who possessed it, who were baptized in its black and choppy waters, such as Nietzsche and Cézanne. He also admired artists from other countries who could capture something fundamentally "Spanish" in their work. For example, the Muse who inspired Bizet to compose his admirable *Carmen* "in the Spanish manner" (*a la española*) had to step aside for the spirit of Debussy, who was in Spain for only a few hours, to see a bullfight in San Sebastián, but whose music, according to Manuel de Falla, "is not written *a la española* but *en español* ["in Spanish"], or rather *en andaluz...*" Lorca played Debussy's piano compositions with a penetrating touch, and he felt that, especially in *La Soirée dans Granada,* the French composer had captured with an eerie accuracy the atmosphere, tone, and feeling of Granada by night. He took joy, too, in playing the Spanish style of the colorist Ravel, who inhabited and revealed, as de Falla also said, "now expressly, now unconsciously, the Andalusian musical idiom."

Duende strikes me as something particularly Mediterranean, allied to fado in Portugal, to *verismo* in Italian opera, and perhaps

to *saudade* when it travels to Latin America. There is a parallel feeling in Sephardic music (with its Indian roots), which so often reminds one of Gypsy music of all kinds (also Indian in its origins), and flamenco, with its strongly Moorish cast. There is always something of a leap in applying the notion of duende to other cultures. It is a matter of finding kindred, rather than identical, feelings.

Lorca praises the duende of Rimbaud, whom it "dresses in the green suit of a saltimbanque," and the duende of Comte de Lautréamont, a precursor of Surrealism, whom it injects with "the eyes of a dead fish…in the early morning of the boulevard" (*Deep Song*). Duende of the Cretan mask and the Arabic song and Arabic dance, which is everywhere greeted with energetic cries of *Allah! Allah!* Andalusia was once an Arabian country, and the flamenco carries in its ancient body some of the harsh, rhythmical elements of Arab music. Thus, Lorca compares these cries to the way performers in southern Spain are greeted with the sincere cry of ¡*Viva Dios!*—a "deep and tender human cry of communication with God through the five senses, thanks to the duende, who shakes the body and voice of the dancer" (*Deep Song*).

The duende may reside as much in the audience as in the maker, in the listener as well as in the interpreting performer or the original composer. Lorca explicitly suggested that the duende travels between the performer and the audience. He called this transference "a sort of corkscrew that gets art into the sensibility of an audience." It is a circuit of communication vitally linking a poet, a poem, and a reader, or a composer, a score, a performer, and a group of listeners. It exists in transaction; it lives in profound connection. And it moves among all art forms. One recalls, for example, how Lorca found duende in the Gypsy dancer La Malena, who in turn heard it when Brailowsky played a fragment of Bach, and cried out, "Olé! That has duende!" (*Deep Song*)

Lorca tended to find duende in the performing arts, but one can also find it in other art forms. It is like an electric current illuminating certain works of art—written poetry and fiction, for example—that have been composed. These finished products seem lit from within and carry a soulful spirit, a dark emotionality, in their bodies.

There are entire poems, and sometimes certain moments in poems, when death arrives like a fateful, sensuous presence and floods the lyric with its own mysterious spirit. It breathes out like a wind in the sails, and fills the poem with the majesty of the incomprehensible. There are a few modern poems that come immediately to mind, that seem touched by the magical, even erotic claw of death itself: César Vallejo's "Black Stone Lying on a White Stone" ("I will die in Paris, on a rainy day, / on some day I can already remember"), Miguel de Unamuno's "It Is Night, in My Study" ("and it is as if around me circled / cautious death"), and Pablo Neruda's "Nothing but Death," which finds a poetic strategy to mimic death's relentless forward movement, the way it becomes a palpable presence taking human beings away, subtracting them from the shoes in which they walk, the clothes they wear, the world of objects they inhabit:

> Death arrives among all that sound
> like a shoe with no foot in it, like a suit with no man in it,
> comes and knocks, using a ring with no stone in it, with no
> finger in it,
> comes and shouts with no mouth, with no tongue, with no
> throat.
> Nevertheless its steps can be heard
> and its clothing makes a hushed sound, like a tree.

Sola la muerte—"Nothing but Death," "Death Alone," "Only Death." Neruda's poem seeks to incarnate the mystery of an always impending arrival, a tangible presence that is simultaneously

an absence. Lorca captures something of that spirit in his eerie 1934 drawing *Solo la Muerte,* in which death arrives as a skeletal oversize figure—a metamorphic creature—with many hands floating far out from his body in all directions and grabbing plants and flowers, grasping everything in his path. He is striding forward while twisting back, calling out like a siren. Commander Death. Attached to his rib cage like a kite on a string, the dreamy face of a lover floats over Death's head.

The Italian poet Cesare Pavese enacts the particularly erotic nature of duende in his late love poem "Death Will Come and Will Have Your Eyes":

> Death will come and will have your eyes—
> this death which attends us
> from morning to night, sleepless,
> deaf, like an old remorse
> or absurd vice.

"All death has one glance," Pavese writes, and the arrival of death is "like heeding closed lips." Pavese personifies a death who attends us like an old familiar, a remorse or vice we cling to, an enemy beloved.

A Spectacular Meteor

RAINER MARIA RILKE MEDITATED often on the subject of death as inseparably intertwined with human life. He believed they were fundamentally one at the core. Death pressures us, he suggested, "to understand our earthly existence as one side of being, and drain it passionately to the dregs." Rilke's autobiographical novel, *The Notebooks of Malte Laurids Brigge,* is a book baptized in death, completely awash in its dark presence. "So this is where people come to live," the book famously begins. "I would have thought it is a city to die in." Death comes at Malte from every corner of Paris. He moves through a province of hospitals, among an army of the poor, of wandering cripples and homeless beggars, of famished human outcries. He is a *flâneur* of death ("The last journey of the *flâneur:* death," Walter Benjamin writes about Baudelaire ambling through the streets of Paris: "Its destination: the new"). Malte is teaching himself to see, he says, breathing in "the existence of the horrible in every atom of air," feeling it condense and harden inside him. He takes action against fear by writing all night in absolute solitude. "To the depths of the unknown," Baudelaire writes at the triumphant conclusion of *Les Fleurs du Mal* (*Flowers of Evil*), "there to find something new." Rilke uses Malte as a vehicle to descend into those depths.

At one key point, Malte begins to quote as an exemplum Baudelaire's prose poem "At One O'clock in the Morning."

Baudelaire's poem is filled with complete revulsion for daily urban life in nineteenth-century Paris, for the unseemly and nauseating business of the world. His speaker—a clear stand-in for himself—moves all too easily through that world and even participates in it, and his own complicity especially repels him. At the end, he leaves the social world behind—or prays to—and the poem turns on a vertical axis. It becomes a prayer for a messianic lyric of deliverance:

> Discontented with everyone and discontented with myself, I would gladly redeem myself and elate myself a little in the silence and solitude of night. Souls of those I have loved, souls of those I have sung, strengthen me, support me, rid me of lies and the corrupting vapors of the world: and you, O Lord God, grant me the grace to produce a few good verses, which shall prove to myself that I am not the lowest of men, that I am not inferior to those whom I despise.

Baudelaire's plea becomes one of Malte's touchstones, as well as Rilke's key inspirations. The *Notebooks* are, above all, a hymn to the inner self one deepens in silence, to the suffering of others incorporated into the body, into consciousness itself, to the soul one creates in the silence and solitude of night. The book returns almost obsessively to the subject of how each of us must find and fashion an individual death, which is the most difficult and solitary task of all. It is a destination. "And when I think about the others I have seen or heard of: it is always the same: They all had a death of their own." This is one of Rilke's most cherished notions: "God, give us each our own death."

Like *The Notebooks of Malte Laurids Brigge,* a great percentage of Rilke's poems seem written in close proximity to death, in striking distance of it, but some go even further, to its very last borders. These poems stand on its shore and drink deeply of its waters. There are in truth any number of uncanny moments in

Rilke's high lyrics when the mind seems to give way before an incomprehensible mystery and, out of a long foreground, the lines of the poem seem to be forming themselves, as if dictated by a force from without that is also somehow a voice within. They seem visited from the other side. Rilke's receptivity to such oracular moments may be one of his most defining characteristics as a poet.

Think, for example, of the conclusion to the poem "Death Experienced," where the actual experience of death seems suddenly to come over us "like / a knowledge of that reality settling in, / so that for a while we act life / transported, not thinking of applause." Or of his haunting elegics "To Hölderlin" ("We are not permitted to linger, not even with what is most / intimate"); to Paula Modersohn Becker, in "Requiem for a Friend" ("I have my dead, and I have let them go"); and to Marina Tsvetaeva ("Waves, Marina, we are ocean! Depths, Marina, we are sky. / Earth, Marina, we are earth"). The poem "Washing the Corpse" has haunted me for thirty years with its image of a heavy, vinegar-soaked sponge left lying on the face of an anonymous stranger who lies there, as if in state, and issues silent commandments, grave laws. And so has the spooky Orphic masterpiece "Orpheus. Eurydice. Hermes," which, Joseph Brodsky mused in 1994, "makes one wonder whether the greatest work of the century wasn't done ninety years ago."

Here is an oddly cryptic and emblematic poem called simply "Death" ("Der Tod"), which Rilke wrote in Munich in November 1915, in the midst of World War I. It begins with the static image of death as a blue liquid distilled into a saucerless cup, and concludes with it as a bright star shooting across the sky and plunging through the inner spaces of the poet's body:

There stands death, a bluish distillate
in a cup without a saucer. Such a strange
place to find a cup: standing on

the back of a hand. One recognizes clearly
the line along the glazed curve, where the handle
snapped. Covered with dust. And *HOPE* is written
across the side, in faded Gothic letters.

The man who was to drink out of that cup
read it aloud at breakfast, long ago.

What kind of beings are they then,
who finally must be scared away by poison?

Otherwise would they stay here? Would they keep
chewing so foolishly on their own frustration?
The hard present moment must be pulled
out of them, like a set of false teeth. Then
they mumble. They go on mumbling, mumbling...

O shooting star
that fell into my eyes and through my body—:
not to forget you. To endure.

Rilke said that the writing of this poem unfolded for him like
a dream. It was a reverie on the inexplicable image of a cup bal-
ancing on the level back of a hand. He saw that cup filled with a
pure liquid, a blue distillation, which he understood to be an ex-
tract of death itself. The ghostly figures in the poem ("What kind
of beings are they then?" he asks) seem to be specters haunting
the breakfast table. Rilke's biographer, Ralph Freedman, tellingly
calls them "babbling, toothless ghosts, skeletal actors or mari-
onette puppets." He reminds us that "Der Tod" was a war poem,
and suggests that the living corpses are "replicas of Death's an-
cient skeleton."

The speaker seems bewildered, maybe even a little angered,
by these bloodless, unfulfilled figures who won't let go of their
earthly existence or presence. They linger, "chewing" over their
old frustrations, haunting a table where they can no longer eat or

drink. It is as if the soul, the living moment, bodily existence it-self, must be surgically pulled out of their mouths. They are de-prived of speech, of breath. And so their voices—and the poem itself—sputter down into incomprehensible mumbling. "Only then they mumble," as William Gass breaks it down, "Mumble... umble... / umble." "Dann lallen sie. Gelall, Gelall." "Then their tongues babble," Edward Snow translates, accurately transposing and capturing the syllabic babble of the German sound: "Lal, gelall." Thus the poem goes underneath speech and trails off into the silence of an incredibly extended ellipsis.

And then suddenly, Rilke said, the last three lines burst out of him. They came to him unbidden, and in the strongest possible contrast to the preceding ones. They have terrific liftoff. He later explained the final image:

> At the end of the poem "Death," the moment is evoked (I was standing at night on the wonderful bridge of Toledo) when a star, falling through cosmic space in a tensed slow arc, simultaneously (how should I say this?) fell through my inner space: the body's dividing outline was no longer there. And whereas this happened then through my eyes, once at an earlier time (in Capri) the same unity had been granted me through hearing.

Rilke immediately understood the spectacular meteor—a comet arcing across the sky and crashing into the water—as a figure for death itself, as something simultaneously lighting up the heavens and tumbling through himself. It's as if he had transposed the arc of a flaming shell into a cosmic image, a cosmic episode. He felt he had taken in the star through his eyes, permeated the mem-brane between the inner and outer worlds, mystically touched a greater unity. The speed with which the irrational splendor of death blazes across the sky of Rilke's memory, enters his body, and suffuses the end of his poem is itself an instance of duende.

Or a quintessentially Rilkean form of it. The major difference between Rilke and Lorca in this regard is that Rilke's figure descends from the invisible heights—it drops down from a celestial source—whereas Lorca's bursts volcanically from below, from the earth itself. They both have vertical power. Both enter and end up in the body, as all art must, since art is by definition an incarnate form of experience. But the difference in the originating source has key artistic repercussions. Rilke's figure is less sensuous and erotic, more purely spiritual. Whereas Lorca's duende will explode with demonic zeal into the urban inferno of his rebellious masterpiece, *Poet in New York,* Rilke's inspiration—an agent of air—will come to him in the form of angels, albeit terrifying ones, the annihilating figures of his masterwork, *The Duino Elegies.*

Swooping In

THERE ARE INSTANCES WHEN a Dionysian spirit seems to be holding itself back through most of a work of art, getting ready to enter at the conclusion, preparing to ascend. Maybe it is scrupulously being prepared for, or perhaps it just swoops in like a comet at the end with a sudden unforeseen energy and feeling. *"Candor seeks its own unforeseeable occasions,"* as Hayden Carruth once forcefully put it. It finds its expressive outlets.

Take Frank O'Hara's justly famous elegy, "The Day Lady Died." This cosmopolitan poem, which he wrote on his lunch hour on July 17, 1959, has an engaging immediacy ("It is 12:20 in New York a Friday / three days after Bastille day, yes / it is 1959") and lively forward motion, a performing dailiness (at first I do this—watch—and then I do that) that carries it breezily along. There are pauses but no rest stops in the poem, commas but no periods. It is all written in a kind of onrushing ethnographic present tense: "I walk up the muggy street beginning to sun / and have a hamburger and a malted"; "I go on to the bank / and Miss Stillwagon (first name Linda I once heard) / doesn't even look up my balance for once in her life"; "I just stroll into the PARK LANE / Liquor Store and ask for a bottle of Strega and / then I go back where I came from to 6th Avenue / and the tobacconist in the Ziegfeld Theatre." It all has a vivacious daily charm. But while he is casually buying his European smokes—a carton of Gauloises

and a carton of Picayunes—the speaker suddenly glances over at a local newspaper. His voice hits a radically different note at this moment, when he spots Billie Holiday's face on the cover of a *New York Post* and abruptly realizes that she is gone:

and I am sweating a lot by now and thinking of
leaning on the john door in the 5 SPOT
while she whispered a song along the keyboard
to Mel Waldron and everyone and I stopped breathing

Billie Holiday's nickname was "Lady Day," and there is a nice reversal of the phrase in the title of O'Hara's poem, which forever marks a fateful day in the calendar. An immediate tension arises in the poem between the past tense of the title and the present tense of what follows. Lady Day was forty-four when she died. She had a range of shattering verbal textures that are filled with duende, even near the end of her life when her voice had dramatically deteriorated. Her phrasing, always the essence of her art, remained intact. As the altoist Jackie McClean once put it: "Her voice was just a shadow of what it had been, yet she still put a song over. Her singing voice was gone, leaving emotion her only tool of expression." She continued to mine her feelings, "to mine her compromised technique for expressive value," as the jazz critic Gary Giddins wrote, and thus "her voice retained its enchantment, a lapsed beauty, a thin, pure, noble siren gleam."

O'Hara heard Billie Holiday sing a couple of times, most fully in the summer of 1957 when she showed up a few hours late for her midnight show at Lowe's Sheridan, an old movie theater. O'Hara waited and was exhilarated by her performance. Holiday wasn't scheduled to appear at the Five Spot, a jazz bar on Fifth Street and Third Avenue, on the night that he managed to hear her for the last time. She turned up to visit a friend, the pianist Mel Waldron, and was later persuaded to break the law by singing. (She had been arrested for heroin use and wasn't permit-

ted to sing in a place that served alcohol.) "It was very close to the end of her life, with her voice almost gone, just like the taste of very old wine, but full of spirit," Kenneth Koch later remembered. "Everybody wanted her to sing. Everybody was crazy about her…"

It's as if the duende had been preparing to sweep into O'Hara's poem at the moment of Proustian transport, the moment when Lady Day's bodily presence, her scorched whisper, takes it over. The sound of her voice is both unexpected and inevitable. It stops the din in a smoky bar; it stops the din in the mind. It is transfixed and transfixing.

O'Hara gives us a memory that is both triggered and pierced by death. Everything on the day of Billie Holiday's death takes on a retrospective glow, and what initially may have seemed to be an anti-elegy because it is so daily and vernacular turns out, in fact, to be an actual one. Everything is memorialized on that day, held in place by its hidden significance. There is a dazzling rightness to that last phrase—"and everyone and I stopped breathing"—that enacts a moment when art ruptures the surface of daily life and stops time. It is a moment of return, of transcendence recalled, reenacted in language, that also reverberates with the hard knowledge of the singer's untimely death.

Billie Holiday is unmistakably a great force of duende, and O'Hara avails himself of some of her tragic beauty in his poem, a quality that he doesn't often capture elsewhere in his urbane, high-spirited work. It is as if Holiday lent him her tragic measure here, her bearing. He delivered what he had been given and lived up to his subject.

O'Hara's poem reminds me of a little girl with a limp I once saw tap dancing on a street corner in New Orleans. She was going through her ordinary repertoire of rehearsed moves when her accompanist hit a string of unexpectedly low chords and suddenly something indecipherable, almost lunatic, jarred awake inside her,

and she started dancing with terrific ferocity. She took off. The dramatic change in intensity was almost frightening. It was also apparent to everyone present. We all understood immediately that something astonishing was taking place before us. The sidewalk seemed to part as the spirit winged through the crowd like a flame. The summer afternoon sizzled. Time stopped. Her duende had arrived.

Ardent Struggle, Endless Vigil

THE DUENDE BESTOWS INTENSITY, which it needs in order to exist. The body is the soil in which it grows. Like all Romantic poets, Lorca sought intensity above all. A passionate openness to the moment—a living presence—was for him the first value in art. He devoted himself to hard work and thrilled to spontaneous creation. "I have been like a fountain, writing morning, noon and night," he told his friend Regino Sáinz de la Maza. "Sometimes I have run a fever, like the old Romantics, but without ever ceasing to feel the intense conscious joy of creation." He was rushing to nail down something fleeting and chimerical, and might well have said with Shelley that poetry "arrests the vanishing apparitions which haunt the interlunations of life." Yet he did not simply relinquish himself to automatic writing, to absolute improvisation, or to a complete Nietzschean Dionysianism. (In truth, neither did Nietzsche. In a recent work about Nietzsche's first book, *The Birth of Tragedy out of the Spirit of Music,* James Porter demonstrates that Nietzsche's Dionysianism involved "'passion controlled' and not limitless frenzied passion.")

Lorca was seeking both inspiration and control over that inspiration. Wild horses, flexible reins. *Disciplina y pasión* ("Discipline and passion"), as he expressed it in a sonnet to celebrate the fiftieth birthday of his mentor in music, the composer Manuel de Falla. Lorca repeatedly worked toward a guiding form even as he

sought a chaos that would explode that form. Such a high degree of difficulty, such a ferocious demand from one's work requires a great degree of technique and effort, geometry and will: "ardent struggle, endless vigil, like all art." Speaking at a New York City tribute to the classical Spanish dancer Antonia Mercé, who was touring the United States, Lorca said:

> While the poet wrestles with the horses in his brain and the sculptor wounds his eyes on the hard spark of alabaster, the dancer battles the air around her, air that threatens at any moment to destroy her harmony or to open huge empty spaces where her rhythm will be annihilated.

There was in Lorca, as in Nietzsche, more of an internal conflict—a dialectical struggle—between Apollo and Dionysus, between classical reason and mantic power, than has generally been recognized. Maurer puts the matter well when he calls the lecture on duende "Lorca's attempt to come to grips with an eternal artistic problem that had troubled him from early youth: a simultaneous longing for form and respect for chaos (for the unknown, for what seems, or *is,* beyond form, beyond human art)."

In an essay entitled "Flamenco," the Polish poet Adam Zagajewski describes going to the movies to see Carlos Saura's *Carmen* on a dreary European day. The film leaves him bored for the first fifteen minutes, quarantined in the darkness, but it springs to life when the main characters begin to experience the quickened breathing of Bizet's opera, the rhythm of flamenco, the harsh Spanish words. Suddenly, the dangerous erotic passions—love, desire, and jealousy—are rolling through the film with a hammering momentum, a great rhythmic force, like ocean waves. "The flamenco becomes the site of a strange meeting of formless passion and passionless form," Zagajewski writes. He suggests that the film could be retitled *Dance Born of the Spirit of Passion and*

Jealousy. Passion allied with rhythm liberates joy, though it cannot curb the darker forces. Indeed, it invites them into the room; it unleashes them in the body. After the film, the poet leaves the dark theater brooding about how form, which he takes as a liberating agent, must constantly confront formlessness, the excess of being, the substance of the world. This is the space—*ardent struggle, endless vigil*—in which art is made.

"Flamenco is a hypnotic art," the scholar Marion Papenbrok reminds us, a means of "achieving ecstasy, a gnostic process." She compares it to Artaud's "Theater of Cruelty." It is a highly emotional mode of knowing that balances body and spirit, that engages and releases participants in a collective drama. It is a flame that catches and burns back and forth between a performer and an audience. Or so Rilke seems to suggest in his poem "Spanische Tänzerin" ("Spanish Dancer"), which rhythmically captures in words a flamenco dancer's fiery energy and propulsive movement, her dramatic gestures. Rilke uses images of fire to track the arc of a flamenco dance from its initial gestures to its triumphant conclusion. What starts as a slow, tentative movement, like the first wavering flutter of a sulfur match, soon flickers and fans out to a ring of watchers "hot, bright, and eager":

> And all at once it is entirely flame.

The dancer seems with a single glance to set her hair afire. With whirling movements, she seems to set her dress ablaze in fiery rapture. Yet her naked arms stretch out like startled snakes:

> And then: as though she felt the fire grow tight,
> she sweeps it all together and casts it off
> disdainfully, and with imperious demeanor
> looks on: it lies there raging on the ground
> and keeps on flaming and refuses to submit—.

But she, with self-assurance and a sweet
exultant smile, looks up triumphantly
and stamps it out with furious little feet.

In the end, the dancer reasserts a cool, assured control over her own flaming art.

The site of a flamenco dance—a place where ardor animates and sometimes trumps technique—is also the space Lorca was trying to negotiate as he passed through cafés of music, museums of order, mosques of chaos. In 1928 he delivered a lecture, "Imagination, Inspiration, Evasion," about the creation of poetry in which he tried to delineate the dual roles of reason, which he somewhat confusingly mislabeled "Imagination," and unreason or irrationality, which he called "Inspiration." His real subject is the limitation of poetic reason, conscious thinking, even in such a great poet as Góngora, whom he had once praised for his "unperturbed" inventiveness and "clear, iridescent, elegant" style. The severely logical imagination, Lorca suggests, can do many things, but it cannot touch the darker forces of nature, or the most incandescent lights, or the realm of the unknown:

> [It] travels and transforms things, endowing them with their purest sense, and it identifies relations which had never been suspected. But it always, always, always works with facts borrowed from the most clear and precise sort of reality. It falls within our human logic, controlled by reason, and cannot escape from it. Its special manner of creation needs order and limits. Imagination is what has invented the four points of the compass and what has discovered the intermediate causes of things. But it has never been able to abandon its hands in the senseless, illogical embers where inspiration is stirring, free and unfettered. Imagination is the first step, the foundation of all poetry... The poet uses it to construct a tower against the natural elements and

against mystery. The poet is unassailable; he orders and is heeded. But the best birds, the brightest lights always get away from him.

Lorca struggled within himself, within his chosen art form, with a need for order and an equally potent (and perhaps more explosive) rage for chaos. His ultimate goal was a creation that would somehow transcend art itself. In the end, he came down on the side of works of art that use technique to go beyond technique, that rupture the geometry of their own imposed forms.

Lorca pictured the creative process as a kind of fantastic combat with the demon, which is closely akin to the way that Baudelaire also viewed it. Here, for example, is how the French poet, who inaugurates our modernity, describes a friend, the artist Constantin Guys, obsessively working through the night. It's late when Baudelaire drops in on him, and the rest of Paris is slumbering in peaceful oblivion: "…how he stands there, bent over his table, scrutinizing the sheet of paper just as intently as he does the objects around him by day; how he *stabs away* with his pencil, his pen, his brush; how he spurts water from his glass to the ceiling and tries his pen on his shirt; how he pursues his work swiftly and intensely, as though he were afraid that his images might escape him; thus he is combative, even when alone, and parries his own blows."

In his essay "On Some Motifs in Baudelaire," Walter Benjamin links this description to the opening stanza of "The Sun" ("Le Soleil"), probably the only place in *Les Fleurs du Mal* where Baudelaire, struggling in the zone between word and thing, portrays the modern poet at work. It comes from the section "Parisian Scenes" ("Tableaux Parisiens"):

Late in this cruel season when the sun
scourges alike the city and the fields,
parching the stubble and sinking into slums

where shuttered hovels hide vile appetites,
I venture out alone to drill myself
in what must seem an eerie fencing-match,
duelling in dark corners for a rhyme
and stumbling over words like cobblestones
where now and then realities collide
with lines I dreamed of writing long ago.

It is just such creative excitation, such artistic dueling, that Lorca was trying to describe and encapsulate in his idea that the true fight—the most ardent struggle—is with the duende. Duende, then, becomes a name for a radically accelerated process of creation in which everything is at stake. It is a term for a black feeling that exceeds itself, for a series of ideas darkening so quickly that they seem to surpass thought. The notion of duende tries to account for a creative zone where Baudelaire fences with words and Guys skirmishes with a black pencil, where Nijinsky sails into a long floating leap that defies gravity, and Picasso thinks on canvas with a blue paintbrush, and Charlie Parker turns an alto saxophone into a gleaming instrument of transport. It is a place where works of art take on an irrational inner glow, a majestic strangeness, like Goya's black paintings.

*All truly profound art requires its creator to abandon himself to
certain powers which he invokes but cannot altogether control.*
ANDRÉ MALRAUX, "GOYA"

The Black Paintings

LORCA WAS USING THE IDEA of duende to try to account
for artistic moments that seem to defy accountability. The presence
of duende is illustrated by that moment late in his life when Goya
passed under the portals of death. In *Self-Portrait with Dr. Arrieta*
(1820), a prelude to the black paintings, the seventy-four-year-old
artist portrayed himself at a point of mortal exhaustion, at death's
door. He is pictured wearing a gray dressing robe, his hands lying
limply on the covers of his bed, his shoulders falling back against
the doctor sitting behind him, holding him up, silently urging him
to take a glassful of medicine. The patient looks stricken, the doc-
tor implacable. These two figures are so striking that it can take the
viewer a while to discover the vague slate-dark figures, insubstan-
tial presences, painted into the background. They are apparitions
welling up from the darkness of the sickroom. They are the spooky
phosphorescent specters—the fever ghosts—who would be se-
cretly unleashed into the black paintings.

The duende moved with lethal force when Goya exchanged
the grays, silvers, and pinks in which he was so expert for a spec-
trum of blacks, when he carved his fates and inscribed his night-
mares directly onto the plaster walls of his property known as
Quinta del Sordo, or House of the Deaf Man. Goya bought the
twenty-five-acre country property just outside Madrid in 1819,
and he lived there for four years in his mid-seventies. He must

have thought he would be entombed there. It was this house on the edge of the Manzanares where he exorcised his demons and crossed the darkest river. The fourteen mural paintings in two rooms, one directly above the other, were violently forged at the dividing point—a shimmering black line—between one world and the next. They were suspended over an abyss.

It must have been a startling experience to enter the lower *quinta* salon. Turn left and you would encounter the imposing figure *La Leocadia,* a pensive young woman veiled in black who seems to stand apart, almost to oversee the nightmare world of the other paintings. Art historians identify her as Leocadia Weiss, the young woman who came to live with the aging artist in his isolated country house. She is a melancholy figure leaning against a tomblike mound. It seems as if she is a young widow mourning a husband who had recently passed over to the other side, who was looking back from the infernal regions.

Turn to the right, to the opposite wall, and you would discover the terrifying picture of a bloodstained Saturn devouring one of his children. He is the ancient deity Kronos, the cannibal Time. Next to him is a picture of Judith's slaying of Holofernes. The other paintings surrounding these two vertical depictions of death are fantastic visions, phantasms, broad scenes from the lower depths, such as *The Sabbat,* which shows a group of monstrous beings huddled together in fear of the *gran cabrón,* a he-goat devil, a weak, menacing figure who cannot seem to control his flock, and *The Saint Isidore Pilgrimage,* which portrays a monstrous procession winding through a nocturnal landscape. The last picture you would see in the lower salon was *A Final Pilgrim,* which depicts two old men, one a feeble pilgrim with a long white beard listening to the other, a demoniacal companion with a widely grinning open mouth. It's as if the devil himself were entreating or mocking the last pilgrim.

Upstairs is *The Witchy Brew,* a small painting of a hooded fig-

ure with a sinister grin. She's holding a spoon over a bowl while another skeletal figure looks on. Two witches, or a witch and her patient, a bewitched one on the edge of death. They're both pointing to the left toward the door, toward any of us who might have come up the stairs and entered their realm. So, too, *The Fates and Their Creation* shows a demonic group swirling through the night air above a darkened landscape. The three malevolent fates are ushering their creation, a hunched, blankly captive figure. It would have been an eerie, exhilarating experience to stand in the middle of a room where soldiers are aiming at a pair of flying demons (*Asmodeus*), two peasants are sinking up to their knees in the ground and bludgeoning each other to death (*The Cudgel Fight*), and a dog—a helpless innocent—is descending into quicksand in a vast bare setting (*The Dog*). Only his head is visible. He is staring up at a wasteland of scumbled browns into an infinitely cold and vacant universe, waiting for a master who will never come. Who knows how long he can hold out?

The sinister forces are loosed and roaming the night in these crafted hallucinations, phantom scenes, nocturnal paintings in which spirits are released into the menacing darkness and bodies are swallowed up by the earth. It's as if Goya was trying to paint underneath the human intellect or beyond it. He despised cruelty. He recognized the evil power of human superstition. He evokes something very ancient in the figure of demons disturbing the night sky, the unconscious mind. He had a gift for inhabiting the evil nightmare. And he pointed toward something very new in his broken and interrupted brushstrokes, his paintings which may never have been finished, and his urgent explorations of the color black, all of which anticipated Modernism. Blackness is the element in which Goya moved and thought. Looking at his late paintings of the night mind, of disruptive consciousness and visionary grandeur, one might revise Manuel Torre's defining statement and say, *All that has black light has duende.*

The Intermediary

THE CREATION OF GENUINE ART demands conscious struggle, formal inventiveness, and reckless courage. Lorca liked to refer to Goethe's assertion, as Eckermann reports it, that "in poetry, especially in what is unconscious, before which reason and understanding fall short, and which therefore produces effects far surpassing all conception, there is always something of the daemonic." Goethe also said that the *Dämonische* "loves to throw itself into significant individuals." He declared, "The songs made me, not I them."

One recognizes that the stakes are always high in the ferocious struggle to make art, which can take over the body like an ecstatic joy or a sudden overwhelming illness. The flamenco singer Juan Talegas once compared the duende to contracting a fever. Talegas was one of the more serene, orthodox, and emotionally restrained of classic flamenco singers—a sort of Ben Jonson of the form—and invariably followed the formal contour and structure of a *cante*. "I had the duende only twice in my life," he testified, "but afterwards they had to carry me out."

Inspiration means in-breathing, indwelling. It is an inhalation. It may be a form of spiritual alertness. It has its roots in "enthusiasm," which derives from the Greek word *enthousiasmos,* or "inspiration," which in turn derives from *enthousiazein,* which means "to be inspired by a god." Such possession is ardent, con-

suming, fanatic. At times it seems to have a life of its own. It is overpowering and, like the muse, it can be appeased only by total devotion. Shelley considered poetic composition both an uncontrollable force beyond the dispensation of the poet's conscious intellect ("Poetry is not like reasoning, a power to be exerted according to the determination of the will. A man cannot say, 'I will compose poetry'") and an internal phenomenon of the deeper mind:

> for the mind in creation is as a fading coal which some invisible influence, like an inconstant wind, awakens to transitory brightness; this power arises from within, like the color of a flower which fades and changes as it is developed, and the conscious portions of our natures are unprophetic either of its approach or its departure.

In his superb work *The Greeks and the Irrational,* E. R. Dodds suggests that Democritus was the first writer—at least the first we know about from ancient Greece—who held that the finest poems were composed "with inspiration and a holy breath." Dodds points to the ancient Greek belief that minstrels derive their creative power from a supreme source. "I am self-taught," says Phemius. "It was a god who implanted all sorts of lays in my mind." So, too, Pindar begged the Muse to grant him "an abundant flow of song welling from *my own* thought." It's striking that these poets characterize inspiration as a power from without that is also a source within. Dodds also notes that for Plato, "the Muse is actually *inside* the poet." The Neoplatonic Shelley spoke of "the visitations of the divinity in man."

The Greeks at one time believed that dreams and visions were objectively seen. They were caused by external forces, divine messengers. But Dodds traces the development of Greek culture to a new Classical Age when these experiences were connected to an occult power that dwells within the self, innate to human beings.

(He finds a strong analogy in shamanistic practices.) The Greeks initially termed that magical or occult self the *psyche,* or "soul," but gradually came to name it the *daimon,* a word with a complicated history for which we have no precise equivalent in English. It means divine power, fate, god. Empedocles believed, for example, that the *daimon* (not the psyche) persisted through successive incarnations. Whereas the psyche was at home within the body, the *daimon* was truly seeking a dwelling place beyond its mortal limits. There is something homeless, something truly "elsewhere" about this indwelling force or spirit, which has a drop of alien blood. It seeks reunion with the transcendent. It stands as the source of our possible divinity, our potential divination.

The *daimon* is a specific figure, the intermediary. "The background remains the mythical one of a space full of demons, the animated Whole," as Massimo Cacciari describes it in *The Necessary Angel,* "but detached from it there is a definite category of beings characterized by a particular and irreplaceable mediating function." Plato defined the *daimon* as "a very powerful spirit...halfway between god and man" (*Symposium*). He has Diotima explain to Socrates the mediating role and function of the *daimons:*

> They are the envoys and interpreters that ply between heaven and earth, flying upward with our worship and our prayers, and descending with the heavenly answers and commandments.
>
> (*Symposium*)

The gods don't communicate to mortals directly, Plato suggests, but rely on intermediary spirits. So, too, mortals need figures to communicate with the gods, and thus the *daimon* becomes the figure of the petition, a source evolving into sacrifices and initiations, incantations and prophecies, divinations and magic spells, sacred poems. Plato further suggests in the *Republic* that it is possible for

the soul to choose its own *daimon,* which is to say, its own potential source of immortality. The *daimon* has a great deal in common with the figure of the angel, and at times seems indistinguishable from it, but there is a strong undercurrent of destiny, of fatalism, in the character of the *daimon* that is not inevitably present in the liberating figure of the angel.

In *Omens of Millennium,* Harold Bloom proposes that the ancient idea of the *daimon,* of a divine or magical inner self, an occult self that is even older than the body, is the origin of all Gnosticisms—Jewish, Christian, and Islamic—and the crucial source for the Hermetic Corpus, which was so foundational for the Italian Renaissance. It is at the core of all heretical mysticisms. And it serves as the distant foundation stone for the Emersonian idea of self-reliance, the central text of the American religion.

Emerson himself referred often to an inner or alternative secret self, "a sort of alter ego or Socratic daemon," as his biographer Robert Richardson explains, "a free prophetic poetic voice or persona who was, of course, himself and yet not his daylight self." Emerson summoned and evoked this voice in the figure of Osman, a wholly interiorized "other," whose name apparently derives from the thirteenth-century founder of the Ottoman empire. He calls up his Osman self at the end of *Nature,* and in his *Journals* recounts a vision that came to him from one of Osman's dreams. Emerson's Osman says: "Let a man not resist the law of his mind and he will be filled with the divinity which flows through all things. He must emanate; he must give all he takes, nor desire to appropriate and to stand still." Osman is Emerson's enchanted, metamorphic, visionary inner voice.

The figure of the *daimon* is one of the artistic night mind and a distant ancestor of Lorca's duende and Rilke's angel. Over time, the *daimon* evolved into the figure of the demon, a word which, taken in its root sense, means an attendant, ministering, or indwelling spirit. In ancient Greek mythology, the *daimon* referred

to a class of supernatural beings less individualized than the gods. The *daimones* were spirits associated with particular places, such as nymphs, who dwelled in trees, springs, and mountains; satyrs, who moved through wooded areas; and Nereids, who were confined to the waves of the sea. The *daemon,* to use the Latin word that is the etymological link to the English *demon,* was an intermediary between mortals and immortals, a liminal being, an inferior divinity, such as a deified hero. This was also the notion of demons, who were appeased by magic rites and not prayed to as gods, in the polytheistic religions of the ancient Near East. But there is no one term in any Near Eastern language, including Hebrew, that is a precise equivalent for "demon." There were good demons, just as there were evil gods. The *Encyclopedia Judaica* points out that in the intertestamental literature, including the Dead Sea Scrolls, it is often virtually impossible to say whether "spirit" is referring to a demon external to a man or to a trait within the human soul.

The later writers and redactors of the Hebrew Bible were the ones who exclusively identified demons with "unclean" and "evil" spirits. This is also the sense of the rabbinical literature and commentary. The idea hardened in the New Testament into the figure of the demon as a malignant being, a devil. It had become an eternally afflicting presence. Thereafter, in normative religious terms, the angel and the demon become alternative figures locked in combat. They embody the sacred and the profane. They are necessary interdependent opposites, like good and evil, each implying and implicating the other. What they retain is the ancient sense of being messengers. They are figures who stand at the doorway of the human limit, pushing the boundaries of the bodily self.

Lorca's figure seems unconsciously related to, and perhaps even emerges from, the figure of the demon, but by using the Andalusian term duende he bypasses the negative Judeo-Christian

implications of "demon." He attributes to the duende a frenzied earthly power, but sidesteps the moral terminology of foul possession. He says explicitly that the duende should not be confused with Christian figures, such as "the theological demon of doubt" who afflicted Luther, or "the destructive and rather stupid Catholic devil who disguises himself as a bitch to get into convents." Lorca also recognizes the pagan Greek ancestry of his high-spirited figure. As he explains it, "The duende I am talking about is the dark, shuddering descendent of the happy marble-and-salt demon of Socrates, whom he angrily scratched on the day Socrates swallowed the hemlock" (*Deep Song*).

Lorca is referring to the fact that Socrates insisted that he was guided in his actions by a divine agency, a specific inward monitor, an oracle. Socrates cites his *daimonion,* a voice that started coming to him in childhood, as an authority he always obeys immediately and without question. It is a suprarational figure—a divine obstruction—who steers him away from doing certain things before he recognizes or understands their consequences. The *daimonion* never advises him on what to do; it never urges him toward any particular course of future action, but instead serves as an intuitive warning system, a moral barometer (*Socrates' Defense*). In the *Republic,* for example, the voice prevents him from suddenly veering away from philosophy, which he considers the ideal use of a human life. It is as if the intruder serves as a "divine" substitute for the instincts or intuitions that Socrates otherwise seems to lack. It represents those instincts projected onto a higher, supernatural plane.

Socrates argues that it is logical for him to believe in supernatural beings without simultaneously believing in the gods (*Socrates' Defense*). He interprets the fact that his *daimonion* remains entirely silent during his trial as key evidence that it is now preferable for him to go off willingly to his death. Death no longer represents a negative thing for him. It is now a positive. It

is this logic that causes Lorca to shudder, since he was himself both fascinated by death and physically terrified of it. The Spanish poet decided that the *daimonion* struck back at Socrates—it scratched him on the day of his death—because it was furious at his stoicism, at the way he accepted his own demise. It sickened at his logic—at least from a modern Spanish poet's point of view—much the same way that the "melancholy demon of Descartes," another ancestor of the duende, "sickened of circles and lines and escaped down the canals to listen to the songs of blurry sailors" (*Deep Song*).

In his devastatingly ironic prose poem "Let's Beat Up the Poor" ("Assommons les pauvres!"), Baudelaire also contrasts Socrates's ancient demon to his own modern one. Socrates's figure, Baudelaire suggests, is like a guardian angel, a good conscience, manifesting itself in order to forbid, warn, and prevent him from doing untoward things ("Poor Socrates only had a prohibiting Demon"), whereas Baudelaire's own uncanny spirit is "a Demon of action, a Demon of combat." It is a much more ambiguous presence, a dark shadow figure springing into action, a satanic voice whispering in his ear, urging him on, telling him what to do. It is a perverse imp of the unconscious who pushes him off the edge, who spurs him into doing shocking things, like attacking beggars out of the blue, beating up the poor, and, consequently, getting beaten up in return.

The same demonic figure ("Le Démon") tags along with the speaker—the *flâneur*—in Baudelaire's lyric poem "Destruction" ("La Destruction"). It is like an impalpable air that fills his lungs with sinful cravings and sometimes transmogrifies into a seductive woman's form. The figure leads him away from "God's regard" into the vast barren spaces of *l'Ennui,* a killing boredom, and thereby becomes the demon of noontide, of acedia, of paralyzing spiritual torpor. It seduces him into the willing arms of destruction.

Yeats's Daimon

AT TIMES IT SEEMS W. B. Yeats took the idea that *the true fight is with the duende* (*Deep Song*) and formulated it into an artistic creed. "We make out of the quarrel with others, rhetoric, but of the quarrel with ourselves, poetry," he said. It is as if he adopted Lorca's intuitive way of invoking and struggling with a secret unknown force, *a mysterious power which everyone senses and no philosopher explains,* and tried to develop it into a cosmology. Yeats was an avid, perhaps even too avid, systematizer, and it is revealing to address his idea of the Daimon or Spirit, which also illuminates Lorca's advocacy of the duende.

Yeats was powerfully attracted to the notion that, as he expressed it when writing about Shakespeare, the Greeks "considered that myths are the activities of the Daimons, and that the Daimons shape our characters and our lives." He fancied the idea that for each of us there existed one archetypal story, a single explanatory myth, which, if we but only understood it, would clarify all that we said and did and thought. That is why he was so drawn to the Greek notion that "the Daimon is our destiny," which he expanded into a summary doctrine in "Anima Hominis":

> When I think of life as a struggle with the Daimon who would ever set us to the hardest work among those not impossible, I understand why there is a deep enmity between

a man and his destiny, and why a man loves nothing but his destiny.

Yeats is picking up the type of *daimon* that, as Dodds explains, first made its appearance in the Archaic Age. It is "attached to a particular individual...and determines, wholly or in part, his individual destiny."

In Yeats's mature cosmology, the self is radically counterpoised to its spiritual opposite, or Daimon. He tended to call that figure the Spirit in his poems and the Daimon in his prose. He liked the hermetic character—the occult nature—of the elusive term. "The Daimon comes not as like to like but seeking its own opposite, for man and Daimon feed the hunger in one another's hearts." The Daimon served him as a kind of counterself, a mask or antiself, raised to a supernatural plane. It is the conflict with the Daimon, Yeats believed, out of which art is made.

Yeats fleshed out his ideas in his 1915 program poem "Ego Dominus Tuus," which stands as the prefatory motto to *Per Amica Silentia Lunae.* (I have always preferred this superbly written "little philosophical book" of 1917, a work that introduces the visionary theater of Yeats's late imagination, to the harsher geometries of his final mythology, *A Vision,* 1937.) Yeats took the mystical title "Ego Dominus Tuus" ("I Am Thy Master") from Dante's *Vita Nuova,* which he read in Rossetti's highly evocative free translation. The poem takes the explanatory form of a dialogue between two figures, *Hic* and *Ille,* whose names are Latin pronouns for "this" and "that." These dueling figures or voices represent Yeats's idea of two opposing types, one "primary," the other "antithetical." He identifies with *Ille* throughout—a subjective, lunar figure associated with the soul. (Hence Ezra Pound's quip that a better title would have been *Hic and Willie.*)

The creative artist, Yeats suggests, must be open to an un-

known power that fills him. He must be able to draw strength from a source he doesn't understand or know. Near the end of the poem, *Hic* asks, "Why should you leave the lamp / Burning alone beside an open book, / And trace these characters upon the sands?" After all, he argues, "A style is found by sedentary toil / And by the imitation of great masters." But *Ille* won't accept this proposition. He responds:

> Because I seek an image, not a book.
> Those men that in their writings are most wise
> Own nothing but their blind, stupefied hearts.
> I call to the mysterious one who yet
> Shall walk the wet sands by the edge of the stream
> And look most like me, being indeed my double,
> And prove of all imaginable things
> The most unlike, being my anti-self,
> And standing by these characters disclose
> All that I seek; . . .

Yeats's mastery comes in questing for an image, in seeking and finding the pure, inevitable, demonic figure. He does so by calling to the other self (an *antiself* or an *antithetical* self), a stranger who is a mysterious double, seemingly kindred in appearance but opposite in nature.

Yeats took to heart Blake's proposition that "Without Contraries is no progression." He developed an entire cosmology based on the idea that there is a mutual dependence and necessary antagonism between two opposite realms: one human and time-bound, the other supernatural and timeless. He argued that mortals need and seek spiritual knowledge (wisdom) from the otherworld, whereas immortals lack physical substance (power) and therefore require mortals to complete their tasks. The poem "Blood and the Moon" defines the terms:

For wisdom is the property of the dead,
A something incompatible with life; and power,
Like everything that has the stain of blood,
A property of the living...

The working out of the conflict between power and knowledge animated Yeats's work from his early poems (such as "Fergus and the Druid" and "Who Will Go with Fergus Now?") to his late plays (such as the *On Baile's Strand, The Only Jealousy of Emer,* and *The Death of Cuchulain*). Yeats's early poetry was, as he confessed to Katharine Tynan, "almost all a flight into fairyland from the real world, and a summons to that flight," but he turned that theme to much deeper ends in his later work, which becomes, as Daniel Hoffman suggests, a "summons not merely to a nebulous escape from necessity but to the repossession of original energy, the powers of life and increase grasped by a mortal at their supernatural source." He was writing a poetry of insight and knowledge.

Yeats articulated his occult theory of antinomies in terms of Irish folklore when he asserted, "By implication the philosophy of Irish faery lore declares that all power is from the body, all intelligence from the spirit." He was explicit in the article "Irish Witch Doctors":

One is constantly hearing that "the Others" must have a mortal among them, for almost everything they do, and one reads as constantly in the old Irish epic tales of mortals summoned by the gods to help them in battles. The tradition seems to be that, though wisdom comes to us from among spirits, the spirits must get physical power from among us.

Yeats was powerfully drawn to tales in which everything is turned upside down, recognizably topsy-turvy. Folklorists and anthropologists have argued that these stories and rituals often serve

as crucial expressive outlets. They draw attention to cultural categories in order to reaffirm or, sometimes, to overthrow them. For Yeats, who was continually trying to substantiate his hermetic ideas by locating them in a "real" community, in an ancient communal system of folk belief, Irish folklore seemed to give license for his idea that the world of the fairies is the exact opposite of the human world and that everything in the otherworld is reversed: north is south, left is right, winter is summer, night is day. This idea of inverted kingdoms is summed up in the enigmatic statement that opens his play *The Hour-Glass:*

> There are two living countries, one visible and one invisible, and when it is summer there, it is winter here, and when it is November with us, it is lambing-time there.

Later in the play, a Wise Man interprets this passage and comments on its occult meaning:

> The beggar who wrote that on Babylon Wall meant that there is a spiritual kingdom that cannot be seen or known through till the faculties, whereby we master the kingdom of this world, wither away like green things in winter.

This is, as the Wise Man also says, "the most mischievous thought that ever passed out of a man's mouth," because it means that we can attain the inner spiritual world only at the cost of our outer physical lives. Or as Rilke once told a young writer, it was impossible to see the Angel without dying of him.

The idea of the inevitable conflict between power (the body, the conscious mind) and knowledge (the spirit, the unconscious mind) stands behind every meeting between a mortal lover and his fairy mistress in Yeats's collected works. This concept of strife informs his Blakean notion that " 'sexual love,' which is 'founded upon spiritual hate,' is an image of the warfare of man and Daimon." He even wondered if there was some secret whispering in

the dark—a kind of hidden conspiracy—between Daimon and sweetheart. Sex became his key metaphor for the momentary meeting or reconciliation of the two worlds. He argued that human beings always try to become their own opposites.

Yeats's philosophy of continual discord between the time-bound human world and the timeless world of eternity is what he called his "centric myth," just as his belief that contraries are a deeply positive force was a touchstone for his theory of personality as well as for his philosophy of history: "Each Daimon is drawn to whatever man or, if its nature is more general, to whatever nation it most differs from, and it shapes into its own image the antithetical dream of man or nation."

It often has been told how in 1917, four days after their marriage, Yeats's young wife, Georgie, surprised him by attempting automatic writing. He was so excited by the obscure messages, by the disjointed but profound spiritual instructions coming through, that he offered to give up poetry and devote himself entirely to deciphering and systematizing the discoveries. "No," was the answer, "we have come to give you metaphors for poetry." The unknown instructors at first took their themes from Yeats's recently published text, *Per Amica Silentia Lunae,* but then branched out. The spirits who spoke to Yeats through his wife's automatic writing were explicit about one of their key aims: "It was part of their purpose to affirm that all the gains of man come from conflict with the opposite of his true being." We grasp reality through a series of oppositions, say, between *this* and *that,* or our inner and outer worlds. Combat with the self, combat with circumstances: these are the twin cornerstones of the entire geometric myth of *A Vision.*

Yeats devised an elaborate system of twenty-eight phases of the moon that correspond to the great revolving wheel of history. It is also a system of human personality, and each phase is associated with a particular constellation of psychological traits. He was

certain that he belonged—along with Dante, Shelley, and Landor—to what he characterized as Phase 17, *The Daimonic Man.* "He is called the *Daimonic* man," Yeats explains, "because Unity of Being, and consequent expression of *Daimonic* thought, is now more easy than at any other phase." The artists who belonged to this particular "phase of being," he suggests, had the clearest path to attaining spiritual harmony, or reunion with an animate God, with an all-inclusive One, the ground of absolute being:

> For one throb of the artery,
> While on that old grey stone I sat
> Under the old wind-broken tree,
> I knew that One is animate,
> Mankind inanimate phantasy.

Yeats employs these esoteric terms and figures in order to try to name and systematize an artistic quest, a spiritual ambition. He was seeking through an idea of struggle to release a truth buried within the self, to find a greater unity. He would tap something eternal. He would free the imprisoned occult or gnostic self, the hidden god who always seems to lie mysteriously beyond us, yet secretly within:

> I sometimes fence for half an hour at the day's end, and when I close my eyes upon the pillow I see a foil playing before me, the button to my face. We meet always in the deep of the mind, whatever our work, wherever our reverie carries us, that other Will.

Ars Poetica?

THIS BOOK ESSAYS PRAISE for artistic inspiration, for the dark dictations and struggles that get embodied in works of art. It is a hymn to the irrational triumphs of art, to romantic imagination. ("Imagination—" Wordsworth writes in Book VI of *The Prelude,* "here the Power so called / Through sad incompetence of human speech, / That awful Power rose from the mind's abyss.") But as a kind of counterweight, a rebellion against art from the precincts of art, it is instructive to recall how a long tradition (the notion that poetry is dictated by a *daimon*) stands behind and hovers around the edges of the work of a great contemporary poet such as Czeslaw Milosz. Milosz has always insisted that his poems come to him as dictations, that he is "seized by trances." "I am no more than a secretary of the invisible thing / That is dictated to me and a few others," he writes in his poem "Secretaries." Thus he began his lectures *The Witness of Poetry,* "Frankly, all my life I have been in the power of a daimonion, and how the poems dictated by him came into being I do not quite understand." Or as he confided to Ewa Czarnecka, "I myself don't know what sort of forces have been seizing me and ordering me to write all these years, perhaps all my life." He acknowledges a kind of poet's rebellion against lyric poetry itself. "My relationship to poetry is quite complicated," he told her. "I am a medium, but a mistrustful one."

Milosz's sense of himself as a skeptical medium drives one of his crucial poems of the late 1960s, entitled "Ars Poetica?" The *ars poetica* is a poem that takes the art of poetry—its own means of expression—as its explicit subject, and Milosz is self-consciously writing at the end of a long tradition of such self-referential poems. That body of work extends from Horace, whose *Ars Poetica* is our first known poem on poetics and the fountainhead of the tradition, to Wallace Stevens, who declared that "the theory of poetry is the theory of life." Like the defense of poetry, the *ars poetica* becomes a particularly necessary form when the efficacy of poetry is called into question and freedom is endangered.

Milosz's poem playfully, ironically, but also genuinely wonders whether or not it is an actual *ars poetica;* hence the question mark in the title. It is certainly not a traditional exploration of the art of poetry. At the same time, the poet is responding to, and perhaps even criticizing, the lyric purity of the tradition ("I have always aspired to a more spacious form / that would be free from the claims of poetry or prose") and wondering whether or not there really is an "art" to poetry. Shouldn't we be able to understand each other without mediation, the poet suggests, "without exposing / the author or reader to sublime agonies?"

At its core, the poem mischievously questions the very decency of artistic possession. It challenges not the authenticity but the virtue of material that has come to us directly from the unconscious. Milosz thus questions the morality of inspiration itself. "In the very essence of poetry there is something indecent," he writes, "a thing is brought forth which we didn't know we had in us":

> That's why poetry is rightly said to be dictated by a daimonion,
> though it's an exaggeration to maintain that he must be an angel.
> It's hard to guess where that pride of poets comes from,
> when so often they're put to shame by the disclosure of their
> frailty.

The poet uses a discursive rational mode here—and the *ars poetica* has often been a discursive self-critical form—to wonder ironically about what it means to be taken over by irrational spirits, to be delivered up to the inspired demonic. He recognizes the vertiginous strangeness of making art, and thereby asks:

> What reasonable man would like to be a city of demons,
> who behave as if they were at home, speak in many tongues,
> and who, not satisfied with stealing his lips or hand,
> work at changing his destiny for their convenience?

There is a modern acknowledgment in this poem that each of us is a vehicle for forces beyond ourselves, an open house where "invisible guests come in and out at will." It's extremely difficult to remain an intact entity, Milosz argues, and he is genuinely humble before the forces that may pour through us. Milosz survived two totalitarianisms (one Nazi, one Soviet) and lived through most of the twentieth century. In the face of negative historical irrationality, a barbarism that has been the hallmark of the modern world, he begins another poem, entitled "Incantation": "Human reason is beautiful and invincible." It's altogether telling that he needs to invoke the ritual of a magic spell to celebrate rationality, to praise the beauty and youth of "Philo-Sophia" (wisdom philosophy) and "poetry, her ally in the service of the good." In the same vein, Milosz's *ars poetica* concludes with a genuine sort of prayer, "with the hope / that good spirits, not evil ones, choose us for their instrument."

Milosz's soulful skepticism is a central, perhaps even constitutive, feature of contemporary Polish poetry itself, since it is also present in the deeply humane work of Wisława Szymborska and Zbigniew Herbert, whose character Mr. Cogito, for example, distrusts "tricks of the imagination" and takes issue with a vatic image of Rimbaud's: "the piano at the top of the Alps / played false concerts for him." There is no place in Mr. Cogito's imagination,

Herbert declares, "for the artificial fires of poetry." Something we might call "Slavic soul" (one hears it in Shostakovich, Penderecki, Górecki, and others) refuses the glorification or identification with a godhead, but nonetheless exists in tragic feeling and tragic beauty.

In a mini-essay entitled "Reason and Imagination: The Nourishers of Humanity" from his ongoing series "The Little Larousse," Adam Zagajewski points out that he instinctively approves of "the great artists and prophets of our times" who "rebel against the dictatorship of reason, rationalism, science, technology, common sense." He admires and identifies with those who work for a return of faith, who endorse the metaphysical imagination, such as Solzhenitsyn, Milosz, Malraux, and Heidegger, who represent the affirmative side of the quest, and T. S. Eliot, Simone Weil, and others, who embody the negative part of the diagnosis. Yet he also points out how susceptible these "nourishers of humanity," who tend to think in holistic, romantic, and organic categories, have been to authoritarian politics, as if their marvelous intelligences had malfunctioned on this one point. Orwell is a crucial antidote here, for he foresaw "the catastrophic threat of both totalitarianisms." It is an enormous error to try to implant those categories in society, for as Zagajewski makes absolutely clear, "there is not even the slightest correspondence between an organic and holistic imagination and an organic and holistic society and state." This is a crucial disavowal, because it allows us to praise the creative power of deep mind and metaphysical imagination, the dimension of the holy in life, while also remaining faithful to a democratic ideal.

Perhaps whoever speaks or writes about the duende should bear these warnings from "the other Europe" in mind and invoke a tutelary spirit, an ancient figure who, one can only hope, watches over each of us and guides our destinies.

A Passionate Ingredient

LORCA BELIEVED THAT THE duende fills the artistic maker with such an extreme feeling that a fresh mode of expression becomes absolutely necessary. It pressures a formal response and seeks a transfiguring music. As he expresses it:

> The duende's arrival always means a radical change in forms. It brings to old planes unknown feelings of freshness, with the quality of something newly created, like a miracle, and it produces an almost religious enthusiasm.

> *(Deep Song)*

Duende loves Orphic enchantments. It is ancient, reckless, and free, and it seeks out the wilds of human emotion enacted through metamorphic artistic terms, which is why its passion animated Sappho's lyric meltdowns, and something like it transfigured into an urban soul cry and visited Ovid at least twice (once in the splendor of Rome, where he was working on his wonderwork, his book of changes, *The Metamorphoses,* and once in his primitive exile in Tomis, on the western shore of the Baltic Sea, enabling him to pen the fifty proud and abject poems of *Tristia*). A harsher, more masculinist form alliterated the Anglo-Saxon cadences of "The Seafarer" ("May I for my own self song's truth reckon") and descended through a clash of swords on the *Be-*

owulf poet, whose clamorous alliterative cadences rise from the dark seafloor—the unconscious sound stratum—of English poetry. The duende is savage and occult, ruthless in its alchemical pursuit of expressiveness in art. It is a passionate ingredient powering the development of English poetry.

When I was in my late teens and early twenties, I tried to educate my sensibility in poetry by putting myself to school on Yvor Winters's reading list. Winters was a western American version of F. R. Leavis. I felt the nobility of this American poet and critic's learning, his passionate defense of critical logic and reason (one of his best books was called *In Defense of Reason*), and I devoured the poetry of the plain style that he so strongly advocated, from Ben Jonson to Edwin Arlington Robinson and J. V. Cunningham.

But I had also felt the deep winds of Romantic poetry opening me up to another form of the lyric, and finally blowing open something I'd imprisoned in myself. I had fallen in love with a poetry of oracles and prophecies. I felt the intoxication of a potential that had been locked deep within the self. I read Emerson as a kind of ministering spirit to the imagination within:

That is always best which gives me to myself. The sublime
is excited in me by the great stoical doctrine, Obey thyself.
That which shows God in me, fortifies me. That which shows
God out of me, makes me a wart and a wen...

Winters had a fundamental, programmatic creed: "The poem is good in so far as it makes a defensible rational statement about a given human experience...and at the same time communicates the emotion which ought to be motivated by that rational understanding of the experience." This consciously reined in—or entirely legislated out of existence—all that is unruly and anarchic about art, everything socially dangerous, emotionally wild, imaginatively free. I was infuriated by Winters's reversal about Hart Crane, whose soaring cadences transported me ("These poems

illustrate the danger inherent in Mr. Crane's almost blind faith in his moment-to-moment inspiration," Winters wrote in *Poetry* magazine in 1930, "the danger that he may turn himself into a kind of stylistic automaton"), and began to search for a terminology that would recognize the motive power of passion, that would treat the poet as a maker while also honoring the moment-to-moment inspiration, the inspired demonic, the irrational. It's a genuine struggle to reconcile the dual romantic inheritance of the artist as a maker and a seer. Lorca's concept of the duende fulfilled a deep personal need, because it provided a language for what I intuited but could not name.

Those were the great times of youth, of mispronouncing names and schooling intuitions, of reading feverishly through the night. I still remember with what wild excitement I searched through English poetry looking for the products of duende, for art stranger than rational logic, deeper than will. It may not have been duende exactly, but something akin to it—a soulful British spirit arising in the presence of death—flung itself madly into Christopher Smart's *Jubilate Agno* and occasionally slipped into Pope's *Iliad* ("Reading the *Iliad*," Edwin Denby writes, "the poem at the height of reason presented the irrational and subjective, self-contradictory sweep of action under inspiration"), but mostly seemed to doze through the rest of the eighteenth century in England, waiting around for Wordsworth and Coleridge, for Blake to start taking spiritual dictation.

"I write," Blake said, "when commanded by the spirits and the moment I have written I see the words fly about the room in all directions." I recall stumbling excitedly onto Blake's assertion that "Inspiration & Vision was then & now is & I hope will always Remain my Element my Eternal Dwelling place." A great number of Blake's works began with a visitation from a ghostly figure who inspired and guided his creation. He was remarkable for his habitual way of conversing with angels, spirits, and demons. Blake

was an extremist of imaginative inspiration. "I have written this Poem from immediate Dictation," he said about his extended work *Milton,* "without Premeditation & even against my Will." He also reported that he felt he could praise his own work because he was no more than its Secretary: "the Authors are in Eternity."

From late April to mid-May 1819, a figure he called "my demon Poesy" spent three and a half exhilarating weeks with a twenty-three-year-old poet living in Hampstead when he wrote "La belle dame sans merci" (a ballad Robert Graves took to be the ultimate celebration of the White Goddess, a figure for the poet's destruction by the lustrous, immortal, predatory Muse), three experimental sonnets ("To Sleep," "How fever'd is the man," and "If by dull rhymes our English must be chained," which is a formal directive, an *ars poetica*), and five odal hymns that brought a dazzling concentration and amplitude to the English lyric ("Ode to Psyche," "Ode on a Grecian Urn," "Ode to a Nightingale," "Ode on Melancholy," and "Ode on Indolence"). The English language reached one of its pinnacles in this short month from what has variously been called the living year, the fertile year, and Keats's annus mirabilis. It was one of those inspired, superabundant, visionary moments that announces itself in poetry like a prophecy, that thunderously bursts out into Keats's *Odes* (all of which are driven by an aching sense of mortality, an excruciating vision of beauty born of death), Rimbaud's *A Season in Hell,* and Rilke's *Duino Elegies.* It overflows into the "Hyperion" fragments and into *Illuminations* and *Sonnets to Orpheus.* At these extended peak moments, in these atemporal storms, it seems as if the poet is taking dictation from a god, and the experience is ruthless, trancelike, and annihilating. Keats's demonic song, like Rilke's Orphic declarations, culminates in a poetry of the highest spiritual access, a human attainment nearly limitless in its apocalyptic splendor.

The Yearning Cry of a Shade

IN 1819, AN ACHINGLY erotic earthly spirit was struggling for escape through the voice of a twenty-one-year-old Italian poet who climbed the hill overlooking his hometown of Recanati and began to fashion the infinite spaces in "L'Infinito":

> And when I hear the wind come blowing through
> The trees, I pit its voice against that boundless
> Silence and summon up eternity.

Giacomo Leopardi's poems awakened to new heights when his supremely classical intelligence—he had spent his adolescence in his father's library ingesting most of the literature of antiquity and, in the process, ruining his health—led him to the brink of an abyss, a space where he suddenly found himself in the grips of *nulla,* a purposeless void. He wrote out of a longing he could scarcely name, a raging Eros that drove his sense of the ideal. "I was terrified at finding myself in the midst of nothingness, myself a nothing," he wrote in his huge notebooks, *Zibaldone.* "I felt that I was suffocating, contemplating and sensing that all is nothing, solid nothingness." He wrote to a friend:

> This is the first time that *noia* not only presses and tires me but harries and rips like the sharpest pain. And I am so terrified by the emptiness of things and the condition of

human beings, that—all passion spent in my soul—I stray outside myself, deeming even my despair an utter nothing.

A sublime and enraptured poetic style, a terrifying vision of emptiness, a despairing feeling of *noia*—a form of spiritual torpor and intellectual paralysis, a kind of energy or desire without an object or a destination—compelled Leopardi to write poems of the deepest solitude, solitude raised to the highest power: "Brutus the Younger" and "The Last Song of Sappho," "To Sylvia," "Night-Song of a Wandering Shepherd of Asia," and "To Himself," which sings of "the boundless emptiness of everything." Leopardi's spirit struggled to cross a final threshold in 1836 and 1837 when the hunchbacked poet ("a walking sepulchre," as he called himself) wrote his two final spiritual testaments, "La ginestra" ("Broom" or "The Desert Flower") and "Il tramonto della luna" ("The Setting of the Moon"), in a whitewashed peasant cottage in a little village above Torre del Greco, twelve miles from Naples on the slopes of Vesuvius. "The student, the writer, the sufferer, the wanderer was only Conte Giacomo Leopardi, but the poet was Orpheus himself," George Santayana wrote. "Long passages are fit to repeat in lieu of prayers through all the watches of the night."

With startled delight, a soulful spirit slipped into a French asylum for eight months in 1841 in order to move unhampered through the hallucinatory visions of Gérard de Nerval as he collapsed time past, time present, and time future, and began in earnest to document the reaches of his secret world, to record the ledger of his madness, *Aurélia,* or *Life and the Dream* (1855). "Our dreams are a second life," Nerval declared, passing through a limbo of shadows to the space where "the spirit world opens before us." Unlike Théophile Dondey, the friend to whom he dedicated *Voyage en Orient* (1851), Nerval did not wear glasses in his sleep so that he could see his dreams, but passed imperceptibly

into the state between sleeping and waking long after he was "cured" and left the asylum, all the years he spent describing "the impressions of a long illness which took place entirely within the mysteries of my soul."

In his early work *Sylvie* (1853), which is the genesis of *Aurélia,* Nerval describes the state of hypnagogic reverie with some precision:

> Lost in a kind of half-sleep, all my youth passed through my memory again. This state, when the spirit still resists the strange combinations of dreams, often allows us to compress in a few moments the most salient pictures of a long period of life.

Sylvie is a hymn to unattainable, unrequited love. It is also a testament to the compressing power of the imaginary realm. It was because of Nerval's special gift for this zone (and his determined commitment to it) that so many later artists who revered reverie and invited vision, from W. B. Yeats to Joseph Cornell, felt such great affinity with him, especially the French Surrealists who rediscovered and claimed him as a foundational spirit. Nerval wrote his late poems in a state he termed *supernaturaliste.* André Breton asserted in *The First Surrealist Manifesto* of 1924 that he might have employed Nerval's term as readily as Apollinaire's coinage, *Surrealism.*

Nerval's duende awakened with wild intensity when he began the poems of his third phase, the twelve mystic sonnets of "Les Chimères" (1854). In this sequence, composed in his *supernaturaliste* state, the beloved is what Nerval calls the *Chimère* or *démon,* and he is the *desdichado,* the "disinherited one," bereft, disconsolate—the outcast whose great love has been lost to death. Everything personal has been transposed to a mythological key.

Here is the first stanza of one of his greatest poems, "El Desdichado":

I am the dark man, the disconsolate widower,
The prince of Aquitina whose tower has been torn down:
My sole *star* is dead—, and my constellated lute
Bears the black *sun* of *Melancolia.*

Nerval refers here to Dürer's engraving *Melancolia I,* the embodied nightmare of depression, an abyss of sorrow, a personified grief that haunted and hunted him down. He bears "the black sun"—despondency's blinding light—and melancholia has become his muse.

In the last stanza of the poem, Nerval declares he has twice descended into the underworld, and come back to tell the tale: "And twice I have crossed and conquered the Acheron." These crossings recall his two previous attacks of madness. He then evokes Orpheus's lyre, the mythological instrument of the archetypal poet, the instrument of pure being, through which he modulates his own melancholy, supernatural music. Whoever listens closely to these chimerical poems, which create a feeling of infinity within the prescribed space of the sonnet, will be able to hear the strains of that ancient lyre piercing their dark nineteenth-century chords.

For the eight excruciating years from 1848 to 1856, the poet Heinrich Heine, one of the most scathing wits in Europe, was entombed in his paralyzed body in the room he was unable to leave, in the hell he notoriously called his "mattress-grave." "I am no longer a divine biped," he announced. "I am no longer the 'freest German after Goethe,' as Ruge called me in healthier days; I am no longer the great pagan no. 2 who was compared to the vine-wreathed Dionysus...I am no longer a zestful, somewhat corpulent Hellene smiling down on gloomy Nazarenes—I am now only a mortally ill Jew, an emaciated image of misery, an unhappy man!"

Heine's demon emerged at the ghostly blue hour of four A.M.—the hour of agony—when he wrenched his startling last

poems from the crypt of his body. "But this sweet anodyne / Was of brief sway," he writes in his hymn to morphine:

> I can be wholly healed
> Only the day the other brother, he
> Who is so pale and grave, lets fall his torch.—
> Sleep is good, yes—death is better—in truth,
> The best were never to have been born at all.

"I am flogging up a great many lines of verse," he wrote in a characteristic letter of 1849, "and many of them bring my pain under control like magic spells, when I croon them to myself."

Especially haunting are Heine's "Lazarus" poems (has there ever been a sequence more literally pledged to the subject of physical dissolution and death, of returning half dead from the grave?); the songs of his "return" to Judaism, "Hebrew Melodies" (both sequences are from *Romancero,* which he called "the third pillar of my lyrical fame"); the muse poems he wrote to the woman he called "Mouche" (or "fly" in French); and his *Poems of 1853 and 1854,* in particular the shocking ballad "The Slave Ship" and the bitterly ironic "Epilogue," which concludes with a stunning allusion to Book XI—the underworld book—of the *Odyssey:*

> That fellow in Homer's book was quite right:
> he said: the meanest little Philistine living
> in Stukkert-am-Neckar is luckier
> than I, the golden-haired Achilles, the dead lion,
> glorious shadow-king of the underworld.

Reading some of Heine's last poetry at his bedside, his friend Alfred Meissner termed it "a call from the beyond...a call of woe as from the shores of Acheron, it is the yearning cry of a shade for sunny life."

I Sing You, Wild Chasm

THE DUENDE SPENT MUCH OF the early 1860s in Amherst, where a shockingly original American poet in a white dress—an heir to Shakespeare—was fracturing the hymn structure, writing against normative Protestantism, and wooing, encountering, and evading the awful, the awe-filled suitor of Death.

A darkening energy charged Herman Melville's sentences whenever he wrote out of what he called the instinctive "knowledge of the demonism in the world," as in his notorious masterpiece *Moby-Dick,* where Ishmael is redeemed by his dark brother Queequeg and Ahab goes to his black doom fighting the sublimely white whale, a figure of unanswerable depths. "I have written a wicked book, and feel spotless as the lamb," Melville famously told Nathaniel Hawthorne, whose own spirit was haunted by memories of Puritanism and shadowed by historical fates, by a guilt so "black" it scalded the white Protestant flesh, by a Calvinist sense of Innate Depravity that led to a second Fall, this one in the New World.

Charles Ives recognized how profoundly Hawthorne was magnetized by the subterranean life of dreams, for in the second movement of the "Concord" Sonata he probes, as he says, "Hawthorne's wilder, fantastical adventures into the half-childlike, half-fairylike phantasmal realms…" "The substance of Hawthorne,"

Ives also explains, "is...dripping wet with the supernatural, the phantasmal, the mystical,...surcharged with adventures, from the deeper picturesque to the illusive fantastic."

F. O. Matthiessen also points out in *American Renaissance* that Hawthorne was compelled by hypnagogic states, by moments between sleeping and waking when "the imagination is thronged by a train of images," and he summons up, as a precise parallel, Edgar Allan Poe's startlingly accurate description—an account that foreshadows Freud—of such a state in *Marginalia:*

> There is...a class of fancies, of exquisite delicacy, which are
> *not* thoughts, and to which, *as yet,* I have found it absolutely
> impossible to adapt language. I use the word "fancies" at
> random, and merely because I must use some word; but the
> idea commonly attached to the term is not even remotely
> applicable to the shadows of shadows in question. They
> seem to me rather psychal than intellectual. They arise in the
> soul, (alas, how rarely!) only at its epochs of most intense
> tranquility,...and at those mere points of time where the
> confines of the waking world blend with those of the world
> of dreams. I am aware of these "fancies" only when I am
> upon the very brink of sleep, with the consciousness that I
> am so.

The duende moved down all the winding, vertiginous paths of Poe's short tales; it plunged with him into his uncanny explorations of dream consciousness, nightmare vision, convulsive mind, his obsessive, rational delineation of trances and swoons, of transitional states between sleeping and waking, hypnagogic zones in which the reasoning or imaginative faculties suddenly flicker and yield to an unknown force. It rejoiced, too, whenever he invoked the invisible fiend he called "the imp of the perverse," an irresistible demon voice that suddenly impels us to do some-

thing unaccountable, something unreasonable and often uncon-
scionable, to peer down into the abyss and then, instead of back-
ing away, to plunge impetuously over the precipice.

This is the same "good demon," a profoundly un-Socratic
one, who everywhere accompanied the speaker of Baudelaire's
"Let's Beat Up the Poor," earning him the right, as he declares, to
"my certificate of insanity." Indeed, the demon hovered over
Poe's spiritual cousin through most of the 1850s as he wrote his
scabrous masterpiece of inverted Christianity, *Les Fleurs du Mal.*
("Must I tell you—you who realized no more than anyone else,"
he wrote to his legal guardian from Brussels in 1866, "that in that
horrific book, I put all my *heart,* all my *tenderness,* all my *religion*
[disguised], all my *hate?* True, I shall write the exact opposite and
swear to God that it's a book of *pure art,* of mimicry and juggling
tricks, and I shall lie through my teeth...") It also swooped
through whenever he went to work on the fifty prose poems that
he wrote in the last twelve or thirteen years of his life, which be-
came the *Petits Poèmes en prose.* There is a furious breeze passing
over all these poems that ricochets between the dual poles he
called *spleen* and *idéal.* ("Now I suffer continually from vertigo,"
Baudelaire wrote in his *Journals,* "and today, 23rd of January,
1862, I have received a singular warning: I have felt the wind of
the wing of madness pass over me.")

In 1873, a mystical trickster flew into a farmhouse at Roche
where a pimply faced teenager, a marvelous *voyant* named Arthur
Rimbaud, was completing *Une Saison en Enfer* in a fever of
work and suffering ("At first it was an experiment," he claimed
in "Delirium." "I wrote silences. I wrote the night. I recorded
the inexpressible. I fixed frenzies in their flight"). So, too, a fren-
zied spirit of passion was in Dublin in 1885 when Gerard
Manley Hopkins reached a pitch of spiritual crisis ("when my
spirits were so crushed that madness seemed to be making

approaches—and nobody was to blame, except myself") that broke a two-year poetic silence and resulted in a group of six poems known as the "terrible sonnets." These poems stretch the sonnet form about as far as it can go without breaking. Hopkins wrote two of them in May: "If ever anything was written in blood," he told Robert Bridges, "one of these was." Part of what was driving Hopkins's poems was a desperately riven homo-erotic energy turned back against itself in self-hatred. Here are four lines from that poem "written in blood," "Carrion Comfort," which illustrate Hopkins's turbulent fight with something inside himself:

> Not, I'll not, carrion comfort, Despair, not feast on thee;
> Not untwist—slack they may be—these last strands of man
> In me ór, most weary, cry *I can no more.* I can;
> Can something, hope, wish day come, not choose not to be.

It is possible that Rimbaud's demiurge did not go with him to Africa, where he never wrote poetry again, but, instead, split itself off into the work of an Italian poet, Dino Campana, and an Austrian one, Georg Trakl. One feels its presence, in any case, in Campana's single book of poems, *Canti Orfici* (*Orphic Songs*), which has a manic lyricism and nightmarish beauty verging on incoherence. Campana completed his book in a few hallucinatory weeks in the autumn of 1913 and then, after a publisher lost the only copy, rewrote it from memory in a few torrid weeks in the spring of 1914. "Among his obscure intentions one can make out a demiurge, the ritualism of the conjurer of poetry which probably never would have been satisfied on the plane of pure lyric," Eugenio Montale explained. "His is a poetry in flight, which always disintegrates at the point of completion." One hears a demonic voice suddenly taking over, crying at the end of Campana's poem "Oscar Wilde at San Miniato":

> ...I screamed, O city,
> O sublime dream of giving
> To the unsatiated chimera bodies in flame—
> Most bitter funereal shudder before the lunar insensible blaze

There is an equally disturbing Rimbaudian presence in the enigmatic speech, the systematic distortion of the senses, the obsessively repetitive imagery, and the irreal atmosphere of Georg Trakl's expressionist poems. In an unusually open letter to his sister in 1908, Trakl described a struggle within him—a shocking alternation between the horrific and the transcendental—that is externally played out in his poetry:

> I believe it must be terrible to live always in full consciousness of all the animal instincts which constantly whirl through life. I have experienced, smelled, touched the most frightening possibilities within myself, have heard the demons howling in my blood, the thousand devils which drive the flesh mad with their spurs. What a horrible nightmare!
>
> Gone! Today this vision of reality has again sunk into nothing...and I, all living ear, listen again to the melodies within me, and my winged eye dreams again its images, which are more beautiful than all reality.

A dialectic operates in Trakl's imagination, one that he entirely recognizes, between the figures, the obsessive figurations, of darkness and light, the demon and the angel.

Trakl's poems have such convulsive beauty, especially the ones written in his final phase, in 1914, that at times one almost has to turn away from the black light of their brazen altars and spiritual flames. In these poems he speaks of "sleep and death, the somber eagles" ("Lament"), and cries out to the spirit of night itself:

I sing you, wild chasm,
Mountains towered up
In nightstorm,
You gray towers
Brimming with hellish grimaces,
With fiery beasts,
Bleak ferns, spruces,
Crystal blossoms.
That you hunt down God,
Gentle spirit,
Sighing in the cataract,
In surging pines.

("The Night")

Night Work

THERE IS CONSOLATION IN the idea that the dark night of
the soul is the duende's special province. Lorca declares, "The
muse of Góngora and the angel of Garcilaso must let go of their
laurel garlands when the duende of St. John of the Cross comes
by" (*Deep Song*). Saint John's subject was spiritual negation and
mystical union, the self alarmed and abandoned utterly, so deso-
late, so desperate in its crying out, so abject in its need for a sav-
ior that it signals a transfiguration. We are moving into the realm
of the self lost and found and lost again, the realm of the sacred.
The dark night is a holy hour when the spirit comes to Saint
John as an erotic visitation, a saving grace, a sovereign hand that
wounds. He is "inflamed by love's desire." He is filled and emp-
tied out. Here are the conclusive three stanzas of "Dark Night," in
Frank Bidart's spirited rendition:

> As he lay sleeping on my sleepless
> breast, kept from the beginning for him
> alone, lying on the gift I gave
> as the restless
> fragrant cedars moved the restless winds,—
>
> winds from the circling parapet circling
> us as I lay there touching and lifting his hair,—
> with his sovereign hand, he

wounded my neck—
and my senses, when they touched that, touched nothing…

In a dark night *(there where I*
lost myself,—) as I leaned to rest
in his smooth white breast, everything
ceased
and left me, forgotten in the grave of forgotten lilies.

Bidart picks up the underlying homoerotic desire and power in Saint John of the Cross's "Spiritual Canticle," which also strongly affected and inflamed Lorca, especially in the cycle of eleven sonnets that he wrote in 1935, generally called "Sonnets of Dark Love." Lorca especially loved the Spanish mystic's image of the "wounded stag"—it is wounded by love—who "comes to the hill." Indeed, Lorca's sequence everywhere reverberates with a sense of what the great Christian mystic poet called the *noche oscura del alma,* or "dark night of the soul."

The duende favors dreams that spill over into waking spells. It favors nocturnes of sleeplessness—the cry of the solitary and the bereft ensouled in poetic form. It favors the urgent reveries and warnings of the night mind. It responds, for example, to the way that Marina Tsvetaeva calls out to be inhabited by something like a demonic spirit in her restless ten-part poem "Insomnia" (1916). She pleads to be liberated from the bonds of day and throws open her doors wide into the night, eagerly relinquishing her social self in order to be inhabited by something stranger and more mysterious ("and people think perhaps I'm a daughter or wife / but in my mind is one thought only: night"). Each of the poems in the sequence is written in a different form, thus giving an ever changing shape to her solitary warnings ("Don't sleep! Be firm! Listen, the alternative / is—everlasting sleep"). Here are the four couplets that comprise section eight:

Black as—the centre of an eye, the centre, a blackness
that sucks at light. I love your vigilance

Night, first mother of songs, give me the voice to sing of you
in those fingers lies the bridle of the four winds.

Crying out, offering words of homage to you, I am
only a shell where the ocean is still sounding.

But I have looked too long into human eyes.
Reduce me now to ashes—Night, like a black sun.

Tsvetaeva's poem is a dark prayer, a joyous hymn to the night. It has a transfiguring Rilkean intensity, that almost religious enthusiasm that Lorca perceives as part of the duende's arrival. Joseph Brodsky identifies Tsvetaeva's extreme intensity when he names her "the falsetto of time. The voice that goes beyond the range of proper notation." It is a transgressive voice, violent and mesmerizing. The speaker of this poem would be broken down and artistically reborn. She prays to the night, "first mother of songs," and cries out to be given a voice equal to the powerful voice of nature itself. Her poem forms a subject rhyme with Trakl's "Lament" ("I sing you, wild chasm"). She might just as well have invoked the wild west wind, like Shelley, and called upon that wind to make her its natural instrument: "Make me thy lyre, even as the forest is." She might just as well have prayed, as Shelley does, "Be thou, Spirit fierce, / My spirit! Be thou me, impetuous one!" Or testified with D. H. Lawrence, "Not I, not I, but the wind that blows through me!" Tsvetaeva's invocation to the night signals her deep desire to become a vatic poet. She would become a vehicle of the vast night itself. In her essay "Art in the Light of Conscience," Tsvetaeva declares that "Blok wrote *The Twelve* in one night, and got up in complete exhaustion, like one who has been ridden." She defines genius as "the highest degree of subjection to

the visitation" and "control of the visitation." Always she courted what she called the true "condition of creation," which was for her a moment akin to dreaming, "when suddenly obeying an unknown necessity, you set fire to a house or push your friend off a mountain top." It is a moment of listening and abandonment ("Let the ear hear, the hand race") to an overriding inner melody.

Depth psychology would suggest that what these poets are describing is a transcendence of the ego, a sense of merging with the whole. The alien force that dwells within us—a demonic inspiration—is experienced as a "death" to the ego, which has been forced to yield the psyche to a nonrational power that has captured it. The duende, then, is a vehicle for surpassing the ego, the rational or day mind. It gives us access to another force within us, the deep or night mind.

It is encouraging to think that the duende, like the muse, responds to artistic callings and sacrifices, to yearning incantations, just as it is heartening to think that the right angel in the gate, the fluid one stepping and gliding through air, rather than the wrong one frozen in stone, responded to Larry Levis when he implored it to walk with him a little in his last book of poems, *Elegy:*

> Walk a few steps more with me,
>
> Show me the house I must still be living in,
> Where eternity was no more than my hand
> Scurrying across a sheet of paper,
>
> Kindling blent to the music of its hush;
> Walk with me a little way past it, now,
> With the wrong, other angel trapped in stone,
>
> With the heavens behind you on fire.

The duende, like the muse and the angel, steps aside for artistic quarrels, for the argument, say, between "pure" and "impure"

poetry (it is bored by credos and polemics—it puts "Creeds and schools in abeyance," as Whitman formulates it near the beginning of "Song of Myself"). It is the passion at the heart of the individual struggle that most matters to it. That is why it hovers over the shoulder of a Mallarmé as much as it sweeps up through the legs of a Neruda, why it storms Thomas Hardy's elegies (*Poems of 1912–1913*) and slips through the seams in W. B. Yeats's longing occultations, why it empowers the lived unintelligibilities of T. S. Eliot's first version of "The Waste Land" ("I had not thought death had undone so many") as well as the irrational cabalistic splendors of César Vallejo's *Trilce* ("Verily, I say unto you that life is in the mirror, and that you are the original, death"). In these works, both of which were published in 1922, language is put under the most intense pressure; reality is radically fragmented and death is omnipresent. Surreal images float loose from their context (remember those whistling "bats with baby faces in the violet light" from part five of *The Waste Land*), and poetic forms are broken down and reconstituted. Art arises out of what Eliot calls some "unknown, dark *psychic material*—we might say, the octopus or angel with which the poet struggles." Eliot's octopus is Lorca's duende, and it remakes poetry out of the struggle with words. "Make way for the new odd number / potent with orphanhood!" Vallejo warns at the end of one poem, staking out an aesthetic. "To create harmony," he contends in another, "one must always rise—never descend! / Don't we rise in fact downward?" The duende arrives and rises downward when language is stressed and stretched almost to the breaking point under the burden of emotion.

Those who are willing to be vulnerable move among mysteries.
THEODORE ROETHKE

Vegetable Life, Airy Spirit

BEFORE TURNING FROM THE duende to the angel, it is use-
ful to glance at two poets of spiritual transition and transforma-
tion, of wild turnings and dark cruxes, of inner Hopkinsian wars.
One is digging down furiously into the earth (Theodore Roethke),
the other storming upward toward the air (Sylvia Plath).

The duende was undoubtedly with Roethke in the "green-
house" poems when he got down on his knees and immersed
himself in the vegetable life of his Michigan childhood ("I can
hear, underground, that sucking and sobbing, / In my veins, in
my bones I feel it"). It's as if Roethke was taking literally Lorca's
idea that the mysterious black sounds that signal the presence of
duende are "the roots fastened in the mire that we all know and
all ignore, the mire that gives us the very substance of art" (*Deep
Song*). The family greenhouse was for Roethke both sacred and
abysmal ground, a natural world and an equally artificial realm, a
locale of generation and decay, order and chaos. His poems ex-
plore the instinctual sources of life from the dank minimal world
of roots ("Root Cellar") to the open flowering realities of young
plants ("Transplants"). Roethke was a major poet of the regressive
imagination and his key subject was birth and metamorphosis, the
snake shedding its skin, the man struggling to regain, in Yeats's
phrase, "radical innocence." The duende stayed with him as he
charted the struggle to be born in the sensuous, radically associa-

tive poems of *The Lost Son* and *Praise to the End!* It was a spiritual progress. "I've crawled from the mire, alert as a saint or a dog," he declared, and "I was far back, farther than anybody else."

> I was privy to oily fungus and the algae of standing waters;
> Honored, on my return, by the ancient fellowship of rotten
> stems.
> I was pure as a worm on a leaf; I cherished the mold's children.
> Beetles sweetened my breath.
> I slept like an insect.

In a revealing "Open Letter," Roethke asserted:

> Some of these pieces, then, begin in the mire; as if man is no more than a shape writhing from the old rock. This may be due, in part, to the Michigan from which I come. Sometimes one gets the feeling that not even the animals have been there before; but the marsh, the mire, the Void, is always there, immediate and terrifying. It is a splendid space for schooling the spirit. It is America.

Roethke's duende was palpable whenever he welcomed the visceral spirits into his work, or proclaimed a condition of pure joy, or channeled his madness by struggling to write poems in the shape of the psyche itself. There was something agitated, earthy, and Lawrencian in his quest. As he expressed it in a notebook entry: "For Lawrence and I are going the same way: down: /A loosening into the dark."

I still remember the first shock—and the exultation—of reading Sylvia Plath's posthumous book *Ariel* (1965). It's a book from which one doesn't ever wholly recover, though it has now been usefully, even necessarily, supplanted by the much more inclusive *Collected Poems* (1981), which also gives a telling and much-needed accurate chronology of the work. The furies were certainly loose and stalking in 1962 and 1963 ("The blood jet is

poetry, / There is no stopping it") when Plath wrote her ferocious last poems in England. The notoriety of Plath's suicide has obscured how dedicated she was to her poetic craft, how persistently she worked to shape experiences, even as she probed the depths—braving taboo subjects, courting a wildness that defies control. In an interview shortly before her death, she stated: "I believe that one should be able to control and manipulate experiences, even the most terrifying, like madness, being tortured... and one should be able to manipulate these experiences with an informed and intelligent mind." There is a dialectic in Plath's poems between the conscious struggle to contain and control experience and the unconscious longing to purge it, the desire and even need for a liberating imagination. It's as if the duende was struggling out of her body to become a spirit of pure air.

Take the title poem, for instance, a stunning example of what Plath once referred to as her "dawn poems in blood." She wrote it on October 27, 1962, her thirtieth birthday, in the midst of a remarkable creative spate. It was just one of the two poems she wrote that day—the other was the ominous "Poppies in October"—and one of the twenty-five she wrote that month. (These highly engendered poems include "Daddy," "Fever 103," "Cut," "Lady Lazarus," and the five bee-keeping poems, which chart a Roethkean descent into the interior, the psyche, and a feverish quest for freedom and renewal: "Tomorrow I will be sweet God, I will set them free").

Plath gives the name "Ariel" to a horse, who is ridden by the poem's narrator. (She regularly took horseback-riding lessons at a riding school in Devonshire, and planned to ride her favorite horse, Sam, on her birthday.) The name summons Shakespeare's airy, otherworldly creature from *The Tempest,* "a lovely, though slightly chilling and androgynous spirit," as Robert Lowell put it. Ariel is a sprite or angel (the name is Hebrew for "the lion of God"); thus it also carries a biblical reference to Jerusalem as a

sacred city: burning, prophetic, sacrificial, holy. Shelley famously associated Ariel with the freedom of the Romantic poetic imagination, and this, too, seems germane since, before her death, Plath prepared a collection of poems to be entitled *Ariel.* (Plath's plan for organizing the book, which is available in the "Notes" to *The Collected Poems,* is notably different from, and much more affirmative than, the order that Ted Hughes gave to the final collection.) As the title for a collection, *Ariel* reverberates with a sense of androgynous power. It evokes the autonomous—the liberating—poetic imagination.

The poem "Ariel" begins at an absolute standstill, in a dead predawn stillness ("Stasis in darkness"). "Power ceases in the instant of repose," Emerson said in his manifesto, "Self-Reliance." "It resides in the movement of transition from a past to a new state, in the shooting of the gulf, in the darting to an aim." As if to illustrate Emerson's point, a feeling of power is immediately unleashed in the poem as the horse takes off and begins galloping violently away, as the rider and the horse flow into each other and become one body:

> God's lioness,
> How one we grow,
> Pivot of heels and knees!...,

Everything contributes to the sense of speeding almost uncontrollably through the darkness—the driving rhythm, the radically foreshortened lines, the enjambed triplets, the clipped sentences, the shadowy imagery ("Black sweet blood mouthfuls, / Shadows"). Emerson also said, "I never was on a coach that went fast enough for me."

There is an especially compelling moment in the poem when an animal fury takes over and is converted into some other form of energy, into a radiant fire that consumes her ("Something else // Hauls me through air"). One notes the double pause—both

a line and a stanza break—that enacts the feeling of some un-known force suddenly taking over:

Something else

Hauls me through air—
Thighs, hair;
Flakes from my heels.

The speaker seems to be leaving her physical body behind, the world that holds her down, the realm of strictures and laws ("Dead hands, dead stringencies"). It is as if an animal force be-comes an angel unleashed in this poem of sexual elation melting into the nothingness of death, the brightness of burning morning, the obliteration of dawn:

And I
Am the arrow,

The dew that flies
Suicidal, at one with the drive
Into the red

Eye, the cauldron of morning.

A Person Must Control His
Thoughts in a Dream

IT IS TOO REDUCTIVE to think of artistic creation as merely
putting oneself in a trance state. We need a fresh vocabulary, a
fuller and more enhanced notion of the artistic trance state in
which one also actively thinks. In John Keats's work, for example,
the daydreaming capacities of the mind are given free rein to
join with a feverishly motive consciousness, with what he calls in
"Ode to Psyche" "a working brain." He combined associative
drift with a mobile working intellect, the mind of a maker. One
feels the intelligence leaping through his spontaneities. Keats had
schooled his fluencies, and a relentless poetic dedication and
craftsmanship stood behind his axiom of Romantic spontaneity:
"That which is creative must create itself."

Turn to Rimbaud and feel the demonic fury and furious logic
in his idea that, as he expressed it to Paul Demeny (May 15, 1871)
in what is commonly referred to as the *Lettre du Voyant* ("Letter
of the Seer"): "The Poet makes himself a *seer* by a long, gigantic
and rational *derangement* of *all the senses*." The adjective *raisonné*
("reasoned" or "rational"), which is often dropped from the state-
ment, is crucial to Rimbaud's idea of aggressively disorganizing
the senses, of controlling the hallucination. It is as if the seer re-
quires a special programmatic training "to make the soul mon-
strous." ("Imagine a man implanting and cultivating warts on his
face," Rimbaud said.) He was consciously, even systematically,

seeking a way of unbridling the intelligence in his search for the unknown. The poetry that attains such a marvelous country, he believed, would no longer merely keep step with reality; "it will *precede* it."

Rimbaud helps us here, because he offers a model of systematic derangement, of thinking through the furies. "Duende has been called the demon that puts flamencos in a trance," Claus Schreiner objects in his introduction to a book of essays by flamenco enthusiasts:

> But the very nature of *cante jondo* contradicts all trance theories. We know, for instance, from trance states induced by mediums in Afro-American culture, that a stammered singsong may be possible, but certainly not the intellectual-emotional exertion of body and soul required by cante jondo.

One sympathizes with Schreiner's wish to defend deep song from anti-intellectual reductions of it, from the *avant-garde primitivism* (the phrase is Timothy Mitchell's) that often infected Lorca's generation, but the problem seems to be an impoverished notion of the trance condition. We need a deeper model for thinking *through* and *inside* the trance state.

This may well be close to the state that the psychologist Mihaly Csikszentmihalyi terms *flow,* which he characterizes as "the way people describe their state of mind when consciousness is harmoniously ordered." He considers it an "optimal state of inner experience…in which there is *order in consciousness.*" Flow hits a deeply unantagonized part of the mind. It is a concentrated fluidity of psychic energy, a highly focused alteration of consciousness.

Poe gave a powerfully clinical analysis of a passive state that he was also learning to control: "Now, so entire is my faith in the *power of words,* that, at times, I have believed it possible to embody even the evanescence of fancies such as I have attempted to

describe. In experiments with this end in view, I have proceeded so far as, first, to control...the existence of the condition: that is to say, I can now...be sure that the condition will supervene, if I so wish it, at the point of time already described." Poe suggests that he was learning to prevent his daydreaming state from lapsing into sleep, to startle it into wakefulness and then transfer it into the realm of memory, to continue the condition. He was thus situating the shadow in active consciousness where he could write it into being, invoking and enacting its presence in language. He said, "Should I ever write a paper on this topic, the world will be compelled to acknowledge that, at last, I have done an original thing."

Recall for a moment how the French poet Robert Desnos, the prototypical Surrealist talker, could intentionally blur the boundary between speaking and writing by erasing the line between waking and dreaming. Here is Louis Aragon's vivid account in *Une vague de rêves* of the poet putting himself into a self-induced hypnotic trance:

> In a café, amid the sound of voices, the bright light, the jostlings, Robert Desnos need only close his eyes, and he talks, and among the steins, the saucers, the whole ocean collapses with its prophetic racket and its vapours decorated with long oriflammes. However little those who interrogate this amazing sleeper incite him, prophecy, the tone of magic, of revelation, of revolution, the tone of the fanatic and the apostle, immediately appear. Under other conditions, Desnos, were he to cling to this delirium, would become the leader of a religion, the founder of a city, the tribune of a people in revolt.

Desnos could simulate these trances ("Is simulating a thing any different from thinking it?" Aragon asked). He could select details from his dreams and give prophetic frenzy a structural shape

on the page. "Thought takes place in the mouth," the Dadaist Tristan Tzara claims, but it also takes place in the shaping hand that guides the disturbance. Desnos himself would come to believe that poetry should be "delirious and lucid." In his late work "Reflections on Poetry" he declared:

> It seems to me that beyond Surrealism there is something very mysterious to be dealt with, that beyond automatism there is the intentional, that beyond poetry there is the poem, that beyond poetry received there is poetry imposed, that beyond free poetry there is the free poet.

Desnos was seeking a domain where he could wed common language to an indescribable atmosphere, where he could identify a "poetic constant" and unify it with themes of the moment, "themes so overbearing they must be expressed at any cost." The project required a lucid delirium.

Inspiration and control over the inspiration. At times the only knowledge we have of the former is the evidence of the latter. Any number of visionary poets, from Rimbaud to Desnos, were seeking a way to name what it means to be an artistic maker in the presence of the inspired demonic. There is an analogy in the key distinction that Mircea Eliade makes between a shaman and a "possessed" person in his authoritative study *Shamanism: Archaic Techniques of Ecstasy.* "A first definition of this complex phenomenon," Eliade contends, "and perhaps the least hazardous, will be: shamanism=*technique of ecstasy.*" Unlike the possessed person, he suggests, "the shaman controls his 'spirits,' in the sense that he, a human being, is also able to communicate with the dead, 'demons,' and 'nature spirits,' without thereby becoming their instrument." The shaman is not a mere vehicle, an unwitting tool of the otherworld, a spiritual victim. He is not mad. Rather, he is a thinking medium, an initiate of spiritual practice, a con-

troller of unknown forces and secret languages, a "technician of the sacred."

In thinking about the imaginative space we are trying to define, the condition of thinking *within* the trance state, the greatest help comes from the supreme example and work of the Spanish Sufi master Ibn 'Arabī (1165–1240), who was sometimes called "the Andalusian." There is a fantastic ingenuity to his book of odes, *Interpreter of Desires.* "A person," he said, "must control his thoughts in a dream." As Indries Shah puts it in his book *The Sufis,* the main source of Ibn 'Arabī's inspiration was "reverie in which the consciousness was still active." Ibn 'Arabī stressed the crucial importance of this Sufi faculty, and he trained his disciples in the active dream state of the creative imagination. This active consciousness moves purposefully through the various dream states evoked in his erotic poems, which are mediations of desire. He writes:

> My heart is capable of every form:
> A cloister for the monk, a fane for idols,
> A pasture for gazelles, the votary's Ka'Ba [temple],
> The tables for the Torah, the Quran.
> Love is the creed I hold: wherever turn
> His camels, Love is still my creed and faith.

Ibn 'Arabī refers often to a realm the Sufis defined as the *mundus imaginalis*—the supersensible world that exists between the sensory and intelligible worlds. That world can be attained only through the vigorous work of what the Sufis called "Active Imagination." Henry Corbin, the scholar of Shi'ite Sufism who is an exemplary guide in these matters, points out that the imaginal realm is a concrete place, a celestial earth, that stands between the visible realm of the senses and the invisible realm of the intellect. This is "the Sphere of Spheres" which the Iranian Sufi master

Suhrawardī (1155–1191) called "the mystical Earth of Hūrqalyā." As Corbin explains in *The Man of Light in Iranian Sufism:*

> Between the world of pure spiritual Lights (*Luces victori- ales,* the world of the "Mothers" in the terminology of *Isrāq*) and the sensory universe, at the boundary of the ninth Sphere (the Sphere of Spheres), there opens a *mundus imaginalis* which is a concrete spiritual world of archetype-Figures, apparitional Forms, Angels of species and of individuals; by philosophical dialectics its necessity is deduced and its plane situated; vision of it in actuality is vouchsafed to the visionary apperception of the Active Imagination.... The idea of the *mundus imaginalis*... Sohravardī declares, is the world to which the ancient Sages alluded when they affirmed that beyond the sensory world there exists another universe with a contour and dimensions and extension in a space, although these are not comparable with the shape and spatiality as we perceive them in the world of physical bodies. It is... the mystical Earth of Hūrqalyā with emerald cities; it is situated on the summit of the cosmic mountain, which the traditions handed down in Islam call the mountain of Qāf.

The alternate earth is a world in which spirits can be embodied, and bodies converted into spirits. We attain that celestial sphere, Ibn 'Arabī taught his disciples, by relinquishing the self to a state of consciously active reverie. The imagination becomes a redefined "organ of understanding," a way of perceiving reality. This startling idea was threatening to normative Islam. As Indries Shah puts it, "Many people sympathized with him, but did not dare to support him, because they were working on a formal plane, and he on an initiatory one."

There are many perils in cross-cultural comparison, and yet the plastic imaginative state Ibn 'Arabī describes, a reverie in

which consciousness is fundamentally active, does seem oddly close to the ductility that Keats saw as an essential feature of the artistic imagination, which is replete with what he famously called "Negative Capability":

> Negative Capability, that is when man is capable of being in uncertainties, Mysteries, doubts, without any irritable reaching after fact and reason.

The displacement of the poet's protean self into another existence was for Keats a key feature of the highest artistic imagination. He attended William Hazlitt's *Lectures on the English Poets,* and he was spurred further to his own thinking by Hazlitt's groundbreaking idea that Shakespeare was "the least of an egotist that it was possible to be" and "nothing in himself," that he embodied "all that others were, or that they could become," that he "had in himself the gems of every faculty and feeling," and he "had only to think of anything in order to become that thing, with all the circumstances belonging to it." Keats took to heart the ideal of "disinterestedness," of Shakespeare's essential selflessness, his capacity for anonymous shape-shifting. Everyone who cares about poetry should read Keats's galvanizing letter to Richard Woodhouse in 1818:

> As to the poetical Character itself…it is not itself—it has no self—it is everything and nothing—It has no character—it enjoys light and shade; it lives in gusto, be it foul or fair, high or low, rich or poor, mean or elevated—It has as much delight in conceiving an Iago as an Imogen. What shocks the virtuous Philosopher, delights the camelion Poet…A Poet is the most unpoetical of any thing in existence; because he has no Identity—he is continually in for—and filling some other Body—The Sun, the Moon, the Sea, and Men and Women who are creatures of impulse are poetical and have about them an unchangeable attribute—the

poet has none; no identity—he is certainly the most unpoet-
ical of all God's creatures.

Keats eagerly sought what he called in "Endymion" the "ar-
dent listlessness" of the trance state. He combined a whole-
hearted imaginative openness to the moment with a heightened
receptivity to the world in all its diverse particularity. What he
found dramatically projected in Shakespeare he might also have
found in the Spanish Sufi poet who declared, "My heart is ca-
pable of every form."

It is helpful to think of the *mundus imaginalis* as a transcen-
dence deployed in language. It is the specific place where Saint
John of the Cross composes his *Spiritual Canticles,* where Arthur
Rimbaud enters a rational delirium and Hart Crane systematically
deranges the senses, where Gérard de Nerval formulates visions
and Robert Desnos simulates trances, where William Blake can-
onizes voices and Samuel Taylor Coleridge troubles dreams, where
W. B. Yeats listens to unknown instructors speaking through his
wife's unconscious and James Merrill contacts spirits through a
Ouija board, where Wallace Stevens imagines that God and the
imagination are One and Rainer Maria Rilke starts taking dicta-
tion from angels.

The Angelic World

THE ANGELIC WORLD, which is one of the Sufi names for the imaginal realm, is the country of the outside. It is the landscape of tangible nowhere, the province of the hidden beyond, the celestial earth. No one can give us precise directions on how to reach this imperceptible sphere, which testifies to the plenitude of the invisible universe. The reality of the angel suggests that "we are surrounded by divine presence and from it we derive the fullness of our being."

The Hebrew Bible has a veritable throng of angels. So does the New Testament, which gives us a fantastic arsenal, as in the awed Revelations of Saint John, where angels are engaged in battling Satan and his demoniacal troops, playing harps and trumpets, swinging palm leaves, pouring out bowls of plagues over the earth, uttering proclamations, and guiding the seer on his path. Unlike the saints, the angels are active agents in running the two worlds, overthrowing the forces of evil and establishing the eternal kingdom of light, which is pictured as a kind of celestial court.

Islam also gives us extraordinary accounts of the angels. One thinks, for example, of the many narratives of the prophet Mohammed's ascents to heaven. According to one seventeenth-century work that the Shi'ites viewed as sacred history, the angel Gabriel accompanied the prophet Mohammed through seven celestial spheres. In the first heaven, Mohammed met Adam and saw

Ismaeel, "the angelic regent of that place," who directed "seventy thousand angelic officers, each of whom commands a division of seventy thousand angels." In the fourth heaven, Mohammed met Idris (Enoch) and discovered an archangel seated on a throne who was in charge of exactly the same number. But the most astonishing episode occurred in the seventh sphere:

> The prophet in his ascension came to a river of light, which Jibraeel directed him to cross, adding it had never yet been passed by angel or prophet. Jibraeel said he bathed in it every day, and washed his wings, and that the Most High, of every drop which fell from his wings, created an exalted angel having twenty thousand faces, and forty thousand tongues, each of which speaks a distinct language unintelligible to the rest.

There are, apparently, a great many mysteries in the celestial realms where God creates angels out of rivers of fire and rivers of light who cannot understand each other, who are fluent in a seemingly infinite number of languages that only He can comprehend.

There has been a tremendous amount of theological speculation over the centuries about every aspect of the angelic orders, such as when God actually created them, since Genesis itself is silent on the subject. Some Jewish sages taught that the angels were created on the second or the fifth day; some maintained that a new batch of angels was created every day who praised God and then disappeared into a river of fire. Others have argued that the creation of these immaterial beings must be continuous, because every pronouncement by God results in the creation of angels, who walk upright and speak Hebrew, can fly from one end of the world to the other, and foretell the future. Thus they have something in common with both men and demons.

In the apocryphal gospel, *The Book of Jubilees,* which retells Genesis and Exodus with an emphasis on *Halakah* (the teachings

of biblical law), God explicitly creates all the spirits who serve him on the first day: "the angels of the presence, the angels of sanctification, the angels of the spirit of fire, the angels of the spirit of the winds, of the clouds, of darkness, of snow, hail, and hoarfrost, the angels of the voices of thunder and lightning, the angels of the spirits of cold and heat, of winter, spring, autumn, and summer, and of all the spirits of his creatures in Heaven and on the earth." These are angels of both the spiritual realm and the natural world. It is "the angel of the presence," for example, who orders Moses on Mount Sinai to write down a secret revelation, God's exact words. Similarly, there is a legend in the *Zohar* that the Kabbalah was brought down by angels to teach the fallen Adam how to recover the original kingdom, his first Edenic world.

There are many other gnostic Jewish legends, such as *The Book of the Secrets of Enoch,* that suggest angels were not created on the first day but on the second, when God created a firmament over the waters, which he called Heaven. ("For all the heavenly troops I made the image and essence of fire. My eye looked at hard rock and, from the gleam of my eye, the lightning received its wonderful nature, which is both fire in water and water in fire... And from the rock I cut off a great fire, from which I created the orders of ten troops of incorporeal angels. Their weapons are fiery and their raiment a burning flame. I commanded that each one stand in order.") Enoch himself became an angel after he vanished into heaven with God: "And Enoch walked with God: and he *was* not; for God took him" (Gen. 5:24). The Kabbalah teaches that Enoch, son of Jared, became the angel Metatron, who guided Rabbi Ishmael through the celestial sphere. The text of "3 Enoch" describes how God elevated Enoch to heaven, provided him with a throne, and transfigured him into a supreme angel: "and he called me, 'The lesser YHWH' in the presence of his whole household in the height, as it is written, 'My name is in

him.'" Metatron was a human being transformed. "I put under his authority the seventy angels of the seventy nations," God reports. (There is a startling parallel in these magical numbers with Majlisi's three-volume life of the prophet Mohammed.) "This one whom I have taken," Yahweh also says, "is my sole reward from my whole world under heaven."

In his early prose piece "A History of Angels," the Argentine fabulist Jorge Luis Borges seems certain that angels were formed when light was created in the firmament of heaven to divide the day from the night. This makes them exactly two days and nights older than we are. "The Lord created them on the fourth day," Borges writes, "and from their high balcony between the recently invented sun and the first moon they scanned the infant earth, barely more than a few wheatfields and some orchards beside the waters." He recalls that the early primitive angels were virtually indistinguishable from stars, as when the Lord answered Job out of the whirlwind and remembered the beginning of the world: "When the morning stars sang together, and all the sons of God shouted for joy" (Job 38:7).

The first literal reference to angels in the Hebrew Bible declares their presence when Adam and Eve are banished from the garden: God "drove out the man; and at the east of the garden of Eden he placed the cherubim, and a flaming sword which turned every way, to guard the way to the tree of life" (Gen. 3:24). These cherubim, guardian of sacred areas, are pictured in Ezekiel as winged hybrid creatures, half human, half lion, like the Sphinx of Egypt (41:18–19). They are a far cry from the ruddy-faced baby cherubim of popular imagination. Rather, they are dreaded, terrifying figures, whose supernatural presence at the gate announces that human beings will never again return unaided to the "garden of God." The angels will be their necessary intermediaries.

There are many direct appearances by God to man in the earliest written portions of the Hebrew Bible—as when Yahweh ap-

pears to Abraham by the oak trees at Mamre, near Hebron (Gen. 18), or descends in fire and speaks to Moses from the midst of a terrifying volcanic eruption on Mount Sinai, and the people have to keep their distance at the foot of the mountain (Exod. 19). But the more normative monotheistic writers and priestly redactors who followed the Yahwist tended to be uncomfortable with these direct visitations, these epiphanies ("the manifestation of a god or spirit in the body"), and substituted angels for his appearance. Later Christian writers are explicit that Adam and Eve's descendants will never again be allowed to gaze upon God directly, without any intercession, as Dionysius the Areopagite (commonly referred to as Pseudo-Dionysius) makes evident: "Someone might claim that God has appeared himself and without intermediaries to some of the saints. But in fact it should be realized that scripture has clearly shown that 'no one has ever seen' or ever will see the being of God in all its hiddenness."

The angels are usually represented as messengers from the Lord, intermediaries for all the prophets. The Hebrew term *mal'ak* and the Greek word *angelos* literally mean "messenger." In Hebrew, angels were often termed "sons of God" (*bene'elohim*) and envisioned, as Elaine Pagels puts it, "as the hierarchical ranks of a great army, or the staff of a royal court." Angels serve as God's agents, but it cannot be taken for granted that they live forever. Some are ephemeral. Walter Benjamin, for example, was captivated by the Talmudic legend that the angels are formed every moment in innumerable bands in order to celebrate God's glory, but as soon as they sing their songs of jubilation they dissolve back into nothingness. They are created to deliver praise and then, as a kabbalistic book says, "pass away as the spark on the coals."

Perhaps no one has seen the face of God and lived, but many have encountered these strange messengers who pass almost imperceptibly between realms, whom the Kabbalah teaches move

up and down so much in the infinite spaces they sometimes won-
der if God dwells "above" or "below." Angels can't always tell if
they are moving among the living or the dead, Rilke reports in
the second of his *Duino Elegies,* where he also provides a richly
descriptive catalog of praise that crosses our usual categories, rup-
turing linguistic boundaries in order to describe beings of sur-
passing nature:

> Early successes, Creation's pampered favorites,
> mountain-ranges, peaks growing red in the dawn
> of all Beginning,—pollen of the flowering godhead,
> joints of pure light, corridors, stairways, thrones,
> space formed from essence, shields made of ecstasy, storms
> of emotion whirled into rapture, and suddenly, alone:
> *mirrors,* which scoop up the beauty that has streamed from
> their face
> and gather it back, into themselves, entire.

Thomas Aquinas warned that we cannot be sure whether
or not the angels have material bodies ("space formed from
essence"), but not many seem to have heeded his metaphysical
caution. Angels are incomprehensible hybrids; they are, like
birds, "the most joyous creatures in the world" (Leopardi), "these
serene animals which approach God" (Umberto Saba), "those
who ever sing / in harmony with the eternal spheres" (Dante).
They are transitions upward, verticalities. They are winding stair-
cases, ladders. The Jacob ladder has been one of the formative
images. One of my favorite uses of it comes from Martin Buber's
Tales of the Hasidim: The Later Masters:

The Ladder

Rabbi Moshe taught:
It is written: "And he dreamed, and behold a ladder set up
on the earth." That "he" is every man. Every man must

know: I am clay, I am one of countless shards of clay, but
"the top of it reached to heaven"—my soul reaches to
heaven; "and behold the angels of God ascending and de-
scending on it"—even the ascent and descent of the angels
depend upon my deeds.

The Hasidic tale of "The Ladder" suggests that we are part dust,
the molded substance of clay, and part air, celestial aspiration,
eternal soul. Yet it turns the visionary sighting of angels into an
earthly ethic, for even the movement of angels seems to depend
on our actions, our deeds in the here and now.

Some think the angels are what we make of them; others con-
sider them the external perceptions of God. Jacob Boehme
treated them as God's thoughts, wingless creatures molded into
human shape. In the chapter "Late Thoughts" from his autobio-
graphical *Memories, Dreams and Reflections*, Carl Jung calls an-
gels "a strange genus" and describes them as "soulless beings who
represent nothing but the thoughts and intuitions of their Lord."
Many have considered them material embodiments of pure mind.
Paul Tillich argues in *Systematic Theology* that they are "concrete-
poetic symbols of the structures or powers of being. They are not
beings but participate in everything that is."

Emanuel Swedenborg, the eighteenth-century Swedish scien-
tist and theologian, talked to angels regularly and with great fa-
miliarity, as if they lived in Stockholm. He was a mining engineer
who had a vision of Jesus on the night of April 6, 1744, and there-
after conversed freely with many spirits. "It has been granted me
to associate with angels and to talk with them as man with man,"
he wrote in his book *Heaven and Hell*; "also to see what is in the
heavens and what is in the hells, and this for thirteen years." Swe-
denborg insisted that all angels were at one time living people. In
his view, angels are souls who have chosen heaven, which appears
in the shape of a perfect human being. (Although he did not

perceive hell directly, he said, it was reported to him on good authority that the infernal realm takes the shape of a devil.) He reported direct contact with the celestial spheres: "From all my experience, which is now of many years," he wrote, "I am able to say and affirm that angels are wholly men in form, having faces, eyes, ears, bodies, arms, hands, and feet..."; they "see and hear one another, and talk together." Swedenborg's angels are not "formless minds" or "ethereal breaths," but sexually differentiated people. They do everything they did on earth—they even experience the "delights" of the marriage bed—but at a higher level. Nonetheless, they can be perceived only by the spiritually cognizant: "But it must be remembered that a man cannot see angels with his bodily eyes, but only with the eyes of the spirit within him, because his spirit is in the spiritual world, and all things of the body are in the natural world. Like sees like from being like." One of the deeper implications of Swedenborg's remarkable doctrines, which had such a great impact on Blake and Emerson, is that spiritual forms are embodied in human shapes, and that heaven and hell are truly supernatural extensions of our innermost human longings and capabilities. They are forms of human resurrection. "Nature recites her lessons once more in a higher mood," Emerson explains in his essay on Swedenborg. Or as Blake writes in his poem "The Divine Image":

> Then every man of every clime,
> That prays in his distress,
> Prays to the human form divine
> Love Mercy Pity Peace.

Blake believed, as he told the Royal Academician Thomas Phillips, "that angels descended to painters of old, and sat for their portraits." This was one of the sources of sublimity in the works of the ancients. Blake was sitting for his own portrait, probably in the winter of 1807, when he told Phillips that he had

it on unmistakable authority that Michelangelo could portray an angel as well as Raphael. Phillips was skeptical (Blake had never seen any of Michelangelo's paintings firsthand), but Blake recalled how one night in the study of his house in Lambeth he closed an edition of Edward Young's *Night Thoughts,* which he intended to illustrate, on a passage that asks, "who can paint an angel?" Suddenly, he cried aloud:

> *Blake:* Aye! Who can paint an angel!
> *A Voice in the Room:* "Michael Angelo could."
> *Blake:* And how do *you* know?
> > He looked all around, but saw "nothing save a greater light than usual."
> *Voice:* I *know,* for I sat to him: I am the arch-angel Gabriel.
> *Blake:* Oho! You are, are you? I must have better assurance than that of a wandering voice; you may be an evil spirit— there are such in the land.

Blake stared in the direction of the voice and became aware of a shining shape, with bright wings, that diffused light. "As I looked, the shape dilated more and more: he waved his hands; the roof of my study opened; he ascended into heaven; he stood in the sun, and beckoning to me, moved the universe. An angel of evil could not have *done that*—it was the arch-angel Gabriel."

The Story of Jacob's Wrestling with an Angel

ANGELS ARE BY DEFINITION superior to human beings, but even those who move the universe are inferior to God. Out of hundreds of possibilities, I will concentrate on three emblematic literary encounters with these inexhaustible beings—the biblical story of Jacob's wrestling with an angel, the Spanish poet Rafael Alberti's collection of lyrics *Concerning the Angels,* and Rainer Maria Rilke's *Duino Elegies*—and then follow up with an account of Paul Klee's remarkable "Angel Series," one work of which— *The New Angel*—had a transporting impact on Walter Benjamin's imagination. Klee's angels seem to be the last (or at least very belated) European angels, and they put in sharp relief some American encounters with the angel: a dream by Ralph Waldo Emerson, a poem by Wallace Stevens, and a short story by Donald Barthelme. These many encounters dramatize what happens when the angel falls into our world and becomes a figure of the agonistic sublime, or a creature of metaphysical anxiety and doubt, or a sign of dark inspiration. The angel also comes when death is possible, when the living look, with memory and imagination, into a realm where the dead go on dwelling in transfigured form. As James Merrill writes in the elegy "A Dedication," "These are the moments, if ever, an angel steps / Into the mind."

"The angel guides and gives like Saint Raphael, defends and avoids like Saint Michael, announces and forewarns like Saint

Gabriel," Lorca wrote, recalling that angels inhabit the air above us and move "in an atmosphere of predestination" (*Deep Song*). But he also adds, "The angel never attacks" (*Deep Song*). Rilke thought differently: In his poem "Der Engel" from *New Poems* (1907), he writes of the hands of a being who comes to visit you at night "to test you with a fiercer grip" and "seize you as if they were creating you." These supernatural hands would come to "break you out of your mould." Rilke's 1907 angel comes from above, but the figure is much closer to the duende—one wrests divinity from demonic hands—and here Rilke writes in the spirit of the Yahwist, the name given to the earliest writer (or writers) of the Hebrew Bible.

The story of Jacob's wrestling with an angel (*Genesis* 32:25–33) is emblematic of the strangeness at the heart of early biblical tales of supernatural encounter. Jacob's engagement with a nameless assailant is a tale of disturbing majesty, and the Yahwist who dramatized this episode, perhaps sometime around the tenth century B.C.E., retained the mystery at the heart of the hieratic confrontation with an unknown force.

To set the scene: After twenty penitential years in Mesopotamia, Jacob was hastily returning to Canaan, land of his birth, where he hoped to be reconciled to his twin brother, Esau, whose birthright and blessing he had taken long ago. They would meet face-to-face. Picture Jacob (Yaakov) on the horizon—the reflective and wily one, the stealthy intellectual of the family, the cunning younger son grown up and traveling home like a prosperous tribal chief with his two wives, Leah and Rachel (one plain and one beautiful), two maids (Zilpah and Bilhah), eleven sons (the future of Israel itself), a host of servants, and large sturdy flocks of animals. The procession wound along a route east of the Jordan River. When Jacob learned Esau was advancing with a force of four hundred men, he divided everyone and everything into two companies; he appealed directly to the Lord ("Pray save me from

the hand of my brother"); and he sent ahead gifts of animals in successive droves to try to appease Esau. Here was one more reminder that Jacob was still guilty and guileful, fearful of his brother's righteous enmity. The mind boggles at what Esau must have thought as he saw the procession approaching—one wave after the next, a veritable tide of goats and kids, ewes and rams, nursing camels and their young, cows and bulls, male and female asses…

Jacob set up camp, but that night he suddenly arose and took his family across the ford of the Jabbok. Then he took his possessions and sent them across. He was left alone, and in the darkness a man came and wrestled with him for hours. All night Jacob fought with the mysterious stranger, whom he could neither see nor name, but he did not falter or turn away from his fate, not even when the stranger dislocated his thigh, until at daybreak the unknown assailant finally grew desperate. We grew up on the splendors of the King James Version, which, in Erich Auerbach's phrase, is "fraught with background," but here is the climactic moment in Everett Fox's spare, imaginative rendition:

> Then he said:
> Let me go,
> for dawn has come up!
> But he said:
> I will not let you go
> unless you bless me.
> He said to him:
> What is your name?
> And he said: Yaakov.
> Then he said:
> Not as Yaakov / Heel-Sneak shall your name be henceforth
> uttered,
> but rather as Yisrael / God-Fighter,
> for you have fought with God and men

and have prevailed.
Then Yaakov asked and said:
Pray tell me your name!
But he said:
Now why do you ask after my name?
And he gave him farewell-blessing there.
Yaakov called the name of the place: Peniel / Face of God,
for: I have seen God,
face to face,
and my life has been saved.

Jacob's experience is akin to dreams and visions, yet is presented by the writer as an event that actually happened. In this regard the author is something of a Kafkaesque dissembler. Everything in this gloomy, mysterious, and eerie experience is presented as literal. The unknown assailant knows the etymology of Yaakov's name (heel-holder), a play on the fact that Jacob had emerged from the womb grasping the heel of his brother Esau. The stranger also gives him a farewell blessing, but this was a common social interaction at the time and didn't require a resort to angels. It was more unusual for the stranger to rename him "Israel," which may mean "God-fighter," or "May God protect." Even so, it was outrageous for Jacob to turn around and claim to have been face-to-face with God, since at the time it was commonly accepted that to see God face-to-face was to die. Jacob saw God and lived.

Jacob's experience can be read through a literary lens and connected to what Wordsworth called "spots of time." It resembles Virginia Woolf's "moments of being" and James Joyce's "epiphanies." Such moments are by definition sudden, unexpected, and apocalyptic. They have a rupturing intensity that is deep and troubling, even terrifying. They are triggered by external events, but they cannot be anticipated or entirely explained in rational terms. Indeed, they create a gap or wide hole in experience,

as the social world dissolves and the visible world is usurped. One world is suppressed as another is encountered. The epiphanic moment always marks a crisis point in a work, a threshold experience. It signals a dramatic turning point for the protagonist, who is deeply changed by the experience. He may even be so shocked that he emerges from it claiming a new name, a new identity. Or that he has seen God face-to-face.

The night setting is indispensable to reading Jacob's story. Textual scholars have pointed to the great antiquity of a tale that bears many resemblances to oral sagas in which a hero struggles against a local river spirit who must be placated or defeated in order to obtain a crossing. It was commonly held in ancient Near Eastern tradition that rivers were infested with demonic spirits, and, as a consequence, some have argued that Jacob's assailant was just such a river demon. Folklore also abounds with tales of ghosts and spirits who, like the figure of Hamlet's father, must slink away before daybreak. The Yahwist uses this tradition to create a spiritually transforming experience in writing. Psychologically, everything must happen under the eerie cover of darkness because Jacob's experience is epiphanic and prophetic, an event out of time. The linear flow and narrative momentum of the overarching story—Jacob's return to his homeland and reconciliation with his brother—are radically interrupted; indeed, what we think of as chronological or historical time is completely ruptured on this night of nights. The event is initiated by two crossings, as Jacob sends everyone and everything to the other side of the tributary, in effect doubly separating himself from the social norm—the world of familiars, the world of possessions. He is enacting a poetic crossing, dispossessing himself of his former character. He is now a solitary traveler left on the edge of a deep gorge. The nocturnal setting is so crucial because he has moved outside the arena of what can be apprehended by daylight and has entered the realm of the visionary. He has moved from eyesight to vision.

The dangerous encounter that follows is the pivotal moment in Jacob's life. It remakes him. The great archaic genius of the Yahwist was to literalize in a human figure the uncanny encounter with the otherworld.

One should keep in mind that Jacob struggles with a man whose identity is unknown to him; he only later takes the stranger to have been a divine emissary. This ambiguity is crucial. The mysterious being is first referred to as a man, then as an *elohim*. Later, Hosea refers to him as a *malach* (12:5) or "messenger." It is thus preemptive to capitalize the word "Man" (as the Living Bible does), and it somehow misses the point to label the section in advance "Jacob wrestles with God" (as the New International Bible does). A great deal of ink has been spilled trying to identify Jacob's angelic assailant (the candidates include Michael, Gabriel, and the celestial patron of Esau), but the *elohim* who blesses Jacob resolutely refuses to identify himself. He will not give away his own name, if he has one. (It is only in the book of *Daniel* that the angels begin to have separate identities and recognizable names.) Jack Miles points out in his book *God: A Biography* that virtually all the commentaries follow Jacob's own retrospective interpretation of the event, though the Yahwist leaves tantalizingly open the question of whether or not Jacob ever actually sees the face of the man who disappears at daybreak. And yet there is also overwhelming warrant in Jacob's entire saga for understanding the struggle as a supernatural encounter. It was foreshadowed in his competitive grappling with Esau in the womb. It resulted in the naming of a nation.

To understand Jacob's encounter, I would additionally apply a brilliant rabbinical comment from the *Bereshit Rabba* (chapter one) that Maimonides cites in *Guide for the Perplexed:* "To Abraham, whose prophetic power was great, the angels appeared in the form of men; to Lot, whose power was weak, they appeared as angels." The prophet's power is greatest when he can read the

signs of divinity. One might even say that at Bethel, Jacob was still like Lot, a lesser prophet, when he had a dream of angels going up and down a stairway that stretched between earth and heaven. He was something of a stronger prophet at the place he named Mahanaim ("This is God's camp!"), when the messengers of the Lord actually met him on the way, though still appearing to him as angels. It was only at Peniel, where he was put to the supreme test, that he truly became like Abraham, a great visionary, a fully conscious prophet: He wrestled with a man and knew him to be an angel.

Jacob is an agonist of the sublime, a person lamed while seizing the transcendental blessing. His nocturnal encounter was an aspiration for the power of the spirit, a terrifying quest for divine vitality. In the first volume of his tetralogy *Joseph and His Brothers,* Thomas Mann describes Jacob's encounter as "a frightful, heavy, highly sensual dream, yet with a certain wild sweetness; no light and fleeting vision that passes and is gone, but a dream of such physical warmth, so dense with actuality, that it left a double legacy of life behind it as the tide leaves the fruits of the sea on the strand at the ebb." The story probably has such great resonance for poets and prose writers because writing itself is an encounter with the unknown, a hard struggle with the unsaid. To write is to stand on the edge of a dark gorge guarded by a mysterious stranger. "The written page is no mirror," Edmond Jabès has asserted. "Writing means confronting an unknown face." Jacob may embrace the angel, but that embrace must also be agonistic, since it is an uncanny confrontation with the unknown. Writing is psychologically dangerous, because it means putting oneself at risk.

Jacob's encounter with an unnamed *elohim* is oddly parallel to the struggle Lorca attributes to the duende, since it is shadowed by mortality. It is anguished, and takes place in a dark country wide open to death. Harold Bloom comes close to this idea in his commentary for *The Book of J* when he nominates the

Angel of Death as Jacob's unknown antagonist. The duende wounds, Lorca said, and fights the creator on the rim of a well, much as the *elohim* marked and permanently injured Jacob on the rim of a wild gorge. The spirit who gives Jacob (Yaakov) the redemptive new name Israel (Yisrael) both wounds and blesses him. "In the healing of that wound, which never closes," Lorca writes in his piece about the duende, "lie the invented, strange qualities of a man's work" (*Deep Song*). Jacob's new name also suggests that he was no longer a heel-holder, a supplanter, but a spiritual figure, a founder, one "who strove with the angel and prevailed."

> In the womb he took his brother by the heel,
> and in his manhood he strove with God.
>
> (*Hosea* 12:3–4)

Concerning the Angels

AFTER A PARTICULARLY TRYING and desperate period in his life, which he called "that well of darkness, that obscure pit where I would thrash about violently, almost in a state of agony," Rafael Alberti wrote the poems of *Sobre los ángeles* (1929). Alberti was Lorca's wary friend and friendly rival in the remarkable circle of poets who came to be known as the "Generation of '27" ("There was magic, *duende,* something irresistible in everything Federico did," Alberti wrote), and his wide-ranging and startling work showed what a parallel and equally dark Andalusian sensibility could do to embody the bodiless figure of the angel. In his autobiography, *The Lost Grove,* Alberti testified that many things contributed to his falling and thrashing about in a seemingly bottomless well of darkness, but, above all, he was wracked by an "impossible love." As he explained the tribe of angels who suddenly arose out of the catastrophic depths, the figures who helped constitute the radical break in his work from his earlier folkloric songs and poems:

> And then there was a kind of angelic revelation—but not from the corporeal, Christian angels found in all those beautiful paintings and religious icons, but angels representing irresistible forces of the spirit who could be molded to con-

form to my darkest and most secret mental states. I released them in waves on the world, a blind reincarnation of all the cruelty, desolation, terror and even at times the goodness that existed inside of me but was also encircling me from without.

To understand the full demoniacal import of Alberti's troubling figures, it helps to remember how he emerged in his early work, especially in his first buoyant collections, *Marinero en tierra* (1925) and *Cal y canto* (1929), as a poet of innocent singing gusto, of exuberant Orphic ambitions, who seemed to serve as the transparent vessel of rivers and mountain peaks, of jubilant winds, sunny skies, and sparkling seas: "El mar. La mar. / El mar. ¡Solo la mar!" ("The sea. The sea. / The sea. Only the sea!") Listen, for example, to "Canción" ("Song"), whose rhythmical short lines, radiant simplicity, and metamorphic marine imagery have a vivifying energy:

> If my voice dies on land,
> take it down to the sea
> and leave it on the shore.
>
> Take it down to the sea
> and make it captain
> of a white man-of-war.
>
> Honor it with
> a sailor's medal:
> over its heart an anchor,
> and on the anchor a star,
> and on the star the wind,
> and on the wind a sail!

There is a lyrical and emotional freedom in this inscribed "song" that characterizes Alberti's youthful work.

But the poet of *Sobre los ángeles* demonstrates an urgent dissatisfaction with his earlier work, a strong intoxication with surrealist imagery, a sense of growing disgust with the political situation in Spain. Thus does he enter the disconsolate territory of T. S. Eliot's *The Waste Land,* of César Vallejo's *Trilce,* and of Pablo Neruda's *Residencia en la tierra* (*Residence on Earth*), finding himself suddenly inhabiting the space of a world hollowed out and devoid of meaning, drained of song. The natural world itself seems to have gone mute on him. The very first poem, "Paraiso perdido" ("Paradise Lost"), formulates the problem and sets the dire tone of this crisis work:

> Where is paradise,
> my shadow, you that were there?
> A silent question.
>
> Cities without answers
> rivers without speech, peaks
> without echoes, mute seas.
>
> No one knows...

It is into the space of nothingness, of the dissolving heavens, of the blackened abyss and the collapsing spirit, of paradise lost, that the poet begins to call on a dead angel to arise and light the way, to cross the shadowy threshold into our world: "Seeking you here I am lost in myself," he cries out, "and my night is forever." The dead angel embodies the final defeat of heaven.

In *Concerning the Angels,* Alberti sings of irrational spirits and uncanny presences. He uses the angels both to evade and to confront himself, to embody his plight. ("I was like a comet forecasting future catastrophes," he wrote in *The Lost Grove.* "No one accompanied me in my illness. I was totally alone.") Out of his desperate need, out of the terrible anguish of "the soul in pain" (to cite the title of one poem), he summons the luckless and

the moldy angel, the deceiving angel, the avaricious, the false, the enraged, the greedy, and the vengeful angel, the angel of ash and the one of ruins, even the Angel Angel ("The earth, nothing"). In *The Lost Grove,* Alberti reports with a kind of furious clarity how he wrote the poems of his angelology:

> An inhabitant of darkness, I began to write blindly at any hour of the night without turning on the light in my room and with a kind of undesirable automatism, spurred on by a trembling, feverish and spontaneous urging that had the effect of making the separate verses literally smother each other so that it was often impossible for me to decipher them the following day. My language became harsh and cutting, as sharply honed as the blade of a sword. The rhythmic cadences crumbled into bits and pieces. Each angel appeared first as a spark and then swept up in columns of smoke, into funnels of ashes and clouds of dust. But what I wrote was not all that obscure, and the most confused and nebulous thoughts took on the shape and reptilian movement of a flame-colored snake.

Alberti keeps discovering the angels as embodiments of both his weird and vacant inner condition and his collapsing outer world, as in the transformative poem "The Angel of Numbers," which is a kind of Orphic poem in reverse. It portrays the drama of what happens to one's childhood angels once the hierarchical universe of which they were a part no longer obtains. Once, he suggests, the heavens were transparent, untouched, protected:

> Virgins with rulers
> and compasses were watching
> the heavenly blackboards.

But now that mathematically clean world has been erased; it has become cloudy, metaphysically uncertain, which is a cause of almost childish grief:

Virgins without rulers,
without compasses crying.

At the end of the poem, Alberti uses the numerical angel to evoke
a cold, lifeless universe that goes on infinitely:

And on the dead blackboards
the angel of numbers
was lifeless, shrouded
on the 1 and the 2,
on the 3, on the 4…

Alberti recalls his Jesuit schooling through a different lens
now, through the figure of grade-school angels ("None of us un-
derstood the dark secret of the blackboard"). He recalls his drift-
ing past through the angels who patrol the sands ("My life was
going to be, and already was, a shore set adrift. / But when you
woke up, you drowned me in your eyes"). He sings of the dead
angels ("You must look for them / in the sleeplessness of forgot-
ten pipes, / in sewers clogged by the silence of garbage"), and of
the one survivor from the downfall of heaven:

it was the day when the last cry of a man bloodied the wind,
when all the angels lost their lives
except for one, and he was left wounded, unable to fly.

A universe of belief has been shattered, and Alberti's angels are
the wounded survivors of the wreckage.

Alberti's bloody struggle with a final surviving angel who has
become earthbound puts him on a gnostic shore similar to the
one where Lorca struggles with his duende. After writing *Con-
cerning the Angels,* Alberti contended the "poets of today" should
be "cruel, violent, demoniac, terrible."

There is a late descendant of Alberti's figure of the last fallen
angel in García Márquez's short story "A Very Old Man with

Enormous Wings" (1968). Here the angelogical tradition seems to have aged rapidly under the skeptical onslaught of the modern era. Here it merges with magical realism. The last angel is now portrayed as a pathetically weak old man who is found lying face-down in the mud of a courtyard in an unnamed rural village. It has been raining for days, and the storms seem to have blown him out of the sky. He can't rouse himself because of his huge buzzard wings, which are dirty and half-plucked. No one knows what to do with this incongruous great-grandfather, who inspires derision instead of reverence in the villagers. He is treated as a curiosity, a kind of circus animal, and soon the family who finds him begins charging admission to see the captive angel. He has been reduced to a spectacle, which is to say that the observers use and distance him to reaffirm their own normality. They have set the limit. But the degraded flesh-and-blood angel shows a superhuman patience and resilience. Slowly he recovers and marshals his strength until in the end he manages to set off in ungainly flight and disappear into the heavens. It is as if in the second half of the twentieth century, a very old South American relative of Kafka's Gregor Samsa had been transfigured into an angel and given a belated reprieve, a return skyward, an unlikely transcendence.

The Rilkean Angel

TEN YEARS BEFORE LORCA'S championing of the duende at the expense of the angel, Rilke had presented in the *Duino Elegies* a much less Christianized, deeper, and more penetrating idea of the angel as a figure of the agonistic sublime. Everyone who loves poetry should remember the oracular opening of the first elegy, which, as Rilke said, seemed to come to him without premonition or forethought as he paced a narrow path along a cliff overlooking the Adriatic Sea. He was thirty-six years old, and struggling with a particularly arid period in his work. His mind was on a tedious business letter that needed his immediate attention, edging up against the solitude he was so assiduously nourishing. And then the first question visited him as a voice out of a violent storm, as if a god had spoken: *Wer, wenn ich schriee, hörte mich denn aus der Engel / Ordnungen?*

> Who, if I cried out, would hear me among the angels'
> hierarchies? and even if one of them pressed me
> suddenly against his heart: I would be consumed
> in that overwhelming existence. For beauty is nothing
> but the beginning of terror, which we still are just able to endure,
> and we are so awed because it serenely disdains
> to annihilate us. Every angel is terrifying.

("The First Elegy," lines 1–7)

Rilke considered the *Elegies* the most mysterious dictation of his life. The angel who storms the imagination is for him a figure of both inspiration and rebuke, a being who surpasses the divisions and contradictions of human consciousness, who is at home in the infinite realms. Rilke's term *Ordnungen* ("orders") suggests the hierarchy so influentially established in the fifth or sixth century by that enigmatic, pseudonymous figure Dionysius the Areopagite. In *The Celestial Hierarchy,* Dionysius conceptualized all reality as hierarchic and triadic. He considered a hierarchy a sacred order, a state of understanding, and an activity approximating as closely as possible the divine. He suggested that the scriptures—the word of God—provided nine exploratory designations for heavenly beings, which were in turn divided into three groups. Rilke knew Dionysius's speculative ranking of the three descending angelic choirs or orders: in the top hierarchy, *seraphim, cherubim,* and *thrones;* in the middle zone, *dominions, virtues,* and *powers;* and in the lowest order, *principalities, archangels,* and *angels.* (In *Reading Rilke,* William Gass places Rilke's figures of divinity at a higher level, in the mid-reaches of eternity, when he translates the first question: "Who, if I cried, would hear me among the Dominions / of Angels?") According to Dionysius, the celestial hierarchy provided an approximate means for a formless, inscrutable God (a transcendent Mind, a Word above and beyond speech) to be represented in forms.

Dionysius's blueprint laying out a nine-tiered structure of heaven was adopted and reworked by such figures as Albert the Great, Thomas Aquinas, and Bonaventure in the twelfth and thirteenth centuries, and it is reflected in a range of major canonical texts from Dante's *Commedia* (the pilgrim who ascends into the heavenly spheres with Beatrice as his guide discovers the nine orders of angels in the form of nine distinct circles of light spinning around the still, radiant point of God's light at the center) to Milton's *Paradise Lost,* and beyond. It infused the spiritual thinking

of Saint John of the Cross. It took on fresh and nearly unrecognizable form in James Merrill's Dantean angelology, *The Changing Light at Sandover*, where a small minority of souls are chosen to move through nine stages of improvement. ("JM IS GOING UP THE SCALE.")

According to the Areopagite structure, then, Rilke's angels are the farthest away from God, the first to intervene in human affairs, *assailants* or *meddlers par excellence*, as he puts it. They are terrifying figures who move in the troubling zone between human beings and the highest invisible divinity. They carry within themselves a divine illumination, and yet that illumination seems to be inaccessible to us, beyond our reach. "Who, if I cried, would *hear* me among the angelic orders?" The angels do not listen to our imploring cries. They are unsympathetic to our desperation. They have a terrifying, inhuman indifference.

To comprehend the Rilkean angel, one needs to put aside the white-robed messengers of God portrayed by Raphael and Botticelli. Rilke himself always downplayed the Christian dimensions of his poem. "The angel of the *Elegies* has nothing to do with the angels of the Christian heavens," he wrote to his Polish translator, Witold von Hulewicz, in 1925:

> The angel of the *Elegies* is that creature in whom the transformation of the visible into the invisible, which we are accomplishing, already appears in its completion...; that being who guarantees the recognition of a higher level of reality in the invisible.—Therefore "terrifying" for us, because we, its lovers and transformers, still cling to the visible.

Before the first two elegies were pressed upon him (or borne unto him) in *Duino Elegies* in 1912, Rilke was working on *The Life of Mary*, a sequence of poems in which the angel appears in somewhat more traditional Christian guise—as a supernatural

protector, a human familiar, a messenger of God. Here he announces her death:

> The identical angel, the great one who
> once brought down the news of her conception
> stood there, waiting for her to notice him
> and said: It is now time for you to appear.

Rilke initially planned *The Life of Mary* as a collaboration with his friend the painter Heinrich Vogeler, and the angel he dramatizes is visually consonant with the traditional iconography of the angelic figure in Christian paintings.

It's that much more startling, then, that the angels who come to him out of the whirlwind in the first *Elegy* have been transfigured into an overpowering and original presence, figures of perfect consciousness and supreme beauty. These angels are the nearest human beings will get to superabundant Being, inhuman perfection, God. ("Not that you could endure / *God's* voice—far from it."—"The First Elegy," 61–62) Yet they are also the signs of the unbridgeable gulf that has opened between the human and the divine.

Whereas Rilke is a passive recipient in "The First Elegy," he becomes an active visionary—a Rimbaudian seer—in "The Second Elegy" when he invokes the angels themselves, the angelic force:

> Every angel is terrifying. And yet, alas,
> I invoke you, almost deadly birds of the soul...
>
> ("The Second Elegy," 1–2)

This invocation is so powerful because it acknowledges an irreparable separation and an insurmountable distance. "The invocation *wrestles* with the Angel" (Cacciari). It puts Rilke in the

same space as Jacob, but a Jacob who must grapple with what cannot be said, cannot be grasped. No wonder "The Second Elegy" mourns the days of Tobias, when there was an utterly easy commerce between human beings and angels. Perhaps now the angel only dwells within the invocation itself, within the invisible space created for it by us, inside of us.

The reference to the angels as "almost deadly" suggests that they *almost,* but do not quite, annihilate us. The notion that they are "of the soul" more than hints at the possibility that they actually exist within us. Rilke notoriously said that the angel of the *Elegies* was much closer to the angels of Islam than to those of Christianity. Reading the opening of "The Second Elegy," one is reminded of Ibn 'Arabī's gnostic, even heretical idea that angels are really the powers hidden in the faculties and organs of man. They are figures for something that dwells deeply within us, something that can be released into the imaginal realm. Yet the cry in "The First Elegy" is, as Gass puts it, "surely an inward cry, a cry to heaven as empty as the air, a cry blown out like a flame." It's as if Rilke's angels have suddenly fallen out of an empty sky, a heaven that has been vacated. They have become figures of an ungraspable, inconceivable beyond. We are awed by their vast indifference.

The Duino Elegies mark a tremendous Modernist rupture with biblical precedents. Or as Cacciari expresses it, "A metaphysical fracture intervenes in the angelogical tradition." The angels of Modernism—of Rilke and Alberti, of Kafka and Klee— no longer guide us past a threshold, or carry messages back and forth from the divine, or lead us back to a first primal unity. Paradise becomes unattainable as soon as we begin searching for it. And the angels have become signs of the human distance from that promise, guardians of a gate that never opens, and never will open. We have been turned back upon our mortal selves.

The Duino Elegies are powered by a frightening sense of transience, by the feeling that everything is rapidly passing away ("How we squander our hours of pain."—"The Tenth Elegy"), by a longing for the transcendental so great it nearly obliterates the speaker, by the certainty that one could attain radiant perfection (the streaming light) only by severing all daily distractions, temporal worries, and human connections. This was a lifelong temptation for Rilke, who had so many troubles with intimate human relations. After he first conceived his poem, he spoke of "getting beyond Man and passing over...to the Angels." He felt as if the angels were sent to him so that he could somehow surpass humanity and regard the world from a transcendental perspective, from within the Angel. The viewpoint is Nietzschean. Yet a desperate ambivalence later entered the poems as Rilke contemplated the full implications of crossing over to the other side and becoming as inhuman as divinity. "It is impossible to see the Angel without dying of him," Rilke said in a letter. That is why there is so much haunted duality in his cry at the end of "The Seventh Elegy":

> Don't think that I'm wooing.
> Angel, and even if I were, you would not come. For my call
> is always filled with departure; against such a powerful
> current you cannot move. Like an outstretched arm
> is my call. And its hand, held open and reaching up
> to seize, remains in front of you, open
> as if in defense and warning,
> Ungraspable One, far above.

("The Seventh Elegy," 97–104)

The Rilkean angel is glorious because he is at home in the infinite open spaces, but terrible because we can experience such a

figure of pure being only at the ultimate cost to ourselves, our identities. Yet he also demonstrates an internal knowing in the same elegy when he testifies that each of us, even the filthiest of homeless children, has experienced fleeting moments of eternity:

> For each of you had an hour, or perhaps
> not even an hour, a barely measurable time
> between two moments—, when you were granted a sense
> of being. Everything. Your veins flowed with being.
>
> ("The Seventh Elegy," 42–45)

The passing world itself survives only in these moments of absolute being, which become part of us, Rilke suggests ("Nowhere, Beloved, will world be but within us."—"The Seventh Elegy"), and he goes on, therefore, to display an internal reverence, to worship a power within: "Temples are no longer known. It is we who secretly save up / these extravagances of the heart" ("The Seventh Elegy").

Rilke is such an unabashed transcendentalist, his spiritual longing for the divine is so tremendous, that he can't believe we exist merely in time. A year before his death, he explained his idea of the interpenetration between life and death in the *Elegies:*

Affirmation of *life-AND-death* turns out to be one in the *Elegies.* . . . We of the here-and-now are not for a moment satisfied in the world of time, nor are we bound in it; we are continually overflowing toward those who preceded us, toward our origin, and toward those who seemingly come after us. In that vast "open" world, all beings *are*—one cannot say "contemporaneous," for the very fact that time has ceased determines that they all *are.* Everywhere transience is plunging into the depths of Being. . . . It is our task to imprint this temporary, perishable earth into ourselves so deeply, so painfully and passionately, that its essence can

rise again, "invisibly," inside us. We are the bees of the invisible. We wildly collect the honey of the visible, to store it in the great golden hive of the invisible. The *Elegies* show us this work, the work of the continual conversion of the beloved visible and tangible world into the invisible vibrations and agitation of our own nature...

It is as if the true enduring mission of the fleeting, generational, visible world is to be wholly incorporated into our inner spiritual beings and, indeed, that's precisely what Rilke suggests in his address to "Things"—the things of this world—in "The Ninth Elegy," which culminates in speaking directly to the earth itself: "Earth, isn't this what you want: to arise within us, *invisible?* Isn't it your dream / to be wholly invisible someday?—O Earth: invisible! / What, if not transformation, is your urgent command?" ("The Ninth Elegy," 72–75) The earth's commanding mission, like ours, is transformation.

Rilke's angel represents a transcendence that can scarcely be endured by mortal beings. We cannot dwell within divinity, he suggests, but can rise up or turn inward to meet it. And we can become—we are here *in order to become*—the sole vehicle of the earth's metamorphic transformation into pure being, the ones who testify to its mute, vanishing, cherished existence. *"Here* is the time for the *sayable, here* is its homeland," he declares in the great "Ninth Elegy": "Speak and bear witness." It is not for happiness or curiosity, he argues,

> But because *truly* being here is so much; because everything
> here
> apparently needs us, this fleeting world, which in some strange
> way
> keeps calling to us. Us, the most fleeting of all.
> *Once* for each thing. Just once; no more. And we too,
> just once. And never again. But to have been

this once, completely, even if only once:
to have been at one with the earth, seems beyond undoing.

("The Ninth Elegy," 11–17)

"Praise the world to the angel, not the unsayable one," he also declares:

> Perhaps we are *here* in order to say: house
> bridge, fountain, gate, pitcher, fruit-tree, window—
> at most: column, tower…But to *say* them, you must
> understand
> oh to say them *more* intensely than the Things themselves
> ever dreamed of existing.

(33–37)

These crucial lines encapsulate Rilke's notion of the Orphic human mission, the creative linguistic project of poetry itself—to praise the things of this world even more deeply than they ever dreamed of being praised, to forever name them, to sing the world's essential being. *Gesang ist Dasein,* he would write: "Song is existence." Song is a messianic instrument of metamorphosis, of transfiguration. It is an incarnate form of praise, a magical embodiment of spirit. The angel was already being displaced by Orpheus as the central figure in Rilke's last inspired explosion, his final testament, the sequence *Sonnets to Orpheus.*

Angel, Still Groping

THE ANGEL GRAVITATES downward in modern times. It enters into the crisis space of anxiety and doubt, having been thrust forcefully out of the celestial spheres. It now moves through the same skies as demons and lost souls. Nor is it exempt from history, a force that blows through its wings like an apocalyptic wind. The debris piles up on earth. Yet the angel waits patiently in front of the closed iron gates like a figure from a Kafka parable. It is nostalgic for a lost paradise. Like us, it has vague and substantial spiritual aspirations.

This is the station of Paul Klee's extraordinary "Angel Series" (*"La série des anges"*), which consists of fifty sheets created over a twenty-five-year period. Klee completed thirty-two of the angels during the last two years of his life, the war years of 1939 and 1940. They are haunted by the specter of his own impending death, as well as by the larger European catastrophe. They are puzzled creatures, the last ciphers of a mystery.

Klee never commented on the nature of his quirky, anthropomorphic angels, and we are left to ourselves to decipher both their visible and hidden meanings. Will Grohmann early on identified Klee's angels with Rilke's as figures who "live in the supreme unity that embraces life and death and see in the invisible a higher reality." This is imprecise at best. There is an approximate relationship, but also a key difference between Rilke's

wholly transcendental angel and Klee's partially transcendental figure, who is still held back by its earthly connections. Klee shows a sometimes bright, sometimes dark playfulness toward his creatures that gives them a decidedly un-Rilkean tone. They are sometimes tragically funny, sometimes cosmically sad, and always more vulnerably human, or part human, than Rilke's superabundant beings.

Klee hit his lightest note in the early lithograph *The Angel Serves a Small Breakfast* (1920). He portrays the angel as a kind of superior server—a friendly nurse in a hospital, or a warm hostess delivering room service in a hotel—who is so eager to serve that the tea is spilling out of the pot she carries on a tray. She wears a heart on her dress and seems like a mock-religious character, a sort of angel from the Red Cross.

Klee's early angels retain the glow and purposefulness of being divine messengers. Sometimes still pictured in flight, as in *Angelus Descendens* (1918) and *Angelus Novus* (1920), these angels seem to carry messages from beyond. ("The immaterial needs no fixed base," Klee once said, "it hovers.") They retain the aura of prophecy. That prophetic aura comes back with furious vengeance in one of Klee's last paintings, *Angel of the Old Testament* (1939), whose angel appears as one of God's wrathful warriors. The angel of judgment is one of the few figures in Klee's angelology who is drawn in accordance with the human face. He has terrifying biblical presence.

Most of Klee's late angels seem to comprise an altogether different order. They are fragmentary, incomplete, elusive creatures. They are often pictured as angels in the making, as in *Angel Becoming* (1920). Unlike Rilke's angels, who have already completed the work of incorporating the visible into the invisible and are therefore terrifying to us who cling to the visible, Klee's angels are earthbound, still undergoing the transfiguration from a human to an angelic form. They are fighting free of their bodies.

They don't descend from the heavens so much as they aspire to them. They are not realizations of the beyond but speculations about it. Thus, one feels the rapturous pain of growing wings in *Unfinished Angel* (1939). The *Angel, Still Female* (1939) is undergoing the metamorphic process of losing her sexual attributes, which materially linger on. As Jürgen Glaesemer writes of this figure rendered in a quasi-cubist way, "With one eye, the angel gazes upward in the direction of heaven; with the other it gazes suspiciously at what is left of its breasts, all that remains of its former existence on earth…" What is disfiguring about the *Ugly Angel* (1939) is that it still retains vestiges of a human body. Klee uses the angels to explore the body's metamorphic transformations. He obsessively returns to the subject of where human beings end and angels begin.

Klee's angels share a common substance, but each one is solitary, a half-transformed loner. Each is undergoing its own death and rebirth, its own refiguration —and this seems Rilkean, but humanly so, as in *The Notebooks of Malte Laurids Brigge*. Thus, one is *Full of Hope—Physiognomic* (1939), one kneeling (1939), one preternaturally alert (1939). The figures of *In the Anteroom of Angelhood* (1939) and *Angel Applicant* (1939) have been caught applying to be let into heaven as it might be imagined by Kafka. It has a cold waiting room and a large bureaucracy. Mistakes are also sometimes made, as in *More Bird than Angel* (1939) and *Miss-Engel* (1939), a figure who has somehow gone awry, who was misconceived or poorly made. There is a tragic dimension to Klee's hybrids, in which a clumsy body is holding back an airy spirit. Yet that body may be the only form that spirit can take. "Man's ability to measure the spiritual, earthbound, and cosmic, set against his physical helplessness," Klee once wrote in his notebooks, "is his fundamental tragedy. The tragedy of spirituality."

Klee's angels are external figures representing our incomplete human transformation from substance to spirit. They are the very

emblems of a redemptive quest. They are "poor," "forgetful," "hopeful." Among Klee's last figures are *Angel, Still Groping* (1939), *Angel, Still Ugly* (1940), and *Vigilant Angel* (1939), a gravely solemn figure who appears in white contours against a black background, almost as a conscience presiding over the others, a restless insomniac, a worrier, the last protector of the wakeful, watchful self. The *Dubious Angel* (1940), which Klee completed just before he entered the sanatorium where he died, is a figure whose very identity is in question. His wing is still partly an arm grafted to a shoulder, and his face blurs into indistinction. He is in the last stages of transfiguration and yet skeptical, doubting and doubtful, wondering about his incomplete metamorphosis. The final harbinger comes as the magisterial *Todesangel* (*The Angel of Death,* 1940).

In a piece he called his "Creative Credo," Klee spoke of creating "a formal cosmos which so closely resembles the Creation that a mere breath suffices to bring to life the expression of religious feelings and religion itself." These angels are that breath, for they carry the obscure breeze of spiritual ambition. They stand like complementary figures to the other dark presences who inhabit Klee's late work, such as *Figure from Hades, Grave Tidings, Another Dark Messenger,* and *Fear Erupting* (all from 1938); or *Man of Mistaken Identity* and *The Earth-Witches* (both from 1939), which "really come out of the earth," as Klee said; or *Gloomy Cruise* (which refers to Hades), *Charon,* and *Sick Man in a Boat* (all from 1940). "Each must obey the command within him, wherever it may lead," Klee once said in a lecture. "Our own heart, however, urges us to go deeper, down to bedrock."

Klee seems to have intuited the striking parallels between the *daimon* and the angel, first in *Daemonie* (*Demonic Vision,* 1939) and then, even more strikingly, in *Daemon* (1940), both of which he created in the midst of the angel series. Klee's *Daemon* has a strong parallel with the figure in *Angel, Still Ugly.* We can't tell in

either painting whether we are looking at one figure or two, and we can't distinguish where one figure ends and another commences. The self and the shadow-self, its anti- or antithetical self, are completely interlocked. Klee was following the etymology of the word *daemon* back to its root in *daimonai,* meaning "divide." His daemon, like his angel, is partly human, partly inhuman. And the artist is struggling to free his occult or immortal self.

Klee seemed to think of death as a passage to the other side, a transfigured music. It was an incomprehensible crossing, a threshold of absolute mystery. He painted death itself in one of his final paintings, *Death and Fire* (oil, 1940). Here a whitish blue-tinged skeleton with thick brown contours floats in space in front of a smoldering red background. He holds a ball above his flattened palm. A black stick figure advances in the right background as if he is the last ferryman, Charon himself moving through the flames. There is no angel in this fiery painting, which has such dark lines, black sounds, demonic force. It has duende.

Klee's very last painting contains a disquietingly black background. Left untitled and unsigned at his death, it has sometimes been called *Late Still Life* or, more profitably, *Composition on a Black Ground.* (All that has black sounds—black light—has duende.) The painting is divided into four primary areas. An orange moon floats in the upper center, a presiding form. There is a still life on the right side (a green coffeepot and a lavender statuette on a round tabletop—an orange disc—strewn with hieroglyphic-looking flowers). In the upper left, there is a group of three or four biomorphic forms, which appear to be vases wedged onto a narrow red table. In the bottom left-hand corner, there is a sheet or card of off-white paper with a drawing on it, a picture within the picture, a smaller work that looks as if it had been thrust into the larger frame. It depicts Klee's final angel.

The angel is a vigorous figure of black lines infused with misty reds and oranges, which give it an immaterial glow. It is not

entirely of this world. Two hands float up from its center. Grohmann plausibly interprets the scene as a version of the story of Jacob wrestling with a mysterious stranger. The two hands, then, are barely restraining an angel of death who is carrying a tiny cross, almost like a signature.

In *Of Angels, Things, and Death,* a recent book-length study of the painting, Mark Luprecht also points to the close similarity between this figure and *Angel, Still Ugly,* a drawing from the same year. It's so close that it might almost be another version of it, as if Klee were quoting himself. As in *Angel, Still Ugly,* we can't really tell if we are looking at one figure or two. Jacob and the angel may well be incarnated here in one figure, a being who retains his hands as the last vestige of his body. Everything else has been consumed by the angelic form. This figure is also extremely close to Klee's 1940 version of the *Daemon,* which he drew in grease crayon on paper and then mounted on cardboard. Klee's *daemon* has an inverted halo floating above its head. Luprecht has strong warrant for identifying Klee's depictions of the angels with the archaic Greek figure of the *daimon,* which he recognizes as a hermetic figure for the occult self.

The New Angel

AN AURA OF PROPHECY surrounds the being with an over-size head and haunting eyes who hovers above the ground in Klee's watercolor on paper *Angelus Novus* (Munich, 1920). The angel hangs in midflight, either ascending or descending—the viewer can't tell which—but not quite earthbound. He is caught in midsphere. Walter Benjamin famously interpreted this new angel as a figure for the angel of history in the ninth section of "Theses on the Philosophy of History" (1940), his last extant piece of writing. Benjamin bought the painting for a thousand marks (fourteen dollars!) from a gallery in Munich in 1921, and thereafter cherished and contemplated it for two decades "as a picture for meditation and as a memento of a spiritual vocation," as his friend Gershom Scholem put it.

Benjamin writes:

A Klee painting named "Angelus Novus" shows an angel looking as though he is about to move away from something he is fixedly contemplating. His eyes are staring, his mouth is open, his wings are spread. This is how one pictures the angel of history. His face is turned toward the past. Where we perceive a chain of events, he sees one single catastrophe which keeps piling wreckage upon wreckage and hurls it in front of his feet. The angel would like to stay, awaken the

dead, and make whole what has been smashed. But a storm is blowing from Paradise; it has got caught in his wings with such violence that the angel can no longer close them. This storm irresistibly propels him into the future to which his back is turned, while the pile of debris before him grows skyward. This storm is what we call progress.

What Klee might well have considered a picture of himself as an angel flying away from the rubble of World War I, Benjamin took twenty years later as a picture of a melancholy prophet being pulled unwillingly into the future. The angel of history notably has his back to that future. He is turned away from it. He stares resolutely into the past, which we see as a disconnected series of events, but he recognizes as a singular catastrophe of monumental proportions. He would serve as a messiah and fix the wreckage, the broken vessels, but he is helpless before the uncontrollable storm of progress. O. K. Werckmeister points out that Benjamin's various drafts of the ninth section of the "Theses" identify the new angel with the idea of the historian as a retrospective prophet. "The visionary glance is lit up by the rapidly departing past," Benjamin wrote: "That is, the visionary has turned away from the future: he perceives its shape in the dusk of the past which disappears before him into the night of time."

The new angel is subject to a future he doesn't look at or see. He possibly may never see it until he fulfills his particular mission, which is to redeem the unparadisal past. His ethic is remembrance. In the last section of his essay, Benjamin invokes the memory of the ancient Jews who were prohibited from investigating the future because it involved them in soothsaying, in magical practices: "The Torah and the prayers instruct them in remembrance, however." The imperative is to remember; the focus is on earthly knowledge. And yet the only potential for redemption from the singular catastrophe of modern history seems messianic

or apocalyptic. ("For every second of time was the strait gate through which the Messiah might enter.") The storm is blowing from Paradise, which is both a garden of pure origins, an original state of existence, and a fantasy of a future beyond time, beyond history, a dream of redemption. Benjamin prefaces the fourteenth section of the "Theses" by quoting from Karl Kraus's poem "The Man Dying," in which God speaks: "You remained at the origin. Origin is the goal." Origin is what the new angel is seeking to obtain through the devastating rubble of time. He is a spiritual seeker, a last utopian dreamer.

In "Walter Benjamin and His Angel," Gershom Scholem traces his friend's long and complex relationship to *Angelus Novus*. The painting also stands firmly behind Benjamin's enigmatic autobiographical notebook entry "Agesilaus Santander." Benjamin's hermetic text, which exists in two versions in his journal, reports that at his birth his parents, suspecting that he might one day become a writer, gave him a secret name that would be revealed to him only upon his maturity. The new name, he says, "remains the name which gathers all the forces of life unto itself..."

> But this name is by no means an enrichment of the person who bears it. It deprives him of many things—above all, of the gift of appearing entirely as the person he was before. In the room I was last living in, even before that person had emerged fully armored and accoutered from the old name, he had displayed his image: *New Angel*.

The new angel is "Agesilaus Santander." This was Benjamin's secret name for himself which, Scholem points out, stands as an anagram for *Der Angelus Satanas* ("The Angel Satan"). Scholem recognizes that Benjamin is drawing upon a kabbalistic tradition that every human being has from birth a personal angel who represents his true or secret self but whose name remains obstinately hidden from him. That celestial self often has an antagonistic

relationship to the human or mortal self. Benjamin's hidden name, The Angel Satan, weds the figure of the angel and the demon in intimate union, forever connecting in one being both the angelic and demonic forces of life.

Benjamin's embodiment of "The Angel Satan" seems virtually indistinguishable from Yeats's notion of the *Daimon*. Both The Angel Satan and the *Daimon* are inner companions, secret selves, mythical figures—one Judeo-Christian, one Greek—for the mystery of human destiny, for the fatefulness of our characters, for fate itself. They are the imaginary figures of our quest for a unity beyond human contradictions.

Benjamin's eerie parable of the new angel—the renamed self—is a story of illumination. In a wonderful essay on Surrealism ("Surrealism: The Last Snapshot of the European Intelligentsia"), Benjamin explicitly links occult experiences with artistic and intellectual work. "We penetrate the mystery only to the degree that we recognize it in the everyday world, by virtue of a dialectical optic that perceives the everyday as impenetrable, the impenetrable as everyday," he says. "The reader, the thinker, the loiterer, the *flâneur,* are types of illuminati just as much as the opium-eater, the dreamer, the ecstatic. And more profane. Not to mention that most terrible drug—ourselves—which we take in solitude." These lines are a trumpet call, since Benjamin points here to the spiritual recklessness and intoxicated excitement of imaginative work. He embodies the very types he names. So, too, one thinks immediately of two writers whose work he illuminates so well in his critical writing: Baudelaire, "the *flâneur,*" and Kafka, "the thinking one, the waiting one." In writing about them, Benjamin was also writing about himself, outlining the contours of his experience. It is no accident that the greatest scholar of the Kabbalah was the one who recognized the spiritual depth and recklessness of Benjamin's project, the truth of his profound

recognition. "The experience of the reader, the thinker, or the *flâneur* already contains everything that the so-called mystical experience contains," Scholem writes: "In the phantasmagoria of his imagination, the picture of the *Angelus Novus* becomes for Benjamin a picture of his angel as the occult reality of his self."

Three American Angels

THE EXPERIENCE OF GOING to meet the angel in the invisible realm, in the space between sleeping and waking—as Swedenborg, Blake, and Emerson did—is an experience of going a little beyond our recognizable human borders. It calls our usual confines into question. It raises the stakes of our risk. It lets the secret, occult self dangerously loose into the world. It is an experience of *beyonding.*

There is a moment in his *Journals* when Emerson playfully cites "our accomplished Mrs. B." who, with a wave of her hand, declares that Transcendentalism means "a little beyond." Emerson entered just such a transcendental space in a strange dream he had in the 1840s, in which he floated freely into the nether spaces, a little beyond the earth. As he recorded it:

> I dreamed that I floated at will in the great Ether, and I saw this world floating also not far off, but diminished to the size of an apple. Then an angel took it in his hand & brought it to me and said 'This must thou eat.' And I ate the world.

The angel who offers the dreamer the earth as a form of food, who demands he devour the world—"This *must* thou eat"—as if it were the original apple in the unsullied garden of "delight," the fruit of our fall, is a radically Emersonian angel, a quintessentially American figure. He is offering the writer the chance to take the

world into his body, to bear an entirely original relationship to the universe. The seductive idea of being an Adamic or primal man runs deep in Emerson's psyche. It has become part of the American unconscious, and runs equally deep in the American mind itself.

Emerson's vitalist angel who feeds him the world seems to me the ancestor of the figure Wallace Stevens calls "the necessary angel." But now Romanticism has turned into Modernism, and the angel has fallen away from the empty heavens. It has been evicted from the dream world of faith, from the utopian realm of a fully sponsored universe.

Stevens's poem "Angel Surrounded by Paysans," the closing piece of *The Auroras of Autumn* (1950), opens with a question by one of the *paysans,* a countryman who, presumably, has an older worldview than the poet and thus still hopes, and perhaps even believes, that supernatural angels are possible: "There is / A welcome at the door to which no one comes?" The rest of the poem is spoken by a character who identifies himself as "the angel of reality," a new angel, a figure who momentarily pauses in the doorway, the sacred threshold between inside and outside, our inner and outer worlds. "For the door is an entire cosmos of the Half-open," Gaston Bachelard notes in a relevant passage from *The Poetics of Space:* "In fact, it is one of its primal images, the very origin of a daydream that accumulates desires and temptations: the temptation to open up the ultimate depths of being."

Stevens's angel comes to the tempting doorway without any supernatural signs or relics—he has no ashen wings, no wear of ore, no tepid aureole, no brightly attending stars. "I am one of you and being one of you / Is being and knowing what I am and know," he says:

> Yet I am the necessary angel of earth,
> Since, in my sight, you see the earth again,

Cleared of its stiff and stubborn, man-locked set,
And, in my hearing, you hear its tragic drone

Rise liquidly in liquid lingerings,
Like watery words awash; like meanings said

By repetitions of half-meanings.

The angel of reality no longer inhabits the heavens, which
apparently have been vacated. It doesn't have any means of trans-
port to the otherworld. Yet it is still a *necessary* angel, an indis-
pensable figure of the imagination, because it provides a cleansing
perspective from which to see the world anew. We need the angel,
Stevens argues, because it is vitally necessary for us to pass behind
the habitual daily world, the familiar "man-locked set." We need
this last vestige of the Romantic imagination, even if it appears as
only half a figure, a remnant, a ghostly apparition, a momentary
projection of the mind. In a letter written to Victor Hammer at
the end of 1949, Stevens described the angel he was struggling so
hard to project:

> The question of how to represent the angel of reality is not
> an easy question. I suppose that what I had in mind when I
> said that he had no wear of ore was that he had no crown or
> other symbol. I was definitely trying to think of an earthly
> figure, not a heavenly figure. The point of the poem is that
> there must be in the world about us things that solace us
> quite as fully as any heavenly visitation could.

Stevens's description is obstinately naturalistic, and yet one
wonders why it is necessary to invoke an *angel* at all, or whether
or not it is even possible to posit an entirely naturalistic angel. The
angel always retains vestiges of supernatural presence. Stevens's
angel of reality seems to be an embodied figure of the religious
imagination once it has been deprived of a belief in God. The
angel is a vital aspiration of the mind itself, of the creative imagi-

nation, "the way of thinking by which we project the idea of God into the idea of man," as Stevens expressed it in his prose reflections on poetry, *The Necessary Angel*. The angel brings us a renewal of earth by providing a slightly unearthly perspective from which to view it. Stevens famously said that the great poems of heaven and hell had all been written, but that the great poems of the earth still remained to be done. His deepest aspiration was to write those poems. Yet it is striking that he found it necessary to invoke a transcendental figure, even a fleeting, contradictory, and landlocked one, for a superbly earthly poetry. The angel may have become a dreamy half-figure, a fleeting presence in the doorway, an inner temptation, a vaguely demonic possibility. But it is still an angel.

Donald Barthelme takes the leap from Modernism to Postmodernism in his comic three-page story "On Angels" (1970). Here the angels are left with an odd, even absurd, philosophical conundrum: "The death of God left the angels in a strange position." The angels are suddenly stricken by doubt, consumed by anxiety. They are unaccustomed, Barthelme suggests, to considering the most basic question about themselves, "*What are angels?*" But now it appears, if they are going to survive, they must manage in a post-Nietzschean universe. They have become, in other words, very much like us.

Barthelme's exquisitely deadpan, quasi-essayistic story raises the question of whether or not angels still can be credible figures of the vital imagination when the cosmology of which they are a part no longer obtains. Barthelme also notices that in writing about angels we always have been, at least in part, writing about ourselves. There is no satisfactory answer to the meaning of angelic existence—the angels need a Descartes—and yet they remain obstinately among us. It is in keeping with postmodern reality that instead of a philosopher the angels get a spokesperson, a spin doctor, a spectacle:

I saw a famous angel on television; his garments glistened as if with light. He talked about the situation of angels now. Angels, he said, are like men *in some ways*.

This may be true, but it is also vague and unsatisfactory. It seems the angels need a god to adore, to inspire them. They need something to believe in beside themselves. The existential crisis of the angels leaves them drifting in a state of metaphysical anxiety, "continuing to search for a new principle." These comically uncertain earthbound angels are our new surrogates. They, too, are shipwrecked, left with the vestiges of dreams, with unspecified spiritual aspirations.

It seems certain that we will always need these strange imaginary beings, creatures of light, winged manifestations of divinity. They are fundamentals of the human imagination. But we need to protect them from superficial callings. There is a haunting description of the last angels in Borges's short history that is still timely and beautiful:

> I always imagine them at nightfall, in the dusk of a slum or a vacant lot, in that long, quiet moment when things are gradually left alone, with their backs to the sunset, and when colors are like memories or premonitions of other colors. We must not be too prodigal with our angels; they are the last divinities we harbor, and they might fly away.

Demon or Bird!

THE ANGEL COMES WITH windy upward drafts, with transcendental longings; the duende arrives with demonic undertow, with downdrafts of emotion. Both are fundamental inner disturbances, fissures of being, ways of putting the self at risk, liberating figures. They are extremities of the human imagination. There is a place on the endangered shoreline where they seem to meet, and where they may be indistinguishable from each other. Bachelard points out that the poet Jules Supervielle spoke of both "exterior dizziness" and "interior immensity." Thus, he says, "the two spaces of inside and outside exchange their dizziness." Rilke wrote: "Works of art always spring from those who have faced the danger, gone to the very end of an experience, to the point beyond which no human being can go. The further one dares to go, the more decent, the more personal, the more unique a life becomes."

It is revealing to concentrate on the space in American art where the radically affirmative side of our native temperament comes up against our equally shadowy longings, where the angel meets its brooding double. This is the realm where American art takes on a dark radiance, where it rises, to use Robert Duncan's title, "out of the black." The high-risk stakes of being open to the present moment—to its void and undertows, its flashing plenitudes—is a key one for Lorca, which is one of the reasons I feel

both the duende and the angel exult in the American difference in art. The Emersonian sense of abandonment to the richness of the present gives an energetic, rapturous, volatile quality to American openness. "Every thing teaches transition, transference, metamorphosis: therein is human power," Emerson declared in his journals. "We dive & reappear in new places." "What is known I strip away, / I launch all men and women forward with me into the Unknown," Whitman declares. "There is only one thing you can do about kinetic, reenact it," Charles Olson writes in "Human Universe." "Art does not seek to describe but to enact." "Today has no margins," John Ashbery writes in "Self-Portrait in a Convex Mirror":

> Today has that special, lapidary
> Todayness that the sunlight reproduces
> Faithfully in casting twig-shadows on blithe
> Sidewalks. No previous day would have been like this.
> I used to think that they were all alike,
> That the present always looked the same to everybody
> But this confusion drains away as one
> Is always cresting into one's present.

The sense of cresting into one's present gives a special frisson to American art when that art struggles with cloudy doubts and secret undertows, when it is driven forward by emotional intensities to reach its maximum heat, as in "As I Ebb'd with the Ocean of Life" and "Out of the Cradle Endlessly Rocking," both of which appeared in the 1860 edition of *Leaves of Grass.*

Pause over Whitman's "wild and plaintive song." There is a driving incantatory power and oceanic drift to "Out of the Cradle"—it was first called "A Word Out of the Sea"—that creates the very rhythm of a reminiscence emerging from the sea waves and the rocking cradle. The poem has an element of lullaby, and carries in its body the lulling motion of the waves, the

consoling sound of the sea, the memory of the cradle's first unity. But this is a lullaby that wounds (as Lorca said about Spanish lullabies), a lullaby of sadness that permeates the universe itself. Whitman's poem gives us the midnight portrait of a boy standing on the "Paumanok" seashore in August and tearfully recalling a moment in some past May when he encountered two birds from Alabama, at first bound joyfully together, united as one, and then painfully separated by death. The speaker recalls—he becomes again—the boy standing alone on the shore, the boundary line between life and death, narrating the main story of two birds forever separated from each other.

Whitman loved Italian opera and, indeed, the poem has a high-operatic quality as it alternates and fuses the bird's expressive song of tragic passion, which follows the slow pattern of an aria ("The aria sinking"), with the boy's separate, downstage, companionable response to the "reckless despairing carols." So responsive is the boy to the bird's caroling despair that the singer seems almost to be instigating the boy's own song, like some knowing, sinister voice rising unseen from the sea. The anxious "outsetting bard" even begins to wonder whether or not the singer ever really had a lover:

> Demon or bird! (said the boy's soul,)
> Is it indeed toward your mate you sing? or is it really to me?

It's as if Whitman's doubt is pulling down and away from, and even inverting, Shelley's invisible skylark ("Teach us, Sprite or Bird, / What sweet thoughts are thine"), who sings with such pure rapture, such glad celestial spirit, and projects so much dynamic uplift and "unbodied joy." The skylark is all lightness and air, the very embodiment of Shelley's "harmonious madness." By contrast, Whitman's anguished figure stands as a kind of natural genius emanating from the black, unknown waters, from the darkly mysterious universe itself. He is a vibrating songbird, a Virgil to

the outsetting Dante ("O you singer solitary, singing by yourself, projecting me, / O solitary me listening"). He seems to provide the necessary demonic song—the word out of the sea—that formulates the boy's still unformulated desire, his future vocation ("The unknown want, the destiny of me").

At the climax of the poem, Whitman carefully goes on to link his initiation into death with his initiation into art—his burgeoning creativity, his bardic calling and craft:

> Whereto answering, the sea,
> Delaying not, hurrying not,
> Whisper'd me through the night, and very plainly before
> daybreak,
> Lisp'd to me the low and delicious word death,
> And again death, death, death, death,
> Hissing melodious, neither like the bird nor like my arous'd
> child's heart,
> But edging near as privately for me rustling at my feet,
> Creeping thence steadily up to my ears and laving me softly all
> over,
> Death, death, death, death, death.
>
> Which I do not forget,
> But fuse the song of my dusky demon and brother,
> That he sang to me in the moonlight on Paumanok's gray beach,
> With the thousand responsive songs at random,
> My own songs awaked from that hour,
> And with them the key, the word up from the waves,
> The word of the sweetest song and all songs,
> That strong and delicious word which, creeping to my feet,
> (Or like some old crone rocking the cradle, swathed in sweet
> garments, bending aside,)
> The sea whisper'd me.

Whitman's seashore lyric is wide open to death, the mortal foe of memory, and his childhood reminiscence has so much duende because it is awakened in the presence of death, because his initiation into art is an arm-to-arm combat with a delicious forgetfulness, with oblivion itself. He has been chosen to remember, which is to say that he has become an Orphic vehicle. A thousand warbling echoes reverberate through him and refuse to die.

"It is not upon you alone the dark patches fall," Whitman declares in "Crossing Brooklyn Ferry." "The dark threw its patches down upon me also." "Out of the Cradle" is a reminiscence—an operatic parable—that considerably darkens the source of Whitman's song, the starting point for his notorious optimism. The poet begins as a tender solitary, a lonely singer by the sea. The word emanating out of that sea is "death," and Whitman's poetry originates in its mysterious presence.

Between Two
Contending Forces

DUENDE IN THE AMERICAN grain. A metaphysics with an international sensibility and a local accent. An open road that leads from the nineteenth to the twentieth century, from Walt Whitman to William Carlos Williams. A notion of falling in order to rise, which is a metaphor that helps to explain the intensity in two modernist books of poems—two crisis works—that Williams wrote in the late teens and early twenties in order to try to save his soul: *Kora in Hell: Improvisations* (1920) and *Spring and All* (1923). Written in white heat, their style is fervent, headlong, embattled, often obscure and contradictory, yet sometimes radiantly clear and luminous. In a short personal lecture delivered in 1973, "Williams and the Duende," Denise Levertov noted that what she first admired in Williams's work was an almost Franciscan sense of wonder at what is usually accounted as the ordinary world, "an illumination reminiscent of Chardin's still-lifes," but that she increasingly came to value the way his work encompasses "the dark, the painful, the fierce." She was picking up on the odd way in which objectivism yields to what is lonely and strange in Williams's work. Levertov connected duende to soul, pointing to a moment in Williams's poem "The Sound of Waves" in which he moves "toward an image in which the mist, rain, sea-spume of language is blown against jutting rock, and takes its hard shape."

But then there's a sudden rupture in the text, a break in the momentum, an interruption of the poem's gathering rhythms. It is marked by five dots—a startling pause, an extended ellipsis, as in Rilke's "Der Tod." Levertov recognized that Williams's duende had arrived:

> Past that, past the image:
> a voice!
> out of the mist
> above the waves and
>
> the sound of waves, a
> voice speaking.

Williams is enacting the experience of going beyond the human world, the human limit. The epiphanic experience ruptures time, and a voice breaks above the waves. It is a broken call in the dark—hence the spatial gap between the words "voice" and "speaking." And it comes from the deep beyond. We have reentered the space of the American sublime.

Kora in Hell is a book of experimental prose poems, a culling of journal meditations that Williams jotted down as a kind of automatic writing every night for a year. Later he added comments and explanatory notes, many of them equally dense and obscure. The title refers to the legend of Spring captured and taken to Hades. As Williams recalled years later, "I thought of myself as Springtime and I felt I was on my way to Hell." Inspired by Rimbaud's *Illuminations, Kora in Hell* is one of Williams's most puzzling, disjunctive, and surreal texts, a broken composition that continually defies rational logic and coherence. It is a text divided against itself, energetically seeking an equilibrium, holding together two conflicting forces and impulses. On the one hand, the improvisations are impromptu and open-ended, asserting the

freedom and primacy of the imagination. They are seized by what J. Hillis Miller calls "an anarchistic rage to demolish everything, all logical or rational forms, all the continuities of history." The destruction of received models and forms is necessary in order to clear a space for spontaneous thought to arise. On the other hand, Williams's aesthetic asserts the primacy of treating objects in the world directly. Thus his thought oscillates between process and the thing itself. Williams's poetic struggle involved finding an equilibrium between these opposing energies and polarities: "Between two contending forces there may at all times arrive that moment when the stress is equal on both sides so that with a great pushing a great stability results giving a picture of perfect rest."

Spring and All is an experimental interweaving of poems and prose manifestoes about poetry. It is, as Williams said, "a travesty on the idea" of typographical form. Chapter headings are printed upside down; chapters are numbered in the wrong order. The poems are untitled. The prose combines violent indictments of contemporary civilization and impassioned pleas on behalf of the imagination. As *Kora in Hell* is a descent into winter and hell, so *Spring and All* is a difficult ascent into the radiance of spring and the temporal world. The underlying subject of the book is the hard necessity of creating "new forms, new names for experience." In this case, the prose rails against the false values of a rootless, materialistic society and calls for the annihilation of old values and forms. Against this materialistic malaise, Williams poses the compensating imagination: "To refine, to clarify, to intensify that eternal moment in which we alone live there is but a single force—the imagination." These are poems of great visual accuracy and precision, lyrics in which familiar objects are clarified and presented in a fresh context, such as the red wheelbarrow upon which "so much depends" and the flowerpot "gay with rough moss." The primary subject of the poems in *Spring and All*

is the difficult struggle to be reborn. The introductory poem
sounds the call for a new world, describes the way in which the
plants, still dazed and "lifeless in appearance,"

> ...enter the new world naked,
> cold, uncertain of all
> save that they enter...

Later they "grip down and begin to awaken."

The Sublime Is Now

EVER SINCE WHITMAN, our poets have been magnetized to the sphere of the American sublime, the engulfing space that Emerson delineates as *"I and the Abyss,"* the intractable sea that Wallace Stevens confronts in "The Idea of Order at Key West," which contains a direct echo of Whitman's poem ("Oh! Blessed rage for order, pale Ramon, / The maker's rage to order words of the sea"). This strip of land at the boundary of the fathomless sea is comparable to the liminal space that Robert Frost repeatedly encounters at the edge of a dark wood, the majestic space where, as Emily Dickinson says memorably, "The Soul should stand in Awe" (#683). The feeling of awe bears traces of a holiness galvanized and deepened by the mysterious presence of death. "No man saw awe," Dickinson also declares in a late poem (#1733). Awe is fateful and sublime, and, in American art, as Barnett Newman put it in a 1948 essay, "The Sublime Is Now." It is a space for schooling the spirit. It is America.

"We are reasserting man's natural desire for the exalted, for a concern with our relationship to the absolute emotions," Newman wrote in his Emersonian contribution to a symposium on the sublime in art: "Instead of making *cathedrals* out of Christ, man, or 'life,' we are making it out of ourselves, out of our own feelings." From the cathedral of our own feelings, from the void of the blank canvas, then, comes the space for revelation, "real and concrete."

Newman is creating the space for what Irving Howe terms "a democratized sublime." It comes from a deep-seeded and risky faith in *inwardness*. It goes on nerve. It flies out into the uncoordinated zone of the work in progress. It emerges in hard passage. "Neither the action nor the actors can be anticipated, or described in advance," Mark Rothko asserted in 1947. "They begin as an unknown adventure in an unknown space." The nakedness of this Adamic impulse, this open-ended process, can be daunting. "With *known* criteria, the work of the artist is difficult enough," Robert Motherwell declared in 1983 in a foreword to a book entitled *Abstract Expressionist Painting in America,*

> with no known criteria, with criteria instead in the process of becoming, the creative situation generates an anxiety close to madness; but also a strangely exhilarating, and sane sense too, one of being free—free from dogma, from history, from the terrible load of the past; and above all a sense of newness, of each moment focused and real, outside the reach of past and future...

This is the protean American self cut loose from the dead hand of the past. It is like a sail leaning out into the downdrafts of wind, the anxious crosscurrents, the upsurges of the open air. It speaks to the radical artistic license—a freedom both terrifying and exhilarating—of complete immersion in the present moment.

There is a duende that goes awry in a swaggering, broad-shouldered regional or nationalist art. Carl Sandburg and Vachel Lindsay come to mind. Lindsay's embarrassing, over-the-top performances of "The Congo" bring to mind an English matador's contention that in Spain, a sense of irony attended those who had duende. "Their performances tended to be either wonderful or awful," Henry Higgins said, "and more often the latter." He concluded that "people who had duende were splendidly imperfect." Higgins preferred cool technique to warm feeling in the ring and

never reached the summit of his art, but his statement may nonetheless apply to a range of figures achieving varying degrees of success. One thinks, for example, of a series of vehement and even aggressive American writers, from Walt Whitman to Theodore Dreiser, whose work could blow wildly off course. Ernest Hemingway and Norman Mailer represent two high-machismo examples in American literature of prose writers with duende whose highly performative books seem to be either wonderful or awful, and seldom in between. They embody at a high level this splendid impurity and imperfection.

One seeks an American art empowered by emotion and enabled by aesthetics. Duende gives us the term for a force that sweeps into American visual art at some of its darkest, moodiest moments. One feels it in Albert Pinkham Ryder's visionary nocturnes and seascapes in which a tiny sailboat—a sign of the solitary human plight—moves on a tempestuous sea; and in Edward Hopper's preternaturally lonely landscapes and small towns and solitary night spaces hollowed out of the city; and in Romare Bearden's sensuous, dramatic renderings of conjure women who people his work, as Ralph Ellison said, "with the ubiquity of the witches who haunt the drawing of Goya"; and in Joseph Cornell's dreamy, oneiric homemade boxes, which are symbolist reveries, time capsules for eternity. As Charles Simic writes in *Dime-Store Alchemy: The Art of Joseph Cornell:*

Street-Corner Theology

It ought to be clear that Cornell is a religious artist. Vision is his subject. He makes holy icons. He proves that one needs to believe in angels and demons even in a modern world in order to make sense of it.

The disorder of the city is sacred. All things are interrelated. As above, so below. We are fragments of an unutter-

able whole. Meaning is always in search of itself. Unsuspected revelations await us around the next corner.

The blind preacher and his old dog are crossing the street against the oncoming traffic of honking cabs and trucks. He carries his guitar in a beat-up case taped with white tape so it looks like it's bandaged.

Making art in America is about saving one's soul.

We are broken vessels, Cornell seems to teach us, aspiring to a lost wholeness. It can be recovered in sudden flashes and memories, in momentary daydreams, in fleeting moments of revelation, in works of art. Cornell *proves,* Simic avows, that in order to make sense of things, even in our skeptical modern world, *one needs to believe in angels and demons.*

One needs to believe, but is it still possible? Rothko addressed this modern or post-Nietzschean dilemma directly when he pointed out that even archaic artists, virtuosos of the dream state, did not address the transcendental realm without mediation. Rather, they "found it necessary to create a group of intermediaries, monsters, hybrids, gods, and demigods." Is this workable in a skeptical age? The transcendental impulse remains urgent within us, Rothko suggests, but we no longer have a vocabulary of imaginary beings to enact it. We are left alone in the universe:

Without monsters and gods, art cannot enact our drama: art's most profound moments express this frustration. When they were abandoned as untenable superstitions, art sank into melancholy. It became fond of the dark, and enveloped its objects in the nostalgic intimations of a half-lit world. For me the great achievements of the centuries in which the artist accepted the probable and familiar as his subjects were the pictures of the single human figure— alone in a moment of utter immobility.

This speaks to the tragedy of benighted spirituality. At the same time, it points to the way that a heroic art can capture the utter desolation, the frozen moment of a solitary figure—a self alone in the world—confronting an abyss. A moment of absolute stillness.

To surpass the familiar world that enshrouds us, the tyranny of the quotidian, a group of American artists simultaneously began to intuit to different degrees that they would need a fundamentally new way of proceeding. They spurred each other on to greater insights. It was both an artistic imperative and a spiritual necessity. "I do not believe that there was ever a question of being abstract or representational," Rothko declared provocatively, but with utter certainty. "It is really a matter of ending this silence and solitude, of breathing and stretching one's arms again."

Painting is a state of being...
JACKSON POLLOCK

In the Painting

IT IS AS IF THE American action painters took to heart the homegrown notion that art is not a record but an event, "the path of the creator to his work." As Emerson formulates it in his essay on Plato, "Our strength is transitional, alternating":

> The experience of poetic creativeness...is not found in staying at home, nor yet in traveling, but in transitions from one to the other, which must therefore be adroitly managed to present as much transitional surface as possible...

The feeling for active transitions, for the energizing power of movement, for the viability of the "transitional surface," reverberates through all the American arts, but seems to have special applicability to action painting. The Emersonian faith in organic process ("For it is not metres, but a metre-making argument, that makes a poem," Emerson affirms in "The Poet") seems almost to anticipate Harold Rosenberg's controversial 1952 assertion:

> At a certain moment the canvas began to appear to one American painter after another as an arena in which to act— rather than as a space in which to reproduce, re-design, analyze or "express" an object, actual or imagined. What was to go on the canvas was not a picture but an event.
>
> The painter no longer approached his easel with an image in his mind; he went up to it with material in his hand

to do something to that other piece of material in front of him. The image would be the result of this encounter.

Richard Poirier points out in *The Renewal of Literature* that the terms "action" and "transition," both borrowed from Emerson, are also key ones in American Pragmatism, especially William James's version of it. Power surfaces in the movement, in James's words, "from one substantive conclusion to another." James might well be describing the transporting process of action painting. Or one key aspect of postwar American poetry. In *Alone with America,* Richard Howard characterizes his own diverse generation of poets (from A. R. Ammons to James Wright) in an Emersonian way as "the children of Midas, who address themselves to the current, to the flux, to the process of experience rather than to its precepts."

Harold Rosenberg's assertion about the deed of painting was partly inspired by seeing a screening of Hans Namuth's pathbreaking film of Jackson Pollock in the process of creating a painting. Thinking about painting as an expressive action, one turns inevitably to that moment in 1947 when Pollock began to lay a bare canvas on the floor of the converted barn that served as his studio on Fireplace Road in Springs, Long Island. Pollock started using sticks and trowels, rather than the more traditional brushes and palette knives, to drip and pour, to spot and dribble, to loop and swirl, to fling paint directly onto the canvas. He was seeking a more visceral and spontaneous contact with his own work, to participate in it physically to an unprecedented degree, almost to inhabit it. He severed contact between the brush and the canvas, and thus ended up almost drawing in air, liberating the artistic gesture and thereby painting more impulsively—or so he hoped—from the unconscious. There is an element of psychic automatism in this process, though Pollock always insisted he controlled the flow of the paint, the color and line. Unlike the Surrealists, he discounted

the workings of chance and downplayed the value of accidents. "This is not automatism or self-expression but insight," Frank O'Hara asserted in a monograph on the artist, adding that Pollock was the "agent" of creative insight, his work the evidence. It is as if Pollock had set out to demonstrate, after Ibn 'Arabī, "One must control one's paint in a dream."

Pollock explained his process in the first (and only) issue of *Possibilities* (1947/49), edited by Robert Motherwell and Harold Rosenberg:

> My painting does not come from the easel. I hardly stretch my canvas before painting. I prefer to tack the unstretched canvas to the hard wall or the floor. I need the resistance of a hard surface. On the floor I am more at ease. I feel nearer, more a part of the painting, since this way I can walk around it, work from the four sides and literally be *in* the painting. This is akin to the method of the Indian sand painters of the West.
>
> I continue to get further away from the usual painter's tools such as easel, palette, brushes, etc. I prefer sticks, trowels, knives, and dripping fluid paint or a heavy impasto with sand, broken glass and other foreign matter added.
>
> When I am *in* my painting, I'm not aware of what I'm doing. It is only after a sort of "get acquainted" period that I see what I have been about. I have no fears about making changes, destroying the image, etc., because the painting has a life of its own. I try to let it come through...

Pollock trusted contact, painting by immersion. He called his studio "the arena." The composer Morton Feldman, who scored Namuth's film in the so-called Glass Sequence, termed Pollock "El Matador." ("And how we watched you, El Matador, waiting for the slaughter or the glory.") There was something both feverish and Zenlike about Pollock's creative process—it enacted

something of the bullfight, something of the dance. There was a risky, entrancing danger in the way he entered the zone of a painting. His color and lines flow all over the canvas and create an all-encompassing environment, a full field effect. He liked gyrating rhythms and courted delirium. Ecstasy and anxiety were two of his natural habitats, the twin poles of his practice.

Pollock listened obsessively to jazz, which makes sense since there is a volatile, improvisatory feeling to many of his finest multicolored canvases. Unlike his peer Willem de Kooning, whose paintings often radiate a sense of harmonious enclosure, Pollock's work creates a sense of vast, unending spaces, of imaginative boundlessness. The scale is majestic, even mythic. His paintings often seem to sail off the edge of the canvas. They have an urgent joy. Look at *Cathedral* (1947), which surges upward toward the infinite, and *Autumn Rhythm* (*Number 30, 1950*), which turns with a radiant seasonal energy, and *One* (*Number 31, 1950*), which stretches more than seventeen feet wide and feels heroic in its spaciousness, as does *Blue Poles* (*Number 11, 1952*), a continent of a painting.

> What we bring back is the sense of the size of it,
> Potential as something permanent is, the way a road map
> Of even the oldest state suggests in its tangled details
> The extent of a country in which topography and settlement
> Interrupt only at random into a personal view...

(Douglas Crase, "Blue Poles")

These highly American paintings—adamant, enlarged, totemic—evoke "a sense of limitless possibility," as Carter Ratcliff puts it, and for the first time give us "a pictorial equivalent to the infinite that spreads through Walt Whitman's *Leaves of Grass.*"

Pollock suffered a grave crisis, and his work subsequently took a dark turn from 1951 to 1953. He was at loose ends. By all

accounts, he resumed drinking after two years of abstinence, leaving his personal life in shambles. He was afflicted by a sense of having exhausted his previous techniques, his all-over strategies. And he had completed his project with Hans Namuth, which may have left him feeling both let down and glaringly exposed. (Namuth's photographs, as well as his two films, are still some of the most intimate and revealing documents available of a painter at work.)

Early in 1950, Pollock viewed an exhibition called "Black or White: Paintings by European and American Artists" at the Samuel Kootz Gallery in New York City. It showed black-and-white paintings by many of his contemporaries, including William Baziotes, Adolph Gottlieb, Robert Motherwell, Mark Tobey, and others. The exhibit helped spur Pollock into action.

Pollock had always relied heavily on thinning and thickening black lines, but now he dramatically upped the ante by eliminating all color from his work. He simplified his palette and rejected the counterweight of whiteness. Like Willem de Kooning, he let figuration seep back into his paintings, which many took as a betrayal of abstractionism, of Modernist principles, but these painters viewed as part of their expressive freedom as artists. "I've had a period of drawing in black," Pollock wrote his friend Alfonso Ossorio, "with some of my early images coming through." The result was a series of all-black paintings that Francis O'Connor has aptly dubbed "The Black Pourings."

The Black Pourings have the disturbing precision of a nightmare. They have the kinesthetic force of Pollock's pourings in color, but feel starker and more agitated. They are bitten by sorrow. Color has been thrown off as an encumbrance. The human figure returns to the work, but often in mutilated form, so that heads, faces, and limbs seem to emerge and recede through a tangled web of black lines. This is Goya as an American abstractionist.

Walking through a gallery of these paintings is like moving through a pervasive black dream, negative space. One is shadowed by secret faces, veiled after-images, lovers and warriors who seem to float up out of the collective unconscious (Pollock was once influentially treated by a Jungian analyst) and then dissolve back into nothingness. There are sacrificial victims. The reclining figure of *Number 14* made Frank O'Hara wonder "if she is not Cassandra waiting at night in the temple of Apollo for the gift of prophecy, as does the figure in *Sleeping Effort.*" There are malevolent female figures (*Number 18* and *Number 22*), reminiscent of de Kooning's women. There is a decapitated Roman head that keeps recurring, "its high, balding forehead and classical features bearing an unsettling likeness to the artist" (as one biographer formulates it). *Portrait and a Dream* seems to be a dark marriage portrait, love as a black extinguished fire.

Pollock had let loose black lines and shapes—figures, demons—that he could not entirely contain or control. They had a mind of their own. The dancer and choreographer Karla Wolfangle recognized this in her piece *Pollock Dances,* performed at the Merce Cunningham Studio in New York City in May 1992. Wolfangle was inspired by Pollock's dancelike intuition that his work was "energy and motion made visible." In her piece, as she explains in a choreographer's statement, five main colors—silver, red, orange, yellow, and green—are embodied as five dancers. Pollock summons and controls them as he moves through space over his canvas, much as he was seen to maneuver in Namuth's films. But the final color is different:

> The last color to emerge is black. It is Pollock's alter ego, a force he cannot control. Instead, it controls Pollock, taunts him, confuses him, and leaves him to destroy himself.

In the last segment of the dance, the colors return and dance triumphantly "in squiggles and splashes of movement interspersed

with long loopy lines." They have the moving grace of *Autumn Rhythm*.

Many artists and critics have considered the sequence of Black Pourings to be an anticlimactic falling-off from the high drama of the "drip" paintings, but I find them courageous in their determination to face down the demons. Pollock was held in the grip of the images in the black paintings, but he wasn't destroyed by them. These works are confrontations with darkness. What finally do they exhibit? "It is the darkness of introspection, self-encounter, sorting out," Francis O'Connor affirms. "It is the dark night, the undersea journey, the working through of depression. It is the facing down of the dark presences in the psyche, separating oneself from them, and re-uniting oneself in a more positive relationship to oneself and others."

It is a form of symbolic renewal. A struggle with one's medium and oneself. Painting with duende.

Light reversed itself. And black was born.
RAFAEL ALBERTI, "BLACK"

Paint It Black

THE ABSTRACT EXPRESSIONIST painters, so named because of their dual commitment to Modernist abstraction and expressive feeling, showed an ongoing interest in exploring the possibilities of black paint. It was the dark underside of their zeal for color. They brushed black lines onto raw canvas with wide strokes and sweeping gestures; they stained black paint onto blank surfaces that seemed to stretch open like empty fields. These painters sought to create in their work a sense of tragic sublimity and of transcendental awe and dread. They painted on heroic scales. They employed black as the dramatic ground of their spiritual longings and aspirations.

Salvador Dalí once told Franz Kline that his black-and-white abstractions were related to Saint John of the Cross, "the poet of the night." Dalí's perceptive remark applies equally well to a whole generation of painters. It fits Clyfford Still's jagged black walls, Ad Reinhart's squares that seemed stunned into silence, and Adolph Gottlieb's explosive "Bursts." Willem de Kooning's nearly all-black abstractions of the late 1940s tapped a collective postwar mood of existential despair. A high-jinks anxiety permeates them. Barnett Newman's breakthrough black-on-black painting *Abraham* (1949), which stands nearly seven feet tall and three feet wide, evokes the sacrifice and tragedy of the father, the sadness of the first patriarch. A long, shiny black stripe—what New-

man termed a "zip"—cuts and divides the matted surface and gives the painting a strongly split and vertical feeling, which is part of its struggle and elegiac grandeur. Black also permeates the atmosphere; it embodies the dark night of the soul in Newman's majestic series *The Stations of the Cross* (1958–1966), where it becomes the color of agony and release.

Mark Rothko's marooned black shapes float like bodies in space and seem to bleed at the far edges. He was inclined to speak of his paintings in a Frostian way as "dramas," and considered the shapes as "performers." They stand like somber actors in a ritual drama, a Greek tragedy. They do not seem serene, but intimate, anguished, violent, and fateful. "They are the breath of a vision, scarcely more than a breath, an existential stain," Stanley Kunitz writes, "a glimpse, a memory, perhaps, of an archetypal simplicity and grandeur: 'Shapes of things interior to Time, Hewn out of chaos when the Pure was plain.'"

Rothko's darkest paintings have the aura of the sacred, the immanence of a revelation, the promise of a secret that is always just about to be disclosed. They testify with the hushed eloquence of religious silence. Both Newman and Rothko were Jewish, and their abstract evocations of the sacred fit the traditional Jewish proscription against graven images. Rothko insisted in an address at the Pratt Institute in 1958—his last public statement—that the artist must have a "clear preoccupation with death," that "all art deals with intimations of mortality," and that "tragic art, romantic art deals with the fact of man born to die." These ideas were infused into all his late mural series.

Nowhere is this spiritual quality more evident than in *The Rothko Chapel,* an octagonal building that stands between the University of St. Thomas and the Menil Collection in Houston. The building itself, originally projected by Philip Johnson but then altered and completed by Howard Barnstone and Eugene Aubry, is so unprepossessing that it comes as something of a

shock to step through the low entrance with two black wooden doors, move quickly through the small, nondescript foyer, and suddenly find oneself in a dimly illuminated space, a chamber of Rothko paintings, with a moody, disturbing splendor.

Rothko spent three years, from 1964 to 1967, in an arduous struggle to create the fourteen large murals that now surround the viewer, in the ecumenical religious space that bears his name. He told Dominique de Menil, who commissioned the chapel, that the concept of an eight-sided building was inspired by the octagonal eleventh-century baptistery of Santa Maria Assunta on the island of Torcello, near Venice. The American chapel has been stripped of any Christian iconography but bears the weight of an old mystery, "the holy hush of ancient sacrifice." In his definitive book on the chapel, Sheldon Nodelman has also suggested that the imposing scale and floor-to-ceiling height of the paintings, the explicit contrast of their dark tones against the lighter walls, "invested them with an architectonic tension reminiscent of lithic ensembles—of the standing stones of Stonehenge...or the Doric temples at Paestum." Rothko was terrifically moved when he first visited Paestum, and, as Dore Ashton recalls, when he was asked by Italian tourists if he had come to paint the temple had replied, "I have been painting Greek temples all my life without knowing it."

The mood Rothko sought to create is somber. There are five enormous paintings on five walls, a triptych on each of the two long side walls, and a triptych comprising the front apse. The triptychs evoke the primitive magic of the number three, an echo of the trinity. All the paintings have a dark red or plum ground, a wine-colored feeling. Seven are monochromatic—Rothko's first monochromatic works—and thus the thickly textured ground is all. The surfaces are dark and atmospheric. The other seven paintings have large black interior rectangles superimposed on their sustaining ground. These shapes push out at the edges and fill up most of the surface, thus creating the feeling of an enor-

mous, unfathomable darkness. Since these stand on the side walls
and the back wall, the viewer feels that darkness encroaching
from the sides and from behind. It is engulfing, absolute. There
is also an incipient confrontation between the lone black-figure
panel that stands on the entrance wall and the luminous triptych
that glows from the front of the room in the apse. In the manner
of an Italian Renaissance painter, the aging Rothko had his assis-
tants apply the ground in these works, but he painted the flat, se-
vere, hard-edged black shapes himself and thus, as his biographer
James Breslin has pointed out, "these impersonal forms were the
only ones painted personally by Rothko." He had a special feeling
for the blank obliterations of the color black.

The chapel paintings radiate a dramatic spiritual presence
and seem to interact with each other, as well as with the viewer
who sits with them for any length of time. One almost feels a se-
cret relationship forming, a kind of nonverbal interior dialogue
between the large-bodied paintings—between, say, the troubling,
murky, radiant maroon canvases, and the impenetrable black
shapes, which are as absolute and unforgiving as nothingness, or
the divine.

Over the years, countless visitors have been affected—some
deeply troubled, some keenly solaced—by these insubstantial pres-
ences that surround them in the changing ministerial light. They
put one in mind of last things. As Robert Rosenblum proposes:

> It is as if the entire content of Western religious art were fi-
> nally devoid of its narrative complexities and corporeal im-
> agery, leaving us with the dark, compelling presences that
> pose an ultimate choice between everything and nothing.
> But the very fact that they create their own hierarchy of
> mood, shape, and sequence, of uniqueness and duplication,
> of increasingly dark and somber variations of plum, ma-
> roon, and black, suggests the presence here of some new

religious ritual of indefinable, yet universal dimensions. And in our secularized world, inherited from the Romantics, a world where orthodox religious ritual was so unsatisfying to so many, the very lack of overt religious content here may make Rothko's surrogate icons and altarpieces, experienced in a nondenominational chapel, the more potent in their evocation of the transcendental.

In his piece *Rothko Chapel* (1971), Morton Feldman so deeply captures the spirit of an abstract Modernist space infused with an ancient religious feeling that the work seems inhabited. "I envisioned an immobile procession not unlike the friezes on Greek temples," he said. Feldman creates a musical equivalency for the solemn, encircling grandeur of Rothko's chamber, a ritual space that evokes the longing and the tragedy of human spirituality. Rothko found a way to pursue religious experience in a secular world. His is a mysticism beset by doubt. Yet sit in that chamber long enough and you, too, may start to hear a repressed music silently welling up in the dim light: the muted tones of plainsong, the solemn processionals of a Greek temple, the gravely beautiful melodies one associates with Jewish synagogues.

Rothko's mural paintings are energized, even inhabited, by the impending presence of death. They are late works. He committed suicide before the chapel was completed, and thus never lived to supervise the installation and lighting, or to experience the hollow space he had created. He told the film director John Huston that he was painting "the infinity of death," or, more precisely, "the infinite eternity of death."

Ancient auras, modern nuances. Something Modernist, but also oddly American. Certainly, something about the stark drama of black and white "colors" suited the sensibility of a group of American abstract painters who came into their own and developed their trademark styles after what many felt was the apoca-

lypse of World War II, and during the heyday of film noir (a French term coined only in 1946). "Noir has deep taproots in American urban culture," Nicholas Christopher explains in his book on the subject: it is "an utterly homegrown, American phenomenon":

> We might say it is the dark mirror reflecting the dark underside of American urban life—the subterranean city— from which much crime, high and low culture, raw sexual energy and deviations, and other elemental, ambiguous forces that fuel the greater society often spring.

The New York painters discovered that they could use black pigments to create a feeling that was sometimes infernal, sometimes transcendent. They entered a zone of black hues that was both boldly contemporary and richly archaic. Black fit the spirit of urban painters who also embraced a Modernist Primitivism: "The chemistry of the pigments is interesting: ivory black, like bone black, is made from charred bones or horns, carbon black is burnt gas," Robert Motherwell explained in a catalog note to the 1950 show *Black or White*. "Sometimes I wonder, laying in a great black stripe on a canvas, what animal's bones (or horns) are making the furrows of my picture."

Motherwell's Black

ROBERT MOTHERWELL HAD A Modernist sensibility and
a Romantic temperament. Intensely literary and international-
minded, philosophically inclined, he could also display an an-
guished sense of identity as a thinking painter, an artist-intellectual.
He countered by wooing spontaneity. He cultivated extremes of
feeling, the radical polarities of black and white without any in-
tervening middle tones or values, "an art," as he called it, "of op-
posite weights, and absolute contrast." He praised painting as "a
totally active act" and "craved the edge," as Dore Ashton has for-
mulated it, quoting Lorca: "His greatest fear: that it could be said:
'You have a voice, you know all the styles, but you will never
bring it off because you have no *duende.*'"

Motherwell had a strong affinity for French Modernist ideas
(from Baudelaire to Breton) and Hispanic culture. The major turn-
ing point in his work came in 1941, when he spent a summer in Mex-
ico under the wing of the Chilean-born Surrealist painter Roberto
Matta. (He said that in three months, Matta gave him "a ten-year
education in surrealism.") Matta introduced him to the process of
psychic automatism, the starting point for all his future work:

> The fundamental principle that he and I continually dis-
> cussed, for his palace revolution, and for my search for an
> *original creative* principle (which seemed to me the thing

lacking in American modernism), was what the surrealists called psychic automatism, what a Freudian would call free-association, in the specific form of doodling.

Psychic automatism offered Motherwell a means of counter-ing his will. Doodling thus represented for him "a process in which one's whole being is revealed, willingly or not." Later, after he read a useful book on the subject of children's art, he replaced the term "doodling" with the more accurate "artful scribbling," but the effect was the same. It was not a style, but a method that tapped deep roots and became a means of access, a way of getting to the authentic self, the preconscious. He liked Saul Steinberg's designation of it as "the brooding of the hand." This form of brooding liberated Motherwell to create his first significant paint-ings—from the oil *The Little Spanish Prison* (1941) to the collage-painting *Pancho Villa, Dead and Alive* (1943).

In the 1950s, Motherwell specifically linked Miró's type of doodling, his way of letting a picture find "its own identity and meaning in the actual act of being made," to Harold Rosenberg's notion of "action-painting." Miró himself often said that forms took reality for him as he worked. "Rather than setting out to paint something," he told James Johnson Sweeney in 1947, "I begin painting and as I paint the picture begins to assert itself, or suggest itself under my brush." It was a key move for Mother-well (and other American painters) to bring a figure like Miró into the mix. He was essentially drawing lines of connection, bringing together and rhyming a Surrealist principle of metamor-phic process, a Freudian idea of free association, and a home-made American aesthetic of action painting.

During the six months he spent in Mexico in 1941, Motherwell formed a relationship with the Mexican actress who would become his first wife, María Emilia Ferreira y Moyers, and befriended Wolf-gang Paalen, a prominent Surrealist residing in Mexico City who

gave him what he playfully called his "postgraduate education in surrealism." He was initiated into the Mexican light, which he connected to his childhood in prewar California and linked to his idea of the Mediterranean ("All ancient and prehistoric art is 'Mediterranean,'" he once claimed with knowing exaggeration). Most of all, he was gripped by the vitality of death in the Latin American country, the way it engulfed everything. A dead man in Mexico, it seems, is as alive as a dead man in Spain. As he later recalled:

> All my life I've been obsessed with death and was profoundly moved by the continual presence of sudden death in Mexico. (I've never seen a race of people so heedless of life!) The presence everywhere of death iconography: coffins, black glass-enclosed horse-drawn hearses, sigao skulls, figures of death, corpses of priests in glass cases, lurid popular woodcuts. Posada...and many other things—women in black, cypress trees in their cemeteries, burning candles, black-edged death notices and death announcements, calling cards and all of this contrasted with bright sunlight, white-garbed peasants, blue skies, orange trees, and everything you associate with life. All this seized my imagination.

The omnipresence of death marked Motherwell for life. It awakened a spirit in his blood and shadowed his work for the next fifty years.

Mexico became substantially real for Motherwell, but, at least at first, Spain was as much a country of the imagination as an actual geographic locale. It represented a dark Stevensian region of the mind. Long before he ever visited Spain, Motherwell created and exhibited a series of paintings named after Spanish towns: *Málaga, Cape la Gratta, Granada* (the first significant statement of what would become his primary forms), and others. One could argue that he painted most of his demonic black-and-white works, his most threatening presences, including his monumental series

Elegies to the Spanish Republic (1948–91), with a Spanish accent. Consider the savage energy of the *Iberian* series (1958–59), and the *Spanish Painting with the Face of a Dog* (1958), and the omnivorous black that covers virtually the entire canvas of *Bull No. 5* (1958), and the barbarous blacks of *The Spanish Death* (1975), and the nightmarish loneliness depicted in *Goya's Dog* (1985). "A twentieth-century American artist," he generalized from his own experience, "is closer to Goya than to the impressionists."

Motherwell liked to speculate that, generically speaking, there were six basic types or "families" of painting-minds. Different families rise to prominence at different historical moments. He suggested that, as far as he could tell, he belonged "to a family of 'black' painters and earth-color painters in masses," a group that included Manet, Goya, Matisse ("don't forget that his greatest color is black"), Miró, and sometimes Picasso. There is no question that he aspired to join this company of painters who used black as a color rather than a tone, who amassed it as a primary territory to explore.

Motherwell particularly recognized how black color has animated Spanish art, from the devastating paintings in the House of the Deaf Man to the large, torn shapes of Picasso's *Guernica*. He illustrated Rafael Alberti's book of poems *A la pintura* (*To Painting*), a celebration of painting dedicated to Picasso, and responded deeply to Alberti's evocation of so-called Spanish black:

4

Spanish black: the five senses
blackened:
black sight
and black sound,
black smell
and black taste; and the painter's black,
black to the touch.

He especially admired the way that *Guernica* expressed Picasso's outrage, *as an individual,* over the Spanish civil war, and likened it to the fury that powered Goya's *Los Desastres de la Guerra.* Picasso's example, the way he *willed* a retention of social values and forged a connection with public events, fueled one of Motherwell's own projects, impelling the moral indignation and sadness that drives his *Elegies to the Spanish Republic.*

Spain was Motherwell's particular vehicle to a tragic art. One breakthrough work, the large version of *At Five in the Afternoon* (1949), which stands as a dramatic prelude to the *Elegies,* takes its title from the line so memorably repeated in the first section of Lorca's "Lament for Ignacio Sánchez Mejías." The heavy ritual tread of the Spanish poet's opening section is like a funeral march. It has a sacred rhythm. Motherwell captures something of the foreboding liturgical cadence in his large black forms—heavy oval and vertical shapes—sweeping processionally across the canvas. He said later that he felt as if he were building a temple:

> The "temple" was consecrated to a Spanish sense of death, which I got most of from Lorca, but from other sources as well—my Mexican wife, bullfights, travel in Mexico, documentary photographs of the Mexican revolution, Goya, Santos, late Hispanic interiors.

Motherwell was drawing upon his fund of Mexican experiences in his quest for a visual equivalent to Lorca's lamentation and the feelings it evoked.

At Five in the Afternoon was a prelude to the *Elegies,* exhibiting a darkness that would preoccupy Motherwell on and off for the rest of his life. A Spanish postcard of Sánchez Mejías became his most prized souvenir, though Lorca's poem had a symbolic resonance for him far beyond the death of a single matador; it evoked "the death of Spain." Motherwell was twenty-one in 1936 when the Spanish civil war broke out, and it represented for

him, as for so many others, the death of idealism. He mourned those who were lost to the war, but he also mourned the loss of social hope, of a collective ideal. The Spanish civil war occupies an equivalent place in Philip Levine's poetry.

Motherwell compared painting the *Elegies* to building an altar, which is to say he considered it a sacred act. What began as "artful scribbling" took on a grave religious aura even as it suggested a larger public statement. The *Elegies* placed Motherwell's work under an international sign. They gave him a way to honor his dual commitment to abstraction and to feeling. They reminded American painting of the contradictory historical forces operating in the twentieth century. "To make an Elegy of Spain / is to make a song of the abyss," Barbara Guest declares in a poem dedicated to Motherwell, "All Elegies Are Black and White." "Black of this land of eternal black," Alberti cries out, "Oh black wall of Spain!" These paintings evoke bitter dreams. They are signs of devotion to a lost cause.

The *Elegies* represent the inverse side of Motherwell's pursuit of brilliant colors in his other paintings. They embody the dark side of his imagination. He discovered in creating some of the first ones a template he would relentlessly pursue: black oval shapes offset and balanced by black vertical shapes painted against a flat white background. Ovals trapped between verticals, egg-shaped bodies squeezed between stiffened boards. Sometimes these shapes flow amorphously into each other; sometimes they are rigidly, even geometrically separated. The simple cutout shapes often give the paintings a collagelike (and hence Modernist) feeling. They come in different sizes, but the effect is singularly severe and monumental.

The shapes in these paintings carry in their bodies a sense of physical anguish, of love and death. They have great metaphoric power. They have been compared to buildings and megaliths, phalluses and wombs, bull's testicles, the hide of Spain. They have

been viewed as metaphors for sexual intercourse. Sensuous and austere, they appear as protagonists in a tragic drama, endlessly coupled and opposed.

The Spanish civil war is never directly described in these works. All of Motherwell's paintings are suggestive, oblique, metaphorical. Thus the contest between pigments (the blacks that absorb light and the whites that reflect it) takes on the aura of an imaginative struggle between life and death—or so Motherwell viewed it. He believed that, in a Jungian sense, he had hit upon "an archetypical image."

"My *Spanish Elegies* are also free-association," he said. "Black is death, anxiety; white is life, éclat." This seems too schematic and allegorical, but it does point to the way that the stark blacks give the paintings a sense of demonic undertow, the whites a clarifying light. Sometimes the ovals seem to escape the enclosing rectangles; sometimes they feel crushed by them. The actors are intertwined; there is nothing between them. The canvas becomes the site of a silent contest, "a massing of black against white, those two sublime colors." A place of *ardent struggle, endless vigil.*

In a 1980 poem of homage, Rafael Alberti describes Motherwell's black as a "profound compact entered into with night." Painting as a pact with the night mind, the night world. A descent into the dark night of the soul. A journey. "I can enter you black dissolved in tears," Alberti writes, "Through black emerge purified."

The postwar American painters treated making art as a form of exorcism, an act of dark sublimity. They found a way to inscribe bodies in space, to create visual rhythm through black and white pigments. Their work has the grandeur of an American optimism that has been defied and challenged. They created night songs of improvisation. Their work is filled with descents and ascents, deaths and entrances.

Deaths and Entrances

TO MOVE FROM AMERICAN painting to American dance in the 1940s is to find a strong equivalency. One emblematic example is in how the duende rises through the irrational splendor of Martha Graham's 1943 ballet *Deaths and Entrances,* which takes its title from a Dylan Thomas book but is based on the three Brontë sisters and their relationship to the wild spirit of the moors. It is an American dance with a British overlay. The irreal frenzied piece, filled with a fervor that verges on unintelligibility, uses ten dancers to personify the memories and fantasies of three women Graham termed "doom-eager." The dance premiered in New York City on December 26, 1943, at the 46th Street Theater. It has an eerie, demonic force. In his *New York Times* review, John Martin, a champion of modern dance, said that it was "ununderstandable" through "the usual organs of understanding" and that it "slips in sensory perceptions." Edwin Denby called it "a poem in the associative or *symboliste* technique, a sequence of tightly packed and generally violent images following a subconscious logic." He also noted that it was Graham's own performance that gave the piece an intense focus "in which one sees this irrational world as a real experience."

Graham was herself one of three sisters, and, indeed, the three female leads (originally played by Jane Dudley, Martha Graham, and Sophia Maslow) were much closer in temperament to Graham

and her siblings than to Charlotte, Emily, and Anne Brontë. It seems that Graham was exploring the interrelationships of her childhood and adolescence. She was also confronting at an acute angle the social confinements and imprisoning roles that confront a headstrong, ardent, and artistically minded young woman.

Many observers have suspected a secret autobiographical impulse driving Graham's agitated and furious performance as Emily Brontë. (If ever there was a British novel saturated with duende—with dark Celtic ferocity and untamed earthly passion—*Wuthering Heights* is it.) In an interview forty years after the ballet's debut, Graham herself called *Deaths and Entrances* "a modern psychological portrait...of women unable to free themselves of themselves to follow their hearts' desires. The most powerful solo goes to Emily, the Brontë who could write: 'And visions rise, and change, that kill me with desire.' "

Ernestine Stodelle provides a useful summary of the essential setting—the emotional through-line—of the piece:

> Three women—one in black, one in gray, one in brown—sit on one side of the stage around a low table strangely resembling a sliced-off tree trunk. They move with jerky, nervous, angular gestures. The One in Brown (Charlotte) seems to be possessed by a brooding misery; the One in Gray (Anne), by a sense of frustration as though she is seized by the feeling that her young life is being wasted away; the One in Black (Emily), the oldest, implacably bitter, seems to have claws of steel.

Deaths and Entrances forays into the past. It was the first dance, as Deborah Jowitt points out in *Time and the Dancing Image,* in which memory played a fundamental, even constitutive role, for almost all the central dramatic actions and feelings are revealed through the imaginative landscape of Emily Brontë, who stands on the threshold of a violent crisis, possibly on the verge

of madness itself. As a choreographer, Graham had to invent, deploy, and stage a method of projection, since so much of what happens takes place within Emily's mind. Her decisive strategy: the three sisters split off into three adults and three children, who view each other across the impassable gulfs of time. The women look back on themselves as girls (called "The Remembered Children") who appear downstage as incarnations of their earlier selves.

> Three children enter...One carries a large conch-shell. She places it on one of two small altar-like constructions on the opposite side of the stage. The sight of the shell nostalgically evokes scenes of carefree play. The children dance with a strange, compulsive abandon. Then the vision fades, and the One in Black is overwhelmed with morbid longing.

The men Emily loves enter and leave the stage not at their own behest, but as they are summoned up and willed by the main character's thoughts, her abiding memory. A goblet stirs up a Proustian recall of first love, and three young men, dressed as for a formal ball, sweep up and embrace the sisters. But the scene darkens with the memory of a fourth man, a lost love, the Heathcliff figure deemed The Poetic Beloved. Graham successively falls backward across the stage until she ends up once more grouped with her sisters around a truncated table, which has a single red chess piece on it. They have come together in their isolation.

The sisters enter into a kind of endgame. The erratic and antagonistic gestures of the two younger siblings soon infuriate the One in Black into paroxysms of rage, a growing fury. Madness starts to consume her. "In one climactic solo," as Jowitt acutely describes it, Graham

> seems to be shuddering herself to pieces. As the dance begins, she is about to move a chess-piece; at the end, as her sisters stare amazed, she triumphantly places a goblet on the

board. Since the goblet has been established as a resonant symbolic object, it's as if she's laying her soul on the board to triumph or be checkmated. In between these moments, her imagination roves through her past, as in a cinema flashback; the journey is interior, fantastic, transformed by recollection.

At the apex of her frenzied dance, the One in Black abruptly stops moving, gathers herself together, and regains control. When she puts the goblet on the table in one elegant, decisive movement, the game is at last concluded. Peace has been restored, destiny accepted, fate embraced.

"Tonight in *Deaths and Entrances*," Graham confessed in one of her notebooks, "while standing, I suddenly knew what witchcraft is—in microcosm—It is the being within each of us—sometimes the witch, sometimes the real being of good—of creative energy—no matter what area or direction of that activity."

Graham's dancing in *Deaths and Entrances,* as in *Letter to the World* (1940–41) and *Appalachian Spring* (1944), has deep undertow: an unrivaled openness to experience, an uncalculated ferocity, what Arlene Croce calls "that mysterious spiritual force that appears to arise from the discipline of Graham technique." It externalizes an inner search, a primordial quest that is somehow both austere and resonant, archetypal and modern.

In a revisionist essay from a feminist perspective, "Women Writing the Body: Let's Watch a Little How She Dances," Elizabeth Dempster points out that modern dance has often been labeled and even condescended to as "terrestrial" (floor-bound, inward-looking) in negative comparison to classical ballet, which is so much more vertically open and aerial. But what has been perceived as a weakness may also be considered a strength, a conscious inversion of classical ballet. In a way, Graham offered a

counterperspective to the American classical ballet George Balanchine was so superbly re-envisioning and re-creating.

In 1944, for example, Balanchine praised the way that American dancers—Allegra Kent and Suzanne Farrell would become the prototypes—could express "clean emotion angelically...a quality supposedly enjoyed by the angels, who, when they relate a tragic situation, do not themselves suffer." This speaks to brilliant technique and unearthly musicality, an emotion distanced and expressed, imbued with aerial or spiritual knowledge. But there is another kind of knowledge that wells up from under the dance floor with a darker undertow. It is less angelic, more anguished and Dionysian. The terrestrial force—its very earthiness—can give a particular modern dance a convulsive downward strength and consequent transforming power, even an agonized uplift and affirmation, as in *Deaths and Entrances*. The pressure exists in the violent falling, in the gravitational pull downward. And yet, as Graham herself stressed, "the dancers fall so that they may rise."

Ancient Music
and Fresh Forms

ONE FUNDAMENTAL SIDE of the American spirit is radically affirmative, and it is perhaps for this reason especially that the duende enters American art when what Emerson calls "the optative mood" turns into a struggle to be reborn, to save one's soul. ("Walt! We're downstairs, / even you don't comfort me," John Berryman cries out in his late poem "Despair," "but I join your risk my dear friend & go with you.") Indeed, duende has something to do with *soul,* with an art that deepens with so much black feeling, so much humanity, that it needs to break loose into fresh form—an art that would transfigure suffering, that would surpass itself. Soul is a very close parallel to duende, whether in Slavic or Motown music, because of its openness to deep emotion, its receptivity to emotional thinking. "All intoxication arises from the depths of life which have become fathomless because of death," Walter Otto explains in his book *Dionysus: Myth and Cult.* "From these depths comes music—Dionysiac music—which transforms the world in which life had become a habit and a certainty, and death a threatening evil."

Lorca often heard the duende breathing at the heart of folk music—in medieval Spanish ballads, in the prototype of the Gypsy *siguiriya,* and in other forms of deep song. It is a spirit one hears in his poems when he takes the measure of flamenco gui-

tarists—a spirit one also hears in Janáček and Bartók and sees in the paintings of Klee and Picasso.

Lorca said that deep song "comes from the first sob and the first kiss." He insisted that the duende favors ancient music and fresh forms, and he heard it singing at the blue daybreak—in the dusky flowering garden—of the Spanish lyric:

> In the garden
> I will die.
> In the rosebush
> they will kill me.
> I was going, Mother,
> to pick roses,
> to find death
> in the garden.
> I was going, Mother,
> to cut roses,
> to find death
> in the rosebush.
> In the garden
> I will die.
> In the rosebush
> they will kill me.

> (*Deep Song*)

The duende that Lorca finds in the simple compulsive rhythms and repetitions of this song, in its eerie fatalism, is a spirit that one hears refigured, transformed to another key, in country blues. It reverberates in the emotional lyrics of Son House and Charley Patton and Howlin' Wolf. In "Introduction to Flamenco," his first published music essay (1954), Ralph Ellison connected flamenco, the appealingly hybrid music of Spain ("a unique blending of Eastern and Western modes"), with the feeling in the blues,

early jazz, and spirituals. "Perhaps what attracts us most to flamenco, as it does to the blues," he said, "is the note of unillusioned affirmation of humanity which it embodies." Ellison compared the Gypsies to the slaves, "an outcast though undefeated people who have never lost their awareness of the physical source of man's most spiritual moments," and he asserted that

> In its more worldly phases the flamenco voice resembles the blues voice, which mocks the despair stated explicitly in the lyric, and it expresses the great human joke directed against the universe, that joke which is the secret of all folklore and myth: that though we be dismembered daily we shall always rise up again.

In another piece, Ellison also compared the flamenco singer Pastora Pavón, *La Niña de los Peines,* to the gospel singer Mahalia Jackson. He ranked them with Lorre Lehmann and Marian Anderson, with Madame Ernestine Schumann-Heink and Kathleen Ferrier. "They are the sincere ones," he said, "whose humanity dominates the artifices of the art with which they stir us, and when they sing we have some notion of our better selves." One recalls, too, that intense moment in *Invisible Man* when an old black woman sings "a spiritual as full of weltschmerz as flamenco."

In his lecture on duende, Lorca calls the Andalusian Pavón a "dark Hispanic genius whose powers of fantasy are equal to those of Goya or Raphael el Gallo" (*Deep Song*) and tells of a time when she was singing without success in a small tavern in Cádiz. She played "with her voice of shadow, of beaten tin," as Lorca describes it, but she got absolutely no response from the audience when she was finished. She was greeted by total silence until someone sarcastically murmured, "¡Viva París!," which Lorca interprets to mean that in Cádiz they care nothing for "ability, technique, skill," but seek something else, something deeper. What he describes next tells us everything about his aesthetic values:

As though crazy, torn like a medieval weeper, La Niña de los Peines got to her feet, tossed off a big glass of firewater and began to sing with a scorched throat, without voice, without breath or color, but with duende. She was able to kill all the scaffolding of the song and leave way for a furious, enslaving duende, friend of sand winds, who made the listeners rip their clothes with the same rhythms as do the blacks of the Antilles when, in the "lucumí" rite, they huddle in heaps before the statue of Santa Bárbara.

(Deep Song)

Lorca's point is that the Andalusian master had to "rob herself of skill and security, send away her muse and become helpless, that her duende might come and deign to fight her hand to hand. And how she sang!"

The voice that Lorca characterizes as "a jet of blood worthy of her pain and her sincerity" sounds like a description of Billie Holiday singing the lynching song "Strange Fruit," which she clinches and attacks with electrifying agony. Or change the gender and it sounds like Robert Johnson, the Gerard Manley Hopkins of the blues form, who sang with so much feverish spirit. The dichotomy between Eros and Thanatos, love and death, and the tension inherent in that dichotomy, burns through his music.

The scorched voice of the duende was assuredly present in a warehouse in the business district in Dallas on June 20, 1937, when a twenty-six-year-old Mississippi blues singer with just one more year to live recorded three songs that are his crowning achievement: "Stones in My Passway," "Me and the Devil Blues," and "Hell Hound on My Trail." The weird demons are loose and walking the open road in these songs. Robert Johnson had a wonderfully lonesome, high, tragic voice, an aching sound, a dramatic falsetto that could turn into a lost and broken howl, and a way of playing the guitar so that it let off a series of shivering vibrato

shocks. When he sings "Stones in My Passway," the strings of the guitar, which is tuned in "Spanish" (an open "G"), echo the words like a haunted twin, a frenzied chorus:

> I got stones in my passway and my road seems dark as night.
> I got stones in my passway and my road seems dark as night.
> I got pains in my heart—they have taken my appetite.

There is a spooky fatalism to the Faustian pact, the price paid for making the devil's music, in "Me and the Devil Blues," which he sings with a slow extremity:

> Early this morning when you knocked upon my door,
> Early this morning when you knocked upon my door,
> I said, Hello, Satan, I believe it's time to go.

(Greil Marcus suggests in *Mystery Train* that "the only memory in American art that speaks with the same eerie resignation is that moment when Ahab goes over to the devil-worshiping Parsees he kept stowed away in the hold of the Pequod.")

And there is a swirling Orphic restlessness, an alarming terror, a mad excitement, that seems to arise from "Hell Hound on My Trail" (the title may come from Francis Thompson's "Hound of Heaven"):

> I got to keep moving, got to keep moving
> Blues falling down like hail, blues falling down like hail
> Ummmmmmmmmm
> Blues falling down like hail, blues falling down like hail
>
> And the days keep on worrying me
> There's a hellhound on my trail
> Hellhound on my trail, hellhound on my trail

The words "got to keep moving" disrupt the blues form, displace the harmony, and weirdly twist the modulations awry. The notes really do seem to be raining down and assaulting the singer

"like hail." The rhythm is fateful, the mood frightened, even desperate. If only the singer could get away. And his voice sounds mortally worried, chased, infernally dogged by a hellhound that is ruthlessly tracking him down, that will never let him escape. These savagely delivered lines reverberate through the song like a series of shock waves. We have come to the tragic end—the emotional apex—of a tradition. "We have reached," as one listener puts it, "the ultimate, and scarifying, disintegration of the country blues."

The recording session continued on after Johnson finished this take, this onslaught of a song, but one feels as if the earth should have opened at so much beauty wrung from terror, which we are still just able to endure. There is more malleable joy in Lorca's duende—in his struggle—than in Johnson's doom-eager, doom-ridden songs which are magnetized downward. Yet, thinking about Johnson, one remembers how Lorca asserted that "deep song sings like a nightingale without eyes. It sings blind, for both its words and its ancient tunes are best set in the night, the blue night of our countryside."

America Heard in Rhythm

LORCA LIKED TO COMPARE American jazz to Spanish *cante jondo,* both of which, he said, had taken root in Africa. After listening to a lot of jazz musicians and blues singers in Harlem in 1929, he revised his version of his initial talk about deep song and declared unequivocally that "the difference between a good and a bad cantaor is that the first has duende, and the second never, ever achieves it." He also characterized duende as "a momentary burst of inspiration, the blush of all that is alive, all that the performer is creating at a certain moment."

Anyone who cares about jazz has felt the intoxications of a Dionysian American art form improvising from the depths. As Al Young writes in his poem "Jazz as Was":

> Hey, it's America heard in rhythm
> & enormous harmonies the color of October;
> swollen & falling, full of seedy surprises
> that make your hoary heart speed up
> and do double time between the born-again beats.

One feels the duende, for example, in the mood nocturne of Louis Armstrong's celebrated "West End Blues," which he recorded with the Hot Fives in 1928. Joe Oliver wrote the simple blues tune, which Armstrong completely transfigured into something one of his biographers, James Lincoln Collier, rightly calls

"Shakespearean," adding that it is "richly clothed, full of event, and rounded to a finish." The song opens with an unaccompanied trumpet solo introduction that has a sad, cascading, and majestic dignity. It takes a mere twelve seconds and consists of four notes that feel like a clarion call rising out of Armstrong's rough-and-tumble past, an orphanhood. This is followed by an odd kind of ensemble chorus, and then a chorus of trombone. In *Music in a New Found Land,* Wilfrid Mellers gives a helpful description of what happens next:

> After the first chorus, however, Armstrong does not play trumpet; instead, he scat-sings in duologue with clarinet. As his voice imitates the instrument, and the instrument imitates him, it is as though he is talking to himself in the quiet of the night; the music is, for Armstrong, relaxed, yet the intimate tenderness of the vocal-instrumental line makes it seem also frail and forlorn.

Collier calls the last chorus of "West End Blues" "almost certainly the most nearly perfect statement in recorded jazz." Near the end of the song, Earl Hines plays a fanciful piano reverie that is finally pierced by Armstrong's intensely long, high B-flat. He holds it for such a dramatically long time that the tension becomes almost unbearable. It feels like a plea, a blast of rude reality. Armstrong's piercing note recalls that moment in Whitman's "Out of the Cradle" when one of the two birds who had been singing together all the time suddenly disappears, unbeknownst to her mate, never to return:

> And thenceforward all summer in the sound of the sea,
> And at night under the full of the moon in calmer weather,
> Over the hoarse surging of the sea,
> Or flitting from brier to brier by day,
> I saw, I heard at intervals the remaining one, the he-bird,
> The solitary guest from Alabama.

Blow! blow! blow!
Blow up sea-winds along Paumanok's shore;
I wait and I wait till you blow my mate to me.

Everyone senses the duende in Charlie Parker's savage and tender alto solos, which are masterpieces of winged calling, of spontaneous creation. It reverberates through the slow bittersweet lament of "Parker's Mood," which has a nervously exacerbated blue passion, and in "Funky Blues," and in the ballad "Embraceable You." Parker performed and improvised on "Embraceable You" on many occasions, but there is nothing quite like the 1947 Dial session when, on the first take, he transformed Gershwin's original theme into something breathtakingly supple and soulful, thereby, in Gary Giddins's words, "turning the almost ridiculous into the absolutely sublime." "Music is your own experience, your thoughts, your wisdom," Parker once said: "If you don't live it, it won't come out of your horn." He awakened his duende, in Lorca's phrase, "in the remotest mansions of the blood" (*Deep Song*), and one feels it driving the adventurous pyrotechnics to something even further and stranger, something free-flying, forbiddingly solitary. One feels, to borrow Langston Hughes's title, the *Bird in Orbit*.

I hear the black sounds haunting the white wail of Art Pepper's alto sax, and the volatile moaning bass that Charles Mingus plays in the ensemble *Mingus Ah Um* (especially in "Better Git It in Your Soul"), and in the sounds of Miles Davis's trumpet, which has an aching, near-deathly purity. Davis offers a particularly compelling case, because he was the youngest member of the four musical architects who rebuilt jazz in the 1940s and never quite had the licks of the other three: Charlie Parker, Thelonious Monk, and Dizzy Gillespie. What he did have was a restless gift for innovation, a rockbed integrity, and something else ineffable. Davis loved the music of Spain, and there are times, as in *Sketches of*

Spain, when he tries to replicate the fluent wailing tone of Spanish folk song. The solo trumpet in his "Solea" from that album reverberates with the tragic quality of deep song or flamenco music itself—a deep soul cry now transplanted to the American city, to the modern urban world.

In an insightful portrait of Davis as "the moody potentate of jazz," the critic Kenneth Tynan introduced the concept of duende to the readers of *Holiday* magazine. "It has no exact English equivalent," he explained, "but it denotes the quality without which no flamenco singer or bullfighter can conquer the summit of his art." Tynan suggested that, for example, Laurence Olivier had this quality but Maurice Evans did not, that Marlon Brando had it but squandered it, that Ernest Hemingway showed it in spades but John O'Hara lacked it, that both Billie Holiday and Bessie Smith attained it but that Ella Fitzgerald never reached it. He concluded, "Whatever else he may lack, Miles Davis has *duende.*"

Davis turned from chords to modes as a basis for improvisation. The apogee of this modal approach—and one of the high points of collective improvisation—was reached more than forty years ago, in the spring of 1959, when the Miles Davis Sextet recorded *Kind of Blue* in two afternoon sessions (March 2 and April 22) at Columbia Records' 30th Street Studio, which had once been a Greek Orthodox church. There was a long foreground to Davis's preparation, but, as Bill Evans's liner notes famously asserted, "Miles conceived these settings only hours before the recording dates." Two recent books on the making of *Kind of Blue* (one by Ashley Kahn, the other by Eric Nisenson) make it clear how consciously Davis was guiding his musicians toward a certain haunting tone while also pushing them into an unprecedented spontaneity. "I didn't write out the music for *Kind of Blue,*" he later explained, "but brought in sketches for what everybody was supposed to play because I wanted a lot of spontaneity in the playing." The result was five songs—"So What," "Freddie Freeloader," "Blue in

Green," "All Blues," and "Flamenco Sketches"—consisting almost entirely of first takes. The performance has a ravishing simplicity. It gives maximum room for individual creative improvisation, for Cannonball Adderley on the alto, for example, and John Coltrane on the tenor sax to express themselves fully, while also knitting the sextet together into a singular texturally varied creation.

In seeking a rationale for the disciplined improvisation that culminated in the groundbreaking album, Bill Evans compared the creation of *Kind of Blue* to a Japanese Zen method of painting, an art that opens intellect to intuition and lets the spirit reign:

> There is a Japanese visual art in which the artist is forced to be spontaneous. He must paint on a thin stretched parchment with a special brush and black water paint in such a way that an unnatural or interrupted stroke will destroy the line or break through the parchment. Erasures or changes are impossible. These artists must practice a particular discipline, that of allowing the idea to express itself in communication with their hands in such a direct way that deliberation cannot interfere.
>
> The resulting pictures lack the complex composition and textures of ordinary painting, but it is said that those who see will find something captured that escapes explanation.
>
> This conviction that direct deed is the most meaningful reflection, I believe, has prompted the evolution of the extremely severe and unique disciplines of the jazz or improvising musician.

Evans is seeking an analogy, perhaps even a language, for the action of art, for the way that conscious control yields to a work entirely open to the moment.

Kind of Blue touches upon the deep mystery of creative process. It has a lasting soulful enchantment.

Hey, I'm American,
So I Played It

THE DUENDE ALSO ARRIVED on August 17, 1969, on a dairy farm ten miles outside Bethel, New York, when Jimi Hendrix played "The Star-Spangled Banner" on his electric guitar so that it reverberated across the fields with the gusto of an American childhood, with the patriotic memory of previous American wars, with the flaming sounds of an undeclared war going on halfway across the world. "The crying of the guitar / starts," Lorca writes in his early poem "The Guitar," a lyric of the Gypsy *siguiriya*:

> The goblets
> of the dawn break.
> The crying of the guitar
> starts.
> No use to stop it.
> It is impossible
> to stop it.

The guitar is crying for things far off. Here is the lively way that James McManus describes the performance in "Great America":

> he may as well be standing at attention
> as the notes whang and toggle, feeding back hard
> through the Marshalls. He's making it talk
> with a vengeance. The air cavalry's "rockets'

red glare" gets warped into painterly screeches,
onomatopoeia at Mach 1:7;
"bombs bursting in air" becomes blistering
napalm cacophony, hyperincendiary payloads
arcing down into inhabited jungle—as Beethoven
under these circumstances might have rendered
this hijacked, underwonderful hymn to Anacreon,
inventing outlandish contrapuntal alignments
and vertical tone combinations, most likely hammering
away through a Fuzz Face on a Rickenbacker twelve-string
or a Synclavier ll suitably retooled by Rog Mayer....
As "proof through the night that our flag was still there,"
Hendrix, deadpan, interpolates George M. Cohan's
"Over there," flashing us back to another Great War's
gung ho vigor and shrapneled, Jim-dandy
aftermaths, then continues the martial motif
on "the land of the free and the home of the brave"
by making the Strat trill like bagpipes.

Couple more reverb-charged chords and it's over.
There's nothing much, really, to say. We're agog.

"Hey, all I do is play it," Jimi Hendrix told Dick Cavett a week or
so later on television. "I'm American, so I played it."

The vernacular note that Hendrix hits here—"Hey, I'm
American, so I played it"—is one that sounds often in the dark
pragmatism and personal agon of our literature (one hears it in
the understated title of William Maxwell's heartbreaking novel *So
Long, See You Tomorrow*). It brings to mind some strong con-
temporary poems about music, such as Philip Levine's "The
Unknowable," about Sonny Rollins practicing his sax—"wood-
shedding"—for hours on the Williamsburg Bridge, and Michael
Harper's "Dear John, Dear Coltrane" ("Coltrane was my Or-
pheus," Harper once said). It pulses, too, in the crying out of

Denis Johnson's *The Incognito Lounge,* which includes lines like these:

> The center of the world is closed.
> The Beehive, the 8-Ball, the Yo-Yo,
> the Granite and the Lightning and the Melody.
> Only the Incognito Lounge is open.
> My neighbor arrives.
> They have the television on.
>
> It's a show about
> My neighbor in a loneliness, a light,
> walking the hour when every bed is a mouth.
> Alleys of dark trash, exhaustion
> shaped into residences—and what are the dogs
> so sure of that they shout like citizens
> driven from their minds in a stadium?
>
> In his fist he holds a note
> in his own handwriting,
> the same message everyone carries
> from place to place in the secret night,
> the one that nobody asks you for
> when you finally arrive, and the faces
> turn to you playing the national anthem
> and go blank, that's
> what the show is about, that message.

We are encountering a moment of desperate musical self-questioning in our poetry, a moment when a quarrel with oneself also becomes a quarrel with one's country, when a personal duende somehow collides with a national spirit and explodes with a demonic democratic energy.

This is a detectable presence in Allen Ginsberg's "Howl," a poem that is a faithful, almost helpless witness, a prophet, of its

own demonic American spirit ("I saw the best minds of my generation destroyed by madness, starving hysterical naked..."). It is there, too, in "America" and "Kaddish." It violently broke loose in the 1960s and early 1970s when in the second phase of their work a number of American poets, notably influenced by Spanish language poetry, especially that of Lorca, Neruda, and Vallejo, and tormented by the war in Vietnam, turned with anguish to the so-called deep image, an image saturated with psyche that was both archaic and new, that concentrated inner and outer energies. The call went out, as Robert Bly put it in 1966, for "a poetry that goes deep into the human being, much deeper than the ego, and at the same time is aware of trees and angels." This is a poetry of what Charles Altieri calls "radical presence," which he characterizes as "the insistence that the moment immediately and intensely experienced can restore one to harmony with the world and provide ethical and psychological renewal." Examples include Robert Bly's *Silence in the Snowy Fields* (1962), James Wright's *The Branch Will Not Break* (1963) and *Shall We Gather at the River* (1968), W. S. Merwin's *The Lice* (1967), Galway Kinnell's *The Book of Nightmares* (1971), and Philip Levine's *They Feed The Lion* (1972). It is there in Denise Levertov's *The Sorrow Dance* (1966) and *Relearning the Alphabet* (1970), where an objectivist aesthetic is bent to social concerns and wedded to religious longings. It is present, too, in C. K. Williams's early work, which explores Vallejo's mode of disjunctive consciousness and, in the process, almost breaks apart with social rage. It almost sings in Gerald Stern's *Lucky Life* (1977). It slants through a central European consciousness in Charles Simic's *Dismantling the Silence* (1971). It takes on an odd elegance in Mark Strand's *Reasons for Moving* (1971) and Donald Justice's *Departures* (1973). It opens up in the first books of Garrett Hongo and Nicholas Christopher and Susan Stewart. It electrifies the anthology *Naked Poetry* and finds an ethnopoetics in *Technicians of the Sacred*. One remem-

bers how many stones and angels suddenly started to appear in our poetry at that time, but it was the duende that broke all the windows and shattered the bright panes of air.

The duende also swept into Robert Bly's polemical little anthology *Leaping Poetry* (1972), which clustered around the idea of "leaping," or rapid association. Bly adapted the ancient Chinese phrase "riding on dragons" to describe the "time of inspiration," the movement between worlds, between planes of thought. "This dragon smoke means that a leap has taken place in the poem," Bly says. "In many ancient works of art we notice a long floating leap at the center of the work. That leap can be described as a leap from the conscious to the unconscious and back again, a leap from the known part of the mind to the unknown part and back to the known." Bly also invokes Lorca's notion of duende to account for Spanish leaping, the ecstatic widening of association. He recognized the elation that comes to a poem when death is present in the room. In his anthology Bly had touched on something extraordinary in poetry, albeit at great sacrifice to the powers of the rational intellect. Yet he was only following the lead of Lorca's essay on duende: "But intelligence is often the enemy of poetry," the Spanish poet declared, "because it limits too much, and it elevates the poet to a sharp-edged throne where he forgets that ants could eat him or that a great arsenic lobster could fall on his head" (*Deep Song*).

Lorca identified the genuine danger of the overly rational intellect, but he also risked a deep anti-intellectualism in doing so, one to which American culture is especially prone. Let us add to the mix Joseph Brodsky's notion of poetry as accelerated thinking. Brodsky identified the capacity of art in general, and poetry in particular, to travel great distances with startling rapidity. "The one who writes a poem writes it above all," he said in his Nobel lecture, "because verse writing is an extraordinary accelerator of consciousness, of thinking, of comprehending the universe." Poetry,

then, becomes a way in which the language fulfills itself and reaches its peak intensity, and art becomes a way of comprehending the world. The imagination is an organ of understanding. And the imagination needs all the faculties at hand, all the sensibility, all the conscious and unconscious intelligence it can galvanize to fulfill its luminous mission.

Fending Off the Duende

IT SEEMS CLEAR WHY certain artists want to fend off the irrational splendors of the duende, sometimes to the detriment of their work, but for the sake of their sanity. And yet, "One of the most notable characteristics of the poems of deep song," Lorca explained in a lecture of 1922, "is their almost complete lack of a restrained, middle tone." The duende shuns the middle way, and it avoids works of art that show too much emotional balance and tranquillity, feelings tamed entirely to reason, to so-called common sense, which is why it shows up in certain neoclassical poets (such as Walter Savage Landor and Louise Bogan) only when it feels the demonic undertow tugging at their forms, the beating wing of madness passing overhead, the sense that, as the baroque Jesuit poet Tomasso Ceva put it, "Poetry is a dream dreamed in the presence of reason."

Yeats's characterization of Walter Savage Landor in *Per Amica Silentia Lunae* is to the point: "Savage Landor topped us all in calm nobility when his pen was in his hand," he said, "as in the daily violence of his passion when he had laid it down." Yeats is even more explicit in *A Vision,* where he describes Landor as "the most violent of men," who used his intellect "to disengage a visionary image of perfect sanity... seen always in the most serene and classic art imaginable."

One senses the rhythm and meter anticipating and trying to prevent the disorder in a range of highly formal modern American poetry, from T. S. Eliot's second book, neutrally entitled *Poems,* and Ezra Pound's "Hugh Selwyn Mauberley," both published in 1920, to Yvor Winters's strenuously didactic meters and John Crowe Ransom's New Critical ironies in the face of lavish death. (Like Thomas Hardy, his primary model, all Ransom's poems are death-haunted.) Holding texts, stays against ruin. One thinks of J. V. Cunningham, who early on announced that "Good sense and skill / Of madness cured me" ("For My Contemporaries"), but whose later work belies the claim. A demonic spirit unwillingly breaks through such witty, tormented poems as "Interview with Doctor Drink" ("I have a fifth of therapy / In the house, and transference there") and "Montana Fifty Years Ago," a lyric that by dryly yet poignantly reciting the external facts—the storied details—of a woman's life ("Gaunt kept house with her child for the old man / Met at the train") allegorically encapsulates a vanished time and place:

> Nothing was said, nothing was ever said.
> And then the child died and she disappeared.
> This was Montana fifty years ago.

Like Wallace Stevens, L. E. Sissman was Orpheus in a business suit—an advertising executive by day and a poet by night. A recent selection of his poems, *Night Music,* once more reminds us how his work was energized rather than deprived by the onslaught of Hodgkin's disease, an illness he recognized as "routinely fatal" ("Instead of a curtain falling, a curtain rose"); how his first book was charmingly entitled *Dying: An Introduction* (1968); how his wit was challenged and schooled by terror; and how his breezy, seemingly effortless epigrammatic couplets and flexible blank verse lines are weighed down by earthly observations, late knowledge, final illness.

Anthony Hecht's *The Hard Hours* (1968) is one of the books that first crystallized my thinking about how some works of art operate by struggling to fend off the duende. In this collection of modern crisis lyrics, a characteristically urbane, decorous, and stately manner comes up against two recurring dangers or threats: madness and history. The crisis generates from inside the self—the individual at the mercy of his own psychic traumas and wounds—but often that crisis (so severe as to amount to a kind of psychotic breakdown) is generated by a personal impotence in the face of overwhelming external circumstances and forces. American poets have often written as Emersonian individualists, as if the self were an imperial entity that can create and determine not only its own destiny but also history itself, yet in *The Hard Hours* the integrity of that self begins to disintegrate as it is invaded from the outside by forces much larger and stronger than it. Power is real; the individual is neither independent nor immune from the cruelty or authority of others. The self, the house of being, is physically and emotionally vulnerable, and experience is crippling. The Adamic poet has eaten the bitter fruit of history and fallen not only into Time, but also into the political realm of History.

Think of the parable of the Pole and the two Jews in "More Light! More Light!" It serves as the book's most bracing example of the way that "casual death" drains away the soul and barbarism dehumanizes its victims. Those victims are not even permitted a "pitiful dignity." The language of the poem is never allowed to take it over or run away with it—as in so many poems magnetized by duende. Rather, it is steady and neutral, even documentary, the outrage distanced, the riveting story told without much commentary:

We move now to outside a German wood.
Three men are there commanded to dig a hole
In which the two Jews are ordered to lie down
And be buried alive by the third, who is a Pole.

Not light from the shrine at Weimar beyond the hill
Nor light from heaven appeared. But he did refuse.
A Lüger settled back deeply in its glove.
He was ordered to change places with the Jews.

Much casual death had drained away their souls.
The thick dirt mounted toward the quivering chin.
When only the head was exposed the order came
To dig him out again and to get back in.

No light, no light in the blue Polish eye.
When he finished a riding boot packed down the earth.
The Lüger hovered lightly in its glove.
He was shot in the belly and in three hours bled to death.

No prayer or incense rose up in those hours
Which grew to be years, and every day came mute
Ghosts from the ovens, sifting through crisp air
And settled upon his eyes in a black soot.

In this bleak twentieth-century exemplum, heroism is unre-
warded and suffering is neither redemptive nor transcendental; it
doesn't signify. The Pole acts humanely (and without any sign
higher than his own conscience), and yet he suffers a death as
slow and brutal as that of his victims, the Jews who have already
lost their souls and now lose their lives, too. The dehumanization
is complete—even the guard is metonymically identified only as
his "Lüger." There are no mourners or saviors in this poem; there
is only the relentless stripping certainty of the death camps. The
Goethean ideal of light—"More light! More light!" was Goethe's
deathbed cry—has been replaced by the banal darkness of evil.
Humanism, like the Age of Reason, is dead. Civilization, repre-
sented by the shrine at Weimar, is effectively over.

There is a survivor in "Rites and Ceremonies." His is the ethic
of the solitary witness. He has "come home" from the camps, but

twenty years later he still can't forget a large room filled with human hair, nor a trainload of some five hundred people who are about to be "made into soap," nor the constant screaming of little children going to their deaths. He stands as a twentieth-century Job cataloging a series of unspeakable horrors and crying out in his anguish to "Father, adonai, author of all things." At night when he sets out to pray, he feels himself being sucked back into the ovens with the millions who "have come to this pass." Prayer is for him a reenactment of suffering. He is a tainted survivor whose afflicted testimony to an invisible God is one of the only memorials for the victims. He is akin to the patient in "Behold the Lilies of the Field" who is "made to watch" the worst atrocity imaginable, who can't turn away from the torture and whose only redemption (sanity) is in the excruciating attempt to find an adequate language for suffering. In their struggle to acquire a language equal to the cruelest extremities of experience, both of these narrators are stand-ins for the poet who is, after all, trying to write a civic poetry after Auschwitz and Buchenwald.

It is against a background of unbearable historical cruelty, of scapegoating and victimization, of compromises and conditions, that we understand how hard one must work to fend off and control what is terrifying and uncontrollable. The traditional ethic of *The Hard Hours*—its sometimes grave, sometimes slangy formal cadences—provides a conscious way of staying the dangerous irrational. Madness is held off; sanity—at least momentarily—triumphant.

Samuel Johnson is a mountaintop example of a writer whose work is energized by the battle between an overriding common sense and an underlying demonic fury. Johnson called madness "the heaviest of human afflictions" and showed, as his biographer W. Jackson Bate expresses it, "a powerful unconscious need to release nervous tension through order, pattern, or rhythm and keep it from overwhelming the psyche—a need to 'divide up' the welter of

subjective feeling and reduce to manageable units." Bate argues that Johnson, who had suffered a breakdown in his twenties, was constantly on the verge of a nervous collapse for at least a three-year period beginning in 1764. He tells the story of a young artist who went to meet Johnson in his rooms and was so discomfited by the silence at the beginning of their visit that he decided he was in the presence of a "madman," until at last Johnson began to talk and "faith…everything he says is as *correct as a second edition.*"

Johnson was terrified that all of his ills were truly "in his head" and once said, "Of all the uncertainties of our present state, the most dreadful and alarming is the uncertain continuance of reason." It is as if the fear of insanity, as well as the need to keep a ferocious grip on logic and reason, drove much of the poignant stoicism of Johnson's work. It also fueled his late prodigious intellectual achievement—his law lectures, his political pamphlets, a new edition of his *Dictionary,* and, especially, the fifty-two *Lives of the English Poets* that are among the triumphs of English critical prose.

It is the hard-fought battle with the duende through formal means, in a formal arena, and not any metrical formulations, that powers such classical and obsessively rational work, from Horace to Paul Valéry, who extolled the pleasures of pure intellect, extreme rationality, and denied the value of enthusiasm for creative concentration. Valéry preferred a state of cool calculation. By contrast, the supremely ironic Byron felt the opposite way and testified to the necessary cathartic release, the power of "enthusiastic" writing. "It comes over me in a kind of rage every now and then," he said, "and then, if I don't write to empty my mind, I go mad." He universalized the experience into a characterization of poetry itself. Poetry, he said,

> is the lava of the imagination whose eruption prevents an earth-quake—they say poets never or rarely *go mad*…but

are generally so near it—that I cannot help thinking rhyme
is so far useful in anticipating & preventing the disorder.

A highly formal and traditional work deepens immeasurably
when one feels the primal murkiness threatening to swell up
underneath the geometric clarity, the verbal concision, and the
ironic wit. The ancient demons are never far from shore. They
dwell within the deeps. They move in the ghostly mists. A highly
rational art is especially haunting when one feels the struggle *in*
the thought, or even underneath the thought; when one senses
something dark welling up from below, from the primordial mud;
when one recognizes the powerful internal pressure of a mind de-
fending itself against itself.

The Existentialist
Flatfoot Floogie

IT IS WORTH UNDERLINING that there is an authentic American art that doesn't have or seek duende, that lives finely within its means and limits, and thereby contributes to our artistic health, to the health of our republic. Think, for example, of William Meredith's scrupulous, gladdening poems (our national discourse would be a lot more civilized if every citizen had a copy of *The Cheer*), or of Richard Diebenkorn's lush, Matissean, light-filled California paintings, or of Ella Fitzgerald's clean, touching versions of songs from Rodgers and Hart musicals. Hayden Carruth makes something like this point with tender eloquence, with a rare spirit of his own, in his heartening homage to Benny Goodman, which starts off with what Delmore Schwartz once called "the beautiful American word, *sure*":

"Sure," said Benny Goodman,

"We rode out the depression on technique." How gratifying
 and how rare,
Such expressions of a proper modesty. Notice it was not said
By T. Dorsey, who could not play a respectable "Aunt Hagar's"
 on a kazoo,
But by the man who turned the first jazz concert at Carnegie
 Hall

Into an artistic event and put black musicians on the stand with
 white ones equally,
The man who called himself Barefoot Jackson, or some such,
In order to be a sideman with Mel Powell on a small label
And made good music on "Blue Skies," etc. He knew exactly
 who he was, no more, no less.
It was rare and gratifying, as I've said. Do you remember the
 Incan priestling, Xtlgg, who said,
"O Lord Sun, we are probably not good enough to exalt thee,"
 and got himself
Flung over the wall at Machu Picchu for his candor?
I honor him for that, but I like him because his statement
 implies
That if he had foreseen the outcome he might not have said it.
But he did say it. *Candor seeks its own unforeseeable occasions.*
Once in America in a dark time the existentialist flatfoot floogie
 stomped across the land
Accompanied by a small floy floy. I think we shall not see their
 like in our people's art again.

There is so much stomping joy immediately followed by such res-
onant nostalgia in Carruth's last lines that it almost lifts the poem
to another plane. This is a quality that animates a great deal of
American popular music, from musicals to pop songs.

 There is no hierarchy between works with duende and works
without it. One can find an enduring solace in many works of
high Apollonian art, and turn often for pleasure and comfort
to the Horatian tradition—to English poets such as Ben Jonson
and Robert Herrick, and to American writers such as William
Matthews, whose wit is a relentless joy, and Richard Wilbur,
whose poems we wouldn't want to live without. These poets teach
us that, as Wilbur has so memorably expressed it, "Love calls us
to the things of this world."

Poet in New York

IT'S STUNNING WHENEVER a work of art braves the risk and welcomes the dangers, when it gives itself over to another power. This is the space of Rilke's angel and Lorca's duende. Lorca himself at least partially schooled his idea of duende on the poetry that emerged from his encounter with the United States. He was shocked and exhilarated by what he found here, and his singular confrontation with America resulted in an elusive, enigmatic, and tortured work, *Poet in New York,* a book, to borrow one of the poet's own phrases, "that can baptize in dark water all who look at it" (*Deep Song*). It is a savage, exultant work. By the time he had arrived in New York City in June 1929, Lorca had already made a radical break with the style of *Gypsy Ballads* and embarked upon what he called "my *spiritualized* new manner, emotion disembodied and pure, disengaged from all logical control—but (mark you!) with a tremendous poetical logic."

As he also confided to a friend in a letter: "Now I am writing a *vein-opening* poetry, a poetry of *escape* from reality, in which all my love of things, my tenderness for things, is reflected feelingly. Love of death and scorn for death." Lorca's struggle with his own duende helps to explain not only the "black sounds" and cryptic imagery of *Poet in New York,* but also why he considered at one point calling the book *The City* and at another *Introduction to*

Death. Death and the city are the twin inspiring presences of the finished work.

Poet in New York (the title was intended as a sort of oxymoron: Could a poet manage to survive in such a city?) is a symphonic cycle of thirty-four poems, a consciously constructed ten-part psychological voyage that begins with an arrival and a descent ("Poems of Solitude at Columbia University") and concludes with a departure ("Flight from New York") followed by an ascent ("The Poet Arrives in Havana"). On one level the book represents, as Lorca once said in a lecture, his "lyrical reaction" to the city, its "extrahuman architecture and furious rhythm," its "geometry and anguish" ("Lecture," *Poet in New York*). He had never been abroad before this trip, and he was staggered by what he witnessed. He was very much an Andalusian in the New World, a sophisticated poet from a provincial place coming to terms with the overwhelming scale and vastness of the city. (He wrote home that "all Granada would fit into three of these buildings.") He was transfixed by what he perceived as "the skyscrapers' battle with the heavens that cover them" ("Lecture," *Poet in New York*), and the book conveys a sense of being "cut down by the sky" ("After a Walk," *Poet in New York*) and a longing and nostalgia for the spacious world of childhood. New York is for him a place where during the day people are "mired in numbers and laws, / in mindless games, in fruitless labors" ("Dawn," *Poet in New York*) and at dusk are poured into the streets in a human flood. He is personally and culturally disoriented in the crowds, and speaks of an unimaginable sadness, of being a "poet without arms, lost / in the vomiting multitude" ("Landscape of a Vomiting Multitude," *Poet in New York*). There is a frenetic quality to the two sections that most consistently evoke the tireless, dehumanized character of the city ("Streets and Dreams" and "Return to the City").

The duende arrives when a poet hits the far limits of art, the outer limits of self. It's as if artists descend into the wilderness of the self and through that struggle reach out to others. "Wake up. Be still. Listen. Sit up in your bed" ("Landscape with Two Graves and an Assyrian Dog," *Poet in New York*)—these are characteristic Lorcaesque imperatives. They are Lorca's nervous feverish warnings. Many of his greatest poems are an insomniac's hallucinatory nocturnes. His sleepless voice is an urgent message from the dark, as in "City that Does Not Sleep" (a nightsong of the Brooklyn Bridge), which relies on large, incantatory free-verse rhythms and repetitions to create a sense of human unreality, of the torments of consciousness, of suffering without end:

> In the sky there is nobody asleep. Nobody, nobody.
> Nobody is asleep.
> The creatures of the moon sniff and prowl about their cabins.
> The living iguanas will come to bite the men who do not
> dream,
> and the man who rushes out with his spirit broken will meet on
> the street corner
> the unbelievable alligator quiet beneath the tender protest of
> the stars.
>
> Nobody is asleep on earth. Nobody, nobody.
> Nobody is asleep.
> In the graveyard far off there is a corpse
> who has moaned for three years
> because of a dry countryside in his knee;
> and that boy they buried this morning cried so much
> it was necessary to call out the dogs to keep him quiet.
>
> Life is not a dream. Careful! Careful! Careful!
> We fall down the stairs in order to eat the moist earth
> or we climb to the knife-edge of the snow with the voices of the
> the dead dahlias.

But forgetfulness does not exist, dreams do not exist;
flesh exists. Kisses tie our mouths
in a thicket of new veins,
and whoever his pain pains will feel that pain forever
and whoever is afraid of death will carry it on his shoulders.

New York becomes a prototype of the twentieth-century urban world as the poet inveighs against the alienation from nature and anthropocentrism of city life, the terrible rootlessness of the crowds, the "painful slavery of both men and machines" ("Lecture," *Poet in New York*), the racism, the social injustice, and the indifference to suffering that seems to permeate the very atmosphere.

Lorca was deeply empathic with black life, and announced that he "wanted to write *the* poem of the black race in North America" ("Lecture," *Poet in New York*). His ambition is most evident in the book's second section, "The Blacks," where the joys of the black aesthetic ("Standards and Paradise of the Blacks") and the anguish of black persecution become the central subjects:

Ay, Harlem! *Ay,* Harlem! *Ay,* Harlem!
There is no anguish like that of your oppressed reds,
or your blood shuddering with rage inside the dark eclipse,
or your garnet violence, deaf and dumb in the penumbra,
or your grand king a prisoner in the uniform of a doorman.

("The King of Harlem," *Poet in New York*)

Black life becomes an emblem of the oppression of persecuted outsiders, "the other." The poet is tortured by the thought of the frenzied suffering around him, "a panorama of open eyes / and bitter inflamed wounds" ("Sleepless City," *Poet in New York*). The blazing city is unquestionably Manhattan, but, as Maurer aptly expresses it in his bilingual edition of *Poet in New*

York, the poem is also "the vigil of modern man in quest of the cosmic *meaning* of so much suffering." Thus Lorca mourns the spiritual desolation of the times, a period devoid of any religious consolation. There is only "the world alone in the lonely sky" ("Christmas on the Hudson," *Poet in New York*).

The three middle sections of the book compose a kind of solitary rural interlude set in Lake Eden Mills, Vermont, and in the Newburgh, New York, countryside. Lorca called the Vermont landscape "prodigious, but infinitely sad," and here, too, the quest for a universal meaning for suffering takes place under the omnipresent sign of death, the nocturnal spaces, the void. The poet is burnished by memories, by the eerie metaphysical sense that all of life is a ghostly metamorphosis. A weird desire for otherness seems to govern all creation. Thus in the surreal poem "Death," everything struggles to become something else—the horse would become a dog, a dog labors to become a swallow, the swallow tries to turn himself into a bee. The poet has his own exalted desire for transfiguration, as if he is moving up the ladder of being, ascending:

And I, on the roof's edge,
what a burning angel I look for and am!

("Death," *Poet in New York*)

The desire for transformation is viewed as coterminous with the life force itself, but that, also, is thwarted by the final metamorphosis. Death rules this kingdom with an unchanging and shapeless hand. The only consolation seems to be that the visit to the country has put the poet into renewed contact with the natural world. He returns to the city in a spirit of prophetic denunciation, and rages against "the conspiracy / of these deserted offices / that radiate no agony, that erase the forest's plans" ("New York," *Poet in New York*).

The enormous size, density, and random violence of America demanded from Lorca a metaphysical adjustment. He continually enjoins his listeners to wake up and pay attention to the wreckage, to be alert to an almost disembodied and conceptual philosophical unhappiness:

> Look at the concrete shapes in search of their void.
> Lost dogs and half-eaten apples.
> Look at this sad fossil world, with its anxiety and anguish,
> a world that can't find the rhythm of its very first sob.

> ("Nocturne of Emptied Space," *Poet in New York*)

"Agony, agony, dream, ferment and dream," Lorca declares in his "Ode to Walt Whitman": "This is the world, my friend, agony, agony" (*Poet in New York*). Lorca found brotherhood with Whitman and a deep affinity with African American culture (and oppression), but America was for him finally a land of anti-duende. Outside of black music and life, he found it hard to detect the American soul cry.

Lorca's continued spiritual anguish is a kind of psychic hell, and only in the final five poems—two odes and three dance poems—does the speaker begin to climb out of it. In the end, he finds a healing refuge in his escape to a rural world (the repeated refrain of the last poem, "Blacks Dancing to Cuban Rhythms," is "I'm going to Santiago" [*Poet in New York*]), and he relishes the discovery of a safer, more unified territory in Cuba, which he calls "the America with roots, God's America, Spanish America" ("Lecture," *Poet in New York*). It is hard to resist reading the narrative arc of this journey allegorically, as a story of psychic disintegration and reconstitution, a descent into the abyss and a tentative reemergence. It is a fierce indictment of the modern world incarnated in city life, but also a wildly imaginative and

joyously alienated declaration of residence—an apocalyptic out-cry, a dark, instructive, metaphysical howl of loneliness.

Poet in New York is Lorca's *Season in Hell.* It is his *Waste Land,* his *Residence on Earth,* his *Orphic Songs.* It is the book that concretized his idea of the demonic, the apotheosis of his duende.

Where Is the Angel?
Where Is the Duende?

LORCA REMEMBERS THAT great art is made when the door is open to the other side, but he also calls us back to the world strangely inspired, as in his waltzing, sexy, high-spirited, death-ward-leaning proclamations of love:

> Little waltz, little waltz, little waltz,
> of itself, of death, and of brandy
> that dips its tail in the sea.

> I love you, I love you, I love you,
> with the armchair and the book of death,
> down the melancholy highway
> in the iris's darkened garret,
> in our bed that was once the moon's bed,
> and in that dance the turtle dreamed of.

> *Ay, ay, ay, ay!*
> *Take this broken-waisted waltz.*

("Little Viennese Waltz," *Poet in New York*)

Lorca teaches us that one spins to the edge of an enormous night and then reels back from the precipice—wounded, yearning, sometimes terrified, sometimes rapturous, occasionally blessed. He gives us a passport to a vertiginous world of tragic imagination, of weird joy. He declares our estranged residence; he returns

us to being itself. For him, writing is a struggle with both geometry and death, a battle between restrictive measurement and exploding chaos, an attempt to bring something that lives out of the void.

Both the duende and the angel take us to the far limits of the human self. That is why it is such a dangerous joy when the duende is released into a work of art, a made thing, which it animates with its breath, a dark fire. It is equally dangerous when the angel wrestles the work of art in the darkness, when it illuminates it with a fiery touch, a darkly luminous blessing. The duende and the angel are figures crediting the imaginary realms that dwell deeply within us.

Where is the angel? It is burning on rooftops, moving through secret passageways and winding staircases, through corridors of light, precarious thrones, scarlet mountain ranges. See it carved in stone in crumbling apartment buildings, country churches, abandoned cemeteries, gathering its strength in railroad yards at sunset that are tinged with immaterial reds, ghostly blues. It flames out like shining from shook foil, like twenty thousand stars purpling at midnight. It flashes its sword in the gate, and troubles your dreams. Listen closely and you may hear a voice that cries from very far down inside you. That voice is trumpeting a liberation.

And where is the duende? It is flinging itself into the vast night. Look for it hiding under your boot soles.

The duende is a wind that breathes through the empty arches over the heads of the dead; it is the wing of a wounded hawk that floats through the crushed grass and flares out of the swollen sidewalks; it is a dream that mocks the bloody mockingbird and flees through the empty subway tunnels and soars out of the broken chest of bridges; it is a joy that burns and a suffering that scalds, like hot ice; it is a cry that rises out of the human body and annunciates "the constant baptism of newly created things" (*Deep Song*).

Notes

PAGE Preface

ix "Whatever has black sounds..." Federico García Lorca, "The
 Duende: Theory and Divertissement," in *Poet in New York*,
 trans. Ben Belitt (New York: Grove Press, 1955), 154.

ix "Art is the path..."; "Doubt not, O poet..." Ralph Waldo
 Emerson, "The Poet," *Essays: First and Second Series* (New
 York: Vintage/Library of America, 1990), 236, 236–37. Here-
 after cited as *Essays*.

x "Blessed is the day..." *The Journals and Miscellaneous Notebooks
 of Ralph Waldo Emerson*, Vol. 4 (Cambridge, Mass.: Harvard
 University Press, 1964), 365. Hereafter cited as *Journals*.

x "But there are neither maps..." "Juego y teoría del duende."
 ("Play and Theory of the Duende.") *Deep Song and Other Prose*,
 ed. and trans. Christopher Maurer (New York: New Directions,
 1980), 45. All further references to this lecture are abbreviated
 Deep Song and cited in the text.

xi "The one thing which we seek..." Ralph Waldo Emerson,
 "Circles," *Essays*, 184.

PAGE Only Mystery

1 "as his biographer..." Ian Gibson, *Federico García Lorca: A Life*
 (New York: Pantheon, 1989), 367. "Few people present can have
 doubted that, in his exploration of the *duende*, that mysterious,

Dionysian inspiration, Lorca was really talking about himself and his own poetic world." Hereafter cited as *FGL: A Life.*

1 "the Buenos Aires PEN Club." Pablo Neruda prints the text of the speech in his *Memoirs,* trans. Hardie St. Martin (New York: Penguin, 1978), 112–14.

2 "Only mystery enables us to live. Only mystery." See Mario Hernández, *Line of Light and Shadow: The Drawings of Federico García Lorca,* trans. Christopher Maurer (Durham: Duke University Press, 1991), 113. Lorca's statement—*Sólo el misterio/nos hace vivir / Sólo el misterio*—appears beneath an ink drawing of a sailor that he penned in Buenos Aires (April 1934) for a book by Pablo Neruda, *Dove Inside, or The Crystal Hand.* Lorca also wrote that "Poetic creation is an indecipherable mystery, like the mystery of man." He said, "Each thing has its own mystery and poetry is the mystery all things have." *Obras completas,* ed. Arturo del Hoyo, Vol. 3 (Madrid: Aguilar, 1986), 681 and 671. See also Sandra Forman and Allen Josephs, *Only Mystery: Federico García Lorca: Poet in Word and Image* (Gainesville: University Press of Florida, 1992).

PAGE Invoking the Duende

3 Ernesto Pérez Guerra's comments, including that Lorca had a deep desire to "yield to the joy of the moment," are cited in Leslie Stainton, *Lorca: A Dream of Life* (New York: Farrar, Straus and Giroux, 1999), 376. Hereafter cited as *Lorca.*

3 "Whenever I speak before a large group…" "Lecture: A Poet in New York." Federico García Lorca, *Poet in New York,* ed. Christopher Maurer, trans. Greg Simon and Steven F. White (New York: Farrar, Straus and Giroux, 1988), 183. All further references to *Poet in New York* are cited in the text. All references to Lorca's "Lecture" are abbreviated "Lecture, *Poet in New York,*" and also cited in the text.

4 "I want to summon up…" Lorca's invocation cited by Christopher Maurer, "Introduction," *Deep Song,* x, who also remarks

that the *cantaor* Don Antonio Chacón liked to ask, before beginning to sing, "¿Los señores saben escuchar?" ("Do you know how to listen?")

Poetic Fact

5 *"hecho poético."* Lorca said: "For the quality of a poem can never be judged on just one reading, especially not poems like these which are full of what I call 'poetic facts' that respond to a purely poetic logic and follow the constructs of emotion and of poetic architecture. Poems like these are not likely to be understood without the cordial help of the *duende."* "Lecture," *Poet in New York,* 184.

5 Lorca's poem "Romance sonámbulo" is translated as "Sleepwalking Ballad" by Will Kirkland, who renders the first line as "Green oh I love you green." *Collected Poems,* ed. Christopher Maurer (New York: Farrar, Straus and Giroux, 1991), 527. It is translated as "Somnambule Ballad" by Stephen Spender and J. L. Gili, who render the refrain line, "Green, how much I want you green." *The Selected Poems of Federico García Lorca,* ed. Francisco García Lorca and Donald M. Allen (New York: New Directions, 1961), 65.

5 "If you ask me why I wrote..." Federico García Lorca, "On the *Gypsy Ballads,"* *Deep Song,* 111–12.

5 "If it is true that I am a poet..." Lorca's letter to Gerardo Diego cited in *Deep Song,* xiii.

6 "sharp profiles and visible mystery." Lorca cited in *Poet in New York,* xvii.

6 "what Hart Crane meant..." "As to technical considerations: the motivation of the poem must be derived from the implicit emotional dynamics of the materials used, and the terms of expression employed are often selected less for their logical (literal) significance than for their associational meanings. Via this and their metaphysical inter-relationships, the entire construction of the poem is raised on the organic principle of a 'logic of metaphor,'

which antedates our so-called pure logic, and which is the genetic basis of all speech, hence consciousness and thought-extension." Hart Crane, "General Aims and Theories," *The Complete Poems and Selected Letters and Prose of Hart Crane,* ed. Brom Weber (Garden City, N.Y.: Anchor, 1966), 221.

6 "Language has built towers..." Ibid., 223.

6 "I am the more zealous..." *Complete Poems and Selected Letters of John Keats,* introduction by Edward Hirsch (New York: Modern Library, 2001), 489.

6 "I am certain of nothing..." Ibid., 489.

PAGE A Mysterious Power

9 "the Spanish Romany word..." Allen Josephs, *White Wall of Spain: The Mysteries of Andalusian Culture* (Ames: Iowa State University Press, 1983), 95.

9 Quotations from *The Love of Don Perlimplín for Belisa in His Garden. Five Plays by Lorca: Comedies and Tragicomedies,* trans. James Graham-Lujan and Richard L. O'Connell (New York: New Directions, 1963), 116.

9 "Lorca playfully claimed..." See Leslie Stainton, *Lorca,* 332.

10 "the word duende..." Christopher Maurer, *Deep Song,* xi.

10 "ghost, demon or spirit in folk music and dancing." Claus Schreiner, ed., *Flamenco: Gypsy Dance and Music from Andalusia,* trans. Mollie Comerford Peters (Portland, Ore.: Amadeus Press, 1996), 171.

10 "deep, trance-like emotion." D. E. Pohren, *Lives and Legends of Flamenco: A Biographical History* (Seville, Spain: Society of Spanish Studies, 1964), 354.

10 "the indefinable life force..." Juan Serrano, Jose Elgorriaga, *Flamenco, Body and Soul: An Aficionado's Introduction* (Fresno: The Press at California State University, Fresno, 1990), xi.

11 "Torre was practically the first..." Christopher Maurer writes: "Manuel Torre (1878–1936?) was one of the first cantaores to sing cante jondo in a natural voice—from the chest not from the throat. When Lorca met him in December 1927, he heard Torre

say, 'What you must search for, and find, is the black torso of the Pharaoh.' (Torre was a Gypsy and thus thought himself an Egyptian refugee)." *Deep Song,* 140.

11 "Flamenco Vignettes." Federico García Lorca, *Collected Poems,* 127.

12 "Death / is coming in…; "Black horses and sinister / people…" Federico García Lorca, trans. Robert Bly, *Lorca and Jiménez: Selected Poems* (Boston: Beacon Press, 1973), 113.

PAGE The Hidden Spirit of Disconsolate Spain

13 "The body is our mode of perceiving scale and, as the body of the other, becomes our antithetical mode of stating conventions of symmetry and balance on the one hand, and the grotesque and disproportionate on the other." Susan Stewart, *On Longing: Narratives of the Miniature, the Gigantic, the Souvenir, the Collection* (Baltimore: The Johns Hopkins University Press, 1984), xii.

14 "O Lord, grant each of us…" ("O Herr, gib jedem seinen eignen Tod…") Rainer Maria Rilke, *Gedichte, 1895–1910,* Volume 1, ed. Manfred Engel and Ulrich Fülleborn (Frankfurt am Main: Insel-Verlag, 1996), 236.

14 "He discovers it all around him…" Pedro Salinas, "Lorca and the Poetry of Death," cited in Allen Josephs, *White Wall of Spain,* 26.

15 Lorca spoke in his lecture on deep song of "the masters of the siguiriya: Curro Pabla 'el Curro,' Manuel Molina, Manuel Torre, and the prodigious Silverio Franconetti, who sang the song of songs better than anyone and whose scream used to open into quivering cracks the moribund mercury of the mirrors." *Deep Song,* 40–41.

15 For a description of the Cante Jondo Festival winners, see Ian Gibson, *FGL: A Life,* 115.

16 "a religious mystery." Lorca's letter to Giovanni Papini cited in Ian Gibson, Ibid., 391.

16 "authentic religious drama…" Lorca's claim cited in Leslie Stainton, *Lorca,* 366.

16 "sacrifice...to an unknown god." Antonio Machado assertion cited in Adrian Schubert, *Death and Money in the Afternoon: A History of the Spanish Bullfight* (New York: Oxford University Press, 1999), 2.

16 "public and solemn..." Lorca's letter to Giovanni Papini cited in Ian Gibson, *FGL: A Life,* 115.

17 "Being born in Granada..." Lorca's statement cited in *Deep Song,* ix.

An Apprenticeship

19 "Death! She insinuates..." Federico García Lorca, *"From* The Life of García Lorca, Poet," *Deep Song,* 133.

19 "Lorca's fear of death..." See Ian Gibson, *FGL: A Life,* 145–46.

20 "I remember his death-like..." Salvador Dalí, *Confessions incontestables,* with André Parinaud (Barcelona: Editorial Bruguera, 1957), 17.

20 *"Forest of Apparatuses..."* Lorca's title noted in Mario Hernández, *Line of Light and Shadow,* 22.

21 "Saintly Objectivity"; "The scent of Saint Sebastian..." Salvador Dalí, "Saint Sebastian" (1927), *The Collected Writings of Salvador Dalí,* ed. Haim Finkelstein (Cambridge, Mass.: University of Cambridge Press, 1998), 21. Finkelstein offers a helpful commentary on the text and suggests that Dalí was creating the verbal equivalency to a De Chirico painting (15).

21 "I had never thought..." Lorca's letter to Dalí cited by Mario Hernández, *Line of Light and Shadow,* 25.

21 "Oh Salvador Dalí..." Federico García Lorca, trans. William Bryant Logan, *Collected Poems,* 591.

22 "senseless black strokes..."; "When I do a purely abstract..."; "One returns from inspiration..." Federico García Lorca's letter to Gasch and two statements at a Góngora conference are cited in Cecelia J. Cavanaugh, SSJ, *Lorca's Drawings and Poems: Forming the Eye of the Reader* (Lewisburg, Pa.: Bucknell University Press, 1995), 21, 53.

23 "In the midst of..." Federico García Lorca, "Poem of the Bull," *In Search of Duende,* ed. and trans. Christopher Maurer (New York: New Directions, 1998), 83.

24 "heroic, pagan..." Lorca's statement cited in Leslie Stainton, *Lorca,* 365.

24 For Lorca's drawing "Andalusian Dancer" with dedication: Mario Hernández, *Line of Light and Shadow,* 32.

24 "Ignacio has just announced..." Marcelle Auclair cited by Leslie Stainton, *Lorca,* 365.

24 Quotations from "Lament for Ignacio Sánchez Mejías," trans. Alan S. Trueblood, *Collected Poems,* 695–709.

25 "Lorca's biographer..." Leslie Stainton, *Lorca,* 367.

25 "When I was composing..." Fernando Vázquez Ocaña, *García Lorca: Vida, cántico y muerte* (Mexico: Biografías Gandesa, 1957), 338.

26 "Ignacio's death..." Marcelle Auclair cited by Leslie Stainton, *Lorca,* 365.

27 "Poets are mediums..." Marcelle Auclair cited by Ian Gibson, *FGL: A Life,* 390.

27 "He only seems free..." A. L. Kennedy, *On Bullfighting* (New York: Anchor Books, 2001), 39–40.

PAGE Between Eros and Thanatos

29 "Whether they come from..." Federico García Lorca, "Deep Song," *Deep Song,* 31.

29 "From my very first steps..." Federico García Lorca, "On the *Gypsy Ballads,*" Ibid., 105.

30 Federico García Lorca, "Rider's Song," trans. Alan S. Trueblood, *Collected Poems,* 447.

31 "The Pain of Soledad..." Federico García Lorca, "On the *Gypsy Ballads,*" *Deep Song,* 112.

31 Christopher Maurer cites the first draft of the poem, *Collected Poems,* 818.

32 "the last will and testament..." Ibid., xxxvii.

32 Quotations from Lorca's ghazals and qasidas, trans. Catherine Brown, *Collected Poems,* 655, 663, 667, 675.

33 "All my emotions..."; "agrarian complex," Federico García Lorca, "*From* The Life of Federico García Lorca, Poet," *Deep Song,* 132–33.

PAGE The Majesty of the Incomprehensible

35 "is not written *a la española...*"; "now expressly, now..." Manuel de Falla's essay, which appeared in a booklet for the *cante jondo* festival he organized with Lorca in 1922, is excerpted in *Composers on Music: Eight Centuries of Writings,* Second Edition, ed. Josiah Fisk (Boston: Northeastern University Press, 1997), 264.

36 "a sort of corkscrew..." Federico García Lorca cited in *In Search of Duende,* ix.

37 César Vallejo, "Black Stone Lying on a White Stone," trans. Robert Bly and John Knoeple. *Neruda and Vallejo: Selected Poems* (Boston: Beacon Press, 1971), 249. Miguel de Unamuno, "It Is Night, in My Study," trans. William Stafford and Lillian Jean Stafford. *Roots and Wings: Poetry from Spain 1900–1975,* ed. Hardie St. Martin (New York: Harper and Row, 1976), 15. Pablo Neruda, "Nothing but Death," trans. Robert Bly. *Neruda and Vallejo,* 25–26. (Lorca penned two drawings for Neruda's "Solo la muerte"—one an *Image of Death,* the other a drawing of the title itself, which includes the first five lines. *Line of Light and Shadow,* 232–33.)

38 Cesare Pavese, "Death Will Come and Will Have Your Eyes," trans. Norman Thomas di Giovanni. *Modern European Poetry,* ed. Willis Barnstone (New York: Bantam, 1966), 321.

PAGE A Spectacular Meteor

39 "to understand our earthly..." Rilke cited by Donald Prater, *A Ringing Glass: The Life of Rainer Maria Rilke* (Oxford: Clarendon Press, 1986), 270.

39 "So this is where..." Rainer Maria Rilke, *The Notebooks of Malte Laurids Brigge,* trans. Stephen Mitchell (New York: Random House, 1983), 3. Hereafter cited as *Notebooks.*

39 "The last journey of the *flâneur...*" Walter Benjamin, *Reflections: Essays, Aphorisms, Autobiographical Writings,* ed. Peter Demetz, trans. Edmund Jephcott (New York: Harcourt Brace Jovanovich, 1978), 152.

39 "Malte is teaching himself..."; "the existence of the horrible..." Rainer Maria Rilke, *Notebooks,* 5, 73.

39 "To the depths of the unknown..." Baudelaire's line, which is cited by Walter Benjamin (*Reflections,* 157–58)—"Au fond de l'Inconnu pour trouver du *nouveau!*"—is translated by Richard Howard, "deep in the Unknown to find the *new!*" *Les Fleurs du Mal* (Boston: David Godine, 1982), 157.

39 Charles Baudelaire, "At One O'clock in the Morning," *Notebooks,* 53; *Twenty Prose Poems,* trans. Michael Hamburger (San Francisco: City Lights, 1988), 25.

40 "And when I think about..." Rainer Maria Rilke, *Notebooks,* 16.

40 "God, give us each our own death." Rainer Maria Rilke, *Rilke's Book of Hours: Love Poems to God,* trans. Anita Barrows and Joanna Macy (New York: Riverhead, 1996), 131.

41 "Death Experienced," Rainer Maria Rilke, *New Poems (1907),* trans. Edward Snow (San Francisco: North Point Press, 1984), 111. "To Hölderlin," "Requiem for a Friend," "Elegy," dedicated to Marina Tsvetaeva Efron, "Washing the Corpse," and "Orpheus. Eurydice. Hermes," *The Selected Poetry of Rainer Maria Rilke,* ed. and trans. Stephen Mitchell (New York: Random House, 1987), 140–41, 72–87, 288–91, 48–53, hereafter cited as *Selected Poetry.*

41 "Written in 1904, 'Orpheus. Eurydice. Hermes,' by Rainer Maria Rilke, makes one wonder whether the greatest work of the century wasn't done ninety years ago." Joseph Brodsky, "Ninety Years Later," *On Grief and Reason* (New York: Farrar, Straus and Giroux, 1995), 376.

41 "Death." Rainer Maria Rilke, trans. Stephen Mitchell, *Selected Poetry*, 401.

42 "babbling, toothless ghosts…" Ralph Freedman, *Life of a Poet: Rainer Maria Rilke* (New York: Farrar, Straus and Giroux, 1996), 401.

43 "Only then they mumble…" William H. Gass, *Reading Rilke* (New York: Alfred A. Knopf, 1999), 168.

43 "Then their tongues…" *Uncollected Poems*, trans. Edward Snow (New York: North Point, 1996), 113.

43 "At the end of the poem…" Rilke's letter cited in *Selected Poetry*, 314–15.

PAGE Swooping In

45 *"Candor seeks its own…"* Hayden Carruth, "'Sure,' said Benny Goodman," *Collected Shorter Poems 1946–1991* (Fort Worden State Park, Wash.: Copper Canyon, 1992), 361.

45 "The Day Lady Died," *The Selected Poems of Frank O'Hara,* ed. Donald Allen (New York: Random House, 1974), 146.

46 "Her voice was just a shadow…" Jackie McClean quote from liner notes to *Let Freedom Ring* (Blue Note CDP 7 465272).

46 "to mine her compromised…" Gary Giddins, *Visions of Jazz: The First Century* (New York: Oxford University Press, 1998), 372.

46 "O'Hara heard Billie Holiday…" Brad Gooch writes that "O'Hara's reaction to her performance was as exhilarated as his reaction to Judy Garland's show at the Palace Theater, after which he had commented to John Button, 'Well, I guess she's *better* than Picasso.'" *City Poet: The Life and Times of Frank O'Hara* (New York: Alfred A. Knopf, 1993), 327.

47 "It was very close…" Kenneth Koch quoted in Brad Gooch, Ibid., 328.

PAGE Ardent Struggle, Endless Vigil

49 "ardent struggle, endless vigil, like all art." Federico García

Lorca, "In Praise of Antonia Marcé, *La Argentina,*" *In Search of Duende,* 63.

49 "I have been like a fountain…" Federico García Lorca, *Collected Poems,* 841.

49 "arrests the vanishing apparitions…" *The Selected Poetry and Prose of Shelley,* ed. Harold Bloom (New York: New American Library, 1966), 444.

49 "'passion controlled'…" James Porter, *The Invention of Dionysus: An Essay on the Birth of Tragedy* (Stanford: Stanford University Press, 2000), 172.

49 "Discipline and passion." Federico García Lorca, "Sonnet in Homage to Manuel de Falla Offering Him Some Flowers," trans. Christopher Maurer, *Collected Poems,* 729.

50 "While the poet wrestles…" Federico García Lorca, "In Praise of Antonia Marcé, *La Argentina,*" *In Search of Duende,* 63.

50 "Lorca's attempt to come…" Christopher Maurer, *Deep Song,* xi.

50 Adam Zagajewski, "Flamenco," *Solidarity, Solitude* (New York: The Ecco Press, 1990), 151–66. "The flamenco becomes the site…" 153.

51 "Flamenco is a hypnotic art…" Marion Papenbrok, "The Spiritual World of Flamenco," in Claus Schreiner, ed., *Flamenco,* 54. Papenbrok also quotes González Climent on "the difficult balance between body, soul and spirit" (55).

51 "Spanish Dancer." Rainer Maria Rilke, trans. Edward Snow, *New Poems (1907),* 145.

52 "His inventiveness is unperturbed and utterly without chiaroscuro"; "Góngora never wanted to be turbid, he wanted to be clear, iridescent, elegant." "The Poetic Image of Don Luis de Góngora," Federico García Lorca, *Deep Song,* 80, 81.

52 "[It] travels and transforms…" Lorca's lecture, "Imagination, Inspiration, Evasion" (1928), cited by Christopher Maurer in *Collected Poems,* lvii.

53 "how he stands there…" Walter Benjamin cites this passage from "The Painter of Modern Life" in his essay "On Some Motifs

in Baudelaire," *Illuminations,* trans. Harry Zohn (New York: Schocken Books, 1969), 163–64. For a different translation of the passage, see *The Painter of Modern Life and Other Essays,* trans. and ed. Jonathan Mayne (New York: Da Capo, 1964), 12.

53 "Walter Benjamin links this..." Walter Benjamin, *Illuminations,* 164.

53 "Late in this cruel season..." Charles Baudelaire, "Parisian Landscape," trans. Richard Howard, *Les Fleurs du Mal,* 87–88.

The Black Paintings

55 "All truly profound art..." André Malraux, "Goya" (1947), *Writers on Artists,* ed. Daniel Halpern (San Francisco: North Point Press, 1988), 116.

55 For the plan of the two rooms with the "Black Paintings" in the *Quinta del Sordo,* see Pierre Gassier and Juliet Wilson, ed. François Lachenel, *The Life and Complete Work of Francisco Goya* (New York: Reynal & Co./William Morrow & Co., 1971), 320. See also Valeriano Bozal, *Pinturas Negras de Goya* (Madrid: Tf. Editores, 1997).

The Intermediary

58 "Goethe's assertion..." *Conversations with Eckermann (1823–1832),* trans. John Oxenford (San Francisco: North Point Press, 1984), 319.

58 "Goethe also said that the *Dämonische...*" Ibid., 319.

58 "The songs made me, not I them." Goethe's claim cited in E. R. Dodds, *The Greeks and the Irrational* (Berkeley: University of California Press, 1951), 100.

58 Juan Talegas said: "Duende, it's like a fever, like malaria. I had the duende only twice in my life..." Claus Schreiner, ed., *Flamenco,* 26.

59 "Poetry is not like reasoning..." *The Selected Poetry and Prose of Shelley,* 443.

59 E. R. Dodds, *The Greeks and the Irrational:* "Democritus was

the first writer...with inspiration and a holy breath..." (82); " 'I am self-taught,' says Phemius..." (10); "Pindar begged the Muse..." (22); "the Muse is actually *inside* the poet" (101).

59 "Poetry redeems from decay the visitations of the divinity in man." *The Selected Poetry and Prose of Shelley,* 444.

60 "The background remains..." Massimo Cacciari, *The Necessary Angel,* trans. Miguel E. Vatter (Albany: State University of New York Press, 1994), 28.

60 "a very powerful spirit..." *Plato: The Collected Dialogues,* ed. Edith Hamilton and Huntington Cairns, Bollingen Series LXII (Princeton, N.J.: Princeton University Press, 1961), 555. Further references to the *Dialogues* are cited in the text.

60 Plato further suggests: "Souls that live for a day, now is the beginning of another cycle of mortal generation where birth is the beacon of death. No divinity shall cast lots for you, but you shall choose your own deity." *The Collected Dialogues,* 841.

61 "Harold Bloom proposes that..." Harold Bloom, *Omens of Millennium: The Gnosis of Angels, Dreams, and Resurrection* (New York: Riverhead, 1996), 137.

61 "a sort of alter ego or Socratic daemon..." Robert Richardson, Jr., *Emerson: The Mind on Fire* (Berkeley: University of California Press, 1995), 349.

61 "Let a man not resist..." Ralph Waldo Emerson, *Journals,* Vol. 7, 450.

62 "it is often virtually impossible to say..," *Encyclopedia Judaica,* Vol. 5 (Jerusalem: Keter Publishing, 1972), 1526.

64 "There is this difference between the Demon of Socrates and my own: that of Socrates only manifested himself to him in order to forbid, to warn, to prevent, while mine deigns to advise, to suggest, to persuade. Poor Socrates only had a prohibiting Demon; mine is a great affirmer, mine is a Demon of action, a Demon of combat." Charles Baudelaire, "Let's Beat Up the Poor," trans. Michael Hamburger, *Twenty Prose Poems,* 77.

64 "I come and go—the Demon tags along," Baudelaire writes,

concluding: "Thereby he leads me out of God's regard / spent and gasping..." "Destruction," trans. Richard Howard, *Les Fleurs du Mal*, 121.

Yeats's Daimon

65 "We make out of the quarrel..." William Butler Yeats, "Anima Hominis," *Per Amica Silentia Lunae* (1917). *Mythologies* (New York: Macmillan, 1961), 331.

65 "the Daimon is our destiny..." Ibid., 336.

66 "attached to a particular..." E. R. Dodds, *The Greeks and the Irrational*, 42.

66 "The Daimon comes not as like..." William Butler Yeats, *Mythologies*, 335.

66 "Ego Dominus Tuus." Ibid., 321–24; *The Poems of W. B. Yeats: A New Edition*, ed. Richard J. Finneran (New York: Macmillan, 1983), 160–62, hereafter cited as *Poems*.

66 "Ezra Pound's quip..." See Richard Ellmann's chapter "Ez and Old Billyum" in *Eminent Domain: Yeats Among Wilde, Joyce, Pound, Eliot, and Auden* (Oxford: Oxford University Press, 1970), 71.

67 "Because I seek..." William Butler Yeats, *Poems*, 162.

67 "Without Contraries..." *The Complete Poetry and Prose of William Blake*, ed. David V. Erdman (Berkeley: University of California Press, 1982), 34.

68 "For wisdom is the property..." William Butler Yeats, *Poems*, 239.

68 "as he confessed to Katharine Tynan..." Yeats wrote to her in 1888: "I have noticed some things about my poetry I did not know before...It is almost all a flight into fairyland from the real world, and a summons to that flight. The chorus to the 'Stolen Child' sums it up—that it is not the poetry of insight and knowledge, but of longing and complaint—the cry of the heart against necessity. I hope some day to alter that and write poetry of in-

sight and knowledge." *The Letters of W. B. Yeats,* ed. Allan Wade (New York: Macmillan, 1955), 63.

68 "as Daniel Hoffman suggests..." *Barbarous Knowledge: Myth in the Poetry of Yeats, Graves, and Muir* (New York: Oxford University Press, 1967), 75.

68 "Yeats articulated his occult..." *Memoirs,* ed. Denis Donoghue (New York: Macmillan, 1973), 166.

68 "One is constantly hearing..." *Uncollected Prose by W. B. Yeats,* ed. John P. Frayne and Colton Johnson, Vol. 2 (New York: Columbia University Press, 1976), 232.

69 "There are two living countries..." *The Hour-Glass. The Collected Plays of W. B. Yeats,* 197. Hereafter cited as *Collected Plays.* Yeats explains: "I thought I discovered the antithesis of the seasons when some countryman told me that he heard the lambs of Faery bleating in November, and, read in some heroic tale of supernatural flowers in midwinter. I may have deceived myself but, if I did I got out of the deception the opening passage in my play *The Hour-Glass...*" William Butler Yeats, *A Vision* (New York: Macmillan, 1966), 210.

69 "The beggar who wrote that..." William Butler Yeats, *Collected Plays,* 53.

69 "Or as Rilke once told..." See Ralph Freedman, *Life of a Poet,* 318.

69 "'sexual love'...'founded upon spiritual'..." William Butler Yeats, *Mythologies,* 336.

70 "centric myth." *The Letters of W. B. Yeats,* 829.

70 "Each Daimon is drawn..." William Butler Yeats, *Mythologies,* 362.

70 Yeats explained: "On the afternoon of October 24th 1917, four days after my marriage, my wife surprised me by attempting automatic writing..." *A Vision,* 8.

70 "It was part of their purpose..." Ibid., 13.

71 "He is called the *Daimonic* man..." Ibid., 141.

71 "For one throb…" "A Meditation in Time of War." William Butler Yeats, *Poems,* 190.

71 "I sometimes fence…" William Butler Yeats, *Mythologies,* 337.

Ars Poetica?

72 "Imagination—here the Power so called…" William Wordsworth, *The Prelude: A Parallel Text,* ed. J. C. Maxwell (New York: Viking Penguin, 1986), 239.

72 "seized by trances." Ewa Czarnecka and Aleksander Fuit, *Conversations with Czeslaw Milosz* (New York: Harcourt Brace Jovanovich, 1987), 228.

72 "Secretaries." Czeslaw Milosz, *The Collected Poems* (New York: The Ecco Press, 1988), 325.

72 "Frankly, all my life…" Czeslaw Milosz, *The Witness of Poetry* (Cambridge, Mass.: Harvard University Press, 1983), 3.

72 "My relationship to poetry…" Ibid., 239. "He hears voices but he does not understand his screams, prayers, blasphemies, hymns which choose him for their medium," Milosz writes in "The Separate Notebooks." "He would like to know who he was, but he does not know." Czeslaw Milosz, *The Collected Poems,* 374.

73 "the theory of poetry…" Wallace Stevens, *Opus Posthumous,* ed. Milton J. Bates (New York: Vintage, 1990), 202.

73 "Ars Poetica?" Czeslaw Milosz, *The Collected Poems,* 211–12.

73 "That's why poetry…" Speaking about his poem "Hope," Milosz said: "The poem was almost *écriture automatique,* written under the daimonion's influence…The daimonion dictated it and I wrote it." *Conversations with Czeslaw Milosz,* 108. Speaking about "Three Winters," he said: "The daimonion and hard work go hand in hand" (133).

74 "Incantation." Czeslaw Milosz, *The Collected Poems,* 210.

74 Quotations from Zbigniew Herbert, "Mr. Cogito and the

Imagination," *Report from the Besieged City,* trans. John Carpenter and Bogdana Carpenter (New York: The Ecco Press, 1985), 17–19.

75 Adam Zagajewski, "Reason and Imagination: The Nourishers of Humanity," *Solidarity, Solitude,* 104–106.

PAGE A Passionate Ingredient

76 "The Seafarer": "May I for my own self song's truth reckon." Ezra Pound, *Translations* (New York: New Directions, 1963), 207.

77 "That is always best..." Ralph Waldo Emerson, "The Divinity School Address," *Nature, Addresses, Lectures. The Complete Works of Ralph Waldo Emerson* (Boston: Houghton Mifflin, 1903), 131–32.

77 "The poem is good in so far..." Yvor Winters, *In Defense of Reason* (New York: The Swallow Press/William Morrow and Co., 1947), 11.

77 "These poems illustrate the danger..." Yvor Winters, "The Progress of Hart Crane," *The Merrill Studies in The Bridge,* compiled by David R. Clark (Columbus: Charles E. Merrill, 1970), 24.

78 "Reading the *Iliad*..." Edwin Denby, *Dance Writings and Poetry,* ed. Robert Cornfield (New Haven: Yale University Press), 3.

78 " 'I write,' Blake said, 'when commanded...' " *Blake Records,* ed. G. E. Bentley, Jr. (Oxford: Clarendon Press, 1969), 322.

78 "Inspiration & Vision..." *The Complete Poetry and Prose of William Blake,* 660–61.

79 "I have written this Poem..."; "the Authors..." *The Letters of William Blake,* 3rd. ed., ed. Geoffrey Keynes (Oxford: Clarendon Press, 1980), 55, 58.

79 "my demon Poesy." "Ode on Indolence," *Complete Poems and Selected Letters of John Keats,* 359.

80 "L'Infinito." *A Leopardi Reader,* ed. and trans. Ottavio Mark Casale (Urbana, Ill.: University of Illinois Press, 1981), 44.

80 "I was terrified at finding..."; "This is the first time..." Ibid., 44, 45.

81 "Brutus the Younger" (which Saint-Beuve thought was "the key to all of Leopardi's negative philosophy"), "The Last Song of Sappho" (which Leopardi said in a note "intends to represent the sorrow of a delicate, tender, sensitive, noble and warm soul encased in an ugly, young body"), "To Sylvia" (a *canzone*), "Night-Song of a Wandering Shepherd of Asia," and "To Himself" ("Henceforth, heap scorn / Upon yourself, Nature, the ugly force / That, hidden, orders universal ruin, / And the boundless emptiness of everything." Ibid., 64–68, 73–75, 158–60, 172–77, 202–203.

81 "a walking sepulchre." Ibid., 3.

81 "Broom" and "The Setting of the Moon," which concludes "And in the night to come / The gods have raised a sign for us, the tomb." Ibid., 206–13, 214–15.

81 "The student, the writer..." George Santayana, "Foreword" to Iris Origo, *Leopardi: A Study in Solitude* (New York: Books & Company / Helen Marks Books, 1999), ix.

81 "Our dreams are a second..." Gérard de Nerval, *Selected Writings,* trans. Geoffrey Wagner (Ann Arbor: University of Michigan Press, 1970), 115.

82 "the impressions of a long illness..." Ibid., 115.

82 "Lost in a kind of half-sleep..." Ibid., 53.

82 "André Breton asserted in *The First Surrealist Manifesto...*" *Surrealists on Art,* ed. Lucy P. Lippard (Englewood Cliffs, N.J.: Prentice-Hall, 1970), 19.

82 "El Desdichado," Gérard de Nerval, *Selected Writings,* 213.

83 "I am no longer..." Heine's public declaration quoted by Jeffrey L. Sammons, *Heinrich Heine: A Modern Biography* (Princeton, N.J.: Princeton University Press, 1979), 308.

84 "But this sweet anodyne..." "Morphine," *The Complete Poems of Heinrich Heine: A Modern English Version,* trans. Hal Draper (Boston: Suhrkamp / Insel, 1982), 807.

84 "I am flogging up..." Heine's comment cited by Hal Draper, Ibid., 943.

84 "the third pillar of..." Heine cited by Jeffrey L. Sammons, *Heinrich Heine,* 310.

84 "That fellow in Homer's book..." "Heine Dying in Paris," *Imitations,* trans. Robert Lowell (New York: Farrar, Straus and Giroux, 1961), 39.

84 "a call from the beyond..." Meissner's statement cited by Jeffrey L. Sammons, *Heinrich Heine,* 134.

PAGE I Sing You, Wild Chasm

85 "All its extraordinary ramifications stem from an assumption antipodal to Emerson's, from what Melville calls the instinctive 'knowledge of the demonism in the world.'" F. O. Matthiessen, *American Renaissance: Art and Expression in the Age of Emerson and Whitman* (New York: Oxford University Press, 1972), 110.

85 "I have written a wicked book..." Ibid., 457.

85 "Hawthorne's wilder, fantastical..."; "the substance of Hawthorne..." Charles Ives, *Essays Before a Sonata, The Majority, and Other Writings,* ed. Howard Boatwright (New York: W. W. Norton, 1970), 39. Wilfrid Mellers writes: "The second movement...deals with the subconscious life of dreams, nightmare, and the sensory impressions of childhood." Wilfrid Mellers, *Music in a New Found Land: Themes and Developments in the History of American Music* (New York: Oxford University Press, 1987), 51.

86 "the imagination is thronged..." F. O. Matthiessen, *American Renaissance,* 74.

86 Quotation from Poe's *Marginalia.* Ibid., 233.

86 "The Imp of the Perverse" is the title of one of Poe's fine (and unfairly neglected) stories. *Tales and Sketches, Volume 2, 1843–49,*

ed. Thomas Ollive Mabbott (Urbana, Ill.: University of Illinois Press, 2000), 1217–27.

87 "my certificate of insanity." Charles Baudelaire, "Let's Beat Up the Poor," *Twenty Prose Poems,* 75.

87 "Must I tell you…" Baudelaire's letter (February 18, 1866) cited in Claude Pichois, *Baudelaire,* trans. Graham Robb (London: Hamish Hamilton, 1989), 335.

87 "Now I suffer continually…" *The Intimate Journals of Charles Baudelaire,* trans. Christopher Isherwood (Boston: Beacon Press, 1957), viii.

87 "At first it was an experiment…" Arthur Rimbaud, "Delirium 11: Alchemy of the Word," *A Season in Hell* & *The Drunken Boat,* trans. Louise Varèse (New York: New Directions, 1961), 51.

87 "when my spirits were so crushed…" *The Letters of Gerard Manley Hopkins to Robert Bridges,* ed. Claude Colleer Abbott (London: Oxford University Press, 1935), 222.

88 "If ever anything was written in blood…" Ibid., 219.

88 "Carrion Comfort," Gerard Manley Hopkins, *Poems and Prose,* ed. W. H. Gardner (New York: Penguin, 1981), 60.

88 "Among his obscure intentions…" *The Second Life of Art: Selected Essays of Eugenio Montale,* ed. and trans. Jonathan Galassi (New York: The Ecco Press, 1982), 66.

88 "Oscar Wilde at San Miniato." Dino Campana, *Orphic Songs,* trans. I. L. Salomon (New York: October House, 1968), 101.

89 "I believe it must be terrible…" Trakl's letter to his sister is quoted in Herbert Lindenberger, *Georg Trakl* (New York: Twayne, 1971), 31.

89 "sleep and death, the somber eagles"; "I sing you, wild chasm…" *Song of the West: Selected Poems of Georg Trakl,* trans. Robert Firmage (San Francisco: North Point Press, 1988), 121, 115.

PAGE Night Work

91 "As he lay sleeping…" Frank Bidart, *In the Western Night: Collected Poems 1965–90* (New York: Farrar, Straus and Giroux, 1990), 6.

92 "Lorca especially loved the Spanish mystic's..." Federico García Lorca, "Holy Week in Granada," *Deep Song,* 54.

93 Quotations from "Insomnia," *Selected Poems of Marina Tsvetayeva,* trans. Elaine Feinstein (New York: E. P. Dutton, 1986), 11–15.

93 Joseph Brodsky says: "Time speaks to the individual in various voices. Time has its own bass, its own tenor—and it has its own falsetto. If you like, Tsvetaeva is the falsetto of time. The voice that goes beyond the range of proper notation." Solomon Volkov, *Conversations with Joseph Brodsky: A Poet's Journey Through the Twentieth Century,* trans. Marian Schwartz (New York: The Free Press, 1998), 41.

93 "Make me thy lyre..." and "Be thou, Spirit..." "Ode to the West Wind," *The Selected Poetry and Prose of Shelley,* 214, 215.

93 "Not I, not I, but the wind..." D. H. Lawrence, *Selected Poems* (New York: Viking, 1959), 74.

93 "Blok wrote *The Twelve*..." Marina Tsvetaeva, *Art in the Light of Conscience,* trans. Angela Livingstone (Cambridge, Mass.: Harvard University Press, 1992), 160.

94 "condition of creation..."; "Let the ear hear..." Ibid., 173, 177.

94 "Walk a few steps more..." Larry Levis, "Elegy with an Angel at Its Gate," *Elegy,* ed. Philip Levine (Pittsburgh: University of Pittsburgh Press, 1997), 65.

95 "Creeds and schools in abeyance..." Walt Whitman, *The Complete Poems,* ed. Francis Murphy (New York: Viking Penguin, 1986), 63.

95 "I had not thought death..." T. S. Eliot, *The Waste Land: A Facsimile and Transcript of the Original Drafts Including the Annotations of Ezra Pound,* ed. Valerie Eliot (New York: Harcourt Brace Jovanovich, 1972), 9.

95 "Verily, I say unto you..." César Vallejo, *Trilce,* trans. Clayton Eshleman (Hanover: Wesleyan University Press, 2000), 199.

95 "bats with baby faces..." T. S. Eliot, *The Waste Land,* 145.

95 "unknown, dark *psychic material*..." T. S. Eliot, "The Three

Voices of Poetry" (1953), *On Poetry and Poets* (New York: Farrar, Straus and Cudahy, 1957), 110.

95 "Make way for the new..."; "To create harmony..." César Vallejo, *Trilce*, 95, 205.

Vegetable Life, Airy Spirit

96 "Those who are willing..." *Straw for the Fire: From the Notebooks of Theodore Roethke, 1943–1963,* selected by David Wagoner (Garden City, N.Y.: Doubleday & Co., 1972), 183.

96 "I can hear, underground..." "Cuttings," *The Collected Poems of Theodore Roethke* (Garden City, N.Y.: Doubleday, 1966), 37.

97 "I've crawled from the mire..."; "I was far back, farther than anybody..." "Praise to the End!," "Unfold! Unfold!" Ibid., 8, 89.

97 "Some of these pieces, then..." "Open Letter," *On the Poet and His Craft: Selected Prose of Theodore Roethke,* ed. Ralph J. Mills, Jr. (Seattle: University of Washington Press, 1966), 41.

97 "For Lawrence and I are going..." Theodore Roethke, *Straw for the Fire,* 154.

97 "The blood jet is poetry..." Sylvia Plath, "Kindness," *The Collected Poems* (New York: Harper and Row, 1981), 270.

98 "I believe that one should be able..." Sylvia Plath, "Interview" (October 30, 1962), in Peter Orr, ed., *The Poet Speaks* (London: Routledge and Kegan Paul, 1966), 167–68.

98 "dawn poems in blood." Plath quoted in Linda W. Wagner-Martin, *Sylvia Plath: A Biography* (New York: Simon and Schuster, 1987), 223.

98 "Tomorrow I will be..." Sylvia Plath, "The Arrival of the Bee Box," *The Collected Poems,* 213.

98 "She regularly took horseback-riding..." Paul Alexander, *Rough Magic: A Biography of Sylvia Plath* (New York: Viking Penguin, 1991), 302.

98 "a lovely, though slightly chilling..." Robert Lowell, "Foreword" to Sylvia Plath, *Ariel* (New York: Harper and Row, 1965), vii.

99 "Plath's plan for organizing the book..." See "The 'Ariel' Poems," *The Collected Poems,* 295.

99 "Power ceases in the..." Ralph Waldo Emerson, "Self-Reliance," *Essays,* 41.

99 "Ariel," Sylvia Plath, *The Collected Poems,* 239–40.

99 "I never was on a coach..." Ralph Waldo Emerson, *Journals,* Volume 4, 316.

PAGE A Person Must Control His Thoughts in a Dream

101 "A rosy sanctuary will I dress / With the wreath'd trellis of a working brain..." "Ode to Psyche," *Complete Poems and Selected Letters of John Keats,* 241.

101 "The Genius of Poetry must work out its own salvation in a man: It cannot be matured by law & precept, but by sensation & watchfulness in itself—That which is creative must create itself." *Letters of John Keats,* ed. Robert Gittings (Oxford: Oxford University Press, 1970), 156.

101 "The Poet makes himself a *seer*..."; "Imagine a man implanting..." Arthur Rimbaud, *Complete Works, Selected Letters,* trans. Wallace Fowlie (Chicago: University of Chicago Press, 1966), 307.

102 "it will *precede* it." See Graham Robb's insightful discussion of Rimbaud's letter in *Rimbaud: A Biography* (New York: W. W. Norton and Co., 2000), 86–87.

102 "Duende has been called the demon..." Claus Schreiner, *Flamenco,* 26.

102 "*avant-garde primitivism.*" Timothy Mitchell, *Flamenco Deep Song* (New Haven: Yale University Press, 1994), 160.

102 "the way people describe..." Mihaly Csikszentmihalyi, *Flow: The Psychology of Optimal Experience* (New York: Harper-Collins, 1991), 6. See also *Creativity: Flow and the Psychology of Discovery and Invention* (New York: HarperCollins, 1996), especially the chapter "The Flow of Creativity" (107–26), wherein he lists nine main tenets of the flow experience.

102 "Now, so entire is my…" Passage from Poe's *Marginalia* cited by F. O. Matthiessen, *American Renaissance,* 233.

103 "Should I ever write a paper…" Ibid., 233.

103 "In a café, amid the sound…" Louis Aragon's 1924 account in *Une vague de rêves* is cited by Maurice Nadeau, *The History of Surrealism,* trans. Richard Howard (New York: Penguin, 1978), 90.

104 "Thought takes place in the mouth…" Carolyn Forché quotes Tristan Tzara's assertion, *"La pensée se fait dans la bouche,"* in her "Translator's Note" to *The Selected Poems of Robert Desnos,* trans. Carolyn Forché and William Kulik (New York: The Ecco Press, 1991), xiii.

104 "Poetry may be this or it may be that. But it shouldn't necessarily be this or that…except delirious and lucid"; "It seems to me that beyond…" Robert Desnos, "Reflections on Poetry," *The Selected Poems of Robert Desnos,* 178.

104 "There is a poetic constant. There are changes of fashion… There are also themes so overbearing they must be expressed at any cost. These themes exist at this moment and must be expressed at this moment." Ibid., 177.

104 "A first definition of this complex…"; "Unlike the possessed person…" Mircea Eliade, *Shamanism: Archaic Techniques of Ecstasy,* trans. Willard R. Trask (Princeton, N.J.: Princeton University Press, 1972), 4, 6. See also *Technicians of the Sacred: A Range of Poetries from Africa, America, Asia, and Oceania,* ed. Jerome Rothenberg (New York: Anchor, 1969). "The poet (who may also be dancer, singer, magician, whatever the event demands of him) masters a series of techniques that can fuse the most contradictory propositions" (xxi–xxii).

105 "A person must control…" Ibn 'Arabī cited in Indries Shah, *The Sufis* (New York: Anchor, 1964), 159.

105 "The source of his inspiration was reverie in which the consciousness was still active. By the exercise of this Sufi faculty, he was able to produce from the innermost mind a contact with

supreme reality—the reality which he explained underlay the appearances of the familiar world." Indries Shah, Ibid., 159.

105 "My heart is capable..." This stanza from *The Tarjuman Al-Ashwag (Interpreter of Desires),* trans. by R. A. Nicholson in 1911, is quoted in Indries Shah, *The Sufis,* 165.

106 "Between the world of pure spiritual..." Henry Corbin, *The Man of Light in Iranian Sufism,* trans. Nancy Pearson (Boulder, Colo.: Shambhala, 1978), 42–43.

106 "an organ of understanding mediating between intellect and sense." Henry Corbin, *Spiritual Body and Celestial Earth,* trans. Nancy Pearson (Princeton, N.J.: Princeton University Press, 1977), xviii.

106 "Many people sympathized..." Indries Shah, *The Sufis,* 162.

107 "*Negative Capability...*" *Complete Poems and Selected Letters of John Keats,* 492.

107 "He attended William Hazlitt's *Lectures...*" The quotations from Hazlitt's third lecture, "On Shakespeare and Milton," are taken from Walter Jackson Bate's chapter on "Negative Capability" in *John Keats* (Cambridge, Mass.: Harvard University Press, 1963), 259–60.

107 "As to the poetical Character itself..." *Complete Poems and Selected Letters of John Keats,* 500–501.

108 "And, truly I would rather be struck dumb / Than speak against this ardent listlessness: / For I have ever thought that it might bless / The world with benefits unknowingly." "Endymion," Ibid., 86.

The Angelic World

109 "we are surrounded by divine presence..." Iamblichus, *On the Mysteries* (Hastings, England: Chthonios, 1989), 8.

109 "According to one seventeenth-century work..." The quotations from the Shi'ite cleric Muhammad Baqir b. Taqi al-Majlisi of Isfahan (1628–99), the author of the three-volume work *Hayat*

al-Qulub, are cited in David J. Halperin, "Hekhalot and Mi'raj: Observations on the Heavenly Journey in Judaism and Islam," *Death, Ecstasy, and Other Worldly Journeys,* ed. John J. Collins and Michael Fishbane (Albany: State University of New York Press, 1995), 270–72.

110 "Some Jewish sages taught..." See the section on Angels in the Talmud and Midrash in the article "Angels and Angelology," *Encyclopedia Judaica,* Vol. 2, 968.

111 "the angels of the presence..." "The Creation of the World," *The Book of Jubilees,* in *The Other Bible,* ed. Willis Barnstone (San Francisco: HarperCollins, 1984), 10.

111 "God's agent is the 'angel of the presence,' who orders Moses to write down God's exact words." Willis Barnstone, Ibid., 10.

111 "a legend in the *Zohar...*" Gershom Scholem, ed., *Zohar* (New York: Schocken, 1963), 27.

111 "For all the heavenly troops..." "The Fiery Essence," *The Book of the Secrets of Enoch* (2 Enoch), in *The Other Bible,* 5.

111 "and he called me..." Cited by David J. Halperin, "Hekhalot and Mi'raj..." *Death, Ecstasy, and Other Worldly Journeys,* 273.

112 "This one whom I..." Cited by Harold Bloom, *Omens of Millennium,* 53.

112 "The Lord created them..." Jorge Luis Borges, "A History of Angels," *Selected Non-Fictions,* ed. Eliot Weinberger (New York: Penguin, 1999), 16.

113 "Someone might claim that God..." Pseudo-Dionysius, *The Complete Works,* trans. Colm Luidheid (New York: Paulist Press, 1987), 157.

113 "as the hierarchical ranks..." Elaine Pagels, *The Origin of Satan* (New York: Random House, 1995), 39. Pagels also points out that "In biblical sources the Hebrew term the *satan* describes an adversarial role. It is not the name of a particular character." The root of the word means "one who opposes, obstructs, or acts as adversary."

113 "Walter Benjamin...was captivated..." See Gershom Scholem, *On Jews and Judaism in Crisis: Selected Essays,* ed. Werner J. Dannhauser (New York: Schocken, 1976), 212–13.

113 "The Kabbalah teaches that Angels ascend and descend in the vast space of the Kingdom, so much so that they wonder whether their Lord dwells 'above' or 'below.'" Massimo Cacciari, *The Necessary Angel,* 1.

114 "Early successes, Creation's pampered..." Rainer Maria Rilke, trans. Stephen Mitchell, *Selected Poetry,* 157. Unless otherwise specified, all further references to *The Duino Elegies* use Mitchell's translation and are hereafter cited in the text.

114 "Thomas Aquinas warned..." "Nevertheless, the daemons are material, as are the gods; it was the innovation of Thomas Aquinas to regard the angels, the equivalent of the gods, as pure spirits." Harold Bloom, *Omens of Millennium,* 62.

114 "the most joyous creatures..." Giacomo Leopardi, "In Praise of Birds," *Operette Morali: Essays and Dialogues,* trans. Giovanni Cecchetti (Berkeley: University of California Press, 1982), 353.

114 "these serene animals..." Umberto Saba cited by Massimo Cacciari, *The Necessary Angel,* vii.

114 "those who ever sing / in harmony..." Dante Alighieri, *The Divine Comedy, Purgatorio 1: Italian Text and Translation,* trans. Charles S. Singleton (Princeton, N.J.: Princeton University Press, 1973), Canto XXX, lines 92–93, 333.

114 "The Ladder." Martin Buber, *Tales of the Hasidim: The Later Masters,* trans. Olga Marx (New York: Schocken, 1948), 170.

115 "Jacob Boehme treated them..." "Boehme's angels, who are God's thoughts, are shaped like humans, being wingless, and they have hands and feet, but they have no teeth, since they eat only the fruit of paradise. These Germanic angels are not mere messengers; God cannot rule nature or human nature without them since they are his only instruments." Harold Bloom, *Omens of Millennium,* 39.

115 "The angels are a strange genus: they are precisely what they are and cannot be anything else. They are in themselves soulless beings who represent nothing but the thoughts and intuitions of their Lord." C. G. Jung, *Memories, Dreams, Reflections,* ed. Aniela Jaffé, trans. Richard and Clara Winston (New York: Pantheon, 1963), 327–28.

115 "concrete-poetic symbols..." Paul Tillich, *Systematic Theology,* Vol. 1 (Chicago: University of Chicago Press, 1951), 260.

115 "It has been granted me..." Emanuel Swedenborg, *Heaven and Hell,* Standard Edition, Vol. 25 (New York: Swedenborg Foundation, 1960), 2.

116 "From all my experience..." Ibid., 39.

116 "Good spirits, with whom I have spoken about this matter, have been deeply grieved at such ignorance in the church about the condition of heaven and of spirits and angels; and in their displeasure they charged me to declare positively that they are not formless minds nor ethereal breaths, but are men in very form, and see, hear, and feel equally with those who are in the world." Ibid., 40.

116 "But it must be remembered..." Ibid., 40.

116 "Nature recites her lessons..." Ralph Waldo Emerson, "Swedenborg; or, The Mystic," *Essays and Lectures* (New York: The Library of America, 1983), 669.

116 "The Divine Image," *The Complete Poetry and Prose of William Blake,* 13.

116 "that angels descended to painters..." Allan Cunningham, *The Cabinet Gallery of Pictures* (1833), reprinted in *Blake Records,* 182–83. The lineation follows Peter Ackroyd, *Blake: A Biography* (New York: Alfred A. Knopf, 1996), 195.

PAGE The Story of Jacob's Wrestling with an Angel

118 "These are the moments..." James Merrill, "A Dedication," *Collected Poems,* ed. J. D. McClatchy and Stephen Yenser (New York: Alfred A. Knopf, 2001), 123.

119 "Der Engel": "The Angel." Rainer Maria Rilke, trans. Edward Snow, *New Poems (1907)*, 83.

120 "fraught with background." Eric Auerbach, *Mimesis: The Representation of Reality in Western Literature,* trans. Willard R. Trask (Princeton, N.J.: Princeton University Press, 1953), 12.

120 "Then he said: / Let me go…" *Genesis 32: 27–31. The Five Books of Moses,* trans. Everett Fox (New York: Schocken, 1995), 155, 157.

123 "Jack Miles points…" *God: A Biography* (New York: Alfred A. Knopf, 1995), 73.

123 "To Abraham, whose prophetic power…" Moses Maimonides, *The Guide for the Perplexed,* trans. M. Friedlander, Second Edition (New York: Dover, 1956), 162. Maimonides also quotes another passage that runs: "Before the angels have accomplished their task they are called men, when they have accomplished it they are angels."

124 "a frightful, heavy, highly sensual dream…" Thomas Mann, *Joseph and His Brothers,* trans. H. T. Lowe-Porter (London: Secker and Warburg, 1956), 58.

124 "The written page is no mirror…" *From the Book to the Book. An Edmond Jabès Reader,* trans. Rosmarie Waldrop (Hanover: Wesleyan University Press, 1991), 179.

124 "Harold Bloom comes close…" *The Book of J,* trans. David Rosenberg, interpreted by Harold Bloom (New York: Grove Weidenfeld, 1990), 217.

PAGE Concerning the Angels

126 "that well of darkness, that…" Rafael Alberti, *The Lost Grove: Autobiography of a Spanish Poet in Exile,* trans. Gabriel Burns (Berkeley: University of California Press, 1981), 258.

126 "There was magic, *duende*…" Ibid., 168.

126 "And then there was a kind…" Ibid., 259–60.

127 "The sea…" and "If my voice dies on land…" *The Owl's Insomnia: Poems by Rafael Alberti,* trans. Mark Strand (New York: Atheneum, 1973), 3, 9.

128 "Where is paradise..." Rafael Alberti, *Concerning the Angels,* trans. Christopher Sawyer-Lauçanno (San Francisco: City Lights, 1995), 5.

128 "Seeking you here..." Rafael Alberti, *Selected Poems,* trans. Ben Belitt (Berkeley: University of California Press, 1966), 71.

128 "I was like a comet..." Rafael Alberti, *The Lost Grove,* 260.

129 "The earth, nothing." Rafael Alberti, *Concerning the Angels,* 65.

129 "An inhabitant of darkness, I began..." Rafael Alberti, *The Lost Grove,* 260.

129 "The Angel of Numbers," "The Grade School Angels," "The Angel of Sand," "The Dead Angels," and "The Surviving Angel." Rafael Alberti, trans. Mark Strand, *The Owl's Insomnia,* 27, 53, 49, 61, 63.

130 C. B. Morris cites Alberti's 1931 statement about "the poets of today" in his book, *Surrealism and Spain 1920–1936* (London: Cambridge University Press, 1972), 44.

130 Gabriel García Márquez, "A Very Old Man with Enormous Wings," *Leaf Storm and Other Stories,* trans. Gregory Rabassa (New York: Bard, 1973), 155–67.

PAGE The Rilkean Angel

132 "It would not agree..." Rilke's letter cited in Ralph Freedman, *Life of a Poet,* 337.

133 "In *The Celestial Hierarchy*..." See Pseudo-Dionysius, *The Complete Works,* 153, 160–61.

133 "William Gass places Rilke's figures..." William H. Gass, *Reading Rilke,* 189.

134 "JM IS GOING UP..." James Merrill, *The Changing Light at Sandover* (New York: Alfred A. Knopf, 1982), 133.

134 "The angel of the *Elegies*..." Rilke's letter cited in *Selected Poetry,* 317.

135 "The identical angel..." "The Death of Mary," trans. Franz Wright, *The Unknown Rilke,* Expanded Edition (Oberlin, Ohio: Oberlin College Press, 1990), 77.

135 "The invocation *wrestles*..." Massimo Cacciari, *The Necessary Angel,* 11.

136 "Ibn 'Arabī's gnostic..." Indries Shah, *The Sufis,* 159.

136 "surely an inward cry..." William Gass, *Reading Rilke,* 59.

136 "A metaphysical fracture..." Massimo Cacciari, *The Necessary Angel,* 9.

137 "getting beyond Man..." Rilke's Nietzschean statement cited by Donald Prater, *A Ringing Glass,* 351.

137 "It is impossible to see..." Rilke cited by Ralph Freedman, *Life of a Poet,* 318.

138 "Affirmation of *life-AND-death*..." Rilke's letter, *Selected Poetry,* 317.

140 "*Gesang ist Dasein*: Song is existence." *The Sonnets to Orpheus* (1, 3). *The Essential Rilke,* Rev. ed., trans. Galway Kinnell and Hannah Liebmann (New York: The Ecco Press, 2000), 150–51.

PAGE Angel, Still Groping

141 "Will Grohmann early on identified..." Will Grohmann, *Paul Klee* (New York: Harry N. Abrams, n.d.), 357.

142 "The immaterial needs..." Klee's statement cited by Will Grohmann, *Paul Klee,* 347.

142 "The angel of judgment..." Gert Schiff, "Klee's Array of Angels," *Artforum,* Vol. 25, #9 (May 1988), 130, 132.

143 "With one eye, the angel gazes..." Jürgen Glaesemer's observation in "Klee and German Romanticism" is cited in Gert Schiff, Ibid., 129.

143 "Man's ability to measure..." Paul Klee, *The Thinking Eye, Notebooks,* Vol. 1 (New York: George Wittenborn, 1964), 407.

144 "In a piece..." Paul Klee's "Creative Credo" cited by Will Grohmann, *Paul Klee,* 181.

144 "really come out of the earth." Ibid., 347.

144 "Each must obey the command..." Ibid., 367.

145 "Klee was following..." See Mark Luprecht, *Of Angels, Things,*

and Death: Paul Klee's Last Painting in Context (New York: Peter Lang, 1999), 83.

146 "Grohmann plausibly interprets the scene…" Will Grohmann, *Paul Klee,* 360.

146 "Mark Luprecht also points…" Mark Luprecht, *Of Angels, Things, and Death,* 61.

The New Angel

147 "Benjamin bought the painting…" See Gershom Scholem, *Walter Benjamin: The Story of a Friendship* (London: Faber and Faber, 1982), 100.

147 "as a picture for meditation…" Gershom Scholem, "Walter Benjamin and His Angel," *On Jews and Judaism in Crisis,* 210.

147 "A Klee painting named…" Walter Benjamin, *Illuminations,* 257–58.

148 "O. K. Werckmeister points out…" "Walter Benjamin, Paul Klee, and the Angel of History." *Oppositions:* 25 (Fall 1982), 117.

148 "The Torah and the prayers…"; "For every second of time…" Walter Benjamin, *Illuminations,* 264.

149 "Benjamin prefaces the fourteenth section…" Ibid., 261.

149 "Gershom Scholem traces…" Gershom Scholem, "Walter Benjamin and His Angel," *On Jews and Judaism in Crisis,* 198–236.

149 Two versions of Walter Benjamin's enigmatic text "Agesilaus Santander" are printed in Walter Benjamin, *Selected Writings, Volume 2, 1927–1934,* ed. Michael W. Jennings, Howard Eiland, and Gary Smith, trans. Rodney Livingstone et al. (Cambridge, Mass.: Harvard University Press, 1999), 712–16. Both were written in August 1933 and remained unpublished in Benjamin's lifetime.

149 "The new name, he says, 'remains the name'…" Ibid., 712.

149 "an anagram for…" About Benjamin's hidden name, Scholem writes: "But even in the new transformation of the old name it retains its magic character. It is the name *Angelus Satanas* which joins together the angelic and demonic forces of life in the most

intimate union." Gershom Scholem, *On Jews and Judaism in Crisis,* 216, 217.

150 "We penetrate the mystery…" Walter Benjamin, "Surrealism: The Last Snapshot of the European Intelligentsia," *Reflections,* 190.

151 "The experience of the reader…" Gershom Scholem, *On Jews and Judaism,* 229.

PAGE Three American Angels

152 "our accomplished…" Ralph Waldo Emerson, *Journals,* Vol. 5, 218.

152 "I dreamed that I floated…" Ibid., Vol. 7, 525.

153 "the necessary angel." Wallace Stevens used a phrase from "Angel Surrounded by Paysans" as the title of his book *The Necessary Angel: Essays on Reality and the Imagination* (New York: Vintage, 1951).

153 "Angel Surrounded by Paysans," *The Collected Poems of Wallace Stevens* (New York: Alfred A. Knopf, 1968), 496–97.

153 "For the door is…" Gaston Bachelard, *The Poetics of Space,* trans. Maria Jolas (Boston: Beacon Press, 1969), 222.

154 "The question of how to represent…" *Letters of Wallace Stevens,* ed. Holly Stevens (New York: Alfred A. Knopf, 1966), 661.

155 "the way of thinking…" Wallace Stevens, "Imagination as Value," *The Necessary Angel,* 150.

155 All quotations from Donald Barthelme's story "On Angels" come from *Sixty Stories* (New York: E. P. Dutton, 1982), 135–37.

156 "I always imagine them…" Jorge Luis Borges, *Selected Non-Fictions,* 19.

PAGE Demon or Bird!

157 "Bachelard points out…" Gaston Bachelard, *The Poetics of Space,* 221.

157 Bachelard also cites Rilke's letter to Clara: "Works of art…" Ibid., 220.

157 "Robert Duncan's title..." Robert Duncan, "Out of the Black," *The Opening of the Field* (New York: Grove Press, 1960), 76.

158 "Every thing teaches..." Ralph Waldo Emerson, *Journals,* Vol. 10, 76.

158 "What is known..." Walt Whitman, "Song of Myself," *The Complete Poems,* 115.

158 "There is only one thing you can do..." Charles Olson, "Human Universe," *Selected Writings,* ed. Robert Creeley (New York: New Directions, 1966), 61.

158 "Today has no margins"; "Today has that special..." John Ashbery, *Self-Portrait in a Convex Mirror* (New York: Penguin, 1976), 79, 78.

158 Quotations from Walt Whitman, "Out of the Cradle Endlessly Rocking," *The Complete Poems,* 275–81.

159 "Shelley's invisible skylark..." "To a Skylark," *The Selected Poetry and Prose of Shelley,* 245–48.

161 "It is not upon you..." Walt Whitman, "Crossing Brooklyn Ferry," *The Complete Poems,* 193.

PAGE Between Two Contending Forces

162 "In a short personal lecture..." Denise Levertov, "Williams and the Duende," *The Poet in the World* (New York: New Directions, 1973), 257–66.

163 "Past that, past the image:..." William Carlos Williams, "The Sound of Waves," *The Collected Later Poems* (New York: New Directions, 1967), 172.

163 "I thought of myself as Springtime..." William Carlos Williams, *I Wanted to Write a Poem: The Autobiography of the Works of a Poet,* ed. Edith Heal (Boston: Beacon Press, 1958), 29.

164 "an anarchistic rage..." J. Hillis Miller, *Poets of Reality: Six Twentieth-Century Writers* (New York: Atheneum, 1969), 338.

164 "Between two contending forces..." William Carlos Williams, *Imaginations,* ed. Webster Schott (New York: New Directions, 1971), 32–33.

164 Williams said that *Spring and All* "was written when all the world was going crazy about typographical form and is really a travesty on the idea." William Carlos Williams, *I Wanted to Write a Poem,* 36.

164 "new forms, new names…" William Carlos Williams, *Imaginations,* 117.

164 "To refine, to clarify, to intensify…" Ibid., 89. Williams also claimed that "the imagination is supreme" (91) and declared that "I let the imagination have its own way to see if it could save itself" (116). He announced: "the imagination is an actual force comparable to electricity or steam" (120).

164 "so much depends…"; "the pot / gay with rough moss." Ibid., 138, 96.

165 "lifeless in appearance…" Ibid., 95.

PAGE The Sublime Is Now

166 "What can be truer…" Ralph Waldo Emerson, *Journals,* Vol. 5, 100.

166 "There may be two or three steps, according to the genius of each, but for every seeing soul there are two absorbing facts,— *I and the Abyss.*" *Journals of Ralph Waldo Emerson,* Vol. 10, ed. Edward Waldo Emerson and Waldo Emerson Forbes (Boston: Houghton Mifflin, 1914), 171.

166 "Oh! Blessed rage for order…" "The Idea of Order at Key West," *The Collected Poems of Wallace Stevens,* 130.

166 "The Soul should stand in Awe"; "No man saw awe." *The Complete Poems of Emily Dickinson,* ed. Thomas H. Johnson (Boston: Little, Brown, 1960), 338, 703.

166 "We are reasserting man's natural desire…" Barnett Newman, "The Sublime Is Now" (1948), excerpted from "The Ides of Art, Six Opinions on What Is Sublime in Art," in Herschel B. Chipp, *Theories of Modern Art: A Source Book by Artists and Critics* (Berkeley: University of California Press, 1973), 553. Hereafter cited as *Theories.*

167 "a democratized sublime." Irving Howe, *The American New-ness: Culture and Politics in the Age of Emerson* (Cambridge, Mass.: Harvard University Press, 1986), 37.

167 "Neither the action…" Mark Rothko, "The Romantics Were Prompted" (1947), excerpted in Herschel B. Chipp, *Theories,* 548.

167 "with *known* criteria…" Robert Motherwell's foreword to William C. Seitz's book *Abstract Expressionist Painting in America,* reprinted in *The Collected Writings of Robert Motherwell,* ed. Stephanie Terenzio (Berkeley: University of California Press, 1999), 257. Hereafter cited as *Collected Writings.*

167 "Their performances tended to be…" Henry Higgins and J. Myers, *To Be a Matador* (London: William Kimber, 1972), 153.

168 "A harsh poetry this, but poetry nevertheless, with the nostalgic imagery of the blues conceived as visual form, image, pattern and symbol—including the familiar trains (evoking partings and reconciliations) and the conjure women (who appear in these works with the ubiquity of the witches who haunt the drawing of Goya) who evoke the abiding mystery of the enigmatic women who people the blues…" Ralph Ellison, "The Art of Romare Bearden," *The Collected Essays of Ralph Ellison,* ed. John F. Callahan (New York: Random House, 1995), 691.

168 "Street-Corner Theology." Charles Simic, *Dime-Store Alchemy: The Art of Joseph Cornell* (New York: The Ecco Press, 1992), 70.

169 "even archaic artists…"; "Without monsters and gods…"; "I do not believe…" Mark Rothko, "The Romantics Were Prompted," in Herschel B. Chipp, *Theories,* 549.

PAGE In the Painting

171 "Painting is a state of being…Painting is self-discovery. Every good artist paints what he is." Jackson Pollock (1956), in Selden Rodman, *Conversations with Artists* (New York: Capricorn Books, 1961), 82.

171 "Our strength is transitional..." Ralph Waldo Emerson, "Plato; or, the Philosopher," *Essays and Lectures,* 641.

171 "For it is not metres..." Ralph Waldo Emerson, "The Poet," *Essays,* 220.

171 "At a certain moment..." Harold Rosenberg, "The American Action Painters," *Art News,* Vol. 51, No. 8 (December 1952), 22.

172 "Richard Poirier points out..." Richard Poirier, *The Renewal of Literature: Emersonian Reflections* (New Haven: Yale University Press, 1988), 13. Poirier also cites (15) William James's statement in *Principles of Psychology* ("The Stream of Thought"): "It then appears that the main end of our thinking is at all times the attainment of some other substantive part than the one from which we have just been dislodged. And we may say that the main use of the transitive parts is to lead us from one substantive conclusion to another."

172 "the children of Midas..." Richard Howard, *Alone with America: Essays on the Art of Poetry in the United States Since 1950,* Expanded Edition (New York: Atheneum, 1980), xiii.

173 "This is not automatism..." Frank O'Hara, "Jackson Pollock," *Art Chronicles 1954–1966* (New York: George Braziller, 1975), 13.

173 "My painting does not..." Jackson Pollock, "My Painting" (1947–48), reprinted in *Jackson Pollock: Interviews, Articles, and Reviews,* ed. Pepe Karmel (New York: The Museum of Modern Art, 1999), 17–18.

173 "the arena." Lee Krasner interviewed by B. H. Friedman in *Pollock Painting,* ed. Barbara Rose (New York: Agrinde Publications Ltd., 1980), n.p.

173 "And how we watched you..." Morton Feldman's memorial statement cited in *Such Desperate Joy: Imagining Jackson Pollock,* ed. Helen A. Harrison (New York: Thunder's Mouth Press, 2000), xix. For a vivid memoir of playing both of the cello parts in Feldman's piece for the soundtrack of Namuth's film, see Daniel Stern, "Morton Feldman's Glass Sequence," Ibid., 305–308.

174 "Ecstasy and anxiety…" See Irving Sandler, *The Triumph of American Painting: A History of Abstract Expressionism* (New York: Harper and Row, 1970), 111.

174 "What we bring back…" Douglas Crase, "Blue Poles," *The Revisionist* (Boston: Little, Brown and Co., 1981), 69.

174 "a sense of limitless…" Carter Ratcliff, *The Fate of a Gesture: Jackson Pollock and Postwar American Art* (New York: Farrar, Straus and Giroux, 1996), 3.

175 "I've had a period…" Jackson Pollock, *Jackson Pollock: A Catalogue Raisonné of Paintings, Drawings, and Other Works,* ed. Francis Valentine O'Connor and Eugene Victor Thaw, Vol. 4 (New Haven: Yale University Press, 1978), 261.

175 "The Black Pourings." See Francis V. O'Connor's catalog essay *The Black Pourings* (Boston: Institute of Contemporary Art, 1980). The aptness of the term is evaluated by Claude Cernuschi in his fine book *Jackson Pollock: Meaning and Significance* (New York: HarperCollins, 1992), 158.

176 "if she is not Cassandra…" Frank O'Hara, *Art Chronicles 1954–1966,* 36.

176 "its high, balding forehead…" Deborah Solomon, *Jackson Pollock: A Biography* (New York: Simon and Schuster, 1987), 223.

176 "energy and motion made visible." Karla Wolfangle's choreographer's statement, "Pollock Dances," in *Such Desperate Joy,* 397–98.

177 "It is the darkness…" Francis V. O'Connor, *The Black Pourings,* 10.

PAGE Paint It Black

178 "Light reversed itself…" Rafael Alberti, *To Painting,* trans. Carolyn L. Tipton (Evanston, Ill.: Northwestern University Press, 1997), 113.

178 "Salvador Dalí once told Franz Kline…" Cited in Deborah Solomon, *Jackson Pollock,* 217.

178 "Barnett Newman's breakthrough…" For a helpful discussion

of *Abraham,* see Thomas B. Hess, *Barnett Newman* (New York: The Museum of Modern Art, 1971), 59–61. Hess points to the historical precedents in Rodchenko's *Black on Black,* which was sometimes shown at the Museum of Modern Art, and thus available for Newman to see, and to Malevich's rumored black-on-black companion to his notorious painting *White on White.*

179 "dramas." "I think of my pictures as dramas; the shapes in the pictures are the performers. They have been created from the need for a group of actors who are able to move dramatically without embarrassment and execute gestures without shame." Mark Rothko, "The Romantics Were Prompted," *Theories,* 548.

179 "They are the breath..." Stanley Kunitz, "Mark Rothko," *A Kind of Order, A Kind of Folly: Essays and Conversations* (Boston: Atlantic–Little, Brown Books, 1975), 149.

179 "clear preoccupation..."; "all art deals..."; "tragic art..." Dore Ashton, *About Rothko* (New York: Oxford University Press, 1983), 154.

180 "He told Dominique de Menil..." Cited in Sheldon Nodelman, *The Rothko Chapel Paintings: Origins, Structure, Meaning* (Houston and Austin: The Menil Collection and the University of Texas Press, 1997), 92–93.

180 "the holy hush..." "Sunday Morning," *The Collected Poems of Wallace Stevens,* 67.

180 "In his definitive book..." Sheldon Nodelman, *The Rothko Chapel Paintings,* 99–100.

180 "I have been painting Greek temples..." Rothko's comment cited by Dore Ashton, *About Rothko,* 147.

181 "There is also an incipient..." Sheldon Nodelman points out that Rothko was hoping to achieve the same confrontational tension that impressed him in the twelfth-century basilica of Santa Maria Assunta. *The Rothko Chapel Paintings,* 93.

181 "these impersonal forms..." James E. B. Breslin, *Mark Rothko: A Biography* (Chicago: University of Chicago Press, 1998), 473.

181 "It is as if the entire content..." Robert Rosenblum, *Modern Painting and the Northern Romantic Tradition* (New York: Harper and Row, 1975), 218.

182 "I envisioned an immobile..." Morton Feldman, program note for *Rothko Chapel* (1972), first performed April 1972, The Rothko Chapel, Houston, Texas.

182 "the infinity of death..." Mark Rothko's statements cited in Sheldon Nodelman, *The Rothko Chapel Paintings,* 306.

183 "Noir has deep taproots..." Nicholas Christopher, *Somewhere in the Night: Film Noir and the American City* (New York: The Free Press, 1997), 36.

183 "The chemistry of the pigments..." Robert Motherwell, catalog note, *Black or White: Paintings by European and American Artists,* Kootz Gallery, February 28 to March 20, 1950. Reprinted in *Collected Writings,* 72.

PAGE Motherwell's Black

184 "profound compact..." Rafael Alberti, "Motherwell's Black," in *Robert Motherwell,* 2nd ed. (New York: Harry N. Abrams, 1982), 102. Text by H. H. Arnason.

184 "an art of opposite..." Robert Motherwell, "Homage to Franz Kline" (1962), *Collected Writings,* 133.

184 "a totally active..." "Letter from Robert Motherwell to O'Hara" (1965), Ibid., 153.

184 "His greatest fear..." Dore Ashton, "On Motherwell," *Robert Motherwell* (New York: Abbeville Press, 1983), 29.

184 "a ten-year education..." Robert Motherwell, "Interview with Sidney Simon" (1967), *Collected Writings,* 159.

184 "The fundamental principle..." Robert Motherwell, "Two Letters on Surrealism" (1978), Ibid., 230.

185 "a process in which..." "An Interview with Robert Motherwell," *Robert Motherwell* (Abrams), 228.

185 "I now prefer the usage 'artful scribbling.'" Robert Motherwell

commenting on his own untitled drawing on India ink in tracing paper, Ibid., 116.

185 "Doodling is the brooding of the hand." Motherwell cites Saul Steinberg's statement in "Letter to Edward Hemming" (1978), *Collected Writings,* 230.

185 "its own identity…" Robert Motherwell, "The Significance of Miró" (1959), Ibid., 120.

185 "Rather than setting out…" Joan Miró, excerpt from a 1947 interview with James Johnson Sweeney, *Theories,* 435.

186 "postgraduate education…" Robert Motherwell, "Interview with Sidney Simon," Ibid., 159.

186 "All ancient…" Robert Motherwell, "Letter to John" (1956), Ibid., 110.

186 "All my life…" Robert Motherwell, "Interview with Bryan Robertson, Addenda" (1965), Ibid., 141.

187 "a Spanish accent." Dore Ashton writes: "If *duende* appears, and it does not always do so in Motherwell's insistent recapitulation of motifs, it appears rightfully as the 'blackest of sounds.' Not *duende* as such: In Motherwell's vocabulary there are other designations. He speaks of his 'demonic' side, aptly using Nietzschean terminology. Quite often the demonic side speaks with a Spanish accent, an acquired dialect that has never failed to set off something quite incalculable in Motherwell's soul." "On Motherwell," Dore Ashton, *Robert Motherwell,* 41.

187 "A twentieth-century American…" Robert Motherwell's statement for a 1973 show of his recent work is cited by Robert T. Buck, "Introduction," Ibid., 7.

187 "six basic types or 'families'." "There may be, say, generically six basic families of painting-minds…" "An Interview with Robert Motherwell," *Robert Motherwell* (Abrams), 231.

187 "Spanish black…" Section Four of Rafael Alberti's poem "Black," Ibid., 178.

188 "He especially admired..." "The Modern Painter's World" (1944), *Collected Writings,* 30.

188 "The 'temple' was consecrated..." Robert Motherwell quoted in April Kingsley, *The Turning Point* (New York: Simon and Schuster, 1992), 309.

189 "To make an Elegy..." Barbara Guest's 1962 poem "All Elegies Are Black and White," in *Robert Motherwell* (Abrams), 100.

189 "Black of this land..." Rafael Alberti, "Motherwell's Black," Ibid., 102.

189 "They have been compared..." Jack Flam's summary in "With Robert Motherwell," *Robert Motherwell,* 11.

190 "an archetypical image." "An Interview with Robert Motherwell," *Robert Motherwell* (Abrams), 228.

190 "My *Spanish Elegies*..." "Robert Motherwell: A Conversation at Lunch" (1962), *Collected Writings,* 137.

190 "a massing of black..." "An Interview with Robert Motherwell," *Robert Motherwell* (Abrams), 229.

190 "I can enter you..." Rafael Alberti, "Motherwell's Black," Ibid., 102.

PAGE Deaths and Entrances

191 "doom-eager." Martha Graham, "Martha Graham Speaks," *Dance Observer* (April 1963), 53.

191 "In his *New York Times* review, John Martin..." Agnes de Mille, *Martha: The Life and Work of Martha Graham* (New York: Random House, 1991), 252.

191 "a poem in the associative..." Edwin Denby, *Dance Writings and Poetry,* 108.

191 "Graham was herself..." Agnes de Mille points out that it was widely considered in Graham's company that the three female characters were in truth Martha and her two sisters. Agnes de Mille, *Martha,* 251.

192 "a modern psychological portrait..." Martha Graham's 1984 interview with Anna Kisselgoff is cited in Agnes de Mille, *Martha,* 252–53.

192 "Ernestine Stodelle provides..." *Deep Song: The Dance Story of Martha Graham* (New York: Schirmer Books, 1984), 123–24.

192 "*Deaths and Entrances...*"; "In one climactic solo..." Deborah Jowitt, *Time and the Dancing Image* (Berkeley: University of California Press, 1988), 211–12.

194 "Tonight in *Deaths and Entrances...*" Martha Graham, *The Notebooks of Martha Graham* (New York: Harcourt Brace Jovanovich, 1973), 87.

194 "that mysterious spiritual force..." Arlene Croce, *Writing in the Dark, Dancing in The New Yorker* (New York: Farrar, Straus and Giroux, 2000), 37.

194 "In a revisionist essay..." Elizabeth Dempster, "Women Writing the Body: Let's Watch a Little How She Dances," *The Routledge Dance Studies Reader,* ed. Alexandra Carter (New York: Routledge, 1998), 224.

195 "clean emotion angelically..." George Balanchine, "The American Dancer," *Dance News* (April 1944), 3, 6.

195 "the dancers fall so that they may rise." Martha Graham's statement is quoted by Elizabeth Dempster, "Women Writing the Body...," *The Routledge Dance Studies Reader,* 224.

Ancient Music and Fresh Forms

196 "Walt! We're downstairs..." John Berryman, "Despair," *Collected Poems 1937–1971,* ed. Charles Thornbury (New York: Farrar, Straus and Giroux, 1989), 208.

196 "All intoxication arises..." Walter F. Otto, *Dionysus: Myth and Cult,* trans. Robert B. Palmer (Bloomington: Indiana University Press, 1965), 140.

197 "comes from the first sob..." Federico García Lorca, "Deep Song," *Deep Song,* 30.

197 "In 'Introduction to Flamenco,' his first"...See *Living with Music: Ralph Ellison's Jazz Writings,* ed. Robert G. O'Meally (New York: The Modern Library, 2001), 95–100.

198 "In another piece, Ellison…" "As the Spirit Moves Mahalia." Ibid., 88–89.

199 "Stones in My Passway," "Me and the Devil Blues," and "Hellhound on My Trail" are all included and cited from the sixteen tracks of *Robert Johnson: King of the Delta Blues* (Columbia 1654).

200 "the only memory in American art…" Greil Marcus, *Mystery Train: Images of America in Rock 'N' Roll Music* (New York: Plume, 1990), 22.

200 "The words 'got to keep moving' disrupt…"; "We have reached…" Wilfrid Mellers, *Music in a New Found Land,* 272.

201 "deep song sings…" Federico García Lorca, "Deep Song," *Deep Song,* 32.

PAGE America Heard in Rhythm

202 "the difference between a good…"; "a momentary burst of inspiration…" Lorca's statements from "Architecture of Deep Song" cited by Christopher Maurer, *In Search of Duende,* viii.

202 "Jazz as Was." *Every Shut Eye Ain't Asleep: An Anthology of Poetry by African Americans Since 1945,* ed. Michael S. Harper and Anthony Walton (Boston: Little, Brown and Co., 1994), 198.

202 "something one of his biographers…" James Lincoln Collier, *Louis Armstrong: An American Genius* (New York: Oxford University Press, 1983), 194.

203 "After the first chorus, however, Armstrong…" Wilfrid Mellers, *Music in a New Found Land,* 304.

203 "almost certainly the most nearly perfect…" James Lincoln Collier, *Louis Armstrong,* 196.

203 "And thenceforward all summer…" Walt Whitman, "Out of the Cradle Endlessly Rocking," *The Complete Poems,* 276.

204 "turning the almost ridiculous…" Gary Giddins, *Visions of Jazz,* 278.

204 "Music is your own experience…" Michael Levin and John S. Wilson, "No Bop Roots in Jazz: Parker," *Downbeat,* September 9, 1949, 19.

204 "If you don't live it, it won't come out of your horn." Charlie Parker's statement cited in Wilfrid Mellers, *Music in a New Found Land,* 343.

204 "Bird in Orbit." *The Collected Poems of Langston Hughes,* ed. Arnold Rampersad (New York: Alfred A. Knopf, 1994), 515.

205 "the tragic quality..." See Wilfrid Mellers, *Music in a New Found Land,* 352.

205 "It has no exact English..." Kenneth Tynan, "The Antic Arts: Miles Apart," *Holiday,* Vol. 33, No. 2 (February 1963), 108.

205 "Miles conceived these settings..." Bill Evans liner notes to *Kind of Blue* (Columbia CK 64935).

205 "Two recent books on the making..." Ashley Kahn, *Kind of Blue: The Making of the Miles Davis Masterpiece* (New York: Da Capo Press, 2000); Eric Nisenson, *The Making of Kind of Blue: Miles Davis and His Masterpiece* (New York: St. Martin's Press, 2000).

205 "I didn't write out the music..." Miles Davis with Quincy Troupe, *Miles: The Autobiography* (New York: Simon and Schuster, 1989), 234.

206 "There is a Japanese visual art..." Bill Evans liner notes to *Kind of Blue.*

PAGE Hey, I'm American, So I Played It

207 "The Guitar." Federico García Lorca, trans. Robert Bly, *Lorca and Jiménez; Selected Poems,* 117.

207 "he may as well be standing..." James McManus, *Great America* (New York: HarperCollins, 1993), 96–97.

208 " 'Hey, all I do is play it,' he says / a week or so later on Dick Cavett. / 'I'm American, so I played it. They made me sing it / in school, so it's sort of a flashback.' " Ibid., 98.

208 "Coltrane was my Orpheus..." Charles H. Rowell, " 'Down Don't Worry Me': An Interview with Michael S. Harper," *Callaloo* 13 (1990), 791.

209 "The center of the world..." Denis Johnson, *The Incognito Lounge and Other Poems* (New York: Random House, 1982), 5–6.

210 "I saw the best minds…" Allen Ginsberg, "Howl," *Collected Poems 1947–1980* (New York: Harper and Row, 1984), 126.

210 "a poetry that goes deep into…" Robert Bly, "The Dead World and The Live World," *American Poetry: Wildness and Domesticity* (New York: Harper and Row, 1990), 238.

210 "radical presence…" Charles Altieri, *Enlarging the Temple: New Directions in American Poetry during the 1960s* (Lewisburg, Pa.: Bucknell University Press, 1979), 78.

211 "riding on dragons…" Robert Bly, "Looking for Dragon Smoke," *Leaping Poetry: An Idea with Poems and Translations* (Boston: Beacon Press, 1975), 1.

211 "Bly also invokes Lorca's notion…" "Wild Association," Ibid., 28–30.

211 "The one who writes a poem…" Joseph Brodsky, "Uncommon Visage," *On Grief and Reason: Essays* (New York: Farrar, Straus and Giroux, 1995), 58.

PAGE Fending Off the Duende

213 "One of the most notable…" Federico García Lorca, "Deep Song," *Deep Song,* 32.

213 "Poetry is a dream…" Tomasso Ceva's (1649–1736) statement cited by Eugenio Montale, "Aesthetics and Criticism," *The Second Life of Art,* 131.

213 "Savage Landor topped us all…" William Butler Yeats, *Mythologies,* 328.

213 "Yeats is even more explicit…" William Butler Yeats, *A Vision,* 144–45.

214 "For My Contemporaries," "Interview with Doctor Drink," "Montana Fifty Years Ago." *The Poems of J. V. Cunningham,* ed. Timothy Steele (Athens, Ohio: Swallow Press/Ohio University Press, 1997), 14, 54, 93.

214 "Instead of a curtain falling…" L. E. Sissman, *Innocent Bystander: The Scene from the '70's* (New York: The Vanguard

Press, 1975), p. 251. For a fuller discussion, see Edward Hirsch, "Brightness Undimmed: L. E. Sissman (1928–1976)," foreword to *Night Music* (Boston: Houghton Mifflin, 1999), xi–xvii.

215 "More Light! More Light!" Anthony Hecht, *Collected Earlier Poems* (New York: Alfred A. Knopf, 1990), 64–65.

216 "Rites and Ceremonies"; "Behold the Lilies of the Field," Ibid., 38–47, 10–12.

217 "the heaviest of human afflictions." W. Jackson Bate, *Samuel Johnson* (New York: Harcourt Brace Jovanovich, 1977), 383.

217 "a powerful unconscious need..." Ibid., 382.

218 "He tells the story..." Johnson's friends "felt the same relief that the young artist Ozias Humphrey felt on first meeting Johnson in his rooms at Inner Temple Lane (September 1764) when, during the long silence at the start, he thought himself in the presence of a 'madman' until at last Johnson began to talk, and 'faith...everything he says is as *correct as a second edition.*'" Ibid., 372.

218 "Of all the uncertainties of our present state..." Ibid., 384.

218 "It comes over me..." *Byron's Letters and Journals,* ed. Leslie A. Marchand, Vol. 8: 1821 (Cambridge, Mass.: Harvard University Press, 1978), 55.

218 "Poetry... is the lava..." Ibid., Vol. 3: 1813–1814 (Cambridge, Mass.: Harvard University Press, 1974), 179.

PAGE The Existentialist Flatfoot Floogie

220 "the beautiful American word, *sure.*" Delmore Schwartz, *Selected Poems: Summer Knowledge* (New York: New Directions, 1959), 27.

220 "'Sure,' said Benny Goodman," Hayden Carruth, *Collected Shorter Poems,* 361.

221 "Love Calls Us to the Things of This World." Richard Wilbur, *New and Collected Poems* (New York: Harcourt Brace Jovanovich, 1988), 233.

Poet in New York

222 "my *spiritualized* new manner..." Lorca's letter to Sebastiá Gasch cited in Ben Belitt's translation of *Poet in New York,* 178.

222 "Now I am writing..." Lorca's letter to Jorge Zalamea cited in Ian Gibson, *FGL: A Life,* 221.

223 "all Granada would fit..." Federico García Lorca, "The Poet Writes to His Family," *Poet in New York,* 203.

224 "In the sky..." From "City that Does Not Sleep." Federico García Lorca, trans. Robert Bly, *Lorca and Jiménez,* 159.

226 "the vigil of modern man..." Christopher Maurer, "Introduction," *Poet in New York,* xix.

226 "prodigious, but infinitely sad." Lorca's letter to Ángel del Río cited in Ben Belitt, trans., *Poet in New York,* 181.

Reading List
The Pleasure of the Text

THIS IS A LIST OF THE KEY FIGURES, of the necessary books, works of art, and pieces of music cited in the main body of the text. It is not a full bibliography, but a record of what has most urgently called out to me in the writing of this book. It is a catalog of studied pleasures, of recommended readings, visual guides, and crucial soundings.

Preface

García Lorca, Federico. "The Duende: Theory and Divertissement," *Poet in New York.* Trans. Ben Belitt. New York: Grove Press, 1955.

———. "Play and Theory of the Duende," *Deep Song and Other Prose.* Ed. and trans. Christopher Maurer. New York: New Directions, 1980. Includes "On Lullabies," "Deep Song," "The Poetic Image of Don Luis de Góngora," "On the *Gypsy Ballads,*" "*From* The Life of García Lorca, Poet," and other pieces.

 Christopher Maurer's translation is also included in his gathering of Lorca's writings about duende and about three art forms especially susceptible to it: art, dance, and bullfighting: *In Search of Duende.* New York: New Directions, 1998.

Emerson, Ralph Waldo. "The Poet," "Circles." In *Essays: First and Second Series.* New York: Vintage/Library of America, 1990.

 I quote throughout this book from *The Journals and Miscellaneous Notebooks of Ralph Waldo Emerson,* ed. William H. Gilman et al. 16 vols. Cambridge, Mass.: Harvard University

Press, 1960–82. For a good compendium, see *Emerson in His Journals.* Selected and edited by Joel Porte. Cambridge, Mass.: Harvard University Press, 1982. For an excellent biography, see Robert Richardson, Jr. *Emerson: The Mind on Fire.* Berkeley: University of California Press, 1995.

Only Mystery

Gibson, Ian. *Federico García Lorca: A Life.* New York: Pantheon, 1989.

Stainton, Leslie. *Lorca: A Dream of Life.* New York: Farrar, Straus and Giroux, 1999.

Hernández, Mario. *Line of Light and Shadow: The Drawings of Federico García Lorca.* Trans. Christopher Maurer. Durham, N.C.: Duke University Press, 1991.

Neruda, Pablo. *Memoirs.* Trans. Hardie St. Martin. New York: Penguin, 1978.

Neruda and Vallejo: Selected Poems. Ed. Robert Bly. Boston: Beacon Press, 1971.

Selected Poems of Rubén Darío. Ed. Alberto Acereda et al. Lewisburg, Pa.: Bucknell University Press, 2001.

Invoking the Duende

García Lorca, Federico. "Lecture: A Poet in New York," *Poet in New York.* Ed. Christopher Maurer. Trans. Greg Simon and Steven F. White. New York: Farrar, Straus and Giroux, 1988.

Poetic Fact

García Lorca, Federico. *Obras completas.* Ed. Arturo del Hoyo. 3 vols. Madrid: Aguilar, 1986.

———. *The Selected Poems of Federico García Lorca.* Ed. Francisco García Lorca and Donald M. Allen. New York: New Directions, 1961.

———. *Collected Poems.* Ed. Christopher Maurer. New York: Farrar, Straus and Giroux, 1991.

Lorca and Jiménez: Selected Poems. Trans. Robert Bly. Boston: Beacon Press, 1973.

Crane, Hart. "General Aims and Theories," *The Complete Poems and Selected Letters and Prose of Hart Crane.* Ed. Brom Weber. Garden City, N.Y.: Anchor, 1966.

Keats, John. *Complete Poems and Selected Letters of John Keats.* Introduction by Edward Hirsch. New York: Modern Library, 2001.

A Mysterious Power

Josephs, Allen. *White Wall of Spain: The Mysteries of Andalusian Culture.* Ames: Iowa State University Press, 1983.

García Lorca, Federico. *Five Plays by Lorca: Comedies and Tragicomedies.* Trans. James Graham-Lujan and Richard L. O'Connell. Introduction by Francisco García Lorca. New York: New Directions, 1963.

―――. *Three Plays: Blood Wedding, Yerma, The House of Bernarda Alba.* Trans. Michael Dewell and Carmen Zapata. Introduction by Christopher Maurer. New York: Farrar, Straus and Giroux, 1993.

ON FLAMENCO MUSIC:

Mitchell, Timothy. *Flamenco Deep Song.* New Haven: Yale University Press, 1994.

Pohren, D. E. *Lives and Legends of Flamenco: A Biographical History.* Seville, Spain: Society of Spanish Studies, 1964.

Claus Schreiner, ed. *Flamenco: Gypsy Dance and Music from Andalusia.* Trans. Mollie Comerford Peters. Portland, Ore.: Amadeus Press, 1996.

Serrano, Juan, and Jose Elgorriaga. *Flamenco, Body and Soul: An Aficionado's Introduction.* Fresno: The Press at California State University, Fresno, 1990.

Woodall, James. *In Search of the Firedance: Spain Through Flamenco.* London: Sinclair-Stevenson, 1992.

Zagajewski, Adam. "Flamenco," *Solidarity, Solitude.* Trans. Lillian Vallee. New York: The Ecco Press, 1990.

The Hidden Spirit of Disconsolate Spain

Manuel de Falla's essay on *cante jondo* appears in his collection *On Music and Musicians*. Trans. David Urman and J. M. Thomson. Boston: Marion Boyers, 1979.

The Essential Falla (Decca, 2CD) contains Falla's major works, including excellent performances of *El amor brujo* (*Love the Magician*), *Noches en los jardines de España* (*Nights in the Gardens of Spain*), and *El Sombrero de tres picos* (*The Three-Cornered Hat*).

Four relevant films directed by Carlos Saura: *Bodas de Sangre/Blood Wedding* (1981), *Carmen* (1983), *El amor brujo/Love the Magician* (1986), and *Flamenco* (1995).

Rubin, William, et al. *Les Demoiselles D'Avignon.* Studies of Modern Art, No. 3. New York: Museum of Modern Art, 1994.

ON BULLFIGHTING:

Hemingway, Ernest. *Death in the Afternoon.* New York: Charles Scribner, 1932.

Kennedy, A. L. *On Bullfighting.* New York, N.Y.: Anchor, 2001.

Schubert, Adrian. *Death and Money in the Afternoon: A History of the Spanish Bullfight.* New York: Oxford University Press, 1999.

An Apprenticeship

Dalí, Salvador. "Saint Sebastian," *The Collected Writings of Salvador Dalí.* Ed. Haim Finkelstein. Cambridge, Mass.: Cambridge University Press, 1998.

Binding, Paul. *Lorca: The Gay Imagination.* London: GMP, 1985.

Hernández, Miguel. *The Selected Poems of Miguel Hernández.* Ed. Ted Genoways. Chicago: University of Chicago Press, 2001.

Gibson, Ian. *The Assassination of Federico García Lorca.* New York: Penguin, 1983.

Between Eros and Thanatos

Barkan, Elazar, and Ronald Bush, eds. *Prehistories of the Future: The*

Primitivist Project and the Culture of Modernism (Cultural Sit-ings). Stanford: Stanford University Press, 1995.

Hiller, Susan, ed. *The Myth of Primitivism: Perspectives on Art*. New York: Routledge, 1991.

Berlin, Isaiah. *Vico and Herder: Two Studies in the History of Ideas*. New York: Viking, 1976.

The Majesty of the Incomprehensible

Paz, Octavio. *The Labyrinth of Solitude: Life and Thought in Mexico*. Trans. Lysander Kemp. New York: Grove, 1961.

Leonard Bernstein's controversial production of George Bizet's *Carmen,* starring Marilyn Horne and recorded in 1973 around the time of the Metropolitan Opera production, still has great passion. Deutsche Grammophone, 2CD.

Jean-Yves Thibaudet gives a splendid rendition of Claude Debussy's "La Soirée dans Granada" (*Estampes*) and *Ibéria* (*Images*): *Piano Music,* Vol. 1 and 2, Decca.

Charles Dutoit directs the Montreal Symphony in inspired versions of Maurice Ravel's *Boléro* and *Rhapsodie espanole,* as part of their recording of Ravel's entire orchestral output. London, 4CD.

Rimbaud, Arthur. *Complete Works*. Trans. Paul Schmidt. New York: Harper and Row, 1975.

Lautréamont, Comte de. *Maldoror & The Complete Works of the Comte de Lautréamont*. Trans. Alexis Lykiard. Boston: Exact Change, 1994.

St. Martin, Hardie, ed. *Roots and Wings: Poetry from Spain 1900–1975*. New York: Harper and Row, 1976.

Barnstone, Willis, ed. *Modern European Poetry*. New York: Bantam, 1966.

A Spectacular Meteor

Freedman, Ralph. *Life of a Poet: Rainer Maria Rilke*. New York: Far-rar, Straus and Giroux, 1996.

Prater, Donald. *A Ringing Glass: The Life of Rainer Maria Rilke*. Oxford: Clarendon Press, 1986.

Rilke, Maria Rainer. *Sämtliche Werke.* Ed. Ruth Sieber Rilke and Ernest Zinn. 6 vols. Frankfurt: Insel, 1955–66.

Throughout this book, I rely on many different translations of Rilke's works:

The Essential Rilke. Trans. Galway Kinnell and Hannah Liebmann. New York: The Ecco Press, 1999.

New Poems (1907). Trans. Edward Snow. San Francisco: North Point Press, 1984.

New Poems (1908). The Other Part. Trans. Edward Snow. San Francisco: North Point Press, 1987.

The Notebooks of Malte Laurids Brigge. Trans. Stephen Mitchell. New York: Random House, 1983.

The Selected Poetry of Rainer Maria Rilke. Trans. Stephen Mitchell. Introduction by Robert Hass. New York: Random House, 1987.

Uncollected Poems. Trans. Edward Snow. New York: North Point Press, 1996.

The Unknown Rilke. Trans. Franz Wright. Introduction by Egon Schwartz. Oberlin, Ohio: Oberlin College Press, 1990.

See also: Joseph Brodsky. "Ninety Years Later," *On Grief and Reason: Essays.* New York: Farrar, Straus and Giroux, 1995.

Gass, William H. *Reading Rilke: Reflections on the Problems of Translation.* New York: Alfred A. Knopf, 1996.

CHARLES BAUDELAIRE:

Les Fleurs du Mal. Trans. Richard Howard. Boston: David Godine, 1982.

The Painter of Modern Life and Other Essays. Ed. and trans. Jonathan Mayne. New York: Da Capo, 1964.

Twenty Prose Poems. Trans. Michael Hamburger. San Francisco: City Lights, 1988.

Benjamin, Walter. "On Some Motifs in Baudelaire," *Illuminations.* Ed. Hannah Arendt. Trans. Harry Zohn. New York: Schocken, 1969.

———. "Paris, Capital of the Nineteenth Century," *Reflections: Essays, Aphorisms, Autobiographical Writings.* Ed. Peter Demetz. Trans. Edmund Jephcott. New York: Harcourt Brace Jovanovich, 1978.

Swooping In

O'Hara, Frank. *The Selected Poems of Frank O'Hara.* Ed. Donald Allen. New York: Random House, 1974.

Holiday, Billie, with William Dufty. *Lady Sings the Blues.* Garden City, N.Y.: Doubleday, 1956.

Ardent Struggle, Endless Vigil

Bennahaum, Ninotchka Devorah. *Antonia Mercé, "La Argentina": Flamenco and the Spanish Avant Garde.* Hanover: University Press of New England, 1999.

Shelley, Percy Bysshe. "A Defense of Poetry," *The Selected Poetry and Prose of Shelley.* Ed. Harold Bloom. New York: New American Library, 1966.

Nietzsche, Friedrich. *The Birth of Tragedy and the Case of Wagner.* Trans. Walter Kaufmann. New York: Vintage, 1967.

Otto, Walter F. *Dionysus: Myth and Cult.* Trans. Robert B. Palmer. Bloomington: Indiana University Press, 1965.

Porter, James. *The Invention of Dionysus: An Essay on the Birth of Tragedy.* Stanford: Stanford University Press, 2000.

The Black Paintings

Bozal, Valeriano. *Pinturas Negras de Goya.* Madrid: Tf. Editores, 1997.

Malraux, André. "Goya," *Writers on Artists.* Ed. Daniel Halpern. San Francisco: North Point Press, 1988.

Gassier, Pierre, and Juliet Wilson. *The Life and Complete Work of Francisco Goya.* Ed. François Lachenel. New York: Reynal & Co. / William Morrow & Co., 1971.

The Intermediary

von Goethe, Johann Wolfgang. *Conversations with Eckermann (1823–1832).* Trans. John Oxenford. San Francisco: North Point Press, 1984.

Dodds, E. R. *The Greeks and the Irrational.* Berkeley: University of California Press, 1951.

Cacciari, Massimo. *The Necessary Angel.* Trans. Miguel E. Vatter. Albany: State University of New York Press, 1994.

Plato: The Collected Dialogues. Ed. Edith Hamilton and Huntington Cairns. Bollingen Series LXII. Princeton, N.J.: Princeton University Press, 1961.

Bloom, Harold. *Omens of Millennium: The Gnosis of Angels, Dreams, and Resurrection.* New York: Riverhead, 1996.

Yeats's Daimon

Yeats, William Butler. *The Collected Plays of W. B. Yeats.* New York: Macmillan, 1952.

Memoirs. Ed. Denis Donoghue. New York: Macmillan, 1973.

Mythologies. New York: Macmillan, 1961.

The Poems of W. B. Yeats: A New Edition. Ed. Richard J. Finneran. New York: Macmillan, 1983.

A Vision. New York: Macmillan, 1966.

Ars Poetica?

Herbert, Zbigniew. *Mr. Cogito.* Trans. John Carpenter and Bogdana Carpenter. New York: The Ecco Press, 1993.

———. *Report from the Besieged City.* Trans. John Carpenter and Bogdana Carpenter. New York: The Ecco Press, 1985.

Milosz, Czeslaw. *The Collected Poems.* New York: The Ecco Press, 1988.

———. *The Witness of Poetry.* Cambridge, Mass.: Harvard University Press, 1983.

Czarnecka, Ewa, and Aleksander Fuit. *Conversations with Czeslaw Milosz.* New York: Harcourt Brace Jovanovich, 1987.

Szymborska, Wislawa. *Poems New and Collected 1957–1997.* Trans. Stanislaw Baranczak and Clare Cavanagh. New York: Harcourt Brace, 1998.

Zagajewski, Adam. *Without End: New and Selected Poems.* Trans. Clare Cavanagh. New York: Farrar, Straus and Giroux, 2002.

A Passionate Ingredient

Sappho: A Garland. The Poems and Fragments of Sappho. Trans. Jim Powell. New York: Farrar, Straus and Giroux, 1993.

The Metamorphoses of Ovid. Trans. Allen Mandelbaum. New York: Harcourt Brace, 1993.

Ovid's Poetry of Exile. Trans. David Slavitt. Baltimore: The Johns Hopkins University Press, 1990.

The Seafarer. In *Ezra Pound: Translations.* Introduction by Hugh Kenner. New York: New Directions, 1963.

Beowulf. Trans. Seamus Heaney. New York: Farrar, Straus and Giroux, 2000.

Winters, Yvor. *In Defense of Reason, Primitivism and Decadence: A Study of American Experimental Poetry.* Denver and New York: The Swallow Press / William Morrow and Co., 1947.

Smart, Christopher. *Selected Poems.* Ed. Karina Williamson and Marcus Walsh. New York: Penguin, 1990.

Pope, Alexander. *Pope's Iliad.* A selection with commentary. Ed. Felicity Rosslyn. Bristol, England: Bristol Classical Press, 1985.

Ackroyd, Peter. *Blake: A Biography.* New York: Alfred A. Knopf, 1996.

The Complete Poetry and Prose of William Blake. Ed. David V. Erdman. Rev. ed. Berkeley: University of California Press, 1982.

The Yearning Cry of a Shade

Leopardi, Giacomo. *A Leopardi Reader.* Ed. and trans. Ottavio Mark Casale. Urbana, Ill.: University of Illinois Press, 1981.

de Nerval, Gérard. *Selected Writings.* Trans. Geoffrey Wagner. Ann Arbor: University of Michigan Press, 1970.

Lippard, Lucy R., ed. *Surrealists on Art.* Englewood Cliffs, N.J.: Prentice-Hall, 1970.

Heine, Heinrich. *The Complete Poems of Heinrich Heine. A Modern English Version.* Trans. Hal Draper. Boston: Suhrkamp / Insel, 1982.

I Sing You, Wild Chasm

Matthiessen, F. O. *American Renaissance: Art and Expression in the Age of Emerson and Whitman.* New York: Oxford University Press, 1972.

Ives, Charles. *Essays Before a Sonata, The Majority, and Other Writings.* Ed. Howard Boatwright. New York: W. W. Norton, 1970.

Poe, Edgar Allan. "The Imp of the Perverse," *Tales and Sketches, Volume 2, 1843–1849.* Ed. Thomas Ollive Mabbott. Urbana, Ill.: University of Illinois Press, 2000.

Hopkins, Gerard Manley. *Poems and Prose.* Ed. W. H. Gardner. New York: Penguin, 1981.

The Second Life of Art: Selected Essays of Eugenio Montale. Ed. and trans. Jonathan Galassi. New York: The Ecco Press, 1982.

Campana, Dino. *Orphic Songs.* Trans. I. L. Salomon. New York: October House, 1968.

Song of the West: Selected Poems of Georg Trakl. Trans. Robert Firmage. San Francisco: North Point Press, 1988.

Night Work

Bidart, Frank. "Dark Night," *In the Western Night: Collected Poems 1965–1990.* New York: Farrar, Straus and Giroux, 1990.

San Juan de la Cruz's Spanish text is also included in John Frederick Nims. *Sappho to Valéry: Poems in Translation.* New Brunswick, N.J.: Rutgers University Press, 1971.

Tsvetaeva, Marina. *Art in the Light of Conscience: Eight Essays on Poetry.* Trans. Angela Livingstone. Cambridge, Mass.: Harvard University Press, 1992.

Selected Poems of Marina Tsvetayeva. Trans. Elaine Feinstein. New York: E. P. Dutton, 1986.

Joseph Brodsky speaks eloquently about Tsvetaeva in Solomon Volkov's *Conversations with Joseph Brodsky: A Poet's Journey Through the Twentieth Century.* Trans. Marian Schwartz. New York: The Free Press, 1998. See his essay, "A Poet and

Prose," *Less Than One: Selected Essays.* New York: Farrar, Straus and Giroux, 1986.

Eliot, T. S. *The Waste Land: A Facsimile and Transcript of the Original Drafts Including the Annotations of Ezra Pound.* Ed. Valerie Eliot. New York: Harcourt Brace Jovanovich, 1972.

———. "The Three Voices of Poetry." *On Poetry and Poets.* New York: Farrar, Straus and Cudahy, 1957.

Vallejo, César. *The Complete Posthumous Poetry.* Trans. Clayton Eshleman and José Rubia Barcia. Berkeley: University of California Press, 1978.

———. *Trilce.* Trans. Clayton Eshleman. Introduction Américo Ferrari. Hanover: Wesleyan University Press, 2000.

Vegetable Life, Airy Spirit

Roethke, Theodore. *The Collected Poems of Theodore Roethke.* Garden City, N.Y.: Doubleday, 1966.

On the Poet and His Craft: Selected Prose of Theodore Roethke. Ed. Ralph J. Mills, Jr. Seattle: University of Washington Press, 1966.

Straw for the Fire: From the Notebooks of Theodore Roethke, 1943–1963. Selected by David Wagoner. Garden City, N.Y.: Doubleday, 1972.

Plath, Sylvia. *The Collected Poems.* New York: Harper and Row, 1981.

A Person Must Control His Thoughts in a Dream

There is a rich psychological literature on creativity and the creative process. A few books I have found helpful in thinking about the mental state conducive to creativity:

Arieti, Silvano. *Creativity: The Magic Synthesis.* New York: Basic Books, 1976.

Csikszentmihalyi, Mihaly. *Creativity: Flow and the Psychology of Discovery and Invention.* New York: HarperCollins, 1996.

———. *The Evolving Self: A Psychology for the Third Millennium.* New York: HarperCollins, 1993.

————. *Flow: The Psychology of Optimal Experience.* New York: HarperCollins, 1991.

Gardner, Howard. *Creating Minds: An Anatomy of Creativity Seen through the Lives of Freud, Einstein, Picasso, Stravinsky, Eliot, Graham, and Gandhi.* New York: Basic Books, 1994.

Runco, Mark A., Robert S. Albert, eds. *Theories of Creativity.* Newbury Park, Calif.: Sage Publications, 1990.

Sternberg, Robert J., ed. *The Nature of Creativity.* New York: Cambridge University Press, 1988.

————, Janet E. Davidson, eds. *The Nature of Insight.* Cambridge, Mass.: MIT Press, 1995.

See also the testimonies in Brewster Ghiselin, ed. *The Creative Process: Reflections on the Invention of Art.* Berkeley: University of California Press, 1996.

Eliade, Mircea. *Shamanism: Archaic Techniques of Ecstasy.* Trans. Willard R. Trask. Princeton, N.J.: Princeton University Press, 1972.

Rothenberg, Jerome, ed. *Technicians of the Sacred: A Range of Poetries from Africa, America, Asia, and Oceania.* Garden City, N.Y.: Anchor, 1969.

THE SUFI POETS AND THINKERS:

Corbin, Henri. *Alone with the Alone: Creative Imagination in the Sufism of Ibn 'Arabī.* Preface by Harold Bloom. Princeton, N.J.: Princeton University Press, 1998.

————. *The Man of Light in Iranian Sufism.* Trans. Nancy Pearson. New Lebanon, N.Y.: Omega Publications, 1994.

————. *Spiritual Body and Celestial Earth: From Mazdean Iran to Shi'ite Iran.* Trans. Nancy Pearson. 2nd ed. Princeton, N.J.: Princeton University Press, 1977.

Shah, Indries. *The Sufis.* Introduction by Robert Graves. Garden City, N.Y.: Anchor, 1964.

The Angelic World

There is a wide and varied literature on angels. Here are works I have found especially helpful, many cited in the text. I am not noting

books already cited, such as Harold Bloom's *Omens of Millennium* and Massimo Cacciari's *The Necessary Angel.*

Adler, Mortimer J. *The Angels and Us.* New York: Macmillan, 1983.

Bachelard, Gaston. *Air and Dreams: An Essay on the Imagination of Movement.* Trans. Edith R. and C. Frederick Farrell. Dallas, Tex.: Dallas Institute Publications, 1988.

Barnstone, Willis, ed. *The Other Bible.* San Francisco: HarperCollins, 1984.

Borges, Jorge Luis. "A History of Angels," *Selected Non-Fictions.* Ed. Eliot Weinberger. New York: Penguin, 1999.

Buber, Martin. *Tales of the Hasidim: The Later Masters.* Trans. Olga Marx. New York: Schocken, 1948.

Collins, John J., and Michael Fishbane, eds. *Death, Ecstasy, and Otherworldly Journeys.* Albany: State University of New York Press, 1995.

Alighieri, Dante. *The Divine Comedy.* Trans. Charles S. Singleton. 3 vols. Princeton, N.J.: Princeton University Press, 1980.

Davidson, Gustav. *A Dictionary of Angels.* New York: Free Press, 1967.

Pseudo-Dionysus. *The Celestial Hierarchy.* In: *The Complete Works.* Trans. Colm Luidheid. New York: Paulist Press, 1987.

Iamblichus. *On the Mysteries.* Trans. A. Wilder. Hastings, England: Chthonios Books, 1989.

Jung, C. G. *Memories, Dreams, Reflections.* Ed. Aniela Jaffé. Trans. Richard and Clara Winston. New York: Pantheon, 1963.

García Márquez, Gabriel. "A Very Old Man with Enormous Wings," *Leaf Storm and Other Stories.* Trans. Gregory Rabassa. New York: Bard, 1973.

McDannell, Colleen, and Bernhard Lang. *Heaven: A History.* New Haven: Yale University Press, 1988.

Milton, John. *Paradise Lost.* Ed. Scott Elledge. New York: W. W. Norton, 1975.

Pagels, Elaine. *The Origin of Satan.* New York: Random House, 1995.

Sardello, Robert, ed. *The Angels.* New York: Continuum, 1995.

Scholem, Gershom. *Kabbalah.* New York: Quadrangle/New York Times Book Co., 1974.

———. Ed. *Zohar: The Book of Splendor: Basic Readings from the Kabbalah.* New York: Schocken, 1963.

Swedenborg, Emanuel. *Heaven and Hell.* New York: Swedenborg Foundation, 1984.

The Story of Jacob's Wrestling with an Angel

Miles, Jack. *God: A Biography.* New York: Alfred A. Knopf, 1995.

Maimonides, Moses. *The Guide for the Perplexed.* Trans. M. Friedlander. 2nd ed. New York: Dover, 1956.

Mann, Thomas. *Joseph and His Brothers.* Trans. H. T. Lowe-Porter. 4 vols. London: Secker and Warburg, 1956.

From the Book to the Book: An Edmond Jabès Reader. Trans. Rosmarie Waldrop. Hanover: Wesleyan University Press, 1991.

Concerning the Angels

Alberti, Rafael. *Concerning the Angels.* Trans. Christopher Sawyer-Lauçanno. San Francisco: City Lights, 1995.

———. *The Lost Grove: Autobiography of a Spanish Poet in Exile.* Trans. Gabriel Burns. Berkeley: University of California Press, 1981.

———. *The Owl's Insomnia.* Trans. Mark Strand. New York: Atheneum, 1973.

———. *To Painting.* Trans. Carolyn L. Tipton. Evanston, Illinois: Northwestern University Press, 1997.

The Rilkean Angel

These are the translations of Rilke's *Duino Elegies* I have found most compelling:

Duino Elegies. Trans. J. B. Leishman and Stephen Spender. New York: W. W. Norton, 1939.

Duino Elegies and the Sonnets to Orpheus. Trans. A. Poulin, Jr. Boston: Houghton Mifflin, 1977.

The Selected Poetry of Rainer Maria Rilke. Ed. Stephen Mitchell. Op. cit., 1982.

"The Duino Elegies" in William Gass, *Reading Rilke.* Op. cit., 1999.

Duino Elegies. Trans. Edward Snow. New York: North Point Press, 2000.

Angel, Still Groping

Grohmann, Will. *Paul Klee.* New York: Harry N. Abrams, n.d.

Klee, Paul. *The Thinking Eye: The Notebooks of Paul Klee.* Ed. Jüng Spiller. Trans. Ralph Manheim. 2nd rev. ed. New York: G. Wittenborn, 1964.

The New Angel

Benjamin, Walter. *Selected Writings, Volume 1, 1913–1926.* Ed. Marcus Bullock and Michael W. Jennings; *Volume 2, 1927–1934.* Ed. Michael W. Jennings, Howard Eiland and Gary Smith. Cambridge, Mass.: Harvard University Press, 1996–99.

Scholem, Gershom, ed. *The Correspondence of Walter Benjamin and Gershom Scholem.* Trans. Gary Smith. Cambridge, Mass.: Harvard University Press, 1992.

Scholem, Gershom. *Walter Benjamin: The Story of a Friendship.* London: Faber and Faber, 1982.

———. "Walter Benjamin and His Angel," *On Jews and Judaism in Crisis: Selected Essays.* Ed. Werner J. Dannhauser. New York: Schocken, 1976.

Three American Angels

Bachelard, Gaston. *The Poetics of Space.* Trans. Maria Jolas. Boston: Beacon Press, 1969.

Barthelme, Donald. "On Angels," *Sixty Stories.* New York: E. P. Dutton, 1982.

Stevens, Wallace. *The Collected Poems of Wallace Stevens.* New York: Alfred A. Knopf, 1968.

————. *Letters of Wallace Stevens.* Ed. Holly Stevens. New York: Alfred A. Knopf, 1966.

————. *The Necessary Angel: Essays on Reality and the Imagination.* New York: Vintage, 1951.

Demon or Bird!

Whitman, Walt. *Poetry and Prose.* New York: Library of America, 1996.

Loving, Jerome. *Walt Whitman: The Song of Himself.* Berkeley: The University of California Press, 1999.

Reynolds, David S. *Walt Whitman's America: A Cultural Biography.* New York: Alfred A. Knopf, 1995.

Between Two Contending Forces

Williams, William Carlos. *The Collected Earlier Poems.* New York: New Directions, 1966.

————. *The Collected Later Poems.* Rev. ed. New York: New Directions, 1967.

————. *Imaginations.* Ed. Webster Schott. New York: New Directions, 1971.

————. *I Wanted to Write a Poem: The Autobiography of the Works of a Poet.* Reported and ed. Edith Heal. Boston: Beacon Press, 1958.

Levertov, Denise. "Williams and the Duende," *The Poet in the World.* New York: New Directions, 1973.

The Sublime Is Now

Frost, Robert. *The Poetry of Robert Frost.* Ed. Edward Connery Lathem. New York: Holt, Rinehart and Winston, 1967.

Dickinson, Emily. *The Complete Poems of Emily Dickinson.* Ed. Thomas H. Johnson. Boston: Little, Brown, 1960.

Chipp, Herschel B., ed. *Theories of Modern Art: A Source Book by Artists and Critics.* Berkeley: University of California Press, 1973.

Howe, Irving. *The American Newness: Culture and Politics in the Age of Emerson.* Cambridge, Mass.: Harvard University Press, 1986.

Homer, William Innes, and Lloyd Goodrich. *Albert Pinkham Ryder, Painter of Dreams.* New York: Harry N. Abrams, 1989.

Goodrich, Lloyd. *Edward Hopper.* New York: Harry N. Abrams, 1971.

Ellison, Ralph. "The Art of Romare Bearden," *The Collected Essays of Ralph Ellison.* Ed. John F. Callahan. New York: Random House, 1995.

Schwartzman, Myron. *Romare Bearden: His Life and Art.* Foreword by Angus Wilson. New York: Harry N. Abrams, 1990.

Simic, Charles. *Dime-Store Alchemy: The Art of Joseph Cornell.* New York: The Ecco Press, 1992.

McShine, Kynaston, ed. *Joseph Cornell.* New York: The Museum of Modern Art, 1990.

In the Painting

Rosenberg, Harold. "The American Action Painters." *Art News.* Vol. 51, No. 8. December, 1952.

Rosenblum, Robert. "The Abstract Sublime," *On Modern American Art: Selected Essays.* New York: Harry N. Abrams, 1999.

Seitz, William C. *Abstract Expressionist Painting in America.* Foreword by Robert Motherwell. Cambridge, Mass.: Harvard University Press, 1983.

JACKSON POLLOCK:

Harrison, Helen A., ed. *Such Desperate Joy: Imagining Jackson Pollock.* New York: Thunder's Mouth Press, 2000.

Karmel, Pepe, ed. *Jackson Pollock: Interviews, Articles, and Reviews.* New York: The Museum of Modern Art, 1999.

O'Connor, Francis V. *The Black Pourings.* Boston: Institute of Contemporary Art, 1980.

O'Hara, Frank. "Jackson Pollock," *Art Chronicles 1954–1966.* New York: George Braziller, 1975.

Rose, Barbara, ed. *Pollock Painting.* New York: Agrinde Publications Ltd., 1980.

Paint It Black

Christopher, Nicholas. *Somewhere in the Night: Film Noir and the American City.* New York: The Free Press, 1997.

Gaugh, Harry F. *The Vital Gesture: Franz Kline.* New York: Abbeville, 1985.

Still, Clyfford, et al. *Paintings, 1944–1960.* New York: Harry N. Abrams, 2001.

Lippard, Lucy R. *Ad Reinhardt.* New York: Harry N. Abrams, 1981.

Doty, Robert, and Diane Waldman. *Adolph Gottlieb.* New York: Frederick A. Praeger, 1968.

Lieber, Edvard. *Willem de Kooning: Reflections in the Studio.* New York: Harry N. Abrams, 2000.

Hess, Thomas B. *Barnett Newman.* New York: The Museum of Modern Art, 1971.

MARK ROTHKO:

Antam, David, ed. *Mark Rothko: The Works on Canvas: catalogue raisonné.* New Haven and Washington: Yale University Press/National Gallery of Art, 1998.

Ashton, Dore. *About Rothko.* New York: Oxford University Press, 1983.

Breslin, James E. B. *Mark Rothko: A Biography.* Chicago: University of Chicago Press, 1998.

Feldman, Morton. *Rothko Chapel; Why Patterns?* New Albion Records. (Sound recording)

Nodelman, Sheldon. *The Rothko Chapel Paintings: Origins, Structure, Meaning.* Houston and Austin: The Menil Collection/The University of Texas Press, 1997.

Motherwell's Black

Robert Motherwell. Text by H. H. Arnason. Introduction by Dore Ashton. 2nd ed. New York: Harry N. Abrams, 1982.

Robert Motherwell. Essays by Dore Ashton and Jack D. Flam. Introduction by Robert T. Buck. New York: Abbeville Press, 1983.

The Collected Writings of Robert Motherwell. Ed. Stephanie Terenzio. Berkeley: University of California Press, 1999.

Deaths and Entrances

Carter, Alexandra, ed. *The Routledge Dance Studies Reader.* New York: Routledge, 1998.

Croce, Arlene. *Writing in the Dark, Dancing in The New Yorker.* New York: Farrar, Straus and Giroux, 2000.

Denby, Edwin. *Dance Writings and Poetry.* Ed. Robert Cornfield. New Haven: Yale University Press, 1998.

Jowitt, Deborah. *Time and the Dancing Image.* Berkeley: University of California Press, 1988.

MARTHA GRAHAM:

de Mille, Agnes. *Martha: The Life and Work of Martha Graham.* New York: Random House, 1991.

Graham, Martha. *The Notebooks of Martha Graham.* New York: Harcourt Brace Jovanovich, 1973.

Stodelle, Ernestine. *Deep Song: The Dance Story of Martha Graham.* New York: Schirmer, 1984.

Ancient Music and Fresh Forms

A few of the writings I have found most stimulating in the literature on jazz and blues:

Dyer, Geoff. *But Beautiful: A Book About Jazz.* New York: North Point Press, 1996.

Ellison, Ralph. *Living with Music: Ralph Ellison's Jazz Writings.* Ed. Robert G. O'Meally. New York: The Modern Library, 2001.

Giddins, Gary. *Visions of Jazz: The First Century.* New York: Oxford University Press, 1998.

Gioia, Ted. *The History of Jazz.* New York: Oxford University Press, 1997.

Gottlieb, Robert. *Reading Jazz: A Gathering of Autobiography, Reportage, and Criticism from 1919 to Now.* New York: Pantheon, 1996.

Mellers, Wilfrid. *Music in a New Found Land: Themes and Developments in the History of American Music.* New York: Oxford University Press, 1987.

Stearns, Marshall W. *The Story of Jazz.* New York: Oxford University Press, 1970.

Williams, Martin. *The Jazz Tradition.* 2nd rev. ed. New York: Oxford University Press, 1993.

ON ROBERT JOHNSON:

Guralnick, Peter. *Searching for Robert Johnson.* New York: E. P. Dutton, 1989.

Marcus, Greil. "Robert Johnson, 1938," *Mystery Train: Images of America in Rock 'N' Roll Music.* New York: Plume, 1990.

America Heard in Rhythm

Harper, Michael S., Anthony Walton, eds. *Every Shut Eye Ain't Asleep: An Anthology of Poetry by African Americans Since 1945.* Boston: Little, Brown, 1994.

Feinstein, Sascha, and Yusef Komunyakaa, eds. *Jazz Poetry Anthology, Volumes 1, 2: The Second Set.* Bloomington: Indiana University Press, 1991–1996.

Louis Armstrong, In His Own Words: Selected Writings. Ed. Thomas David Brothers. New York: Oxford University Press, 1999.

Collier, James Lincoln. *Louis Armstrong: An American Genius.* New York: Oxford University Press, 1983.

Giddins, Gary. *Celebrating Bird: The Triumph of Charlie Parker.* New York: William Morrow, 1987.

Woideck, Carl. *Charlie Parker: His Music and Life.* Ann Arbor: University of Michigan Press, 1996.

ON MILES DAVIS:

Davis, Miles, with Quincy Troupe. *Miles: The Autobiography.* New York: Simon and Schuster, 1989.

Kahn, Ashley. *Kind of Blue: The Making of the Miles Davis Masterpiece.* New York: Da Capo, 2000.

Nisenson, Eric. *The Making of Kind of Blue: Miles Davis and His Masterpiece.* New York: St. Martin's, 2000.

Tynan, Kenneth. "The Antic Arts: Miles Apart." *Holiday.* Vol. 33, No. 2, 1963.

Hey, I'm American, So I Played It

Murray, Charles Shaar. *Crosstown Traffic: Jimi Hendrix and the Rock N' Roll Revolution.* New York: St. Martin's, 1989.

 Jimi Hendrix plays "Sky Church," "The Star-Spangled Banner," and "Purple Haze" in *Woodstock 2.* Director: Michael Wadleigh. *Jimi Hendrix: Live at Woodstock* (MCA) features Hendrix's entire legendary set.

Berg, Stephen, ed. *Naked Poetry.* New York: Bobbs Merrill, 1977.

Bly, Robert. *Leaping Poetry: An Idea with Poems and Translations.* Boston: Beacon Press, 1975.

Fending Off the Duende

Johnson, Samuel. *The Complete English Poems.* Ed. J. D. Fleeman. New York: Penguin, 1971.

———. *Lives of the English Poets.* Ed. George Barbeck Hill. New York: Octagon, 1967.

Bate, W. Jackson. *Samuel Johnson.* New York: Harcourt Brace Jovanovich, 1977.

The Existentialist Flatfoot Floogie

Livingston, Jane, et al. *The Art of Richard Diebenkorn.* Berkeley: University of California Press, 1997.

Gourse, Leslie, ed. *The Ella Fitzgerald Companion: Seven Decades of Commentary.* New York: Schirmer, 2000.

Carruth, Hayden. *Collected Shorter Poems 1946–1991.* Ford Worden State Park, Wash.: Copper Canyon Press, 1992.

Matthews, William. *Selected Poems and Translations 1969–1991.* Boston: Houghton Mifflin, 1992.

Meredith, William. *The Cheer.* New York: Alfred A. Knopf, 1980.
Wilbur, Richard. *New and Collected Poems.* New York: Harcourt Brace Jovanovich, 1988.

Poet in New York

Federico García Lorca. *Poeta en Nueva York/Tierra y luna.* Ed. Eutimio Martín. Barcelona: Ariel, 1981.
Translations of *Poet in New York* in chronological order:
The Poet in New York and Other Poems of Federico García Lorca. Trans. Rolfe Humphries. New York: W. W. Norton, 1940.
Poet in New York. Trans. Ben Belitt. Introduction by Angel Del Rio. Op. cit. 1955.
Robert Bly's excerpts in *Lorca and Jiménez: Selected Poems.* Op. cit. 1973.
Poet in New York. Ed. Christopher Maurer. Trans. Greg Simon and Steven F. White. Op. cit. 1988.

CRITICISM:
Harris, Derek. *García Lorca: Poeta en Nueva York.* London: Grant and Cutler, 1978.

Where Is the Angel? Where Is the Duende?

de Solms, É. *Anges et Démons.* Introduction by R. P. Louis Bouyer. Yonne, France: Zodiaque, 1972.

Selected Discography

FLAMENCO
Antalogia del Cante Flamenco, Hispavox, 3 records.
Colección Federico García Lorca, Sonifolk. A recording of Lorca's flamenco music collection.
Duende: From Traditional Masters to Gypsy Rock, Ellipsis Arts, 3 audiocassettes.
Early Cante Flamenco: Classic Recordings from the 1930s, Arhoolie.
Fosforito, *El Cante de Fosforito,* Belter.
Grandes Figures du Flamenco: Volume 1 (Pepe Matrona), Volume 2

(El Niña de Almadén), Volume 3 (La Niño de los Peines), Volume 4 (Terremoto), Volume 5 (Ramón Montoya), Volume 6 (Carmen Amaya), Volume 7 (Manolo Caracol), Volume 8 (Manuel Agujerta), Volume 9 (Antonio Mairena), Volume 10 (Pepe Marchena), Volume 11 (Niño Ricardo), Volume 12 (Tío Gregorìo El Borrico), Le Chant du Monde.

Antonio Mairena, *Gran Historia del Cante Gitano-Andaluz*, Columbia, 3 records.

Antonia Mercé, *Colección de Canciones Populares Españolas*, Sonifolk. A 1931 recording of La Argentina singing a repertoire of classic Spanish songs, including flamenco, with Lorca accompanying her on the piano.

Carlos Montoya, *Guitarra Flamenca*, Hispavox.

Paco de Lucía, *El Duende Flamenco*, Phillips.

Sabicas, *The Day of the Bullfight*, ABCS.

Juan Talegas, *Una Reliquia del Cante Gitano*, Columbia.

Terremoto, *Genio y Duende del Cante Gitano*, Hispavox.

Manuel Torre, *Los ases del Flamenco: Manuel Torre/El Tenazas de Moron*, EMI.

JAZZ AND BLUES

Louis Armstrong, *The Hot Fives, Volume 1; The Hot Fives and Hot Sevens, Volume 2* and *Volume 3; Louis Armstrong, Volume 4: Louis Armstrong and Earl Hines*, Columbia.

Chet Baker, *The Best of Chet Baker Plays; Let's Get Lost: The Best of Chet Baker Sings*, Pacific Jazz.

Clifford Brown, *Clifford Brown and Max Roach at Basin Street*, Mar- Mercury.

John Coltrane, *A Love Supreme; Live at the Village Vanguard*, Impulse.

Miles Davis, *Kind of Blue; Round About Midnight; Sketches of Spain*, Columbia.

Ella Fitzgerald, *The Rodgers and Hart Songbook*, Verve, 2CD.

Dizzy Gillespie, *The Complete RCA Victor Recordings 1937–1949*, Bluebird / RCA, 2CD.

Benny Goodman, *Live at Carnegie Hall: 1938 Complete,* Columbia, 2CD.

Coleman Hawkins, *Body and Soul,* Bluebird/RCA.

Billie Holiday, *The Complete Commodore Recordings,* Commodore, 2CD; *Lady in Satin,* Columbia.

Son House, *Father of the Delta Blues: The Complete 1965 Sessions,* Columbia, 2CD.

Howlin' Wolf, *The Chess Box,* Chess Records, 3CD.

Blind Lemon Jefferson, *The Best of Blind Lemon Jefferson,* Yazoo.

Robert Johnson, *The Complete Recordings,* Columbia, 2CD.

Lightnin' Hopkins, *Double Blues,* Fantasy.

Mississippi John Hurt, *Last Sessions,* Vanguard.

Jackie McLean, *Let Freedom Ring,* Blue Note.

Charles Mingus, *Mingus Ah Um; Let My Children Hear Music,* Columbia.

Theolonius Monk, *Genius of Modern Music, Volume 1 and Volume 2,* Blue Note.

Charlie Parker, *Charlie Parker,* Verve; *Charlie Parker on Dial: The Complete Sessions,* Spotlite/Dial, 4CD; *Charlie Parker Memorial: Volume 1* and *Volume 2,* Savoy.

Charley Patton, *Charley Patton: Founder of the Delta Blues,* Yazoo.

Art Pepper, *Art Pepper Meets the Rhythm Section,* OJC/Contemporary.

Bud Powell, *The Genius of Bud Powell,* Verve.

Sonny Rollins, *The Bridge,* RCA.

Bessie Smith, *The Collection,* Columbia.

Lester Young, *The "Kansas City" Sessions,* Commodore.

Acknowledgments

THIS BOOK GREW OUT OF an initial essay entitled "The Duende," which was published in *American Poetry Review* (July/ August 1999) and benefited a good deal from the articulate enthusiasm and advice of its editor, Stephen Berg. I also delivered it as a lecture at the Bread Loaf Writers' Conference, and I am especially grateful to my friends Michael Collier and Patricia Hampl, among others, for their perceptive advice.

The Demon and the Angel was undertaken and written under the generous auspices of a MacArthur Fellowship, which helped make it possible.

My special thanks to the poets Nicholas Christopher and Adam Zagajewski for their enabling conversations about poetry in general and about this essay in particular. Stuart Dybek generously shared with me his wide-ranging knowledge of many art forms, but especially music of all kinds, and I am indebted to him for his rich insights into the work at hand. I am lucky to have a fine agent in Liz Darhansoff. I also consider myself deeply fortunate to have such an exceptional instigating editor and friend in André Bernard. He is a model presence.

This book is dedicated to the poet Philip Levine, who has so much duende.

My deep love goes to out to my wife, Janet Landay, and to our son, Gabriel Hirsch, sustaining sources.

Permissions Acknowledgments

Douglas Crase, excerpt from "Blue Poles" from *The Revisionist*. Copyright © 1981 by Douglas Crase. Reprinted with the permission of Little, Brown and Company (Inc.).

J. V. Cunningham, excerpt from "Montana Fifty Years Ago" from *The Poems of J. V. Cunningham*, edited by Timothy Steele. Copyright © 1997 by J. V. Cunningham. Reprinted with the permission of Swallow Press/Ohio University Press.

Everett Fox (trans.), excerpt from *Genesis 32: 27–31: The Five Books of Moses*. Copyright © 1983, 1986, 1990, 1995 by Schocken Books. Reprinted with the permission of Schocken Books, a division of Random House, Inc.

Barbara Guest, excerpt from "All Elegies Are Black and White" from *The Location of Things* (New York: Doubleday, 1962). Reprinted with the permission of the author.

Anthony Hecht, excerpt from "More Light! More Light!" from *Collected Earlier Poems*. Copyright © 1990 by Anthony E. Hecht. Reprinted with the permission of the author and Alfred A. Knopf, a division of Random House, Inc.

Heinrich Heine, excerpt from "Morphine" from *The Complete Poems of Heinrich Heine: A Modern English Version*, translated by Hal Draper (Boston: Suhrkamp/Insel, 1982). Reprinted by permission.

Edward Hirsch, "The Duende" from *American Poetry Review* (July/August 1999). Copyright © 1999 by Edward Hirsch. Reprinted with the permission of the author.

Denis Johnson, "Incognito Lounge" (excerpt) from *The Throne of the Third Heaven of the Nations Millennium General Assembly: Poems Collected and New*. Copyright © 1995 by Denis Johnson. Reprinted with the permission of HarperCollins Publishers, Inc.

"Stones in My Passway" and "Me and the Devil Blues" words and music by Robert Johnson. Copyright © 1978, 1990, 1991 King of Spades Music. All rights reserved. Used by permission.

Giacomo Leopardi, excerpt from "L'Infinito" from *A Leopardi Reader*, translated by Ottavio Mark Casale (Urbana: University of

Index